In fine Style

The Art of Tudor and Stuart Fashion

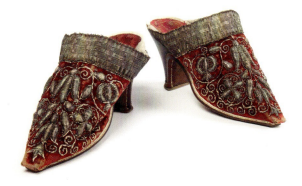

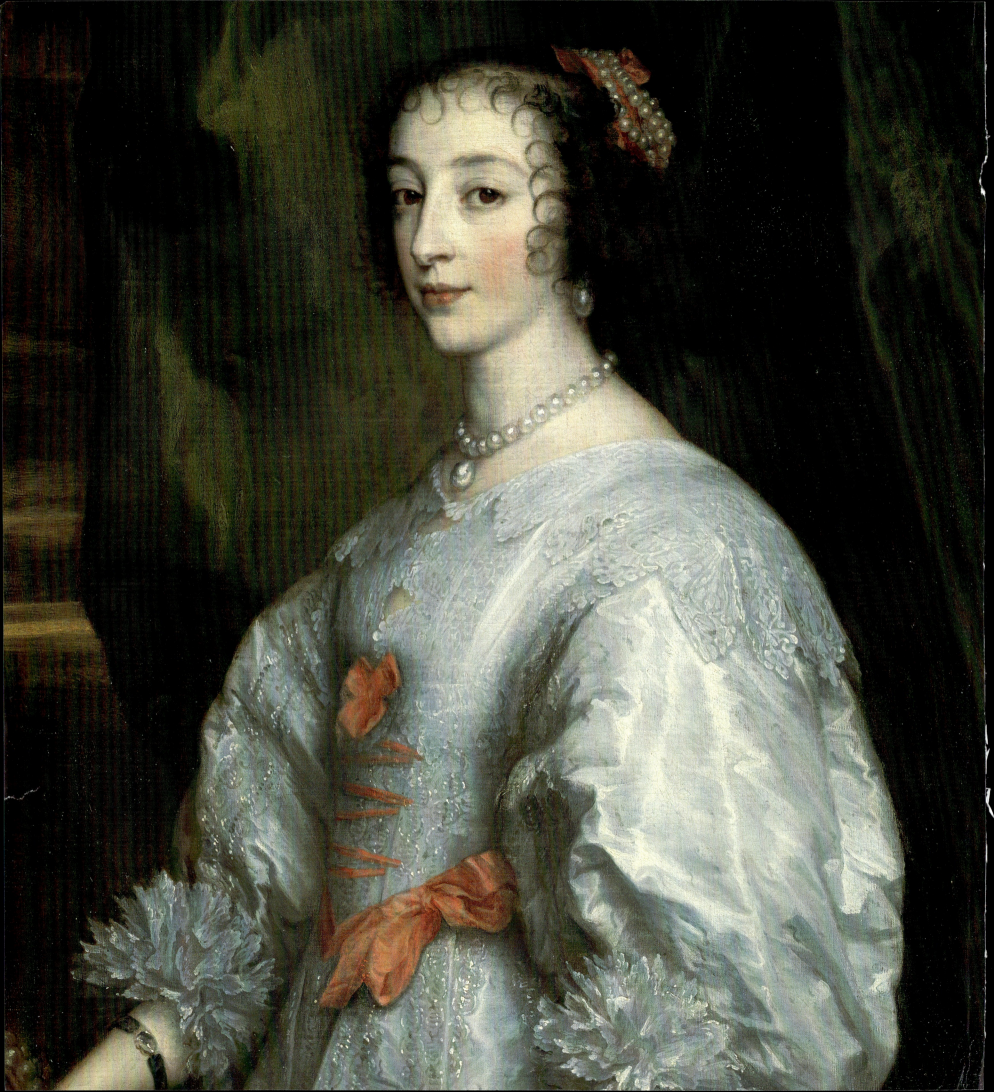

In fine Style

The Art of Tudor and Stuart Fashion

ANNA REYNOLDS

ROYAL COLLECTION TRUST

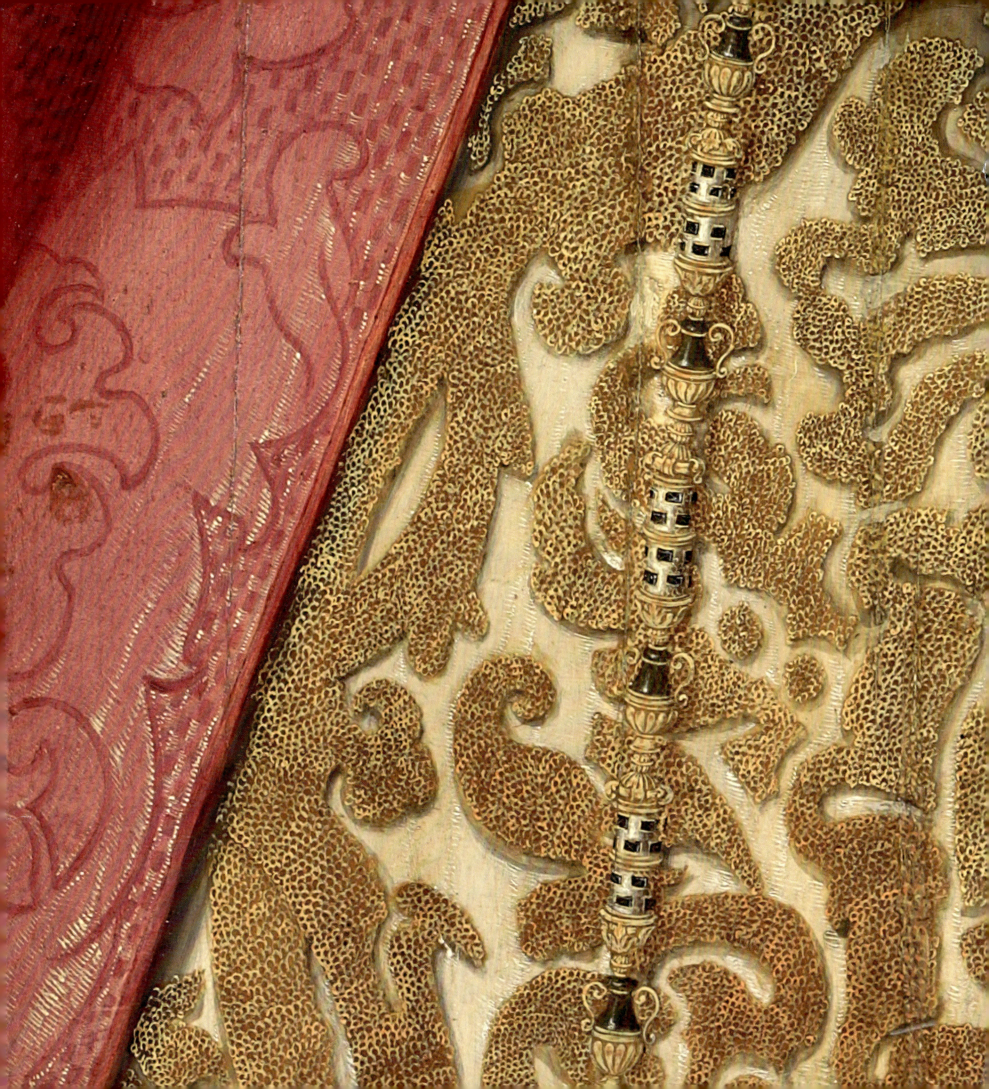

CONTENTS

INTRODUCTION
6

CHAPTER 1
DRESS AND ITS MEANINGS
10

CHAPTER 2
DRESSING WOMEN
30

CHAPTER 3
DRESSING MEN
78

CHAPTER 4
DRESSING CHILDREN
120

CHAPTER 5
PAINTING DRESS
134

CHAPTER 6
FASHION ACROSS THE BORDERS
184

CHAPTER 7
PAINTED FOR BATTLE AND THE HUNT
222

CHAPTER 8
PLAYING A PART
266

NOTES 288

GLOSSARY 292

BIBLIOGRAPHY 294

ACKNOWLEDGEMENTS 295

INDEX 296

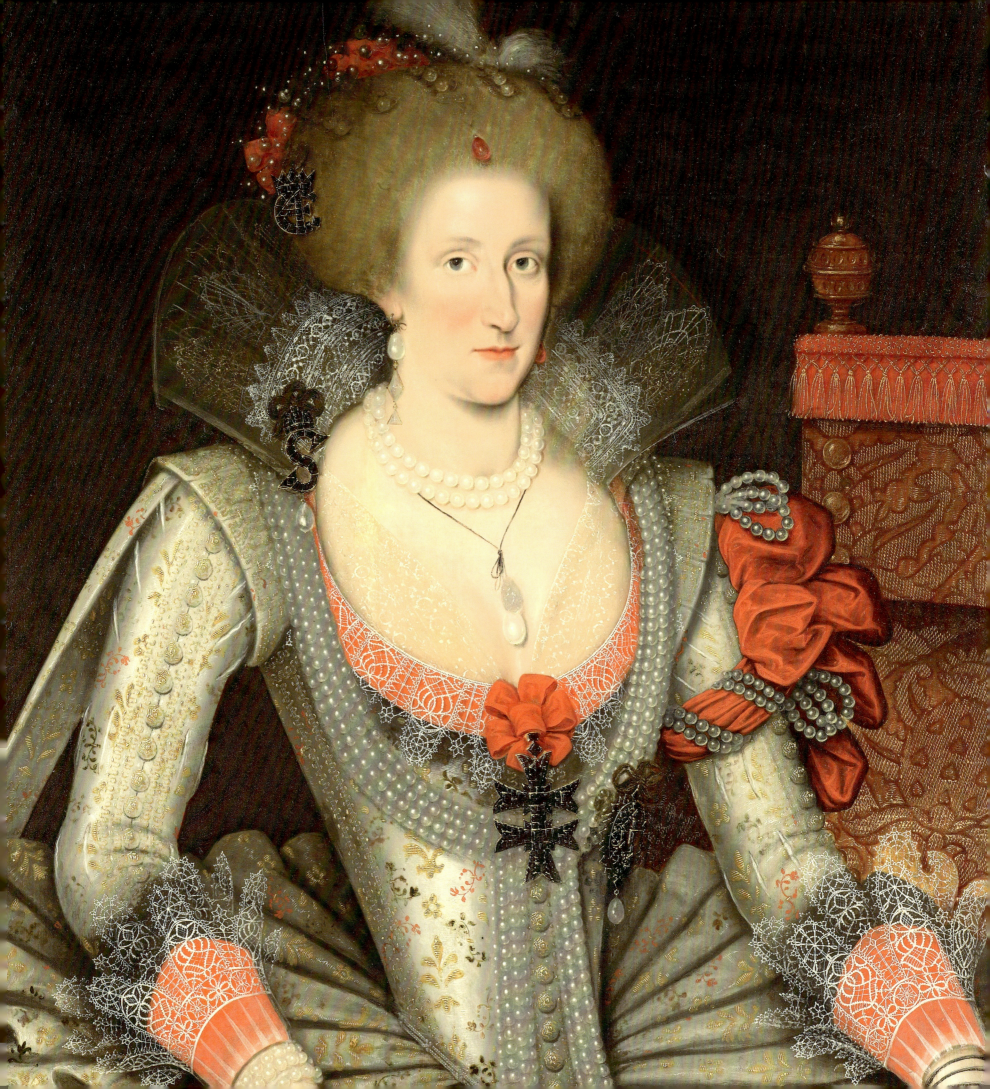

INTRODUCTION

THE WORD 'finery' – first used during the 1670s as a descriptive term for elaborate and showy attire – encapsulates the qualities so intrinsic to the fashionable elite clothing of the Tudor and Stuart eras. In their rich fabrics, shimmering jewellery and complex hairstyles, monarchs and those surrounding them were moving displays of expensive finery from head to toe. These leading tastemakers of the period were, in the words of one seventeenth-century poet, 'walking pictures'.[1]

This book discusses fashionable clothing worn between the year 1485 when Henry VII acceded to the throne of England as the first monarch in the House of Tudor, and the death of Queen Anne, the last Stuart monarch, in 1714. Due to the scarcity of surviving garments, especially from the earlier period, it does this largely through portraits – the majority of which are in the Royal Collection. Throughout, however, the book recognises and emphasises the vital role that extant garments and objects play in developing our understanding of the fashions worn, and wherever possible comparable three-dimensional objects are included to reveal more about those items portrayed in paint. The title is a deliberate play on the dual use of the word 'style' – as both a mark of that which is modish and of-the-minute, and also as a term that captures the concept of artistic technique. The paintings, and the clothes depicted within them, can be interpreted as works of art.

This is not just a survey of royal fashion. Monarchs are included, of course, but fashion was also of major concern to a broader group of people – the monarch's extended family, the men and women making up the court, together with the upwardly mobile and increasingly wealthy gentry classes. The book examines the way that these figures clothed themselves each day. Portraiture of the sixteenth and seventeenth centuries inevitably portrays the elite members of society – those individuals whose wealth made the commissioning of a portrait possible. The situation is exaggerated within the Royal Collection, where the provenance of the works of art is intrinsically bound up with the royal household. This text, therefore, tells a story of elite fashion during the Tudor and Stuart period.

During this period style was dictated by the court. The 'trickle-down theory' of fashion explains that the clothes of the elite are imitated in modified form by the lower social orders.

Fig. 1 (detail) Attributed to Marcus Gheeraerts the Younger (c.1561–1635), *Anne of Denmark*, 1614.
Oil on panel, 110.5 x 87.3 cm. RCIN 404437

He flutters up and down like a Butterfly in a Garden; and while he is pruning of his Peruque takes Occasion to contemplate his Legs and the Symmetry of his Britches. He is part of the Furniture of the Rooms, and serves for a walking Picture, a moving Piece of Arras. His Business is only to be seen, and he performs it with admirable Industry, placing himself always in the best Light ... His Taylor is his Creator, and makes him of nothing.

'A Huffing Courtier' from *Characters*, Samuel Butler, 1667–9

The higher orders then change their styles in order to differentiate themselves from the masses and the process starts again, in a repeating cycle of changing fashions.[2] To the Tudor and Stuart elite, fashionable clothing was a means to display social status – and, for most of the period, to be fashionable required dressing in the most luxurious, sumptuous and expensive clothing available. This type of attire was reserved for the wealthiest section of society, who could afford the most complex, highly decorated silks, and had plenty of spare time to devote to the pursuit of fashionability and the lengthy process of dressing. Rich clothing was not seen as a sign of weakness and ostentation but as a legitimate and admirable proclamation of an individual's worth. Conspicuous consumption was even viewed as a form of charity, a way for the rich to redistribute wealth throughout society by providing employment and work for idle hands. But at the end of the seventeenth century we see the beginnings of a self-conscious shift towards a new aesthetic, a more modest and understated style of clothing for men at least – although by this date such fashionable styles are more frequently shown in fashion plates than formal portraiture.

In the sixteenth century it was customary for a portrait to show a sitter in formal attire, often a courtier in court dress – that is, dress worn to be received at court, the form of which was governed by a rigid code of etiquette. This usually consisted of the most formal, least comfortable outfit in a sitter's wardrobe, constructed of the most expensive highly decorated fabrics, its formality intended as flattery to the monarch. But court dress became increasingly eschewed by the most fashionable, for certain occasions at least (including sitting for a portrait). By the second quarter of the seventeenth century many English portraits show their sitters self-consciously avoiding the formality of court dress, and by the end of the century court dress had become an out-of-date style worn for specific occasions only and infrequently depicted in paint.

Chapter 1 looks at some of the messages that clothing in portraiture can convey to both the original and the present-day audience. By then discussing, through portraits, the various elements making up male and female clothing during the period, chapters 2, 3 and 4 are intended to help the modern viewer understand more about the various layers of clothing, and may encourage a deeper appreciation of the expense and labour involved in producing such extraordinary garments. Chapter 5 addresses some of the ways in which portrait artists depicted

the various types of fabrics, and highlights the difficulties of translating three-dimensional garments into two-dimensional representations. It also discusses some of the studio practices adopted by artists that related specifically to the portrayal of clothing. While the main focus of this book is on the fashions worn within England and Scotland it is impossible to ignore the huge influence played by fashions of other countries, given that the connections between royal courts were both intimate and far-reaching. Chapter 6 looks into some of the ways fashions were spread between countries. It also discusses some of the key ways that Italy, Spain, France and the Low Countries exerted their influence on styles within England, and identifies some of the distinctive features of fashions within each region. Chapter 7 examines the links between fashion and the battlefield, and discusses why members of the nobility chose to be painted in military attire. The final chapter examines the notion of playing a role, be it performing on stage for the courtly masque or in the Restoration playhouse. A glossary provides definitions of the most common words for each item of dress during the period.

Fashion seeks novelty and so, by its very nature, fashionable clothing changes over time. While the pace of change in fashion remained much slower during this period than today, it quickened during the seventeenth century and we start to get a sense of seasonal changes. Deliberately excluded from consideration in this analysis are fossilised styles of dress retained for ceremonial purposes – coronation robes, for example, or those worn by members of chivalric orders. It also excludes ecclesiastical, clerical and legal attire, as well as household livery. Such garments are deliberately backward-looking, emphasising tradition over innovation, and are less reflective of the choices of the wearer than fashionable clothing. Sometimes, however, it can be hard to disentangle the two as the world of ceremonial can cross into the world of fashion. Charles I, for example, ordered in 1626 that all Knights of the Garter have the badge of the Order embroidered on the left side of their outer garments – this was applied to all clothing, including riding coats and fashionable cloaks.[3]

This is the first publication to concentrate exclusively on costume history with particular reference to the paintings in the Royal Collection. It is hoped that examining the collection's wide range of treasures specifically through the lens of fashion may lead to an insightful exploration of a fascinating period, giving a new perspective on the importance of clothing to portraits and to the people represented within them.

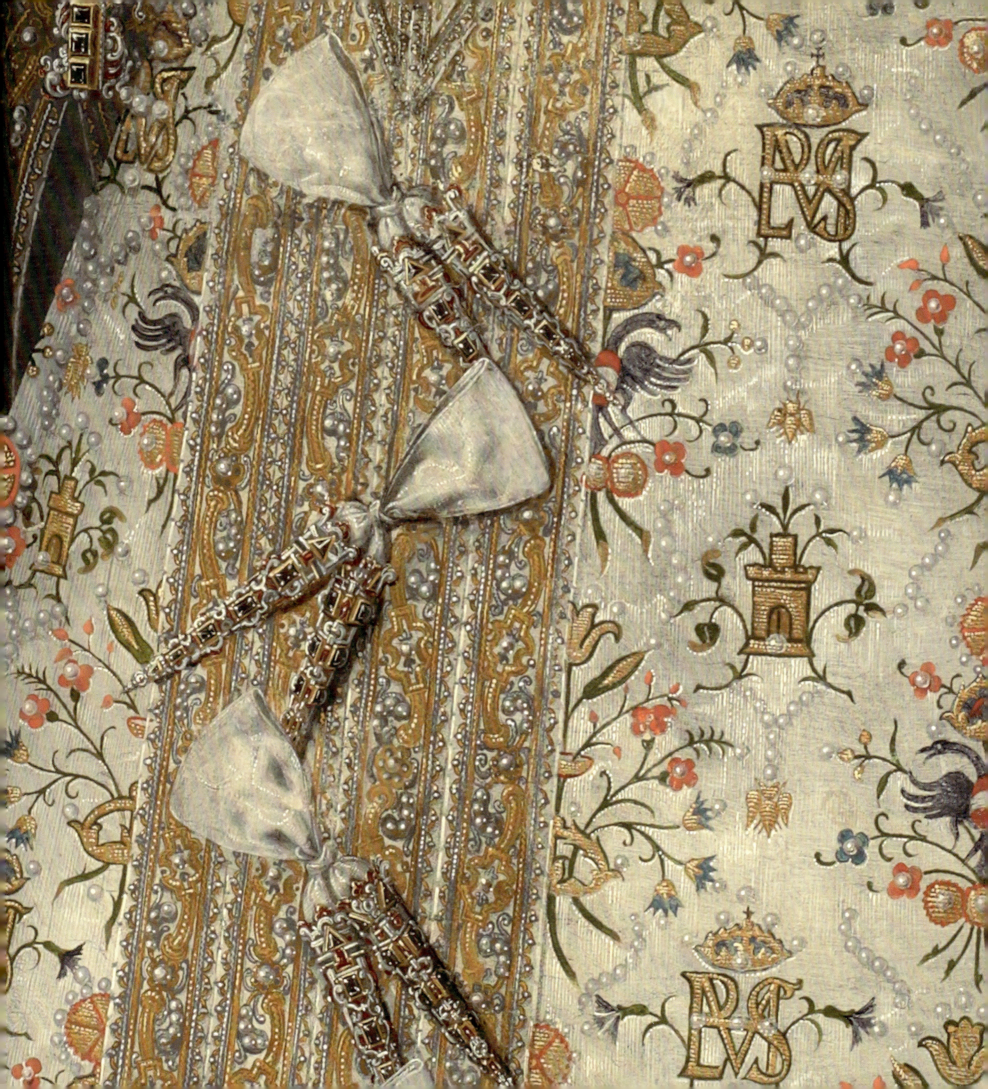

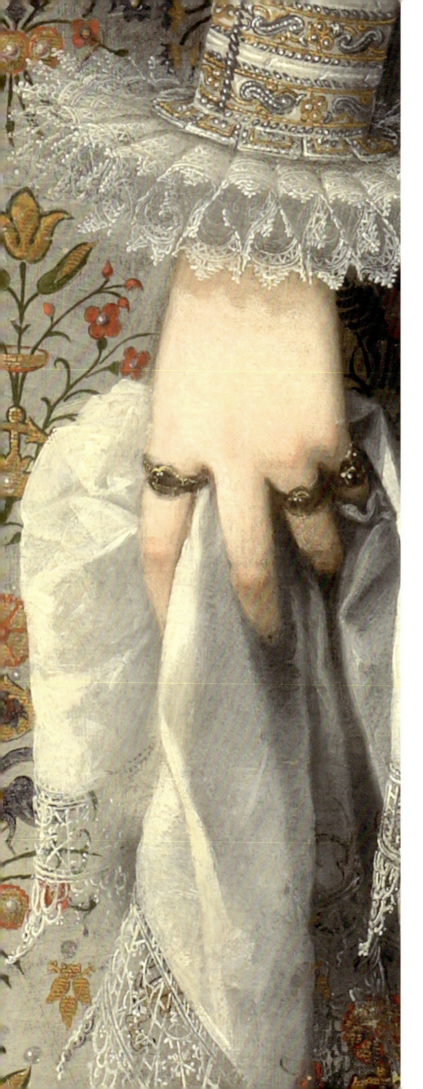

1

DRESS AND ITS MEANINGS

Costly thy habit as thy purse can buy,
But not express'd in fancy; rich, not gaudy:
For the apparel oft proclaims the man ...

Polonius to Laertes, *Hamlet*, Act I, scene iii

EVEN when it conceals the body, clothing is revealing. For the sixteenth- or seventeenth-century audience, clothing could reveal information about a wearer's social position, wealth, religion, nationality, marital status, fashionability and so on. Today, given our inevitably incomplete knowledge of the social context in which the paintings were produced and viewed, some of the subtle nuances have been lost. Traditionally, the importance of clothing in portraiture to the modern viewer or researcher has usually been as a tool for dating a portrait. Yet the clothing worn, together with the manner in which it has been painted by the artist, can reveal so much more – it can help identify a sitter, artist or provenance, and more broadly can provide information about sixteenth- and seventeenth-century society and attitudes.

This chapter places fashionable clothing of the Tudor and Stuart period within its cultural context, looking at the varying attitudes of monarchs towards fashion, and at the court culture that placed such emphasis on fashionability. It then demonstrates why clothing (sometimes viewed as a superficially appealing but ultimately frivolous element of a painting) can be so integral to its interpretation. It examines what clothing in a portrait can reveal, while also demonstrating the importance of surviving garments and other sources.

MONARCHS AND FASHION

Like the population as a whole, monarchs varied in their personal interest in fashion and used clothing in different ways. For a king like Henry VIII, highly aware of the role of art, architecture and performance as a tool for propaganda, clothing constructed from rich fabrics played a vital role in the creation of both his personal image of magnificence as well as the reputation of his court as prosperous during a period of severe religious disruption (fig. 2). For his daughter Elizabeth I, dress was a key component in her iconography, its colour and complex symbolism contributing to the cult of the Virgin Queen. Portraits depict the idiosyncratic and eclectic patterning of clothing and jewellery that was a feature of her dress (fig. 3). Amongst the Stuart monarchs, Charles I cultivated a less ostentatious vision of fashionability than his predecessors – its restrained elegance fitted with the monarch's reserved personality and tendency to favour grandeur and formality, a taste which was to some extent tempered by his young and vivacious French queen Henrietta Maria and the influence of fashions from an increasingly powerful French court. Upon his restoration to the English throne in 1660 their son Charles II, with severely limited funds

Pp. 10–11 (detail from fig. 12) Juan Pantoja de la Cruz (c.1553–1608), *Margaret of Austria, Queen Consort of Philip III of Spain*, c.1605.

Fig. 2 Remigius van Leemput (d. 1675), *Henry VII, Elizabeth of York, Henry VIII and Jane Seymour* (copy of 'The Whitehall Mural'), 1667.
Oil on canvas, 88.9 x 99.2 cm. RCIN 405750

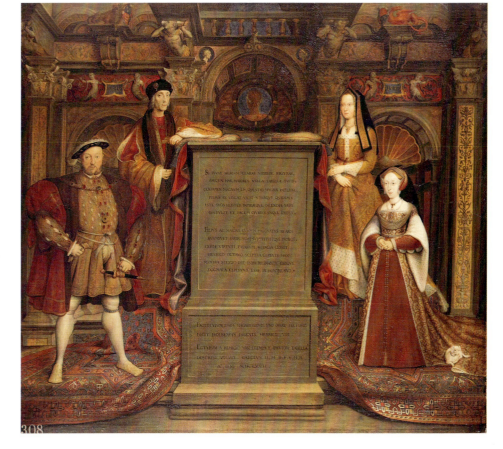

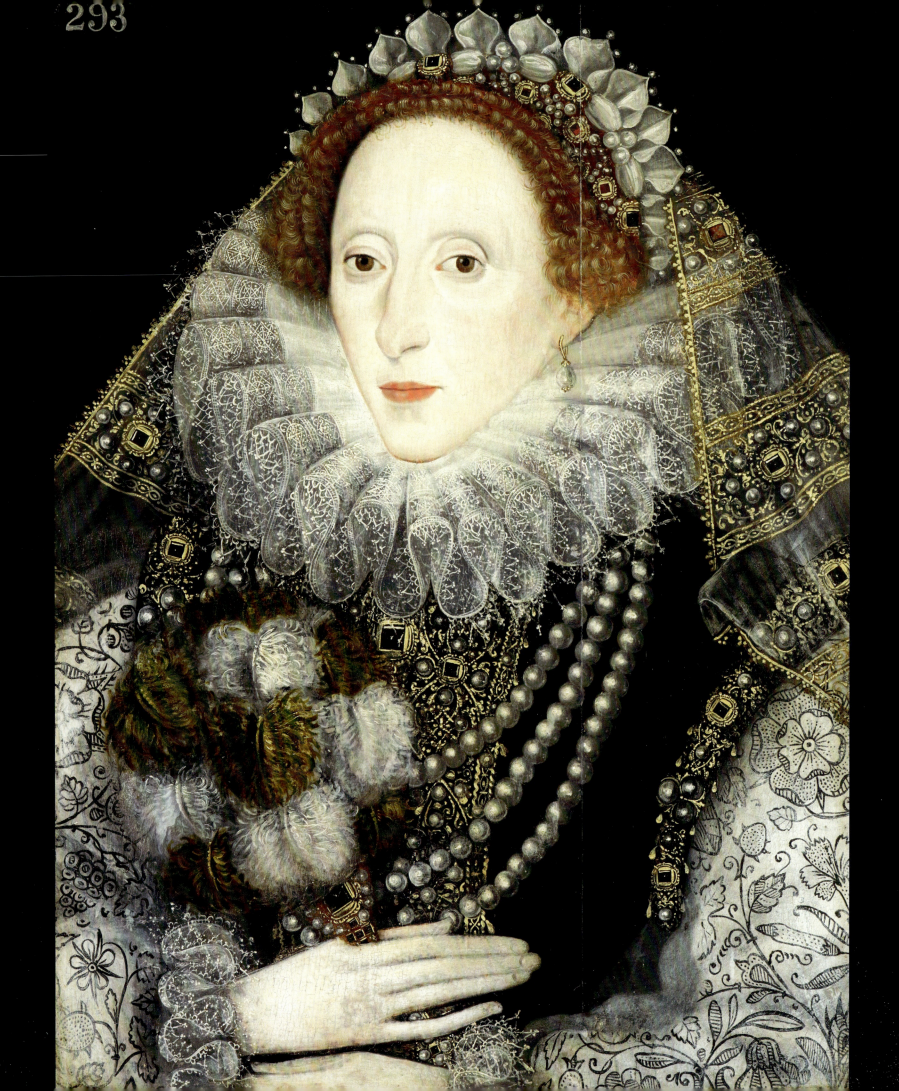

at his disposal, was unable to compete with other European rulers in the lavishness of his clothing. Yet he made his mark in other ways – and his pivotal role in the development of the three-piece suit will forever give him a starring role in the history of male fashion. Mary II as a glamorous young woman on the throne enjoyed contemporary fashions and, once given the budget to indulge this interest, spent a significant sum on clothing and accessories. Even for those monarchs traditionally considered less interested in fashion, evidence suggests that many understood the value of fashion at court and appreciated fashionability in others. While neglectful of his own appearance, James I strove to present his court as cultured and fashionable throughout Europe, and expected his courtiers to be finely dressed. William III is traditionally regarded as a military-minded and serious monarch, yet this and his dedication to the Calvinist faith did not preclude him from wearing stockings in vivid colours or running up an annual lace bill of £2,459 in 1695–6 (equivalent to over £215,000 in today's money).[1]

The influence of the royal family over their households and the court meant that they were often seen as leaders of fashion. Several examples exist of particular innovations being attributed to particular royals. The introduction of blackwork embroidery to England from Spain, for example, is often credited to Catherine of Aragon, and the popularisation of the Spanish farthingale in England to the arrival of her entourage. Catherine of Braganza announced in 1666 that she would start a fashion for shorter skirts to coincide with the launch of the new male vest by her husband. The resulting trend for raised hemlines, which revealed shoes and silk stockings to the ankle, spread throughout the court and was reported by the French ambassador.[2]

Even when a monarch was not directly responsible for the initial development of a new fashion, its adoption by members of the royal family gave it a seal of approval that made it desirable. Diarist Samuel Pepys, for example, only started wearing a wig after overhearing the Duke of York say that he was going to wear one. Some fashions were in homage to a monarch – to greet William of Orange from the Dutch Republic after the Glorious Revolution of 1688, the population wore orange ribbons in their hats and headdresses, while female courtiers wore orange dresses.[3] Sir Peter Lely's depiction of Mary, Princess of Orange, in a dark orange gown (fig. 4) is surely no coincidence (although his palette did tend to favour warm colours). This particular shade is used relatively infrequently by the artist, and is possibly a reference to her new title or to the colour of the Dutch flag.[4]

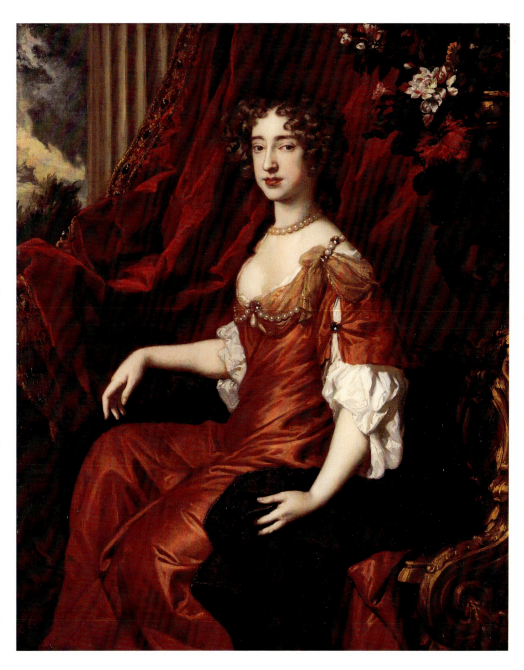

Fig. 4 Sir Peter Lely (1618–80), *Mary II when Princess of Orange*, 1677(?).
Oil on canvas, 126.0 × 102.3 cm. RCIN 402587

OPPOSITE
Fig. 3 British School, *Elizabeth I*, c.1580–5.
Oil on panel, 56.9 × 43.7 cm. RCIN 405749

DRESS AND ITS MEANINGS 15

THE COURT

As one historian has written, 'the court was not only a machine of government; it was also the machine for conspicuous expenditure'.[5] Fashioning the personal appearance of people at court formed a significant proportion of that expenditure. The physical location of this 'machine' was the Palace of Whitehall, a vast and sprawling collection of buildings on the banks of the Thames, estimated to consist of around 2,000 rooms. It is visible in the background of fig. 5. After its seizure from Cardinal Wolsey, Whitehall was rebuilt by Henry VIII in the 1530s. It remained the most important royal residence until its almost complete destruction by fire in 1698 – essentially the period under discussion in this book. The monarch's apartments were at Whitehall when at court in London (a peripatetic lifestyle meant much time was also spent at other royal residences outside the capital).

A change in the structure of the court at the beginning of this period caused the distinction between the public and private life of the monarch to become more pronounced. The new configuration, completed by Henry VIII, was modelled on the French court. Only the limited few with access to the Privy Chamber (under the Tudors) or the Bedchamber (under the Stuarts) were granted the closest access to the monarch. The First Gentleman of the Bedchamber (known as the Groom of the Stool) at the court of James I, for example, slept in the same room as the king, and amongst other jobs was responsible for putting on his shirt each morning.[6] On the other side of this physical and symbolic divide (marked by the room known as the Presence Chamber), the monarch lived a semi-public life at court. Gerrit Houckgeest illustrates one of these semi-public events in his painting of Charles I, Henrietta Maria and the Prince of Wales dining in public (fig. 6). The royal party, seated on the left, are attended by servants (in orange livery) and courtiers (in the left foreground wearing suits of red and black). In the distance, behind a balustrade, members of the court are permitted to watch the occasion. To be allowed access to the monarch, whether as part of the larger court circle or as one of the exclusive group granted access to the private apartments, was an important privilege for the select few.

A key obligation for the courtier was to reflect the glory of the monarch through splendid attire. In addition, one of the best ways to get noticed at court was through the use of clothing – sartorial competitiveness prompted an insatiable search for the novel in order to distinguish one courtier from the herd. Competition also extended to the process of gift-giving. Courtiers were expected to provide the monarch

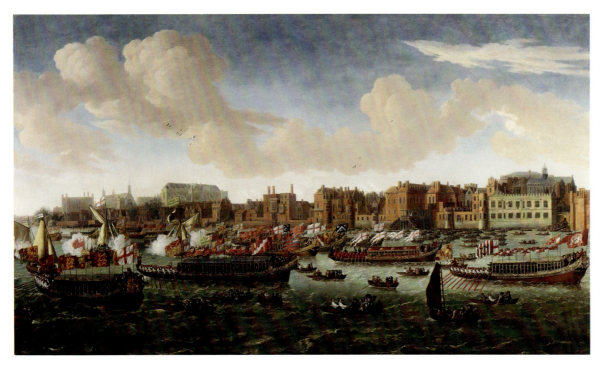

Fig. 5 British School, *The Lord Mayor's Water-procession on the Thames*, 1670–97. Oil on canvas, 151.3 x 260.5 cm. RCIN 402608

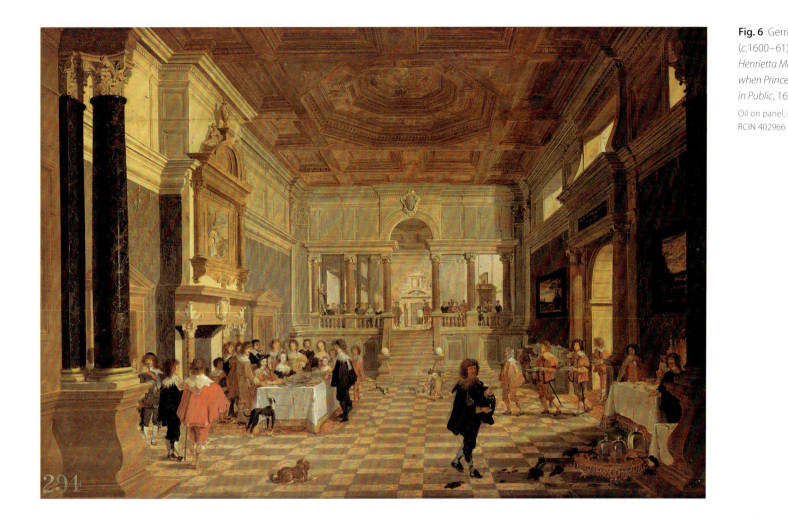

Fig. 6 Gerrit Houckgeest (c.1600–61), *Charles I, Queen Henrietta Maria, and Charles II when Prince of Wales Dining in Public*, 1635.
Oil on panel, 63.2 x 92.4 cm.
RCIN 402966

with gifts on New Year's Day each year, and these frequently consisted of items of clothing or accessories. In the gift roll of 1533/4, for example, Henry VIII is recorded as receiving 16 linen shirts decorated with embroidery, including one from Anne Boleyn.[7] The giving of gifts was not one-directional, and many household positions brought with them perquisites as part of the job – at the court of Charles II, for example, the monarch's Grooms of the Bedchamber were entitled to keep the king's personal linen, replaced every three months. While some members of the royal household were issued with household livery as a benefit of their position (such as Grooms of the Bedchamber), the majority were required to purchase their own clothes. Courtiers were usually men and women from noble landowning families, with funds available for frequent clothing changes – although courtiers could still be driven to bankruptcy in their pursuit of fashion.[8]

CLOTHING AND THE LAW

The Tudor monarchs also played a role in dictating the clothing worn by the population, through legislation specifying what types of material, colours and garments could be worn by each rank in society – so-called 'sumptuary laws'. These laws, a form of which had been in existence in England since 1337, were designed with two stated purposes in mind – to maintain the social order (through clearly identified class distinctions), and to stimulate the domestic economy by limiting the importation of furs, fabrics and trims from abroad.[9] In England

DRESS AND ITS MEANINGS 17

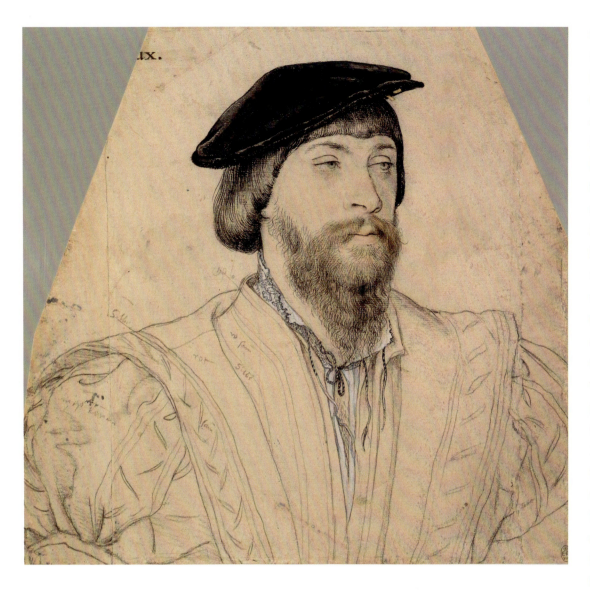

Fig. 7 Hans Holbein the Younger (1497/8–1543), *Thomas, 2nd Baron Vaux*, c.1533. Black and coloured chalks, pen and ink, brush and ink, white and yellow bodycolour, and metalpoint on pale pink prepared paper, 27.9 x 29.5 cm. RCIN 912245.

these laws reached their apogee during the sixteenth century under Henry VIII and Elizabeth I, both of whom set out a series of constantly redefined, increasingly specific statutes, reflecting the short lifespan of fashion by this date. At one point Elizabeth I attempted a catch-all by banning novelty itself, 'any new kind or form of apparel, and ... garnishing thereof' was to be punished 'as if the said garment or garnishing had been specifically prohibited'.[10] That such legislation was seen as necessary is evidence of the escalating social upheaval during the sixteenth century, with the development of a wealthy and powerful merchant class, born without noble birth but with money and the inclination to buy expensive clothing in imitation of their social superiors. The last proclamation dates from 1597, and upon the accession of James I to the throne of England the laws were repealed under pressure from Parliament. Both James I and Charles I attempted to dictate clothing choices by statute, but this was rejected by Parliament. At different points in his reign Charles II issued various bans on foreign imports, such as lace, with the express intention of stimulating the domestic economy rather than for reasons of social discrimination.

For transgressors of sumptuary laws during the sixteenth century, punishment included confiscation of the offending garment, fines of up to £10 per day, or three months in jail. Rewards were offered for informants, consisting of half the fine plus the restricted garment (the informant's status would have dictated whether or not they could have actually worn it).[11] In reality such laws proved impossible to enforce and were largely ignored – their ineffectual nature even being recognised at the time. In fact the forbidding of certain fashions will probably only have enhanced their desirability. The most frequent offenders were members of the nobility and the rich merchant classes, pushing the boundaries beyond their precise rank. The authorities were reluctant to punish such individuals (who were perhaps able to utilise their influential contacts to escape punishment). Tailors responsible for producing the prohibited garments were more easily identified, through searching their shops, and punished.

One way in which legislation probably did play a role is in the case of portraiture. Regardless of whether someone flouted a certain clothing law in their everyday life, they would

presumably have been less keen to record such misdemeanours for posterity. Several sitters seem to have taken care to dress in their portrait up to the limit allowed them by law, such as Thomas, 2nd Baron Vaux (fig. 7). According to notes in the artist's hand the sitter's red velvet gown is trimmed with silver thread. The wearing of crimson or scarlet velvet had only been extended to include barons in the revised law of 1533, while nobles of this rank were only allowed to wear cloth-of-gold or -silver in their doublets.[12] For Holbein's drawing of William Parr, later Marquess of Northampton (see fig. 166), extensive notes again indicate that the sitter wears a fur-lined gown of purple velvet over a white velvet doublet and white satin sleeves. According to the last of Henry VIII's acts of apparel, issued in 1533, purple silk was not to be worn by anyone other than the king and his family. However, as captain of the Gentleman Pensioners, an important liveried position, the sitter was exempt from such laws.[13] His clothing may be a conscious reference to this exceptional social position. Such drawings were routinely used by Holbein as preparatory studies for subsequent oil portraits, although no associated painting with these drawings is known and the precise colour and type of clothing worn by each sitter were obviously deemed of great importance.

MANAGING ROYAL CLOTHING

The Court was the centre for the Great Wardrobe, a rather nebulous institution that initially consisted of a physical location for the storage of royal clothing near St Paul's but developed into an organisational department within the Royal Household, headed by the Master of the Great Wardrobe.[14] Within this department was the Wardrobe of the Robes, headed by the Master/Mistress of the Robes (depending on the monarch's gender), and housed wherever the monarch was located at a particular time. The managerial posts for these departments were important and highly influential positions at court. During the sixteenth century the Great Wardrobe was responsible for supplying fabric for the monarch's clothing, and for hiring the appropriate craftsman to have the material made into garments. It was also responsible for storing clothing, and accounting for the finances involved. The Wardrobe of the Robes employed a much smaller number of staff and served a kind of valet role, cleaning and repairing clothing, and ensuring it was available for the monarch on a day-to-day basis. By the seventeenth century, however, the balance between these two departments had shifted, with the Wardrobe of the Robes playing an increasingly important role in supplying and managing the monarch's personal (and therefore fashionable) clothing. The Great Wardrobe continued to supply ceremonial and livery attire.

The survival of several royal inventories provides invaluable information about royal clothing. Detailed accounts were taken throughout Henry VIII's life, together with an inventory after the king's death in 1547.[15] They reveal that the monarch was proprietorial about his possessions, and that the careful management of his clothing was a priority. Another important royal inventory is that taken in 1600 which catalogued the contents of the Wardrobe of the Robes towards the end of Elizabeth I's reign, a total of approximately 1,900 items including garments, accessories, jewels and lengths of fabric. This was split into two inventories – the Stowe inventory included items in current use by the monarch, while the Folger included items

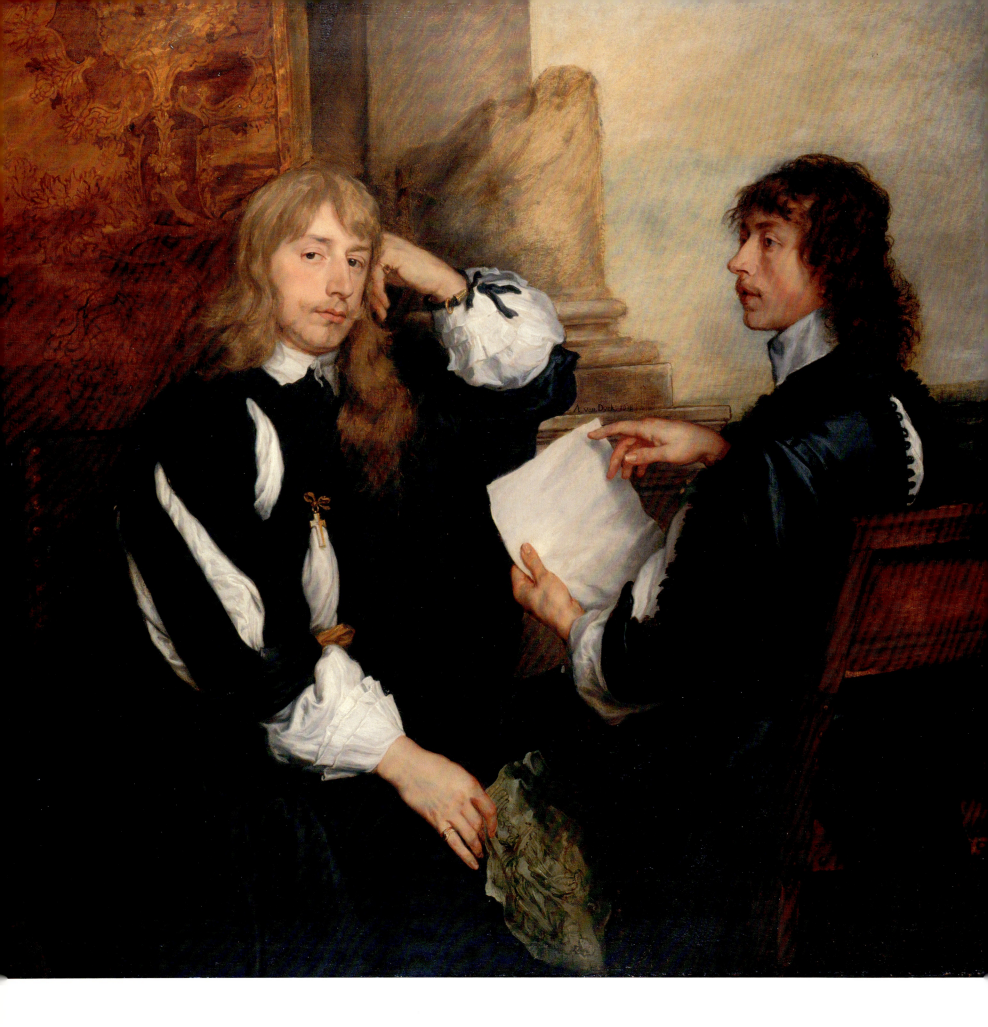

20 IN FINE STYLE

in store at the Baynard's Castle site near St Paul's.[16] The early Stuarts were less careful about the management of their clothing, and the Great Wardrobe was rife with corruption.[17] The wardrobe accounts for the years 1633–5 have been published, giving fascinating insights into the clothing purchases of Charles I for that year, but unfortunately no indication of the total number of garments in his possession.[18] The clothing sold as part of the Commonwealth Sale after the execution of Charles I has also been examined.[19] Research into the wardrobe accounts of Queen Henrietta Maria and Charles II is ongoing.[20] The clothing of Mary Tudor has also recently been examined within its political context.[21]

THE PLACE OF CLOTHING IN PORTRAITURE

Clothing forms one component of physical appearance, but it can also be used to imply conceptual elements of someone's identity. It can be used to symbolise a wearer's underlying character and state of mind – if they are fashionable, noble, careless, grieving, joyful and so on. It can also be used as an indication of social relationships (loose hair was a sign of being unmarried; veils were worn by widows), as well as gender, social status or profession. During the sixteenth and seventeenth centuries, someone viewing a person or their portrait would have been conditioned to interpret what that clothing represented. The drapery worn in portraits of women at the court of Charles II, for example, would have been a symbol of the sitter's elite status through its allusions to classicism (evidence of an educated mind), as well as its suggestion of 'undress', implying an aristocratic carelessness. We must however be wary of applying inaccurate modern interpretations. The untidy appearance of Thomas Killigrew and his companion (fig. 8) has been interpreted as a symbol of their grief – in the same year that this portrait was painted, Killigrew's young wife Cecilia Crofts had died of the plague, leaving behind a young son. However, it is more likely that they are simply following the prevailing trend for an artfully dishevelled and 'undone' appearance that was fashionable at this date, particularly in portraits by Anthony van Dyck, although Killigrew's jewellery does seem to reference this recent bereavement (see Chapter 3).

One practical reason for dress being so important in portraiture is that it takes up such a large proportion of the painting's surface – and is often painted in eye-catching colours. This effect is exaggerated further by the frequent use of textiles to form a backdrop to the sitter. This is taken to extremes in a *c*.1615 portrait of Prince Henry Frederick (fig. 9), whose clothing has obviously been designed to co-ordinate with the curtains, chair and chest surrounding him, creating an en-suite effect with powerful impact. Taken in conjunction with the woven carpet upon which he stands, the only parts of the canvas not covered in painted textiles are the head and hands, together making up an estimated 3 percent of the picture surface.[22]

ABOVE

Fig. 9 Attributed to Flemish School, *Prince Henry Frederick* (?), *c*.1615.
Oil on canvas, 128.5 x 102.2 cm. RCIN 403511

OPPOSITE

Fig. 8 Sir Anthony van Dyck (1599–1641), *Thomas Killigrew and William, Lord Crofts*, 1638.
Oil on canvas, 132.9 x 144.1 cm. RCIN 407426

Fig. 10 Nicholas Hilliard (1547–1619), *Mary, Queen of Scots*, c.1578–9.

Watercolour on vellum laid on card, 4.5 x 3.7 cm. RCIN 420641

A contemporary treatise on Limning (miniature painting) records that Hilliard developed an innovative technique of separating his white pigment into three different grades. According to this technique the satin of the sitter's white bodice would have been painted using the finest of these grades, while the next grade would have been used to depict the white linen of her ruff and the white used to make up the pinkish carnation skintone, the coarsest grade.

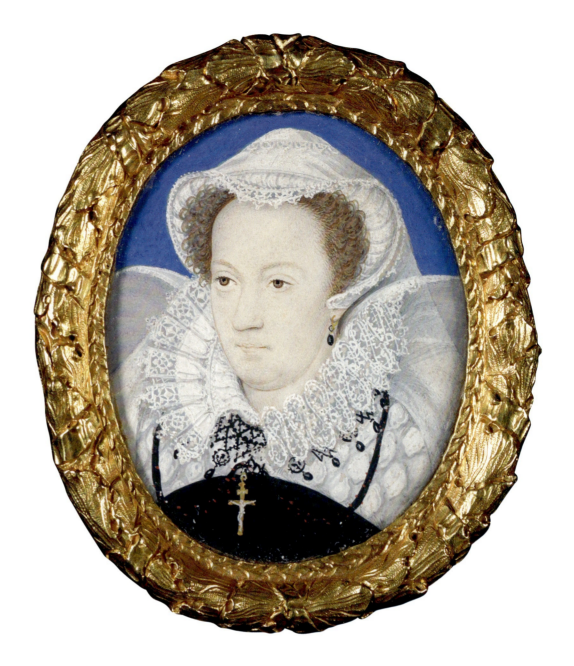

That clothing was viewed as important by the artists themselves is indicated by the fact that often the most expensive pigments were reserved for painting costume. The most obvious example is the use of expensive ultramarine derived from lapis lazuli for the robes of the Virgin Mary in depictions of the Virgin and Child. Nicholas Hilliard used three different grades of white pigment in his miniatures – the lowest quality was used to depict a sitter's skin, the intermediate quality for depiction of linen, and the finest for painting satin (fig. 10).[23] The complexity of a sitter's clothing was also a factor dictating the final selling price of a painting. A pair of portraits produced by George Gower in 1573 illustrates this point clearly. Elizabeth Willoughby's portrait cost 20 shillings whereas that of her husband cost 10 shillings. Since the two portraits are the same size, presumably the cost was driven by the clothing worn by each sitter – that of the female is far more complex and colourful than the sombre black attire of the male.[24]

PORTRAITS – WHAT CLOTHING CAN REVEAL

Unlike surviving garments, paintings allow us to see the fashionably correct way of wearing clothing – how garments looked on the body, how they were padded, how they were combined, accessorised or held. Portraits bring clothing back to life. They enable us to imagine how it would have felt to wear the clothes, and what noises they would have made – the tinkling of metal *aglets* (decorative tags attached to ribbons used to tie garments together), or the rustling of a thick silk overskirt as it passed against petticoats beneath. They give a sense of the posture required and the rules of deportment to be obeyed. Firmly dated portraits provide evidence about when certain styles were worn. The evolution of sixteenth-century embroidery, for which a large number of surviving undated examples exists, is made possible by comparison with sixteenth-century portrayals of similar examples.[25] The association of clothing with identified sitters in portraits also enables an interpretation of potential symbolism contained within clothing and embroidery that is no longer available once a garment has been dissociated from its original wearer.

The importance of clothing and hairstyles to modern viewers and researchers for dating portraits has long been recognised. The most useful clues are often in the seemingly minor details – the height of a waistline, or a silk design. Such details change more frequently than do the combination of actual garments worn; the introduction of a completely new garment is a relatively infrequent occurrence. The limitations of dating portraits purely through a sitter's clothing should also be recognised, however. Fashions took time to spread, and continued to be worn in provincial areas for longer than they were maintained at court. Sometimes older generations continued to wear styles that had passed out of fashion amongst the younger members of society. A group portrait by Barent Graat nicely illustrates this point (see fig. 199). Here the mother and father of the family retain styles from their youth, fashionable in the Netherlands during the first three decades of the seventeenth century, whereas the more experimental younger generation are apparently willing to adopt the new colourful fabrics and hairstyles imported from France.

In addition to their usefulness in dating a painting, clothing and accessories can also help identify a sitter, artist or provenance of a painting, particularly when combined with documentary evidence. The identity of the lady depicted in a *c*.1540 miniature by Holbein (fig. 11) has been established as the sole surviving authentic representation of Henry VIII's fifth wife Katherine Howard – through her jewellery. As part of his wedding gift the king gave his new queen an upper billiment to trim the top of her French hood 'of goldsmith work enamelled and garnished with 7 fair diamonds, 7 fair rubies and 7 fair pearls', together with a gold pendant set with 'a very fair table diamond and a very fair ruby with a long pearl hanging at the same', and a necklace 'containing 29 rubies and 29 clusters of pearls being 4 pearls in every cluster'.[26] Some of the same jewels are depicted in the miniature. In a *c*.1605–11 portrait of Margaret of Austria, the white silk gown is woven with the castle and lion representing the house of Castile-León and

ABOVE AND BELOW (DETAIL)
Fig. 11 Hans Holbein the Younger (1497/8–1543), *Portrait of a Lady*, perhaps *Katherine Howard*, *c*.1540.
Watercolour on vellum laid on playing card, height 6.3 cm. RCIN 422293

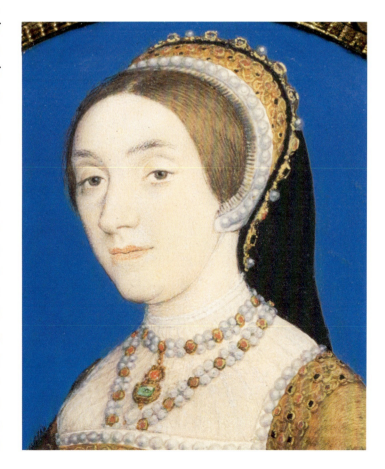

DRESS AND ITS MEANINGS 23

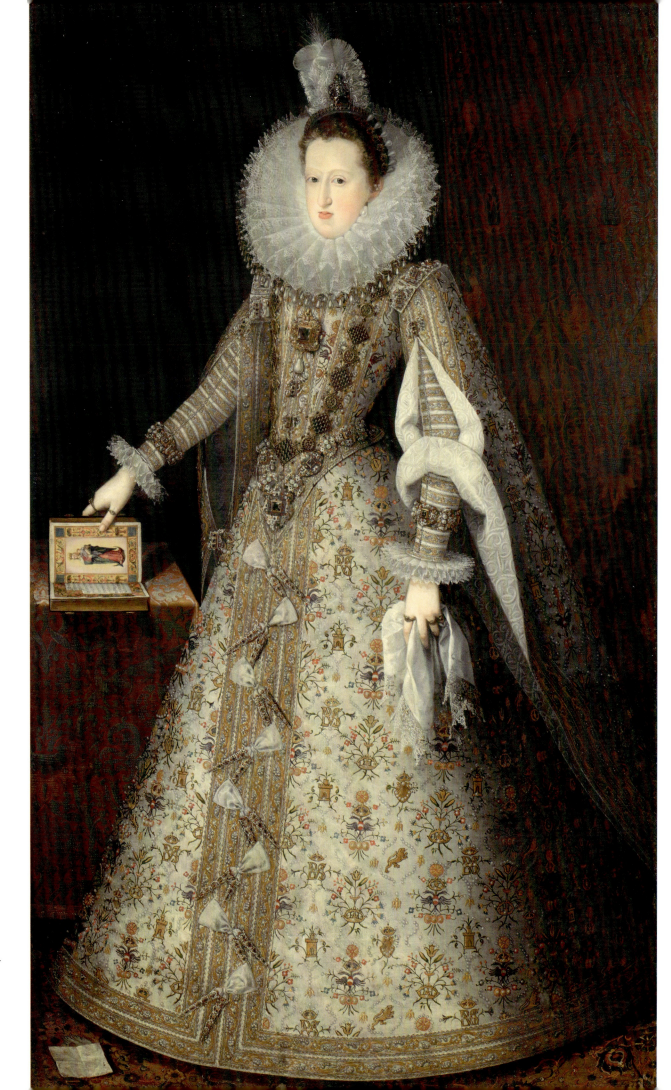

Fig. 12 Juan Pantoja de la Cruz (c.1553–1608), *Margaret of Austria, Queen Consort of Philip III of Spain*, c.1605.
Oil on canvas, 204.6 x 121.2 cm. RCIN 404970

the double-headed eagle representing the house of Austria (fig. 12). Documentary evidence about this painting indicates that she is wearing her wedding dress, although the painting was produced several years after the event. This information is helpful in understanding more about the context and purpose behind the commissioning of the painting (see page 208).

The method by which clothing has been painted can sometimes provide a key piece of evidence about the identity of an artist. It has been demonstrated, for example, that the precise technique of brushwork used to depict highlights in a specific type of fabric woven with gold thread in early sixteenth-century Netherlandish paintings can be as distinctive as handwriting.[27] This topic is discussed further in chapter 5.

PORTRAITS – WHAT CLOTHING CAN CONCEAL

The physical nature of a portrait means that the information it provides can be limited. The popular bust or half-length format for portraiture, which focuses attention on the sitter's face, obviously excludes a large proportion of their clothing. Documenting changes in collars through portraiture is therefore easier than for shoes. The most popular pose adopted during this period, of a sitter at a slight angle to the viewer, completely conceals the back and only provides a clear view of one side. Genre scenes showing figures engaged in a variety of activities from all angles, however, are far more revealing. *Charles II Dancing at a Ball at Court* shows figures from the back, revealing for example the complexities of the fashionable female hairstyle (detail from fig. 13).

An artist is not obliged to represent an outfit as it appears, nor to represent a sitter wearing clothing they actually own. Unlike a photographic record, a portrait comprises both artist's and sitter's personal choices about what elements to include and emphasise, and which to downplay for purposes of artistic effect. The extent to which Tudor and Stuart artists played a role in choosing, modifying or even creating the costume of their sitters is a question open to debate, with few clear-cut answers. Direct comparison of a painting with the clothing depicted, which would enable an understanding of how far an artist has modified the appearance of a garment for its portrayal in paint, is of course limited by the extremely small number of such pairings surviving.[28] A comparison with depictions of fashionable dress by other artists of a similar date, together with the use of complementary sources such as fashion plates, prints, surviving garments and inventories, suggests that at certain times, particularly during the second half of the seventeenth century, this element of artistic interpretation was significant.

Portraits may provide more accurate clues about colours worn than surviving garments, since dyes used in clothing can be very sensitive to light and have often undergone some change in colour. However, pigment layers in a painting can also change over time, which may alter the effect of a sitter's clothing and perhaps mislead the viewer about its original appearance. Red lake pigments, for example, are notoriously fugitive – a garment originally painted purple can appear more blue today than intended.

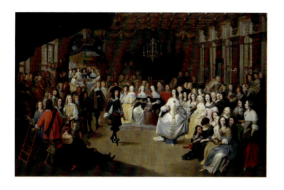

ABOVE AND BELOW (DETAIL)
Fig. 13 Hieronymus Janssens (1624–93), *Charles II Dancing at a Ball at Court*, c.1660.
Oil on canvas, 139.7 × 213.4 cm. RCIN 400525

Fig. 14 (interior of fig. 94) Doublet associated with Charles I, 1620s.

Brown silk satin embroidered with blue silk cord. Private collection

The tailor responsible for making this garment (see page 96 for full image) has cleverly ensured that even the smallest scraps of leftover fabric (known at the time as 'cabbage') were not wasted. Small triangles of the greenish-yellow silk are reused in the lining for two laps below the waistline of the doublet. The re-use of small pieces of fabric in such an expensive garment is indicative of the precious nature of raw materials used to make clothing during the period.

OPPOSITE

Fig. 15 (detail) Sir Anthony van Dyck (1599–1641), *Charles I and Henrietta Maria with their two eldest children, Prince Charles and Princess Mary ('The Greate Peece')*, 1632.

Oil on canvas, 303.8 x 256.5 cm. RCIN 405353

Sitting for a portrait was an infrequent and important event. Sitters often wore their most expensive clothing, reserved for special occasions only. Even the aristocracy did not wear the richly decorated clothing displayed in portraits every day. Inventories reveal that plainer, more understated items were included in the wardrobes of even the most wealthy. Moreover, portraits usually represent garments in pristine condition, untainted by signs of wear such as stains or the running of non-colour-fast dyes. Skirts hang in flawless folds, ruffs are arranged in perfectly regular pleats, stockings usually lie flat to the calf. While a portrait may represent the first outing of a newly acquired outfit (perhaps purchased specifically for this purpose), this will not always have been the case. Not all sitters will be wearing brand new clothing – its expense made clothing infrequently replaced. Since exterior garments were not washed but spot-treated or brushed down, artists would have had to demonstrate some sensitivity in hiding visual imperfections. The labour involved in maintaining this state of apparent perfection exemplifies why pristine clothing was a symbol of status – the wearer can afford servants to keep it looking perfect, and can change their clothing frequently, with a large enough wardrobe to swap a lightly soiled garment for a fresh alternative.

THE VALUE OF CLOTHING

Surviving garments tell a different story to this vision of perfection. They show sweat marks, alterations and occasional mistakes in decorative effects – hallmarks of clothing that has adorned a real human body and been made by the skilful but fallible human hand. They reveal what a garment looks like from the back and side. They enable an understanding of construction techniques, such as the number of layers of fabric required to create a stiffened doublet, or how breeches were prevented from falling down. They show how people got into their clothes, whereas portraits often give the impression of a figure sewn into their garments. They reveal what fabrics such as a three-piled silk velvet actually feels like, and how its appearance changes under different light conditions. Moreover, clothes can reveal biographical information about a wearer that cannot be gleaned through portraits alone. Alterations can reveal how they changed shape over a lifetime (records show that Elizabeth I's clothes were let out, indicating that she put on weight);[29] patterns of wear can show whether someone was left- or right-handed.[30] Examined in conjunction with paintings the information provided by garments is invaluable and complementary – accordingly, surviving garments are compared alongside paintings in this study wherever possible.

Unfortunately very few items of clothing from the sixteenth and seventeenth centuries have survived, particularly in England. This is in part due to the fragile nature of textiles in general, highly sensitive to atmospheric conditions and exposure to light. In addition, the raw materials and laborious processes involved in producing fabric made it highly valuable, resulting in continuous recycling. Even small off-cuts of fabric were retained for re-use (fig. 14).

The inherent value of clothing is clearly demonstrated by comparing its cost to paintings. According to Charles I's wardrobe accounts for 1633–4, an elaborately embroidered black suit similar to that being worn by the monarch in van Dyck's *'The Greate Peece'* (fig. 15) cost £146. The cost of the enormous painting, produced by an artist whose reputation was

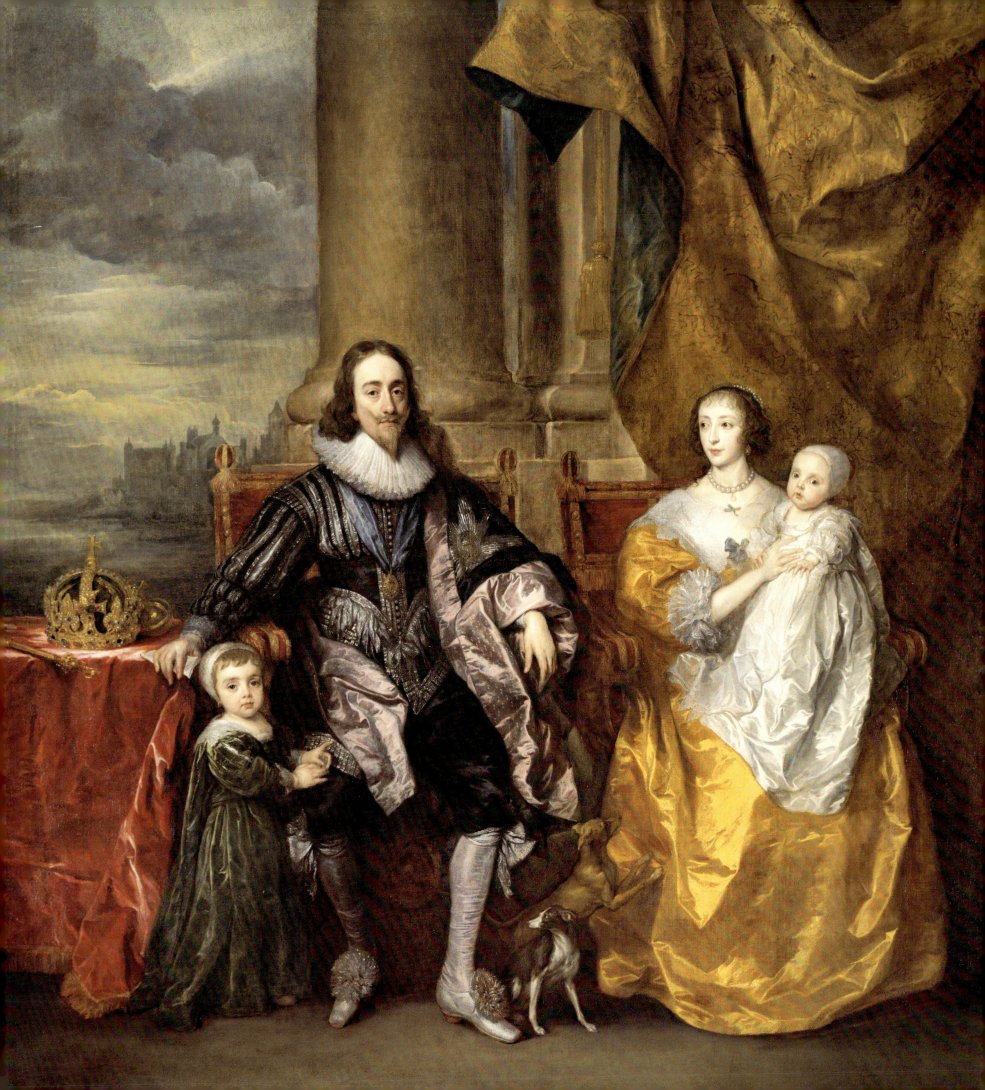

Fig. 16 (front and side views)
Germain Pilon (c.1540–90), *Catherine de' Medici*, c.1583.
Bronze, 87.0 x 58.5 x 30.5 cm. RCIN 20796

The sculptural nature of clothing at this date can be particularly well conveyed through the portrait bust format – in this example the exaggeratedly large padded sleeve-rolls and deeply hollowed pleats of Catherine de' Medici's ruff are especially striking from the side.

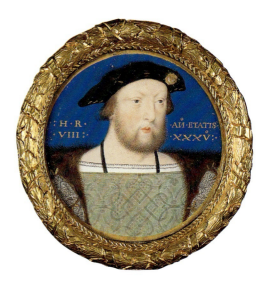

Fig. 17 Lucas Horenbout (c.1490/5–1544), *Henry VIII*, c.1526.
Watercolour on vellum laid on playing card, diameter 4.8 cm. RCIN 420640

Although his wardrobe inventories reveal Henry VIII frequently ordered green clothing he was rarely painted in the colour – making the green doublet worn here an unusual feature.

already well-established on the continent, was £100.[31] Charles I's less ornate suits are in the range of £40–50 each, while a sumptuous example of light-blue satin embroidered in gold cost £226 (equivalent to over £20,000 in today's money).[32] In the previous century, seven doublets and two cloaks belonging to the Earl of Leicester were valued in 1588 at £543, making the average cost of each garment more than the price Shakespeare paid for a house.[33] The value of clothing was well recognised at every level of society, making the display of rich fabrics and jewellery in portraits immediately evoke their huge financial worth.

Given the intrinsic value of the materials (as opposed to the cost of tailoring, which was relatively low), clothes were often repaired, re-lined and altered as body shapes or fashions changed. The composite nature of fashions at this date meant that clothes were often taken apart and the pieces reused. Skirts less frequently survive than bodices because the large amount of fabric contained within them could easily be used to make up another garment. Clothes could also be cut up for another purpose. Anne of Denmark is believed to have cut up the clothes of Elizabeth I for use in the court masque of 1604.

Royal clothes were often given away as perquisites to members of the royal household – every January Queen Anne ordered new clothes and divided her old clothes into heaps and 'stood by whilst the bedchamber Women chose as they were eldest'.[34] Sarah Churchill, Duchess of Marlborough, who worked as Mistress of the Robes for Queen Anne between 1704 and 1710, retained a large amount of her mistress's clothing, which was seen by Horace Walpole visiting Blenheim in 1760.[35] As they got more worn clothes were passed down to servants, or sold via a thriving second-hand market. Clothing was a highly transportable form of currency and could be stolen or easily liquidated. Metal threads in fabric could be melted down to release the precious metals. Linen rags which had originated as a shirt were ultimately recycled into paper. The Civil War in England also had a large detrimental effect on the survival of clothing and jewellery from the period. The auction of the 'Late King's Goods' in 1649 included the sale of 17 items which had belonged to Henry VIII.[36] Henrietta Maria sold several important royal jewels in exile in order to raise funds for the royalist cause.

Some items that have survived from the period appear to have done so because of a link to a monarch, rather than because of their inherent value. The intimate relationship between clothing and the physical properties of the royal body makes garments such as handkerchiefs and night-caps particularly prone to such romanticised associations.

OTHER SOURCES

Besides surviving garments, other important sources for information about historical clothing to compare alongside portraits include sculpture, fashion plates and prints, and documentary evidence such as historical inventories, letters, diaries and so on. Prints sometimes reveal more detail than paintings, as line becomes increasingly important in the absence of colour information. Printmakers may focus on different elements of dress to those that are most appealing to the painter, who instead will tend to see the figure in terms of masses rather than lines.[37] Satirical prints, too, can be useful in highlighting elements of dress perhaps overlooked by artists. The pitfalls of a search for fashionability are a common point of ridicule, and such prints

often emphasise someone's position in the fashion lifecycle – whether they are hyper-fashionable, a fashion follower or behind the times. Abraham Bosse's theatrically posed cavaliers represent the height of fashion, almost to the point of mockery (fig. 18). His prints suggest that in the year of publication (1629), the accessories proudly displayed here were especially up-to-date. However, the manner in which satire uses exaggeration for effect must of course be recognised.

Inventories reveal information about clothing that a person actually owned. This can sometimes be at odds with the evidence from portraiture. Henry VIII's inventories, for example, reveal that the monarch owned clothing in a wide range of colours, despite the fact that his portraits usually portray him in those colours most associated with monarchy – red, gold and black (see fig. 2). They also reveal information about his clothes worn for recreational activities such as riding, which formed an important part of his life but which is ignored in his portraiture. Very occasionally, it is possible to match up a portrait with a contemporary description. The portrait of Henrietta Maria wearing masque dress is an interesting example (see fig. 252). The account book kept by Mary, Princess of Orange, later Queen Mary II survives in the Royal Collection and demonstrates in her own hand her love of contemporary fashion – which some might suggest verges on the obsessive. While her portraits focus on fashionably negligent interpretations of up-to-the-minute attire or ceremonial dress, we know that in the autumn of 1694 Mary II ordered 43 pairs of shoes, and between September and December she ordered 31 mantuas, 15 nightgowns and 16 pairs of stays.[38] Other documents providing invaluable information include letters, etiquette books, royal proclamations and diaries. The inimitable Samuel Pepys was preoccupied with clothing, and his diary is full of fascinating information on fashionable styles for men and women during the 1660s.

ARTISTS AND FASHION

By choosing painting as a career, many artists during this period were following in their father's footsteps, such as Daniel Mytens, Hans Holbein the Younger and Frans Pourbus the Younger. Of those who were not, it is interesting to note that many who excelled in depictions of clothing and accessories had family backgrounds that would have exposed them to fabrics or jewellery from an early age. This is perhaps no surprise given the close links between the fine and decorative arts during the period, plus the existence of a social structure which encouraged an artisan's son to follow his father's career path, in either the same or a closely related field. Van Dyck's father and paternal grandfather were silk merchants in Antwerp, while his mother was a skilled embroiderer. Inigo Jones was the son of a clothworker. John Michael Wright and Abraham Bosse were both sons of tailors. Vermeer's father worked in an industry making an expensive type of silk-satin known as *caffa*. Albrecht Dürer, Nicholas Hilliard and John de Critz were all sons of goldsmiths. While making a causal link between family history and a talent for depicting fabrics, jewels and other finery is perhaps taking the point too far, we may speculate that such exposure may have given these artists an early interest in such objects, along with an extraordinary sensitivity to their aesthetic qualities – features that are so evident when looking at their portraits.

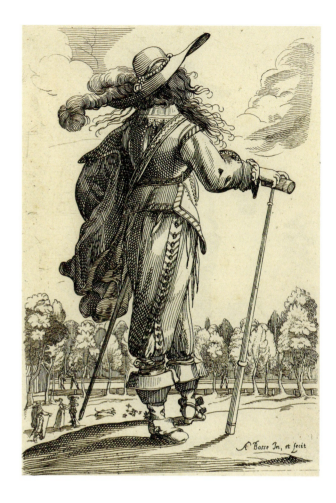

Fig. 18 Abraham Bosse (1602–76), *A man seen from behind*, etching, in *Le Jardin de la noblesse francoise, dans lequel ce peut ceuillir leur manierre de vettements*, Paris: Melchior Tavernier, 1629.
RCIN 1075196

DRESS AND ITS MEANINGS

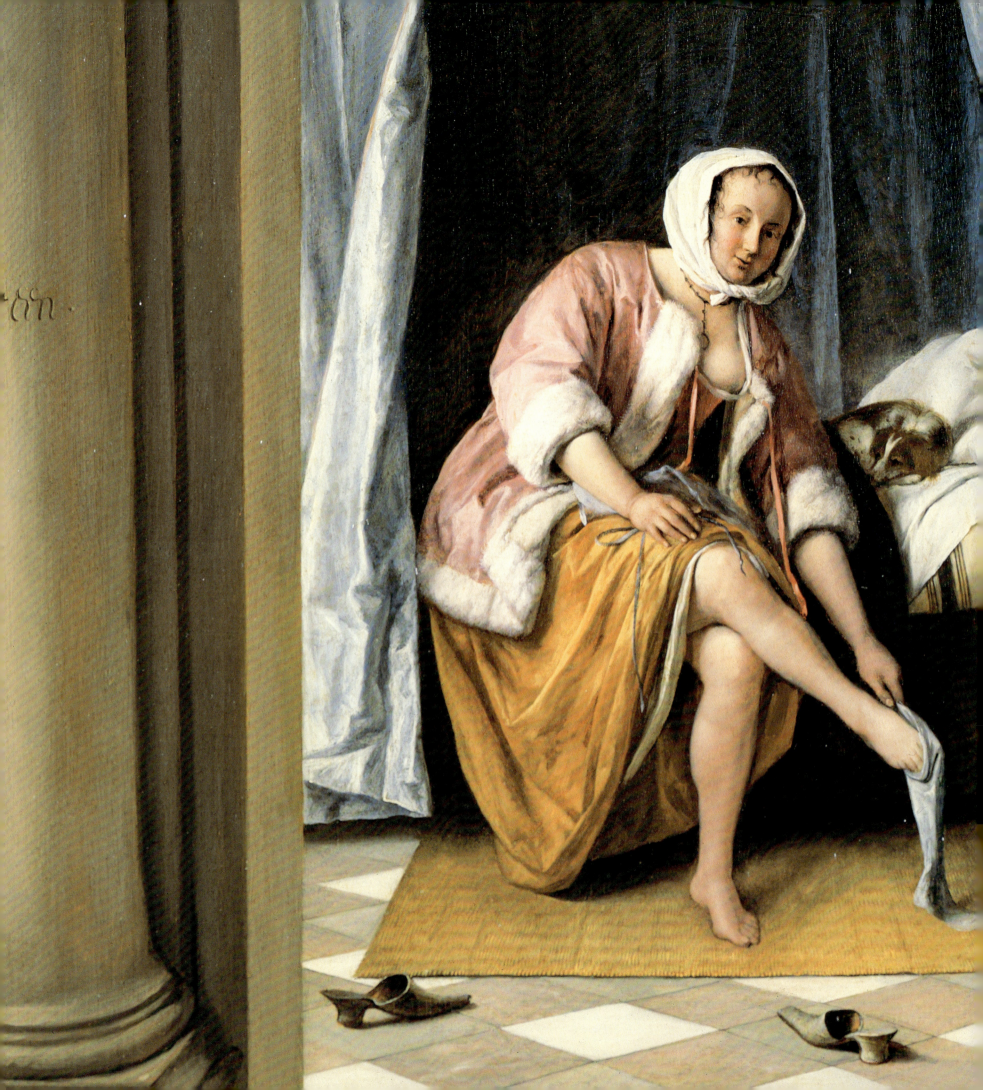

2

DRESSING WOMEN

With silken coats and caps and golden rings,
With ruffs and cuffs and fardingales and things;
With scarfs and fans and double change of bravery,
With amber bracelets, beads and all this knavery.
What, hast thou dined? The tailor stays thy leisure,
To deck thy body with his ruffling treasure.

Petruchio, *The Taming of the Shrew*, Act IV, scene iii

PAINTING is a flat art. Unlike the sculptor, or indeed the tailor, the painter creates a sense of depth and space through a variety of visual illusions rather than actual three-dimensionality itself. It is through the sensitive contrast of light and shade, the subtle gradations of colour, the variability in detail across the paint surface and so on, that the skilful painter models a sitter dressed in tactile silks and gravity-defying balloon-shaped breeches. Typically, it is the outer garments and accessories that are depicted, the last to be added when the sitter dresses each day. Sometimes other layers of clothing are indicated – a linen smock glimpsed through a slashed sleeve, a skirt parted to reveal a contrasting patterned underskirt. The viewer can often infer that the subject is wearing unseen layers below, to provide shaping for example, particularly when the clothing bears little resemblance to the natural form of the human figure beneath and the fabrics do not hang as expected.

By examining the layers of paint below the surface, we can understand more about the techniques used by an artist. But to find out about the clothes the sitter wears beneath their exterior world-facing layers, an understanding of dress history and an examination of surviving garments are required. This chapter uses paintings in the Royal Collection to describe and discuss the various layers of dress worn by women during the Tudor and Stuart period. While addressing the broad changes in fashions in terms of items of clothing, silhouette and surface decoration, the chapter is not organised chronologically. Instead it works through the layers, starting with those closest to the skin. Generalisation is inevitably needed in such a brief survey of a time period spanning over 200 years, during which frequent changes in all elements of attire were seen.[1]

There are several difficulties when identifying clothing depicted in early portraits of the sixteenth and seventeenth centuries. One is terminology. Contemporary accounts use a huge variety of words to describe components of dress, and without directly related surviving examples it can be difficult to understand to what a term refers, or to differentiate between two seemingly identical objects (a variation which might have been obvious to the contemporary viewer). This book uses the most common and least controversial word for each item of dress, and definitions are provided in the glossary. The second major issue when identifying what a sitter is wearing is that an artist may not have depicted what was actually being worn, and might even deliberately obscure or invent an item of clothing for artistic effect. Another important issue is that the disentangling of the various layers must sometimes be inferred, based on a small amount of painted information. Comparison with other examples in a variety of media can be illustrative, but interpretation of clothing worn in portraiture is sometimes open to individual readings of the various clues available.

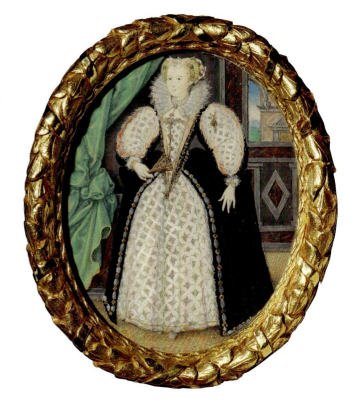

Fig. 19 Nicholas Hilliard (1547–1619), *Portrait of a Lady, perhaps Penelope, Lady Rich*, c.1589.
Watercolour on vellum laid on card, 5.7 x 4.6 cm. RCIN 420020
Unusually for a miniature, the subject here is shown full-length, and the distortions to the natural body shape by the layers of clothing on top are clearly evident. The inclusion of a five-pointed star ('stella') in her hair is the most compelling piece of evidence for the identification of the figure as Penelope, Lady Rich, thought to have been the inspiration for 'Stella' in Sir Philip Sidney's *Astrophel and Stella*.

Pp. 30–31 (detail from fig. 26) Jan Steen (1626–79), *Woman at her Toilet*, 1663.

SMOCKS, STAYS AND STOCKINGS

The first item that women of all classes would put on throughout the period was a long linen *smock* (also known as a *shift*), which provided a comfortable and washable layer next to the skin and would typically reach to mid-calf level. For an elite lady it would be made from finely woven linen, bleached white using a complex series of processes. Elite women would expect to change their linen daily. Constructed in a simple T-shape, the smock could be high-necked and designed to be seen above the neckline of the layers above, or low-necked and hidden. In a portrait of Catherine of Aragon (fig. 20), the smock has a slit-shaped opening at the neck and is fastened with black ties. Smocks were often embroidered in a variety of geometric or naturalistic designs. Catherine of Aragon was a talented embroiderer (she made shirts for Henry VIII, even continuing to do so during his divorce proceedings against her), and is associated with the arrival of this style of embroidery in England from Spain. Known as *blackwork* (although it was sometimes executed in monochromatic blue, green or red silk), it was usually embroidered in black silk on white linen in double running stitch.[2]

In *Elizabeth I and the Three Goddesses*, Venus has removed her clothes and has used her smock to cover the stool upon which she sits (fig. 259; detailed in fig. 21). This is a fascinating depiction of a complete smock, not usually seen in a portrait. The smock is made of voluminous linen which has been gathered at the cuffs and neckband to form narrow frills. A very similar example, with the same bands of vertical embroidery, is in the Metropolitan Museum, New York (fig. 22). Unlike the goddess, therefore, the smock is not an invention of the artist.[3] This exquisite surviving example is embroidered with acorn and pomegranate motifs in purple silk and outlined with silver-gilt thread, whereas Venus's is embroidered in green silk. Both examples illustrate that the embroidery on linen undergarments does not usually completely cover the garment but instead is focused on those areas most likely to be seen through gaps in the layers above, particularly the sleeves. Both the painted example and the surviving garment have a round neckline, and both are very full.

Linen smocks for women (shirts for men) were regularly washed, unlike the other layers of dress, which were brushed down or spot-treated. A clear indication of what was regularly laundered is provided by Falstaff in *The Merry Wives of Windsor* (Act III, scene v). He hides in a 'buck-basket ... with foul shirts and smocks, socks, foul stockings, greasy napkins', and describes the result as the 'rankest compound of villainous smell that ever offended nostril'. A portrait of Mary I (fig. 23) depicts a small decorative frill at the wrists of her linen smock, embroidered in a strapwork-and-foliate pattern with red silk. The artist has ensured that the same figure eight of the design has been pulled through the slits surrounding the wrist in

OPPOSITE

Fig. 20 British School, *Catherine of Aragon*, sixteenth century.
Oil on panel, 57.5 × 44.6 cm. RCIN 404746

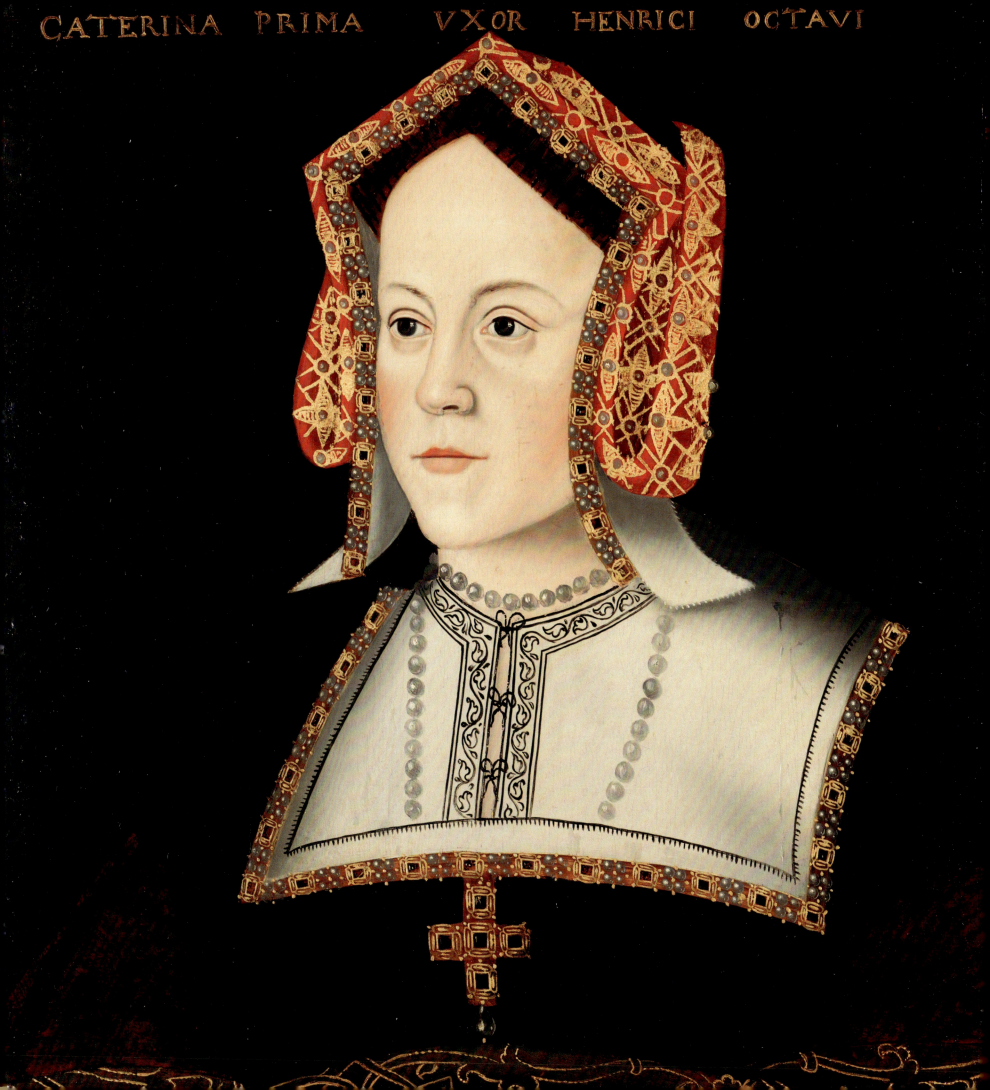

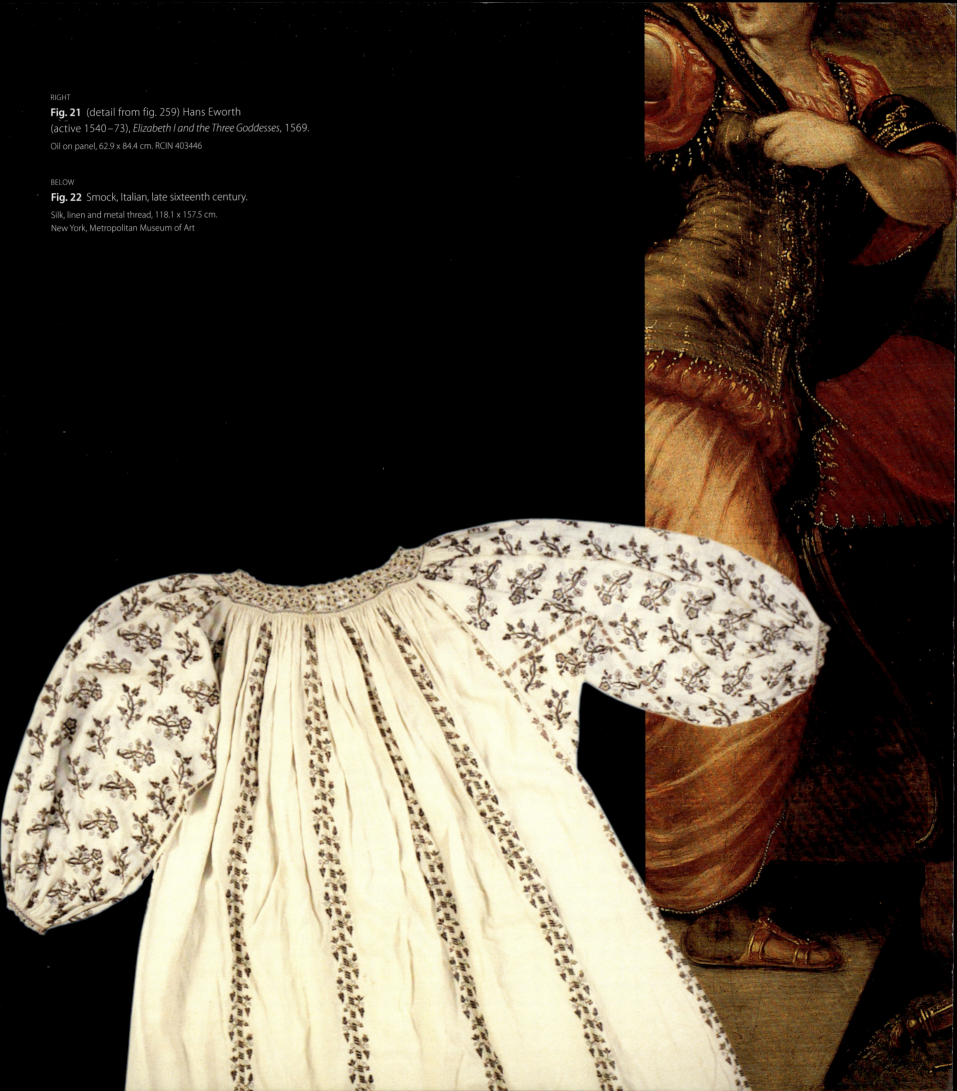

RIGHT
Fig. 21 (detail from fig. 259) Hans Eworth (active 1540–73), *Elizabeth I and the Three Goddesses*, 1569.
Oil on panel, 62.9 x 84.4 cm. RCIN 403446

BELOW
Fig. 22 Smock, Italian, late sixteenth century.
Silk, linen and metal thread, 118.1 x 157.5 cm.
New York, Metropolitan Museum of Art

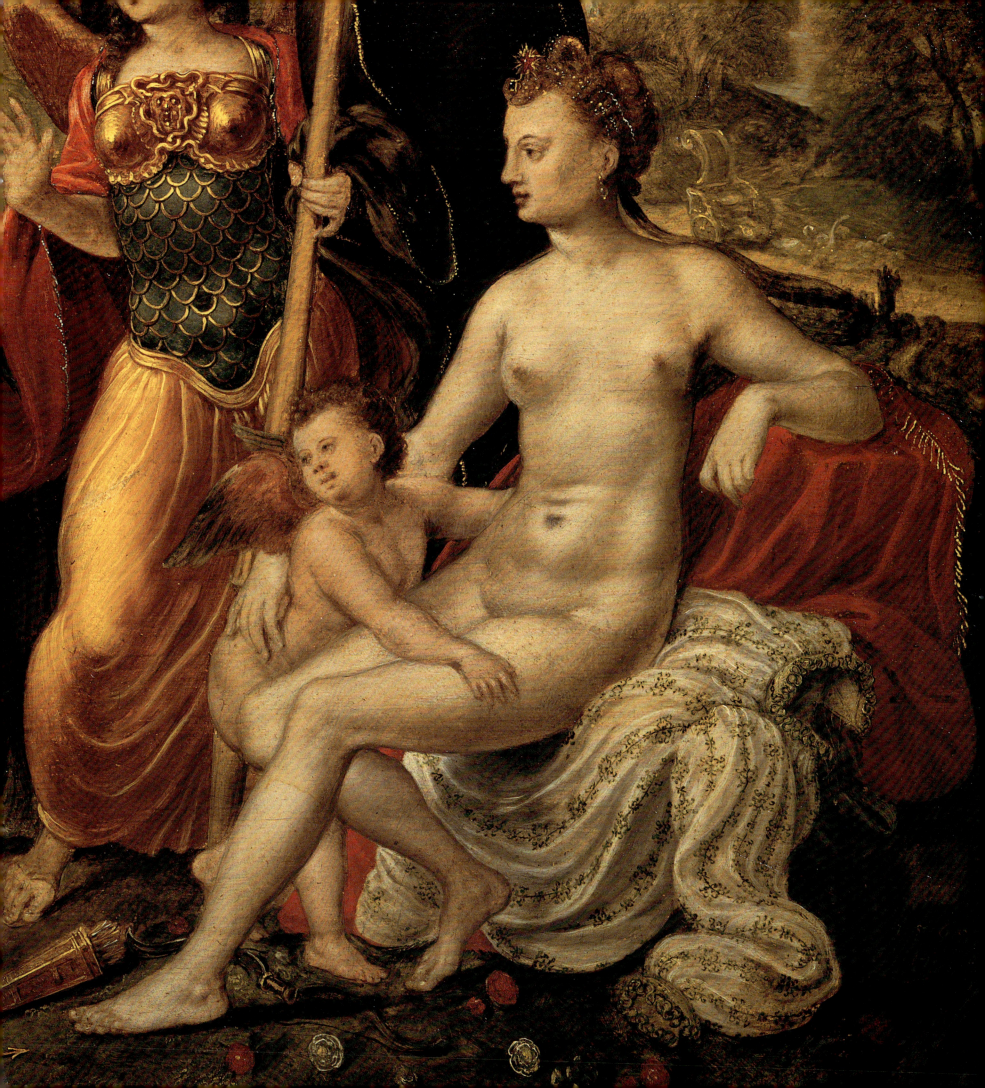

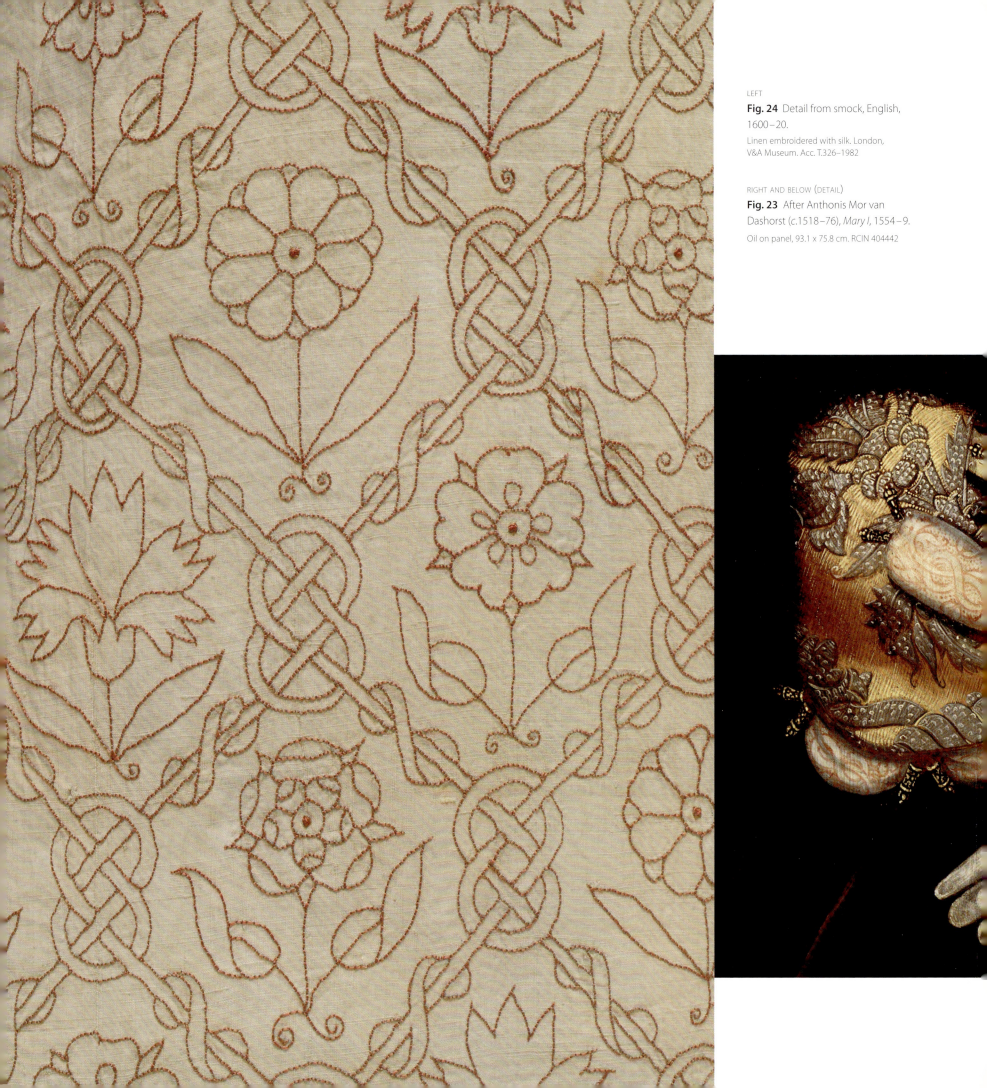

LEFT
Fig. 24 Detail from smock, English, 1600–20.
Linen embroidered with silk. London, V&A Museum. Acc. T.326–1982

RIGHT AND BELOW (DETAIL)
Fig. 23 After Anthonis Mor van Dashorst (c.1518–76), *Mary I*, 1554–9.
Oil on panel, 93.1 x 75.8 cm. RCIN 404442

the gold cloth forming the sitter's foresleeves – something that would have been difficult to achieve or maintain for any length of time. A similar extant smock embroidered with this type of embroidery is in the Victoria & Albert Museum, London (fig. 24) dating from over 50 years later – illustrating that designs combining geometric strapwork and naturalistic flowers were still popular well into the seventeenth century.

On her upper body over her smock a woman would wear a stiffened garment to shape and support the torso. In the first half of the sixteenth century this had an integral skirt and was known as a *kirtle*.[4] By the second half of the sixteenth century the two garments were being cut separately and the kirtle referred only to a skirt, with the stiffened top half being more frequently termed a *pair of bodies* (later bodice) and during the seventeenth century developing into *stays*, a separate stiffened garment normally concealed by layers above.

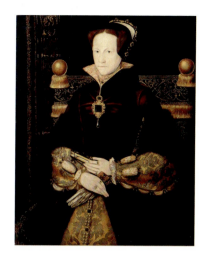

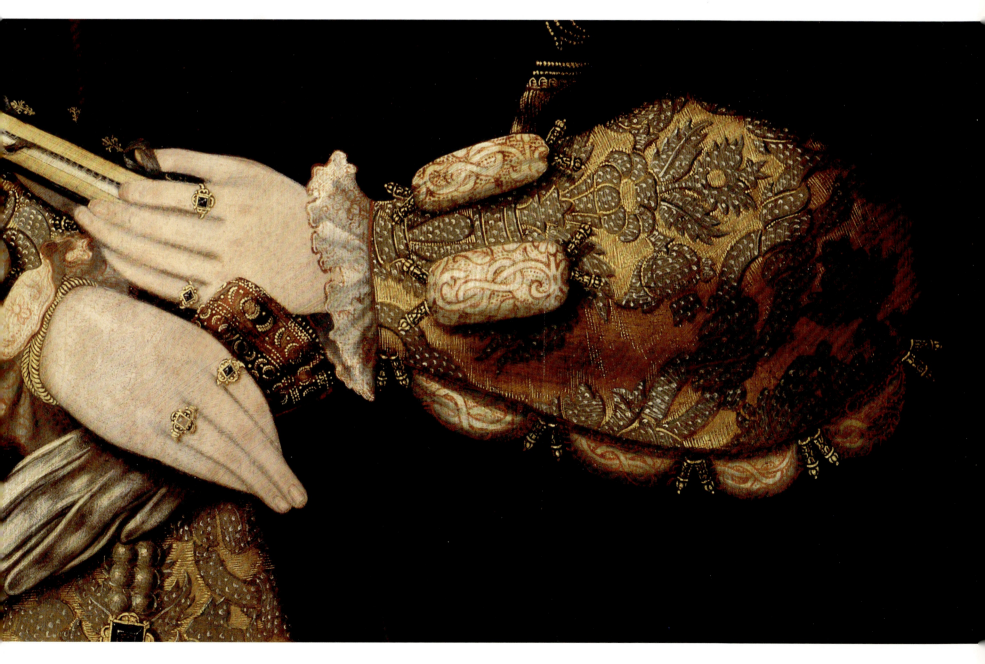

DRESSING WOMEN 39

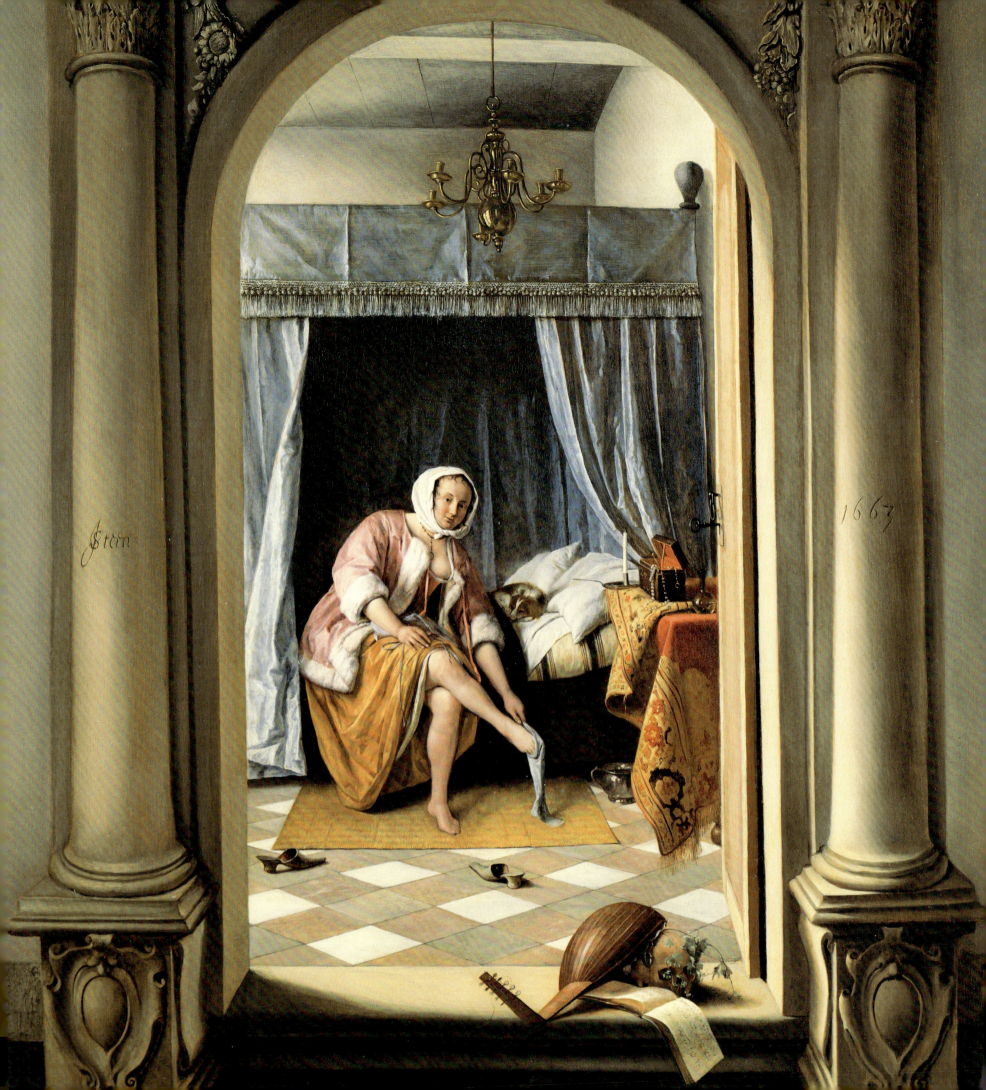

Usually constructed with vertically stitched channels containing strips of stiff but flexible baleen (whalebone) or bents (dried grasses), seventeenth-century stays are rarely shown in paintings and the *c*.1600 portrait of Elizabeth Vernon, Countess of Southampton (fig. 25) is particularly unusual. The countess reveals her long-waisted pink stays beneath her unpinned waistcoat. The seated figure in Jan Steen's *Woman at her Toilet* (fig. 26) also has her fur-trimmed jacket open to reveal a glimpse of pink stays beneath. The underlying moralising sentiment of the Dutch scene suggests that the protagonist is possibly undressing (and thus tempting the viewer into vice), while Elizabeth Vernon is getting dressed – a time-consuming process which for an elite lady in this period would require assistance. A pin-cushion on the table holds round-headed pins, an essential means of fastening items of dress together – for example attaching interchangeable sleeves to a bodice, or creating the arrangement of pleats in a skirt which might vary from day to day. While pins are rarely seen in painted portraits of the period, one notable exception is Holbein's *Jane Seymour* (Kunsthistorisches Museum, Vienna), which shows a line of gold-headed pins down the side of the sitter's bodice, clearly indicating how the garment was put on. Pin-holes are often seen on surviving garments, and pins of various lengths survive in some number. Thousands of pins of varying sizes were supplied to Elizabeth I every six months.[5] Lacing, buttons, and hooks and eyes were other important means of fastening clothing throughout the period.

On the lower half of their body, below the long smock, elite women would wear *stockings* (also known as *hose*), cut from woven cloth or knitted, and held up with garters. Drawers were apparently not worn in England until the nineteenth century. In 1561 Elizabeth I is said to have been presented with her first pair of knitted silk stockings, and by 1577 she had stopped wearing cloth versions altogether.[6] Stockings could finish above or below the knee, and were sometimes worn with under-stockings to protect the silk ones. They are rarely depicted in portraits due to the long length of the skirts, although the lady in *Woman at her Toilet* (see fig. 26) is shown in the process of either pulling on or off a pale blue stocking. Like many Dutch genre scenes, there is more to this than first meets the eye. Pulling on a stocking is an action found in a Dutch emblem book, *Sinnepoppen* by Roemer Visscher (1614), where it is used as a metaphor. In the same way that a stocking pulled on (or off) too quickly is likely to tear, if the viewer succumbs to sensuality, as offered in this picture, it could ultimately lead to ruin. In a play on words, the Dutch word for stocking (*kous*) used as slang meant fornication.[7]

FARTHINGALES AND PETTICOATS

A striking yet invisible layer in portraiture is the *farthingale*, worn beneath the skirt, which creates the characteristic Elizabethan and Jacobean silhouette. The farthingale was tied around the waist and was constructed of fabric stiffened with rings of a firm material such as whalebone, stiff reeds or rope. Its introduction to England is credited to Catherine of Aragon's entourage, bringing the style over from Spain in 1501.[8] Farthingales were probably not extensively adopted in England until the 1540s, and are first recorded in the Royal Wardrobe accounts of 1545.[9] Princess Elizabeth wears a cone-shaped farthingale beneath her red gown in fig. 27. A Spanish tailoring manual from 1580 specifies that a typical circumference around the

OPPOSITE (DETAIL)
Fig. 26 Jan Steen (1626–79), *Woman at her Toilet*, 1663.
Oil on panel, 65.7 × 53.0 cm. RCIN 404804

BELOW
Fig. 25 Unknown artist, *Elizabeth Vernon, Countess of Southampton*, c.1600.
Oil on panel, 135 × 89 cm. The collection of the Duke of Buccleuch & Queensberry

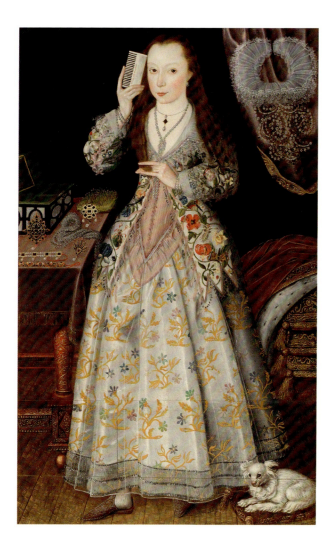

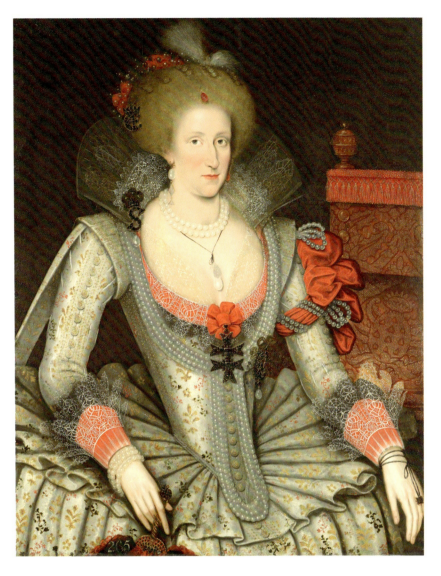

ABOVE

Fig. 28 Attributed to Marcus Gheeraerts the Younger (c.1561–1635), *Anne of Denmark*, 1614.
Oil on panel, 110.5 x 87.3 cm. RCIN 404437

OPPOSITE

Fig. 27 Attributed to William Scrots (active 1537–53), *Elizabeth I when a Princess*, c.1546.
Oil on panel, 108.5 x 81.8 cm. RCIN 404444

base of the farthingale is 'slightly more than thirteen handspans', which has been estimated to equal nearly three metres.[10]

During the reign of Elizabeth I the farthingale developed from the Spanish conical style into the drum-shaped wheel farthingale, worn with the skirt arranged into flounces pinned to the farthingale beneath, then left to fall to the ground. This is clearly seen in the 1614 portrait of Anne of Denmark (fig. 28). She particularly admired this style of dress, and insisted the farthingale be worn at court long after it ceased to be fashionable. The Venetian Ambassador in 1617 wrote of Anne, 'Her Majesty's costume was pink and gold with so expansive a farthingale that I do not exaggerate when I say it was four feet wide in the hips'.[11] In the portrait her skirt and bodice are of matching silk, a silver-grey background woven with small sprigs of flowers. Arranged into approximately 30 deep flounces, the skirt opens down the front – two buttons to fasten it can be seen just below the long string of pearls. Anne rests her hands on the shelf-like section of the farthingale around her waist, a position that helped stop the garment from swaying in an uncontrolled manner. Arranging the fabric into such pleats took a significant length of time and an expanse of surplus fabric was required – outward signs of conspicuous leisure and conspicuous consumption. Elizabeth of Brunswick, in a portrait of a very similar date, wears her skirt pinned in a different arrangement, with a narrow ruffle encircling the edge of the farthingale (fig. 29).

In its last incarnation, the wheel farthingale was worn tilted up at the back, an effect in part created by the use of a *busk* (a strip of wood, ivory or bone) inserted into a central channel in the front of the stays or bodice, which extended below the farthingale and pushed it down in the front, thereby raising the back. Busks could be given as gifts from a lover, and were sometimes carved with amorous images or intimate poems. The farthingale was sometimes worn over a moon-shaped padded bum roll for extra support, and to facilitate the tilting effect. Women in England began to stop wearing wheel farthingales after the death of Anne of Denmark in 1619. The farthingale would not reappear again until the eighteenth century, in the form of the hooped petticoat, and in the nineteenth century as the crinoline. Women did, however, apparently continue to wear bum rolls for some time longer which provided a less exaggerated effect.

With these shaping undergarments a woman might wear one or more *petticoats*. The outer petticoat could be highly decorated and was frequently designed to be seen, not hidden. Portraits do not reveal that often what appears to be a rich petticoat, visible beneath a skirt parted at the front (as in the portrait of Princess Elizabeth, fig. 27) is actually a *forepart*. This consisted of a triangle of expensive fabric, which was then sewn onto the kirtle beneath with the less expensive fabric hidden by the upper skirt at the sides and back.

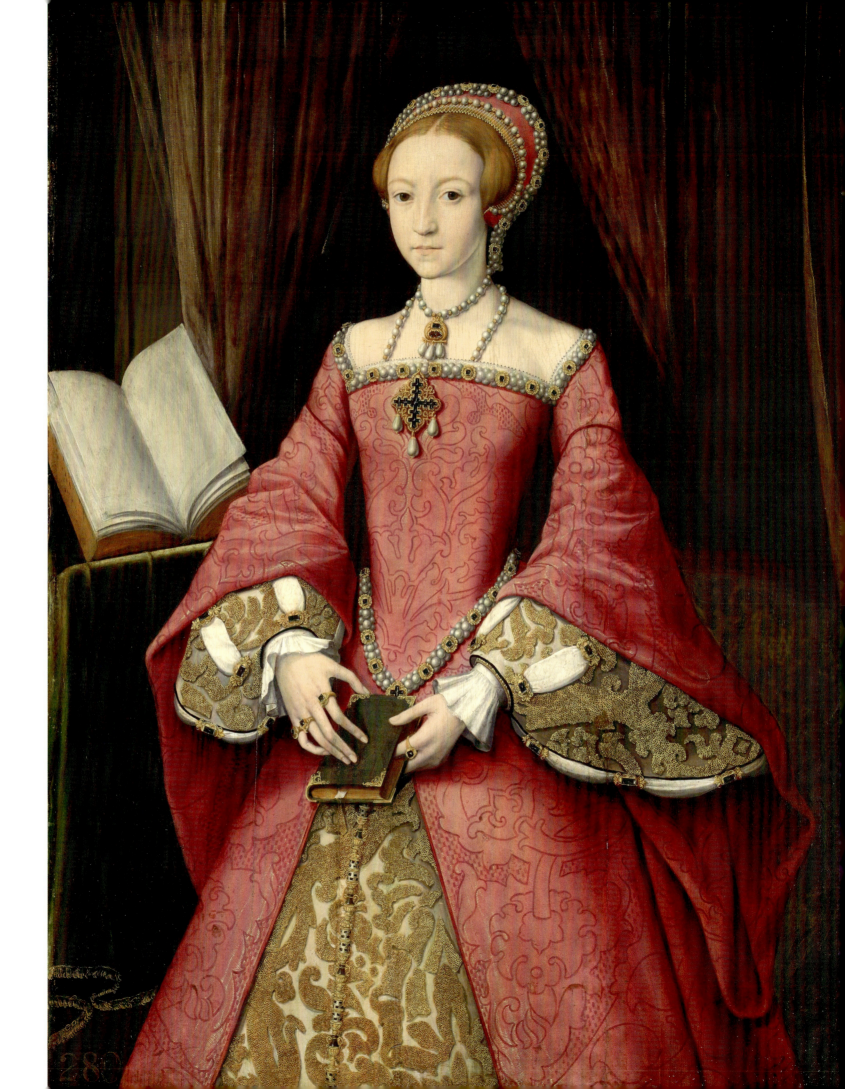

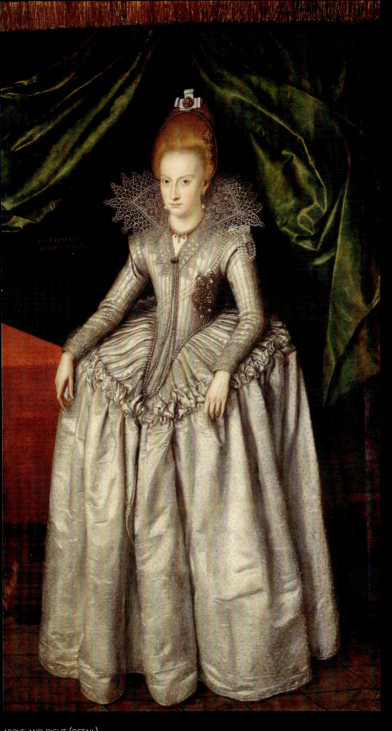
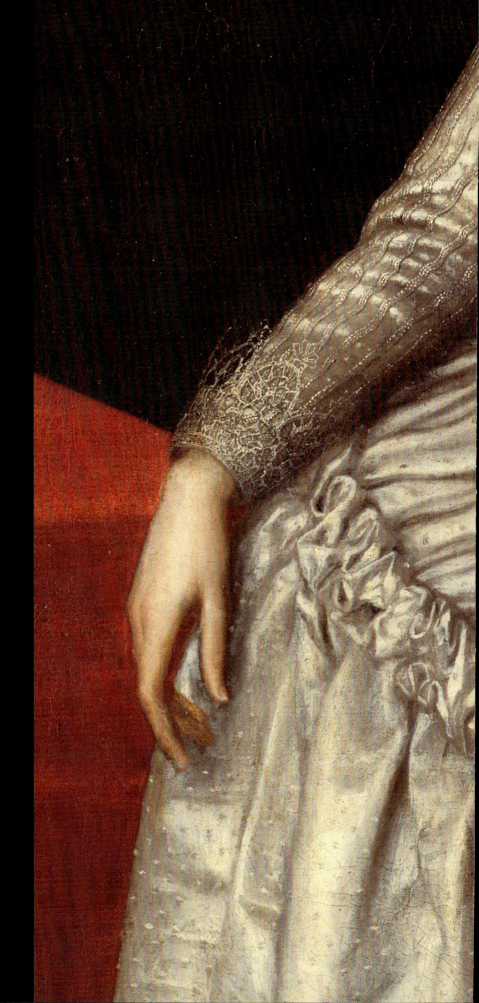

ABOVE AND RIGHT (DETAIL)
Fig. 29 Attributed to Jacob van Doort (d. 1629), *Princess Elizabeth of Brunswick-Wolfenbuttel*, 1609.
Oil on canvas, 193.9 x 112.6 cm. RCIN 404963

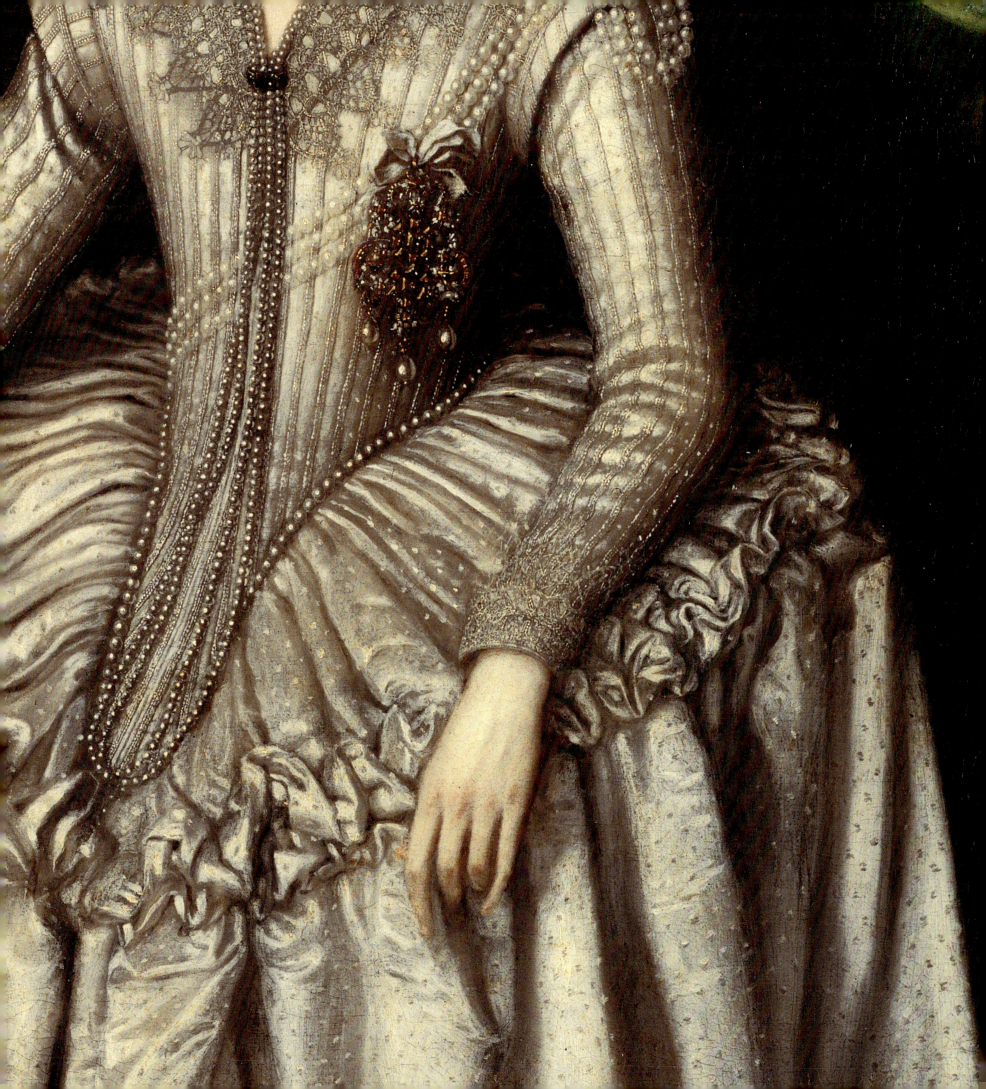

BELOW AND OPPOSITE
Fig. 30 Woman's bodice, c.1660–5.
Green silk with metal thread lace. London, Museum of London. Acc. 54.31

BODICES, SKIRTS AND GOWNS

In the sixteenth century, over her kirtle and/or petticoat a woman would wear a gown which could be either cut tight to the body ('French gown') or more loosely ('loose-bodied'), although as the century progressed these were increasingly cut in two pieces and became known as the bodice and skirt with the gown becoming an optional layer worn on top (see below). The bodice and skirt remained the most popular combination of garments for women until the end of the seventeenth century.

By the 1660s the fashionable female bodice was very stiff, with a long pointed centre front and sleeves set low in the armholes. A surviving example dating from *c*.1660-65 (fig. 30) bears a striking resemblance to that worn by a figure in the right foreground of Hieronymus Janssens's *Charles II Dancing at a Ball at Court* of the same date (fig. 31). By examining the bodice we find out that it fastens at the back and is heavily boned – a garment like this is stiff

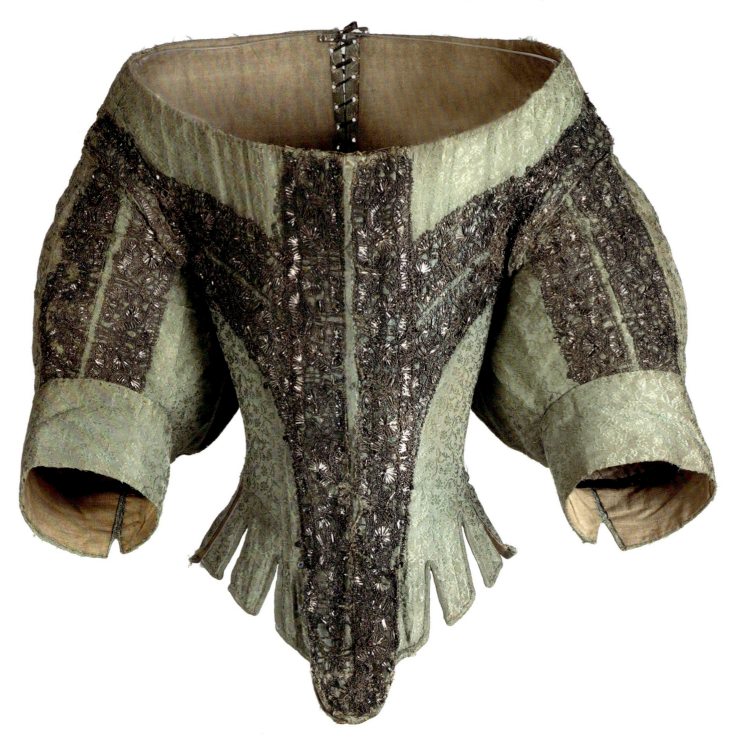

46　IN FINE STYLE

enough to have been worn without stays beneath. The Italian green silk is of an earlier design than the bodice itself, and was probably woven during the first quarter of the seventeenth century. Perhaps the bodice was re-made from an earlier one. The metal thread lace would have been particularly expensive, costing more than the silk. The painting shows how such a bodice would have been worn and accessorised. The painted example is worn with a matching green skirt and a brightly contrasting red petticoat, along with ribbon-trimmed gloves. The cuffs of the short full sleeves are covered by a puff of linen from the smock beneath. In the surviving bodice the pleated sleeves are set deeply into the back – this would have restricted the movement of the arms and, together with the boning, indicates that a certain deportment was necessary. Charles II and his sister Mary, Princess of Orange, are dancing the French *courante*, which was described by a dancing master in 1725 as a 'very solemn Dance' which 'gives a more grand and noble Air than other Dances'.[12]

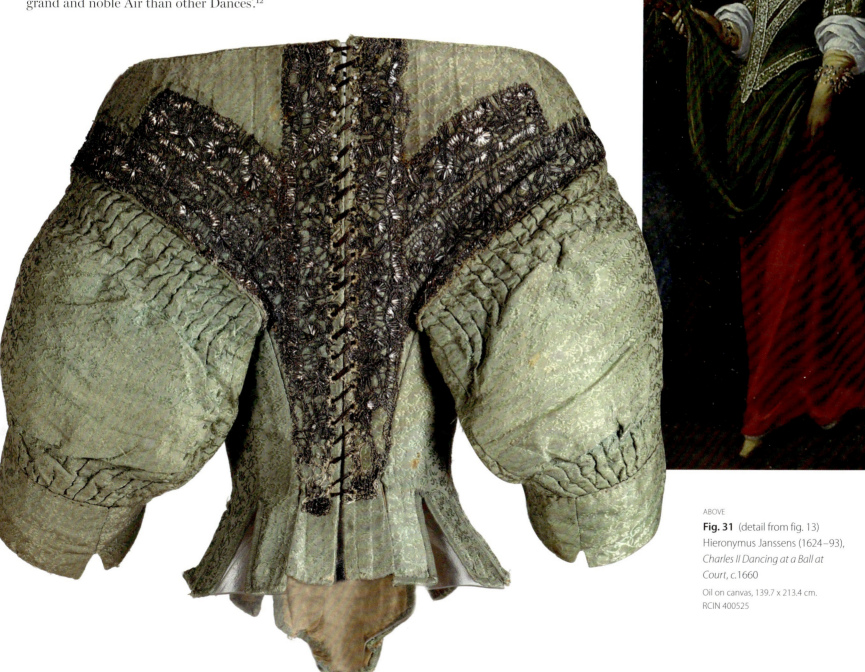

ABOVE
Fig. 31 (detail from fig. 13)
Hieronymus Janssens (1624–93), *Charles II Dancing at a Ball at Court*, c.1660
Oil on canvas, 139.7 x 213.4 cm.
RCIN 400525

DRESSING WOMEN 47

OPPOSITE

Fig. 32 Rembrandt van Rijn (1606–69), *Agatha Bas*, 1641.
Oil on canvas, 105.5 x 83.9 cm. RCIN 405352

BELOW

Fig. 33 (detail from fig. 27) Attributed to William Scrots (active 1537–53), *Elizabeth I when a Princess*, c.1546.
Oil on panel, 108.5 x 81.8 cm. RCIN 404444

While all the ladies in the Janssens image wear collars arranged around the necklines of their bodices, either of lace or of thin silk in muted colours, during the late Elizabethan and Jacobean reigns, extremely low necklines revealing pale flesh were considered appropriate for formal court dress. The desirable white *décolletage* could be artificially created with white lead, then painted with blue veins to emphasise the translucency of the skin, and the surface glazed with egg white. A means by which a woman wearing a low-cut bodice could choose to preserve her modesty, particularly during the day or when outside, was to include a *partlet* (usually of linen and decorated with embroidery or pleating) and/or a *kerchief*, often folded diagonally with the two corners not quite meeting and wrapped around the shoulders. Agatha Bas wears both together in her portrait by Rembrandt (fig. 32), each trimmed with lace to match the collar beneath, which extends across the shoulders and trims the neckline. The slight indentation of the folded edges of the kerchief suggests that it has been pinned into position. Agatha's husband was a wool merchant, so was directly involved with the clothing trade. Her dress consists of a black gown worn over a *stomacher* (a decorative triangular panel sometimes used to fill a gap between the two front edges of an open bodice) of white silk patterned with gold flowers and decorated with diagonal black laces. She wears a pale pink silk skirt, and carries a highly fashionable folding fan prominently displayed. The manner in which Rembrandt painted these fabrics, together with other small features such as the fine pleats in her cuffs to create their conical shape, demonstrates the relatively fine level of detail that the artist was including at this date, which he later tended to simplify.

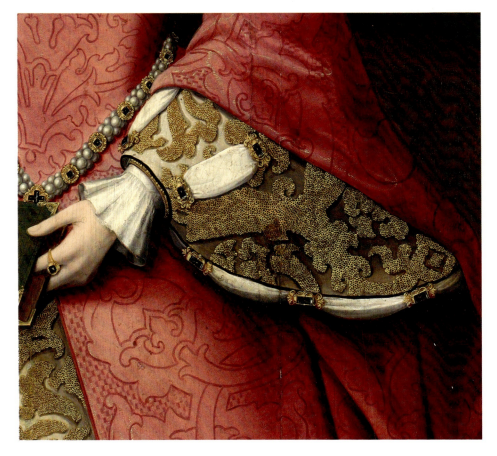

In the sixteenth century sleeves could be separate garments. Tied or pinned at the shoulder seam, this allowed the wearer to create different combinations. Sleeves might also be worn with contrasting *foresleeves*. In the portrait of Princess Elizabeth (fig. 27, detailed in fig. 33), the foresleeves match the forepart and are constructed of silk woven with silver and gold thread. A later portrait of Elizabeth as queen (fig. 3, detailed in fig. 34) depicts the silhouette of the late sixteenth century, when voluminous *trunk sleeves* were often padded with rolls of fabric or stiffened with whalebone. Another fashion seen in other portraits of the period, and which perhaps this artist is attempting to represent, is gossamer-thin *oversleeves*, through which the decorative pattern of blackwork embroidery on the sleeves below shimmers.[13] A very similar blackwork design can be seen in a surviving example in Edinburgh (fig. 35). A variety of different stitches create a range of patterns – an effect that the unknown artist of this portrait attempts to represent through spots and hatched lines in assorted directions. A different style of sleeve can be seen in the 1630 portrait of Lady Bowes (fig. 36). The sitter

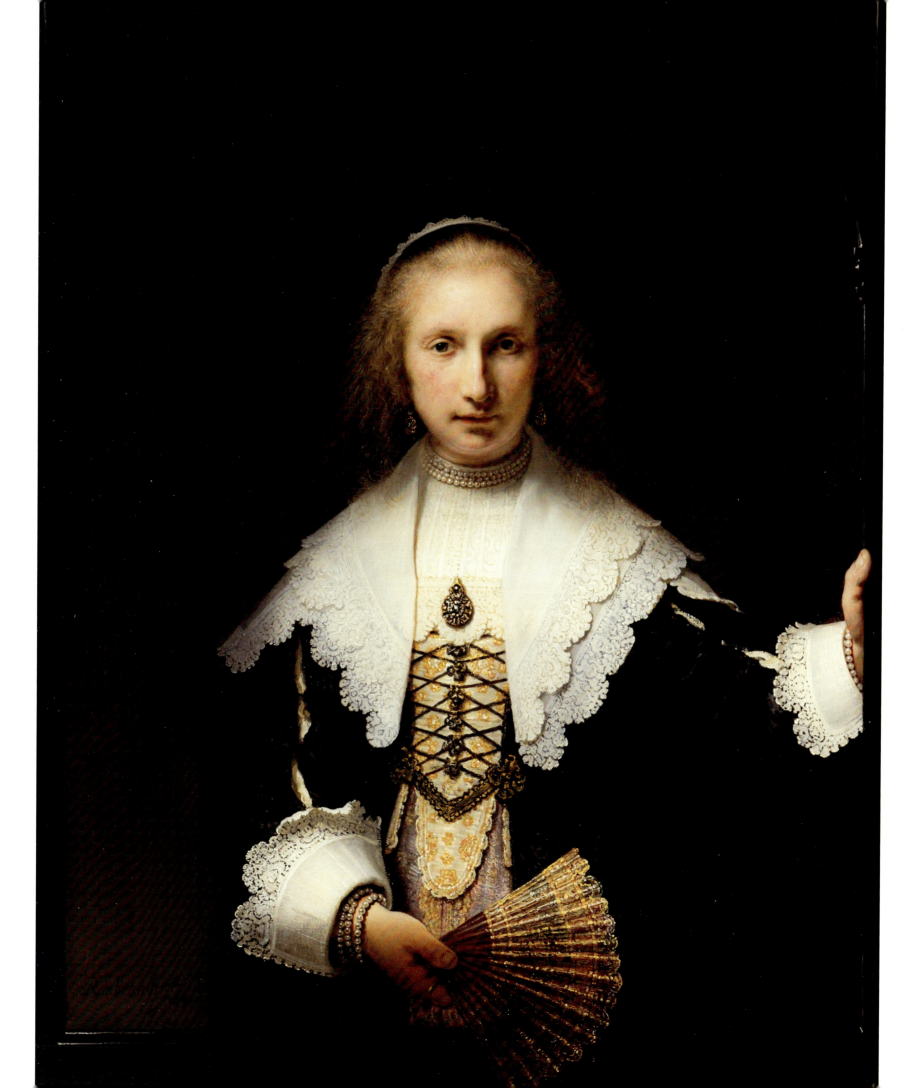

ABOVE LEFT
Fig. 34 (detail from fig. 3) British School, *Elizabeth I*, c.1580–5.
Oil on panel, 56.9 x 43.7 cm. RCIN 405749

ABOVE RIGHT
Fig. 35 Panel of white linen embroidered with black silk and gold, c.1585–90.
Edinburgh, National Museums of Scotland. Acc. 1929.152

RIGHT
Fig. 37 Nicholas Hilliard (1547–1619), *Elizabeth I*, c.1560–5.
Watercolour on vellum laid on card, diameter 5.2 cm. RCIN 420944

OPPOSITE
Fig. 36 British School, *Lady Bowes*, 1630.
Oil on canvas. 182.5 x 108.3 cm. RCIN 409146

wears a yellow satin bodice and skirt, embroidered and decorated with *spangles* (an early form of sequins). Her sleeves are in the *virago* style, which consisted of *panes* (strips) of fabric gathered into puffs by ribbon ties at the elbow, and are very characteristic of this date in both England and in France.

Floor-length overgowns, usually black and either tight-fitting on the upper body or cut more loosely, were often worn over the bodice and skirt from the second half of the sixteenth century until the early 1630s when they became less fashionable in England amongst the elite. They could be lined with fur for warmth. They continued to be popular in France, Spain and the Netherlands, where the overgown was deemed particularly appropriate for formal occasions or for portraits.[14] Elizabeth I wears this type of loose overgown in an early miniature, perhaps depicting her at her accession (fig. 37). Her gown is fastened at the front with *aglets*, and has puffs at the shoulder with hanging sleeves behind.

Gerrit van Honthorst was one of the first artists to show English women in the more casual combination of bodice and skirt without black gown. The convention to depict women without the black gown was extended by Anthony van Dyck, whose English sitters are shown in this more casual manner, contributing to their sense of informality and making his portraits more colourful. In his c.1632 portrait of Henrietta Maria (detailed in fig. 38), the queen is depicted in a white satin bodice decorated with silver braid along the seams, without a

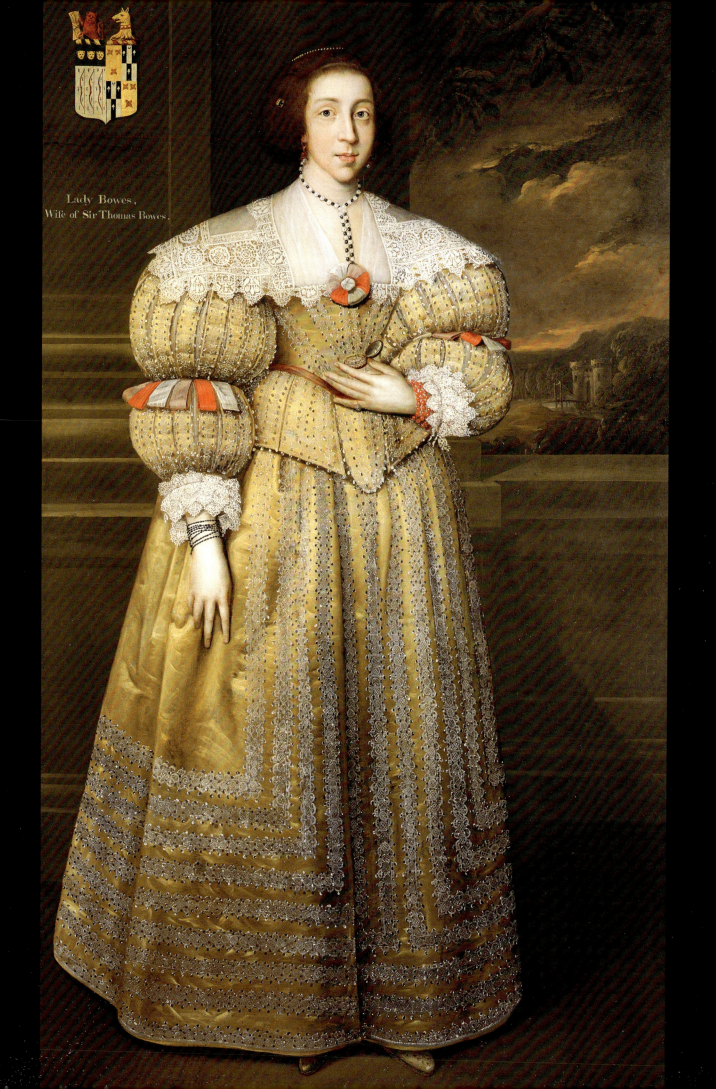

Lady Bowes,
Wife of Sir Thomas Bowes.

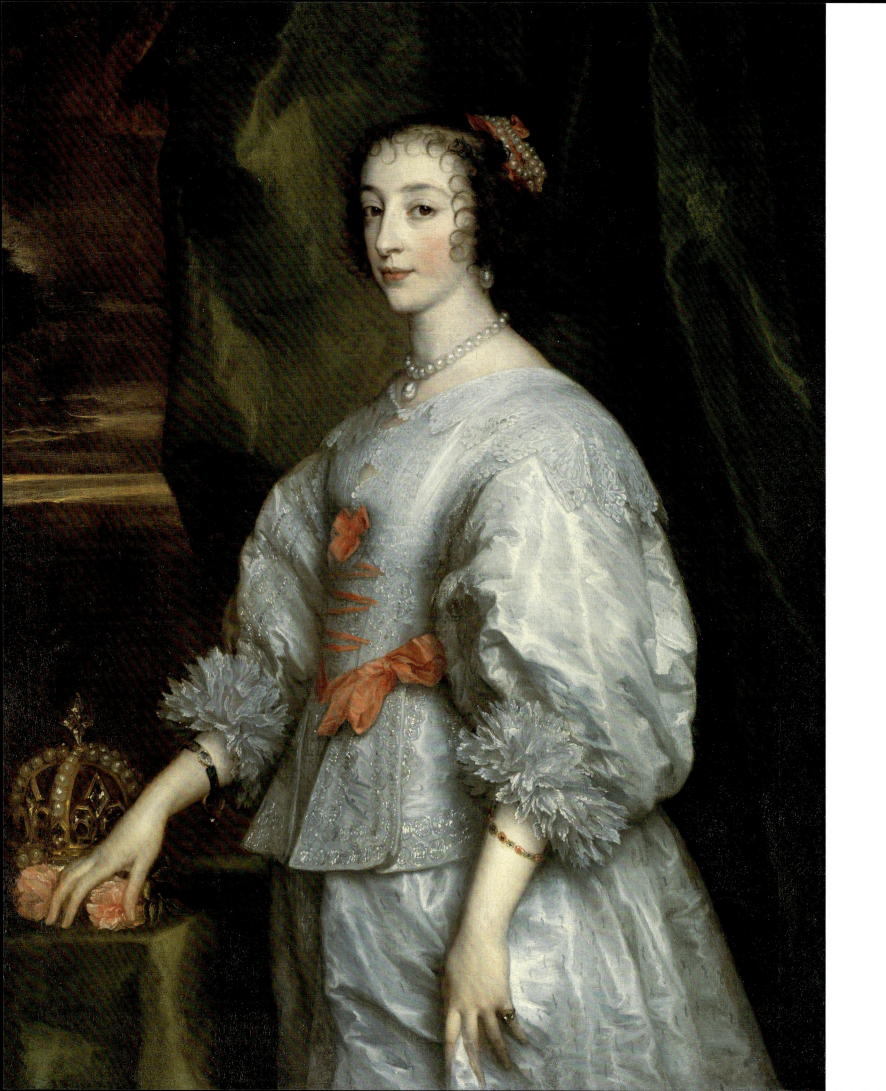

gown. Coral-coloured ribbons on the stomacher add touches of warmth to the otherwise cool colour palette, and co-ordinate with the ribbon and pearl ornament in the hair and bracelet on the left wrist. The fabric has been *pinked* to produce a decorative and regular pattern of tiny wavy cuts across the surface, adding interest to the plain silk satin, an effect achieved through the use of a special knife on the fabric, usually before it was sewn together. A surviving silk-satin bodice of the same date (fig. 39) shows a number of similar features, including the wide sleeves ending at the elbow and the decorative slashing. By examining the back of the bodice we get a sense of how Henrietta Maria's outfit might have looked from the back, with a square neckline and sleeves pleated and set deeply in the back.

There was no specific maternity clothing during the period, and accounts do not even reflect adjustments made to existing clothing. One option was to add an additional panel of fabric (known either as a *stomacher* or *placard*) between the two sides of a bodice. Or the lacing on the front of the bodice could be loosened,

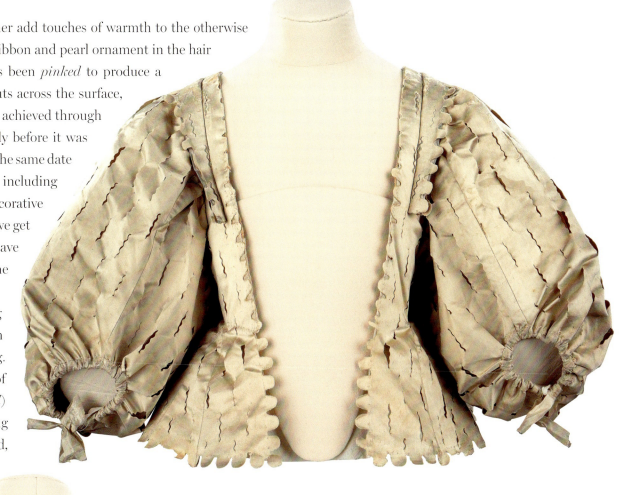

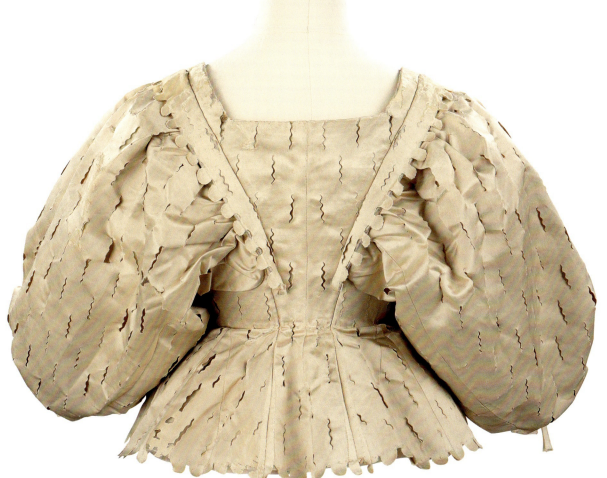

ABOVE AND LEFT
Fig. 39 Bodice, British, 1630–9.
Satin, linen and whalebone, 42.5 x 88.0 cm.
London, V&A Museum. Acc 172–1900

OPPOSITE
Fig. 38 Sir Anthony van Dyck, (1599–1641), *Queen Henrietta Maria*, c.1632.
Oil on canvas, 109.0 x 86.2 cm. RCIN 404430

DRESSING WOMEN 53

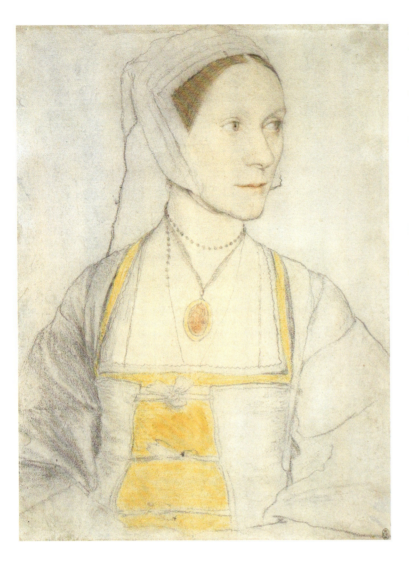

ABOVE
Fig. 40 Hans Holbein the Younger (1497/8–1543), *Cicely Heron*, c.1526–7.
Black and coloured chalks, 37.8 × 28.1 cm. RCIN 912269

OPPOSITE
Fig. 41 British School, *Portrait of a Woman*, c.1620.
Oil on canvas, 89.7 × 80.6 cm. RCIN 406064

as in Holbein's portrait of Cicely Heron (fig. 40). This is one of the earliest 'pregnancy portraits', a form of self-presentation that enjoyed a particular vogue in England during the late sixteenth and early seventeenth centuries. While such portraits served both to commemorate the process of pregnancy and its dynastic associations, the high mortality rate meant that they also often provided a record of a woman in the final months of her life.[15]

WAISTCOATS, NIGHTGOWNS AND MANTUAS

Before getting dressed or to receive visitors in the privacy of her own home, a woman might wear an informal combination of a *waistcoat* with skirt. The unidentified sitter in fig. 41 is wearing an embroidered waistcoat of this type. Her loose hair, unusual for someone of this age and unheard of for a married woman unless in her bedroom or dressing room, suggests that this is a very intimate portrait. Hair worn loose was associated with virginity.[16] The sense of intimacy is furthered by the waistcoat's unusual low neckline (more in keeping with contemporary court styles).[17] The high waistline in this portrait gives the impression of pregnancy, although by this date (c.1620) waistlines had begun to rise and this is perhaps an interpretation of the fashion – its scalloped bottom edge reveals that this is not an adaptation of a longer garment, but was made to be this length.[18]

Another comfortable option was a nightgown, made of silk or cotton and often lined with fur. Frequently imported from Asia, in the seventeenth century these became known as *Indian gowns*, although the fabric might be from a variety of different countries, and they were often made up in England. In a Holbein portrait, unique at this date (c.1533–6) for depicting a woman in informal dress, the sitter (thought to be Anne Boleyn) seems to be wearing a fur-lined nightgown over a linen smock (fig. 42). It has been conjectured that this could be the black satin nightgown given as a gift by Henry VIII to Anne during their courtship, and that its depiction here is intended to demonstrate its particular significance and expense.[19]

A seventeenth-century nightgown can be seen in the portrait of Henrietta d'Auverquerque, Countess of Grantham (fig. 43). She wears her belted silk nightgown over her smock, apparently without stays. During the seventeenth century the nightgown was gradually worn for more formal occasions, and it is believed to be the origin of the *mantua*, a fashionable style of day dress introduced in the 1670s which, although worn with stays, provided comfortable relief from constrictive court styles of bodice and skirt.[20] Although popular in England at the end of the seventeenth century, mantuas rarely appear in portraits at this time – but they are often seen in fashion plates and prints. In a 1694 print of Mary II (fig. 44), the queen wears a fashionable mantua cut along the lines of Henrietta's nightgown – without a waist seam, and with the two sides of the front pleated into shape and joined by a stomacher. Below the waist, the skirt is pulled back on each side and pinned or tied into a complex and stylised arrangement of drapery forming a train and opening to reveal a petticoat underneath. A comparable

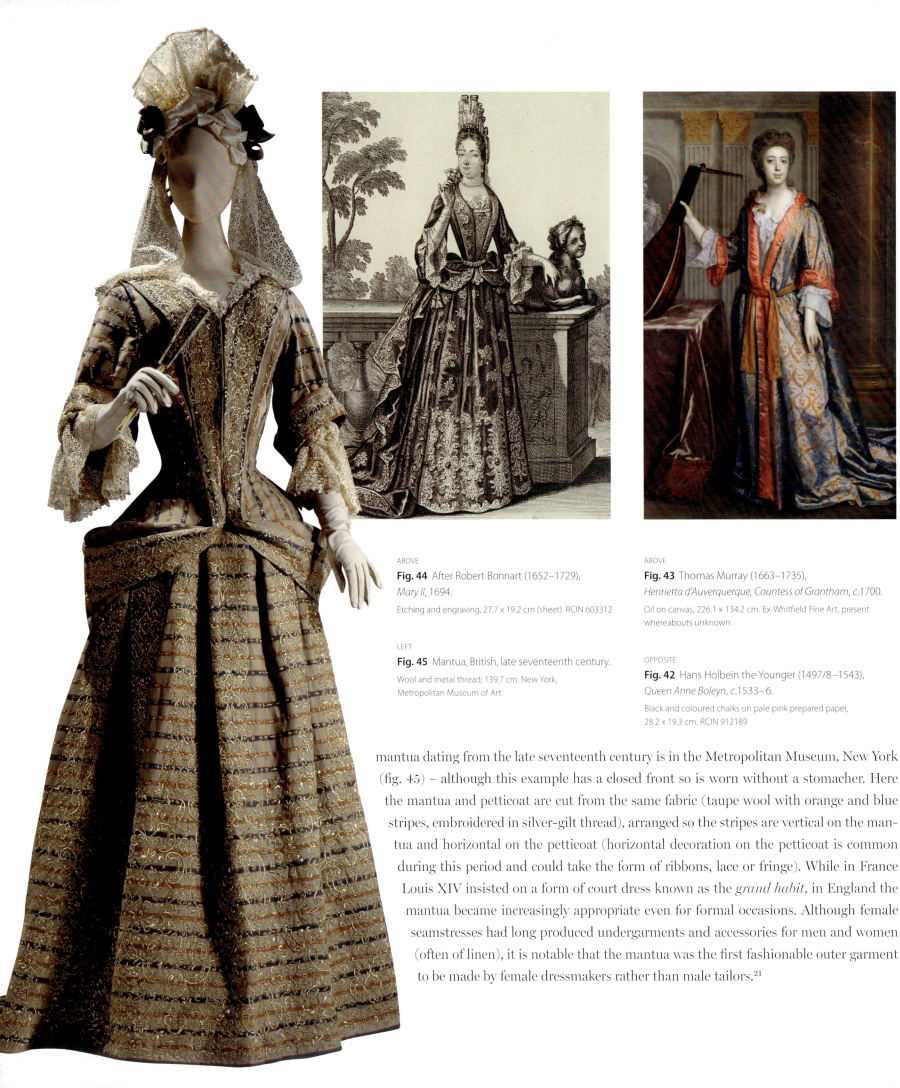

ABOVE
Fig. 44 After Robert Bonnart (1652–1729), *Mary II*, 1694.
Etching and engraving, 27.7 × 19.2 cm (sheet). RCIN 603312

LEFT
Fig. 45 Mantua, British, late seventeenth century.
Wool and metal thread; 139.7 cm. New York, Metropolitan Museum of Art

ABOVE
Fig. 43 Thomas Murray (1663–1735), *Henrietta d'Auverquerque, Countess of Grantham*, c.1700.
Oil on canvas, 226.1 × 134.2 cm. Ex-Whitfield Fine Art, present whereabouts unknown

OPPOSITE
Fig. 42 Hans Holbein the Younger (1497/8–1543), *Queen Anne Boleyn*, c.1533–6.
Black and coloured chalks on pale pink prepared paper, 28.2 × 19.3 cm. RCIN 912189

mantua dating from the late seventeenth century is in the Metropolitan Museum, New York (fig. 45) – although this example has a closed front so is worn without a stomacher. Here the mantua and petticoat are cut from the same fabric (taupe wool with orange and blue stripes, embroidered in silver-gilt thread), arranged so the stripes are vertical on the mantua and horizontal on the petticoat (horizontal decoration on the petticoat is common during this period and could take the form of ribbons, lace or fringe). While in France Louis XIV insisted on a form of court dress known as the *grand habit*, in England the mantua became increasingly appropriate even for formal occasions. Although female seamstresses had long produced undergarments and accessories for men and women (often of linen), it is notable that the mantua was the first fashionable outer garment to be made by female dressmakers rather than male tailors.[21]

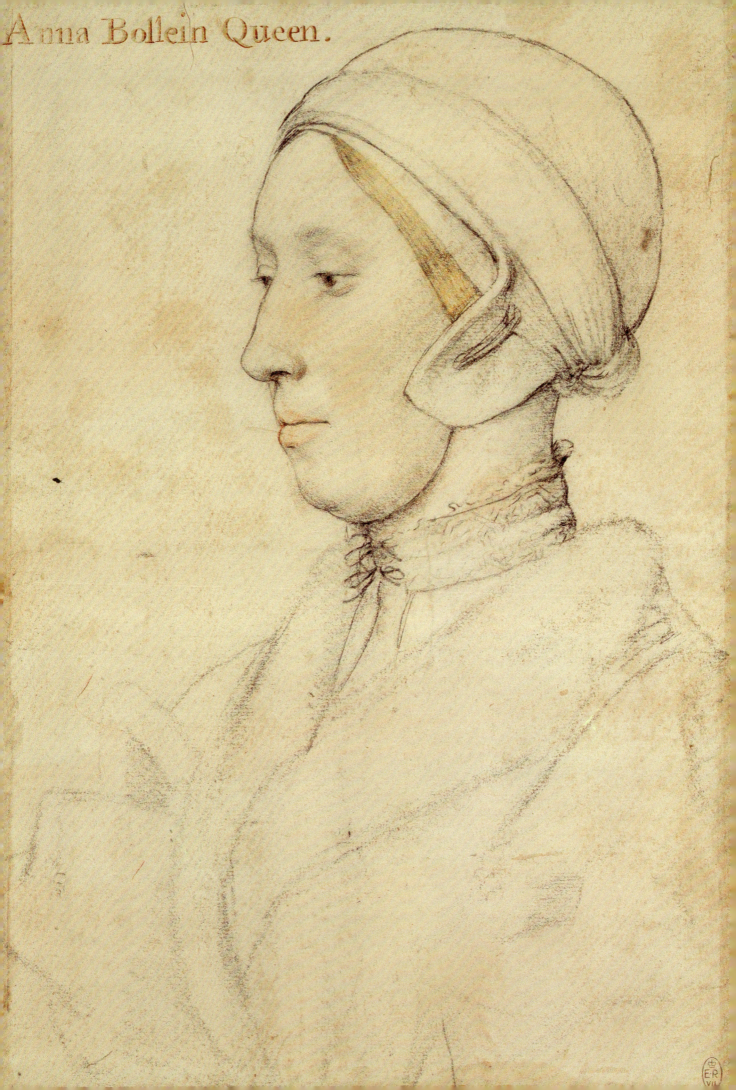

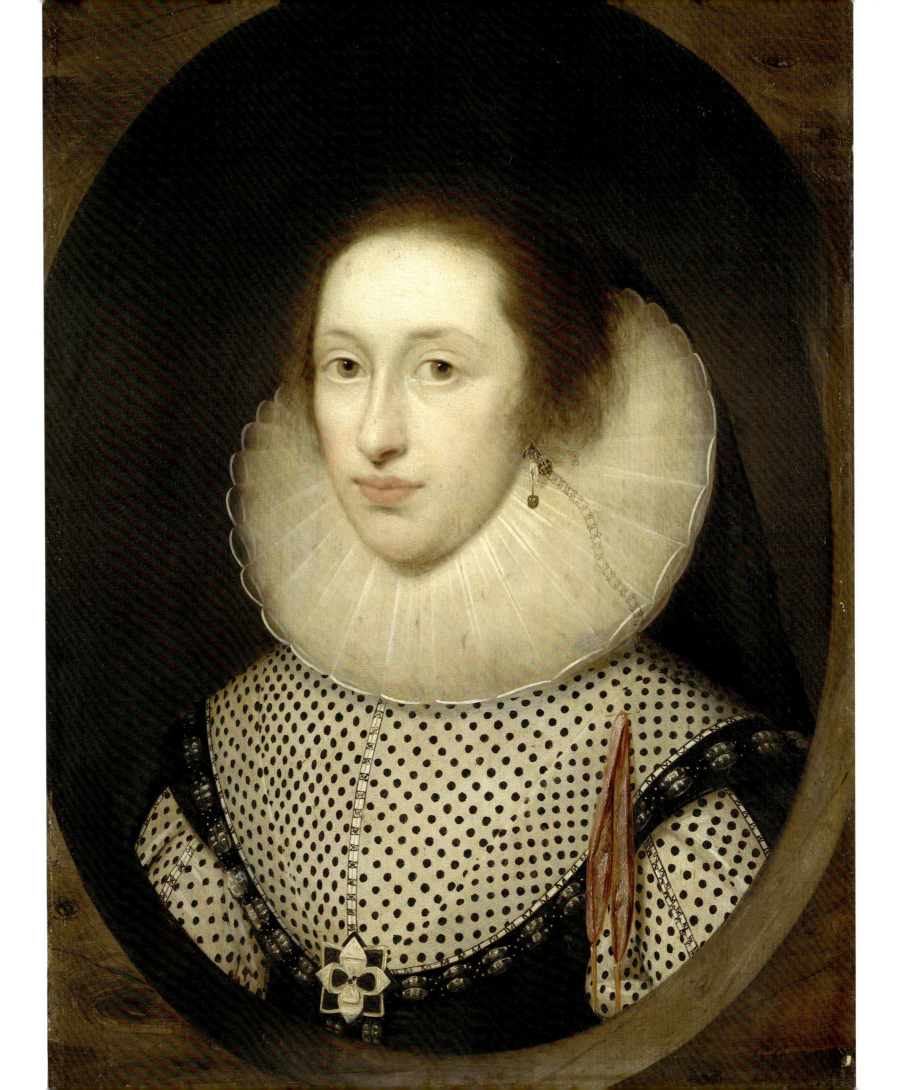

COLLARS AND CUFFS

One of the most important ways for an elite woman to demonstrate her wealth and fashionability was her choice of collars and cuffs. Originating as the small decorative frill at the neck and wrist of the smock, both developed into more practical detachable versions, then pinned or sewn on. Fine delicate lace could therefore be washed separately by specialist lace laundresses. A huge variety of styles of neckwear was popular throughout the period, varying from the cartwheel ruffs so characteristic of the late Elizabethan period, to the wide falling bands worn by women and men at the Caroline court, and subsequently the highly three-dimensional lace collars of the Restoration court.

Setting a *ruff* into a complex arrangement of pleats was an extraordinarily time-consuming process, involving starch and hot steel poking sticks (heated over a fire), around which the starched linen would be set. The process had to be repeated every time the ruff was washed, or sagged through wear and exposure to damp air. In Ben Jonson's *Every Man out of his Humour*, Puntarvolo warns his companion to 'keep close; yet not so close, thy breath will thaw my ruff'.[22] Before setting, a ruff comprised a flat length of linen finely gathered into a neckband with many tiny pleats. An example from the Bayerisches Museum, Munich (fig. 46) has 530 tiny pleats and is formed from $16\frac{1}{2}$ yards of linen, which would provide enough fabric to produce deep figure-of-eight shapes. Fitting this density of pleats into such a short neckband required incredibly finely woven delicate linen – but the finer the linen, the more frequently it required re-setting into shape.[23] The artistry and skill of the laundress, responsible for creating such a complex gravity-defying effect, forms a striking feature of portraiture in this period. The same ruff could be set in a variety of different ways, and group portraits show that different settings were fashionable simultaneously. According to portrait evidence, ruffs could have up to seven layers, each individually set, although most surviving examples have a maximum of four layers.[24]

The style of ruff being worn in Cornelius Johnson's portrait of an unknown woman (fig. 47) was becoming rather unfashionable in England by the time of the painting, suggesting that the sitter was perhaps a member of the provincial gentry or merchant classes who lagged behind the court. Linen neckwear usually fastened at the front, and in this example the two front edges were probably pinned together to conceal the gap. The fine linen ruff is set into approximately 30 figure-of-eight pleats; to achieve the tilted effect it would have rested on a *supportasse* (also known as an *underpropper* and *picadil*) at the back. An example can be seen in fig. 48. While being constructed from stiff cardboard, it is covered with white silk, suggesting this was not a purely functional item but was also intended to be seen. A wired rebato probably covered in red silk can be seen in the 1609 portrait of Elizabeth of Brunswick (fig. 49).[25] Layering of neckwear was common – Anne of Denmark wears her open French collar (see fig. 28) along with a lace-trimmed smock.

ABOVE

Fig. 46 Linen ruff, *c*.1620–40
Munich, Bayerisches Nationalmuseum,

OPPOSITE

Fig. 47 Cornelius Johnson (1593–1661), *Portrait of a Lady*, 1624.
Oil on panel, 43.8 x 33.0 cm. RCIN 402978

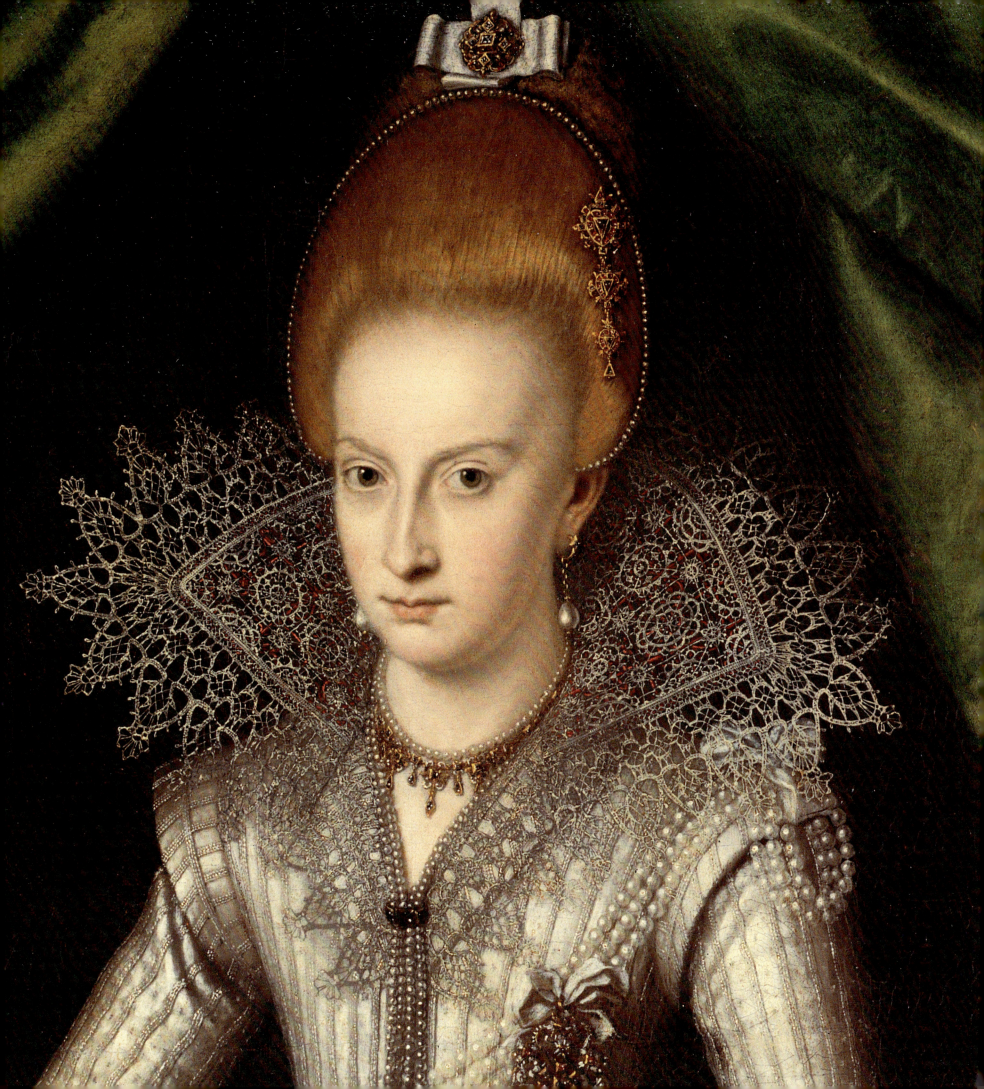

OPPOSITE
Fig. 49 (detail from fig. 29) Attributed to Jacob van Doort (d. 1629), *Princess Elizabeth of Brunswick-Wolfenbuttel*, 1609.
Oil on canvas, 193.9 x 112.6 cm. RCIN 404963

BELOW
Fig. 48 Supportasse, British, 1600–25.
Card and silk, 26.0 x 30.4 cm. London, V&A Museum. Acc. 192–1900

Collars and cuffs of both *needle lace* and *bobbin lace* were popular throughout the period, although at certain dates one technique was more dominant than the other. Needle lace has its origins in the cutwork of the sixteenth century, whereby individual threads of a piece of woven linen are cut away and the gaps filled with buttonhole stitches in intricate designs. It therefore initially utilised the directions of the right-angled threads used to construct the piece of linen, and designs typically had a geometric foundation – as seen in fig. 235, in which circular motifs and stars are contained within a regular grid of squares. Later needle lace (known as *punto in aria*, literally 'stitch in the air') was freed of the constrictions of geometric boundaries by the removal of the woven fabric ground, allowing greater flexibility in the designs.

In contrast to needle lace, the bobbin lace technique probably developed out of the *passe-menterie* industries of Italy or Spain and was originally used to make narrow borders from silk and metal threads. By the second half of the sixteenth century linen threads were being used, and the resulting lace (also known as *bone lace* after the composition of the original bobbins) developed into freely flowing softly scalloped designs, visible for example in Rembrandt's portrait of Agatha Bas (see fig. 32). In the sixteenth century bobbin lace was a cheaper alternative to needle lace, being quicker to produce, but by the 1630s Flemish bobbin lace could be as expensive as needle lace.

It is often very difficult to identify the type of lace in a painted image alone, particularly since the two techniques were increasingly used to imitate the styles of the other – and sometimes both were used on the same item. For surviving lace, detailed examination and handling is often necessary to identify the techniques used and region of production. Italy (particularly Venice) and Flanders were the main centres making early lace, although France became increasingly important during the seventeenth century.

Portraits predominantly depict women wearing the ivory-coloured lace that was most popular, although sometimes lace was coloured, either by tinting with pigments during the processes of washing/starching or by using coloured silks as the raw materials. Tints were usually very subtle, using soft vegetable dyes or smalt (powdered glass containing blue cobalt). The ruff in fig. 46 still has traces of blue starch in certain areas. The blue tint was probably intended to give the optical illusion of bright white, by counteracting

DRESSING WOMEN 61

OPPOSITE
Fig. 51 (detail) Daniel Mytens (*c*.1590–1647), *Elizabeth, Queen of Bohemia*, 1626–7.
Oil on canvas, 196.4 x 114.4 cm. RCIN 400094

BELOW
Fig. 50 Embroidered gloves, *c*.1595–1605.
Worshipful Company of Glovers. Acc. 23342+A

the yellow hue of linen. However, during the early years of the seventeenth century a more obvious yellow colour based on saffron (an expensive dye derived from the stigmata of the crocus flower) became fashionable. The unknown woman in fig. 41 wears a lace collar dyed with yellow starch decorating the neckline of her embroidered waistcoat, with matching yellow lace cuffs in a scalloped pattern. Anne Turner, enterprising businesswoman and waiting-woman to Lady Frances Howard, was credited with the introduction of yellow starch to England from France. The dyed yellow lace fell out of fashion after Turner was hanged in 1615 for her involvement, along with her mistress, in the murder of Sir Thomas Overbury by poisoning. According to some accounts she was executed wearing a yellow 'cobweb Lawn ruff', with the hangman wearing bands and cuffs of the same colour.[26] Although no references to yellow starch are found in court wardrobe accounts after 1625, the decline of yellow lace was probably more gradual than later commentators claimed.

ACCESSORIES

A number of popular accessories are commonly depicted in portraits during the period. Gloves, with their symbolic associations of elite status and friendship, are a common feature, and are often carried to suggest their importance in social exchange. Traditionally given as favours at weddings, to mourners at funerals, or as gifts for the monarch, gloves could be expensive items of clothing, although less expensive pairs were worn on a daily basis.[27] Queen Mary II ordered two dozen pairs each month (it was common for the monarch to wear new gloves nearly every day).[28] Gloves such as those seen in fig. 50 were often made by two different craftsmen – a glover to make the main body of the glove, and an embroiderer to make the highly decorative and colourful *gauntlet* extending over the wrist, which here is also edged with fringing. Portraits, however, tend to show men and women wearing plain leather gloves rather than these more ornate surviving examples.

In Daniel Mytens's portrait of Elizabeth of Bohemia (fig. 51), the sitter wears gloves of a supple, fine beige doeskin or kid which crumple gently at the wrist, stopping short of the extraordinarily ornate and expensive three-tiered lace cuffs. Her hands, with wrists wrapped with strings of pearls, were fully completed before the gloves were added; the skin colour shows through (the white paint used for the gloves has probably become more translucent over time). As it was not the artist's usual practice to complete the skin layer before adding clothing or accessories, this is most likely to be a later change of mind by the artist (or perhaps the suggestion came from the sitter?). The fingers of the gloves extend some distance beyond the end of the fingertips in the fashionable manner, a lengthening effect enhanced by the use of embroidered lines of decoration

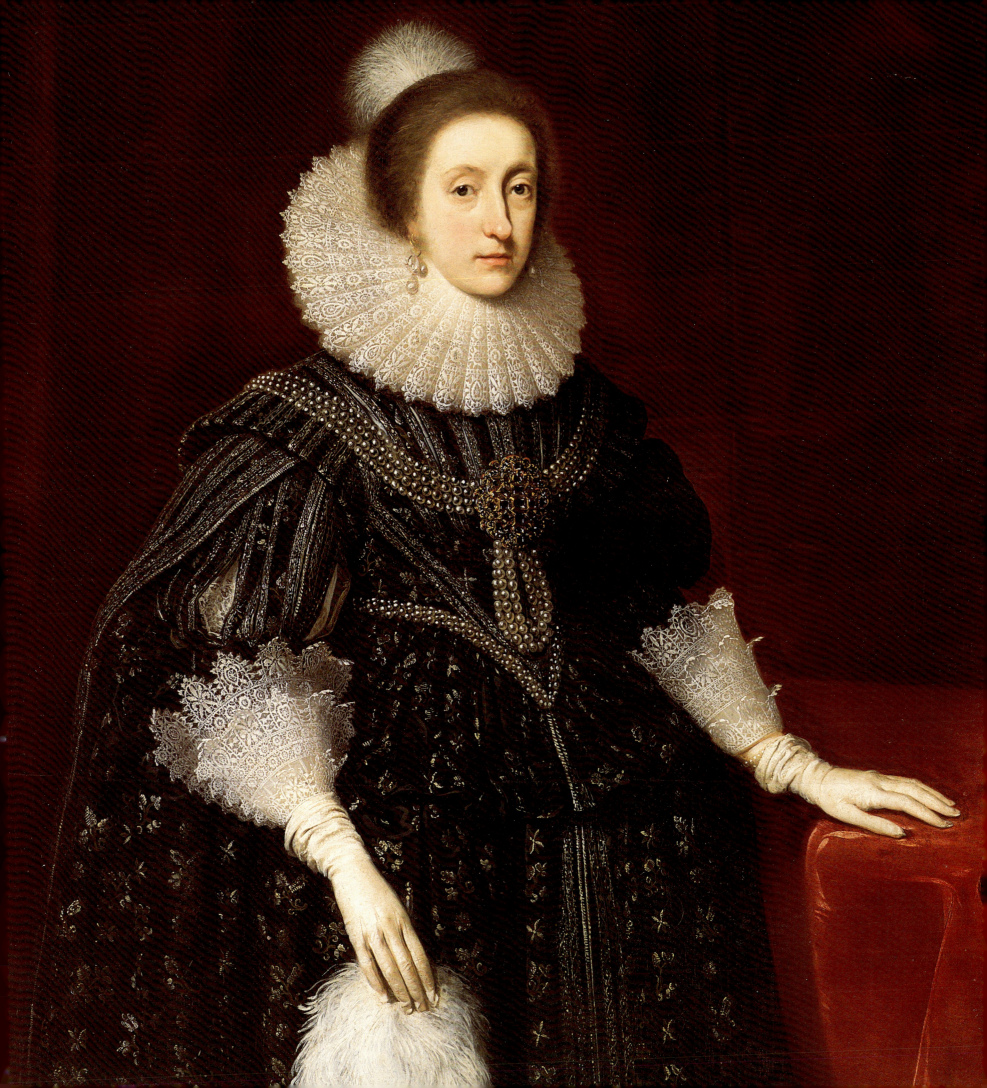

along the fingers and also extending back onto the hand. This creates an elegant length to the fingers – and indicates that the wearer is exempt from practical jobs. The development of this fashion has been associated with Elizabeth I, who was proud of her hands and long graceful fingers, and would remove a glove for a courtier to kiss her hand as a mark of particular favour. Conversely she would wear rings on top of gloves to indicate metaphorical distance.[29] It is perhaps unsurprising that painters choose to emphasise the queen's un-gloved hands. Although she was frequently presented with gloves as New Year's gifts, only one painting is known that shows her actually wearing them. In Hans Eworth's *Elizabeth I and the Three Goddesses* (fig. 259; detailed in fig. 52), she wears white gloves with short tabs decorated with silver cord.[30] Her appreciation of gloves, however, is indicated by the fact that she holds them in many other portraits. By the 1630s gloves echoed the wider shift towards a restrained elegance and minimal surface decoration, and became plainer. Women's gloves also became longer, as bodice sleeves became shorter, and by the 1690s elbow-length gloves were worn outside with the mantua.

Unlike gloves, women's shoes are infrequently shown in portraiture of this period, being either excluded by the popular bust-length format or concealed by long skirts. Inventories and actual shoes, however, have survived and are revealing. Elizabeth I's inventories show that in the early years of her reign she favoured velvet shoes, ordering up to 40 pairs a year. But by the 1570s she was ordering more pairs made from Spanish leather than of velvet.[31] In addition she also ordered multiple pairs of *pantofles* (overshoes which had only a toe and deep cork sole, and protected the shoe beneath from dirt) and slippers. A pair of *buskins* (knee-length boots), constructed of soft brown leather and by tradition associated with Elizabeth I, survives in the Ashmolean Museum, Oxford.

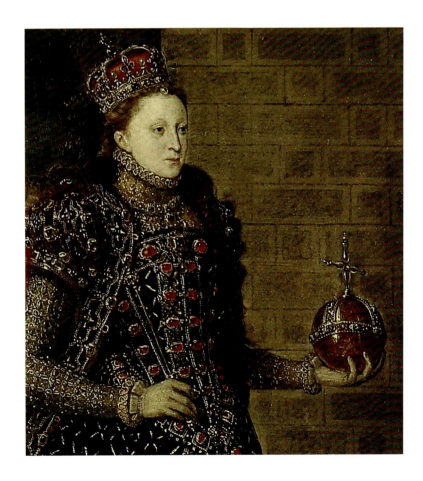

Fig. 52 (detail from fig. 259) Hans Eworth (active 1540–73), *Elizabeth I and the Three Goddesses*, 1569.
Oil on panel, 62.9 x 84.4 cm. RCIN 403446

Women's feet are more frequently shown in genre pictures or crowd scenes. In Janssens' *Charles II Dancing at a Ball at Court*, the skirt and petticoat of the seated figure in the foreground have risen sufficiently to reveal a heeled shoe of yellow leather, fastened with red ribbon ties (fig. 13; detailed in fig. 53). In this example the toe is pointed, although women's shoes could also be made with square or even forked toes, and the red heel is of a moderate height. Another type of shoe is clearly depicted in Steen's *Woman at her Toilet* (see fig. 26). On the floor is a pair of indoor slippers, strewn untidily as though taken off in haste. Backless, they are constructed of plain buff-coloured leather again with a moderately high heel. It is unusual to see a pair of shoes unworn in paintings of this period, but as we have seen, this painting was intended to be read as an allegorical scene with a moralistic message. Like the saucepan and the lute – well-documented sexual symbols of female genitalia in Dutch genre scenes – the concave interior of the shoes, both of which deliberately face the viewer, might be considered in the same manner.

The Museum of London has a pair of highly decorative red velvet mules associated with Queen Henrietta Maria (fig. 54). The uppers are of crimson red silk velvet, decorated with raised silver thread and sequin

embroidery of a particularly high quality. The date of these mules (c.1651–70) places them after the execution of Charles I, and they were probably made on the Continent during Henrietta Maria's period of exile. The narrow band of white kid (known as the *rand*), visible between the sole and the upper part of the shoe, helps with dating. Characteristic of the later part of the seventeenth century, this is an early example including this feature. The shape of the black leather heels is also suggestive of French origin.

At the Tudor court it was not considered appropriate for women to be bareheaded. In the drawing thought to represent Anne Boleyn (fig. 42), the sitter wears a linen *undercap*, shaped and wired to cover her ears, with a separate piece of linen passed around the top and tied at the nape of the neck. At this period such undercaps could be worn either as informal dress or underneath a more formal hood to protect it from the hair. Catherine of Aragon (fig. 20; detailed in fig. 55) wears an *English* or *gable* hood, consisting of a piece of white linen fabric edged with a jewel-set band, beneath red cloth-of-gold lappets set with pearls pinned up over each ear. Two pieces of black fabric hang from the crown of the head down her back. The geometric shape surrounding the face is achieved through the use of a wired support, an example of which is in the Museum of London.[32] As Holbein's portrait of Lady Ratcliffe demonstrates (fig. 56), for a period in the 1530s some fashionable women at court chose to pin up one long black side lappet, with the other hanging down to the shoulder – an asymmetric effect more typical of the Baroque, and rather at odds with the general Renaissance principles of harmony and balance. The drawing indicates exactly how the lappet was pinned and folded back on itself to achieve the final arrangement, while the artist's inscription of *schwarz felbat* (black velvet) provides information about the fabric.

The widespread view is that a new style of headdress, the *French hood* (curving around the head in a semi-circle unlike the angular English hood and worn further back on the head revealing more of the hair), was popularised during the 1530s by Anne Boleyn who would have known it from her time at the court in France. However, it has been demonstrated that the French hood appears before the arrival of Anne Boleyn in England in 1522.[33] Perhaps in an attempt to dissociate herself from her predecessor, Henry VIII's next wife, Jane Seymour, returned to the English hood, which she wears in her portrait by Holbein of c.1536–7 (RCIN 912267). She did not allow her attendants to wear the French hood.[34] Although it is tempting to suggest that Princess Elizabeth was aware of the significance of her headdress and was making a conscious reference to her mother when she chose to return to the French hood in

ABOVE

Fig. 53 (detail from fig. 13) Hieronymus Janssens (1624–93), *Charles II Dancing at a Ball at Court*, c.1660. Oil on canvas, 139.7 x 213.4 cm. RCIN 400525

BELOW

Fig. 54 Mules, c.1651–70.
Crimson velvet decorated with raised silver thread and sequin embroidery. London, Museum of London. Acc. 30.76.a-b

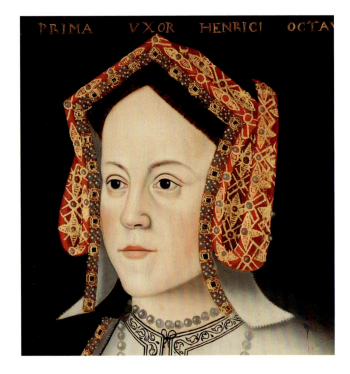

ABOVE
Fig. 55 (detail from fig. 20) British School, *Catherine of Aragon*, sixteenth century.
Oil on panel, 57.5 × 44.6 cm. RCIN 404746

RIGHT
Fig. 56 Hans Holbein the Younger (1497/8–1543), *Lady Ratcliffe*, c.1532–43.
Black and coloured chalks, pen and ink, brush and ink, and metalpoint on pale pink prepared paper, 30.1 × 20.3 cm. RCIN 912236

OPPOSITE
Fig. 57 François Clouet (c.1520–72), *Mary, Queen of Scots*, c.1560–1.
Oil on panel, 30.3 × 23.2 cm. RCIN 403429

her c.1546 portrait attributed to Scrots (see fig. 27), by the 1540s it had been adopted throughout England. The *upper* and *nether billiments* (bands of decoration on the back and front respectively) are set with pearls, and a piece of striped and crimped *cypress* (fine gauze) has been wired to curve over the ears.

Another particularly recognisable form of headdress worn during the sixteenth century was known as a *Paris head* (now more commonly known as a Mary Stuart cap). Worn by widows, it consisted of a wired linen cap which dipped over the centre of the forehead. In François Clouet's portrait of Mary, Queen of Scots (fig. 57), the nineteen-year-old sitter wears a form of mourning dress known as *deuil blanc* to mark the loss of her father-in-law, mother and husband within the space of eighteen months. She wears a white Paris head over a white undercap (just visible at the forehead), with a white veil down the back known as a head-rail. Beneath her chin is a barbe of fine transparent linen through which it is possible to see her black dress

66 IN FINE STYLE

with its fashionably arched neckline. For the pale-skinned queen, this was deemed a flattering style of attire, exaggerating the desirable whiteness of her complexion, 'the whiteness of her face rivalled the whiteness of her veils, and in this contest artifice was the loser, the veils paling before the snows of her skin'.[35]

Although by the seventeenth century the convention to be depicted with head covered was no longer observed, it remained usual for women to be depicted in portraits with their hair dressed. Towards the end of the century a tall style of headdress (known as a *frelange*) became increasingly complex and could reach extraordinary heights.

During the sixteenth century a common way for a wealthy woman to carry small necessary items was by attaching them to a *girdle* round the waist. *Pomanders* (decorative containers filled with aromatic substances such as ambergris, orris or rosemary to scent the air),[36] prayer books, fans and scissors might be transported in this way, and are occasionally seen in full-length female portraits of the period. Bags are rarely depicted in paint although they survive in some number – several decorative examples in the Royal Collection reflect the variety of shapes and styles that were found. One example is constructed of gold thread and yellow taffeta with a cord drawstring, in the shape of a frog (fig. 58). Although unlikely to have been worn regularly at court, it must have been appreciated for its novelty, and in so doing exemplifies one of the key factors driving new fashions – the search for the innovative and different.[37] During this period, the elite rarely needed to carry money; accounts were instead settled on a periodic basis. Instead these small receptacles might have been used as 'sweet bags' – to carry sweet-smelling perfumed powder or dried flowers, and to scent clothing when in storage. They might also have been given as part of the New Year's gifts to the monarch, when they would have contained coins or other small presents.

While small accessories are sometimes included in portraits from the sixteenth and early seventeenth centuries, they are often omitted by later artists such as van Dyck. However, fashionable accessories held particular appeal for the Bohemian printmaker Wenceslaus Hollar, who moved to England in 1637 under the patronage of the influential Thomas Howard, 2nd Earl of Arundel. His etchings are invaluable in bringing objects from this later period to life. The first of Hollar's major series focusing on attire was published in 1643, comprising 40 etchings of English women and was entitled *Theatrum Mulierum* (The Theatre of Women). Like another of his series entitled *The Four Seasons* (fig. 59), showing women dressed throughout the year, the importance of these prints to dress historians lies in the fact that they depict women from a variety of social orders – and from the front, side and back. They wear the sort of expensive indoor clothing commonly depicted in portraits, but also fashionable clothing worn for travelling or walking outside. Hollar's prints show how clothing actually works, how the layers were pinned back and so on.[38]

A Group of Muffs, Kerchiefs, Fans, Gloves and a Mask (fig. 60) by the same artist has a particularly tactile three-dimensional quality. Hollar seems to have relished the contrast in texture between the various types of fur, feathers and lace. On the left-hand side is a *vizard*

Fig. 58 Purse in the shape of a frog, seventeenth century.
Gold thread and coiled silk, 10.0 x 6.0 cm. RCIN 37043

OPPOSITE
Fig. 59 Wenceslaus Hollar (1607–77),
(TOP LEFT) *Spring*, 1643.
Etching, 27.0 x 19.2 cm (sheet). RCIN 802403
(TOP RIGHT) *Summer*, 1644.
Etching, 26.9 x 18.9 cm (sheet). RCIN 802404
(BOTTOM LEFT) *Autumn*, 1644.
Etching, 27.0 x 18.6 cm (sheet). RCIN 802405
(BOTTOM RIGHT) *Winter*, 1644.
Etching, 26.7 x 19.2 cm (sheet). RCIN 802406

Welcom sweet Ladie you doe bring Spring. That makes the Earth to looke so greene
Rich presents of a hopefull Spring, As when shee first began to teeme.

How Phœbus, crowns our Symer dayes Summer Her lovely neck, and brest are bare,
With stronger heate and brighter rayes, Whilst her fann doth coole the Ayre.

As Autumnes fruit doth mourne and wast Autumne So of herselfe (she feares) she shall
And if not pluckt it droppes at last, If not timely gather'd, fall.

The cold, not cruelty makes her weare Winter For a smoother skinn at night,
In Winter, furrs and Wild beastes haire Embraceth her with more delight.

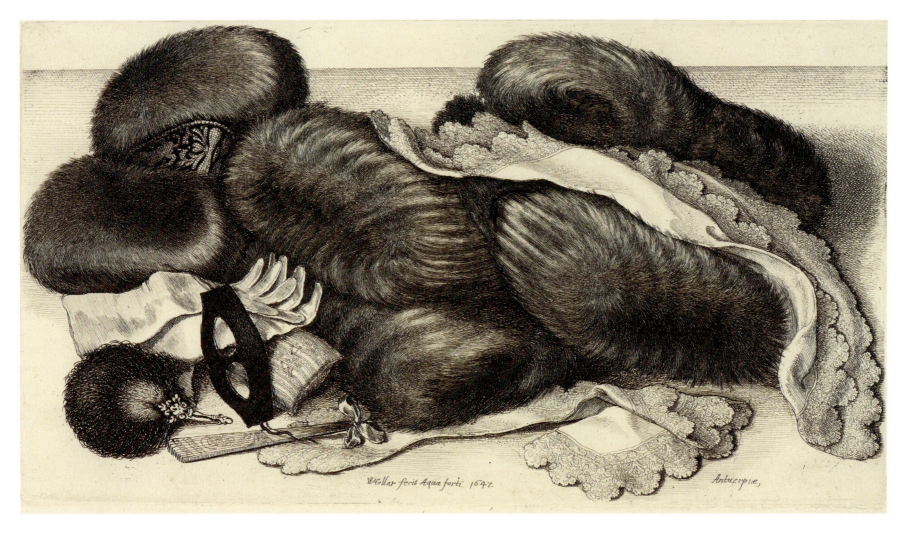

Fig. 60 Wenceslaus Hollar (1607–77), *Group of muffs and articles of dress*, 1647. Etching, 11.5 x 21.0 cm (sheet). RCIN 804215

(mask, often of velvet), worn since the second half of the sixteenth century by the fashionable lady to protect her desirably pale complexion from the sun. These could be tied on, attached to a stick, or held in place by biting a button between the teeth. Vizards had historical connotations with prostitution and the concealment of identity that such a profession often necessitated, but by the seventeenth century they were worn by the fashionable elite. The use of fur in the construction of elite clothing had gone out of fashion by this date, although it remained in use for muffs for both sexes to provide comfort against bitter weather. Muffs could also contain pockets, making them useful for carrying small objects, and could be perfumed.

Fans were luxurious and fashionable accessories, which also served as costly status symbols. The earliest examples consisted of feathers set into a jewelled handle – Elizabeth I carries a fan of this type in fig. 3. The arrival in Europe of folding fans from Japan and China, during the late sixteenth century, made them a fascinating novelty. Both types are included by Hollar in his engraving. Agatha Bas carries a folding fan with a decorative fan leaf prominently displayed in her portrait (fig. 32). It has been suggested that its position is a deliberate allusion to her pregnancy, since fans can be understood as symbols of marital love.[39] However, the fact that she was only in her second month of pregnancy at this time makes this unlikely.[40]

JEWELLERY

Portraits are useful records of jewels and how they were worn, since jewellery from this period is a rare survival, frequently remodelled as tastes changed. Many of Elizabeth I's figurative jewels were taken apart to manufacture objects in gold plate for diplomatic gifts or to make new jewels in more up-to-date styles.[41] During the Elizabethan period, jewellery often held symbolic significance – both in terms of the gemstones used (many of which were considered to have magical properties) and the settings, which were often elaborately enamelled and included references to classical or mythological figures.

The Darnley Jewel (fig. 61), a heart-shaped locket (known as a tablet in the sixteenth century) worn pinned to the bodice or around the neck, is a particularly important example of Renaissance jewellery. Numerous emblems and mottoes cover its surfaces in a complex iconographical display. It was probably commissioned during the 1570s by Lady Margaret Douglas, Countess of Lennox, perhaps as a memorial to the deaths of her husband, Matthew Stewart, and son, Lord Darnley, and to express her hope for the legacy of the family through her grandson, later James I of England and VI of Scotland. On the front, enamelled allegorical figures each carry their attributes – Faith carries a cross and lamb, Hope an anchor, Victory an olive branch and Truth a mirror. A crown set with rubies and an emerald, and a winged heart formed from a blue glass cabochon stone, both open to reveal mottoes in sixteenth-century Scots, translating as 'What We Resolve' and 'Death Shall Dissolve'. Although the goldsmith is not known, the workmanship is of the highest quality and illustrates clearly the Renaissance emphasis on the equal importance of the mount to the gemstone itself, and the value placed on jewels with symbolic associations.

Anne of Denmark had a particular love of expensive jewellery and in 1597 appointed Edinburgh jeweller George Heriot her goldsmith for life – he travelled south upon James I's accession and produced a number of pieces for the royal couple. Jewels in the form of ciphers were particularly popular during the Jacobean period, and Anne of Denmark had a number of items of this type that recur frequently in her portraits. In a miniature of c.1611–12 (fig. 62) she wears an 'S'-shaped jewel in reference to her mother, Sophie of Mecklenburg, and a crowned 'C' encircling a '4', a gift from her brother Christian IV of Denmark in 1611. Its appearance here, therefore, sets 1611 as the earliest possible date for the production of this miniature.[42] These jewels emphasise her own dynastic importance in its own right, separate to that of consort to the English king. She also wears a portrait miniature inside a decorative case pinned to her bodice with a pink ribbon, on the left-hand side over her heart. All three items are also visible in the Gheeraerts portrait (see fig. 28), along with a magnificent double-cross brooch at her breast set with diamonds.

Similarly sentimental but far more enigmatic is the earring worn by the unknown sitter painted by Cornelius Johnson (fig. 47; detailed in fig. 63). Only apparently worn in one ear, the earring consists of four separate components attached to the ear on a black silk thread. In the front, a pair of praying hands, enamelled in white *champlevé*, hold a string from which is suspended a dark sphere, perhaps intended to represent a skull. A very similar Spanish pendant in the form of a hand is in the Metropolitan Museum, New York (fig. 64), of approximately

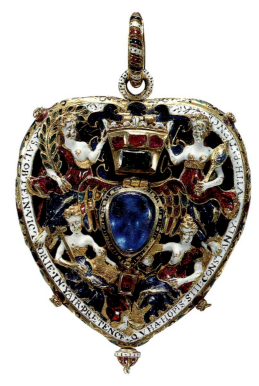

ABOVE

Fig. 61 The Darnley or Lennox Jewel, Scottish, c.1571–8.

Gold, enamel, Burmese rubies, Indian emerald and cobalt-blue glass, 6.6 × 5.2 cm. RCIN 28181

BELOW

Fig. 62 Isaac Oliver (c.1565–1617), *Anne of Denmark*, c.1611–12.

Watercolour on vellum laid on playing card, 5.3 × 4.2 cm. RCIN 420041

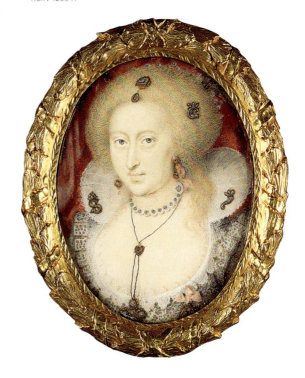

ABOVE RIGHT
Fig. 63 (detail from fig. 47) Cornelius Johnson (1593–1661), *Portrait of a Lady*, 1624.
Oil on panel, 43.8 x 33 cm. RCIN 402978

ABOVE LEFT
Fig. 64 Pendant in the form of a hand, possibly Spanish, 1600–50.
Rock crystal with enamelled gold mount set with emeralds, 6.7 cm. New York, Metropolitan Museum of Art. Acc. 1982.60.394

ABOVE
Fig. 65 Pendant with miniature of Elizabeth I, miniature by Nicholas Hilliard (1547–1619): c.1585; case: c.1600.
Gold, champlevé enamel, Burmese rubies and a diamond, 1.7 x 1.1 x 0.7 cm. RCIN 17197

the same date as this painting. The pendant is constructed of rock crystal while the mount is of enamelled gold set with emeralds. Looking back to the portrait, a heart-shaped jewel also hangs from the earring. This is set with ten gemstones (probably diamonds) and may be a tiny locket – a similar locket only 1.2 cm tall is in the Royal Collection and contains a miniature of Elizabeth I (fig. 65). Perhaps most unusual is the delicate chain suspended from this cluster, which snakes across the ruff and extends across the sitter's bodice to the left shoulder seam where it is probably pinned. *Lovelocks* (locks of a lover's hair hung from the ear) were by this date an established fashion for both men and women, and one possibility is that this could be a chain woven of human hair – several examples of seventeenth-century lace woven from hair still exist in the V&A Museum.[43] However, the open and regular nature of the pattern suggests instead fine metalwork, as hair is slippery and does not maintain its shape easily. The sitter also wears a ribbon *point* trimmed with a metal aglet pinned to her bodice over her heart, perhaps serving as a memento of a lost loved one (see fig. 47). During this period ribbons were given

as love token between both sexes – Thomas Carew's poem 'Upon a Ribband' praises the 'silken wreath' that entwines the flesh just as the mind is entwined by love.[44] When taken in conjunction with the sitter's black clothing and plain ruff, this jewellery is suggestive of mourning and indeed specific mourning jewellery became increasingly fashionable during the seventeenth century.

Jewellery could be used to demonstrate a wearer's faith. Henrietta Maria occupied the difficult position of being an openly Catholic queen in a Protestant country at a time when many were suspicious of Catholic influences over the king and court. Despite owning several large and expensive diamond crosses, and despite claiming that she never took off a certain cross necklace, Henrietta Maria's early portraits are devoid of such overtly devotional jewellery.[45] By 1636, however, she is shown wearing crosses in her portraits, for example the portrait by van Dyck of 1638 (see fig. 156) – suggesting that she had become more open about displaying her religion through her attire.[46]

Just as today, diamonds were highly prized during the sixteenth century, but they often appear black in portraits of the period. This can be explained firstly by limitations in gemstone-cutting techniques, which constrained the dispersion of light, and secondly due to coloured foil backs sometimes placed behind the stones. Until new types of cut were developed to optimise their light-reflecting abilities, it was for their hardness and lustre that diamonds were considered so precious, rather than their brilliance. The point-cut is often depicted in sixteenth-century portraits, and utilises the naturally occurring octahedral form of the diamond. Eleanora of Austria (fig. 66) wears a point-cut diamond on the index finger of her right hand, and a point-cut ruby on her left. The angle of her hands makes the shape of the stone particularly clear, whereas many portraits show the stones from the top where the cut is difficult to discern and is complicated by the shape of the base, which may be visible through the top of the stone. With developments in gem-cutting techniques and the subsequent rise in

BELOW AND BELOW RIGHT (DETAIL)
Fig. 66 Joos van Cleve (active 1505/08–1540/1), *Eleanora of Austria*, c.1531–4.
Oil on panel, 71.3 x 58.7 cm. RCIN 403369

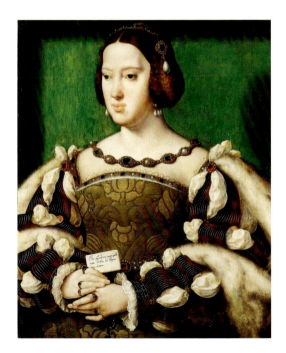
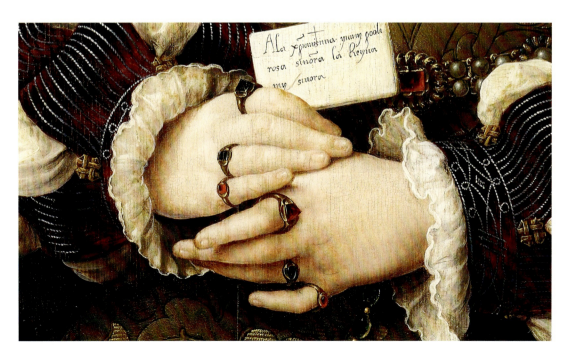

status of gemcutters, mounts tended to become simpler as the focus shifted to the quality and size of the gems themselves. *Portrait of a Woman*, perhaps intended to represent Anne of Denmark (fig. 67), depicts jewels in simple square settings as bodkins in her hair, probably pinned into a wired pad beneath the hair. A very similar pendant was found in the Cheapside Hoard (fig. 68), consisting of two faceted rose-cut sapphires and a spinel drop with a single pearl remaining. The gemstones are mounted in plain gold wire frames similar to those seen in the portrait.

Sometimes important diamonds can be recognised in portraits. One example is the Mirror of Portugal, a table-cut diamond which in 1691 weighed $25^{3}/_{8}$ carats.[47] It was sold by the King of Portugal, Dom António to Elizabeth I, who had it set into a gold mount with an enamelled floral design as a pendant suspended from a gold chain. It is worn by Henrietta Maria in the 1638 profile portrait by van Dyck (fig. 69). She then pawned the diamond during the Civil War in exchange for a loan. It ended up in the possession of Cardinal Mazarin who bequeathed it to the French Crown in 1661. After the theft of the French crown jewels during the French Revolution in 1792 the Mirror of Portugal disappeared and has not resurfaced since.

Another example of a recognisable jewel in a portrait is the large and perfectly symmetrical pear-shaped pearl now known as *La Peregrina* ('The Wanderer'), which still survives today. It can be seen in the portrait of Mary I after Anthonis Mor, suspended from a diamond brooch (fig. 70). At the time of its discovery the pearl was the largest in existence, at $58 \,^{1}/_{2}$ carats. It was presented by Philip II to Mary I as an engagement gift, but returned to the Spanish Crown after her death and also appears in the portrait of Margaret of Austria (fig. 71).[48] All pearls seen in portraiture of this period are naturally formed examples, since artificial cultivation techniques were not developed until the early twentieth century. Their rarity and expense made them enduringly fashionable amongst the elite.

Elizabeth I maintained a love of pearls throughout her life. Their creamy colour and purity suited her preferred colour scheme of black and white, and they symbolised virginity and the full moon. Sometimes Elizabeth was characterised as the Moon Goddess, in reference to the goddess Diana (or Cynthia), renowned for chastity. Portraits frequently show her clothing and hair covered in pearls – fashions of the period dictated a focus on abundant surface decoration – as well as large pear-shaped pearls hanging from one or both ears.[49]

Queen Anne of Denmark and Henrietta Maria were frequently painted wearing pearls, the smooth surfaces often offset against the contrasting texture of a lace collar, and they were the most popular form of jewellery for women throughout the seventeenth century. An unusual necklace is that worn by Queen Anne in the half-length Gheeraerts portrait (see fig. 28), comprising a large teardrop-shaped pearl with a jewel of exactly the same size and shape carved from a hard stone, perhaps rock crystal, hanging from the same string. She also wears grey pearls wrapped around the sash on her left arm, and four long ropes of pearls around the shoulders, which are looped down to the waist line to give a massed effect. In contrast to this abundance of pearls, both Daniel Mytens and van Dyck in the 1630s generally show Henrietta Maria with only a single pearl necklace and a pair of particularly large teardrop-shaped pearl earrings which still exist today, and are known as the 'Mancini Pearls' (fig. 69).

OPPOSITE
Fig. 67 British School, *Portrait of a Woman*, c.1605–10.
Oil on panel, 58.5 x 44.1 cm. RCIN 402736

ABOVE
Fig. 68 Three-drop pendant, late sixteenth to early seventeenth century.

Gold, enamel, blue sapphires, spinel, pearl, 7.2 cm.
London, Museum of London. Acc. 14104

DRESSING WOMEN 75

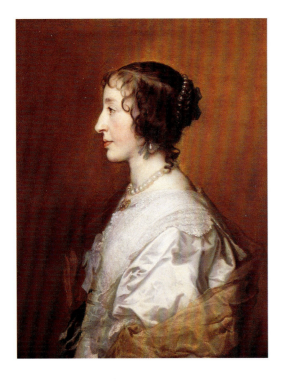

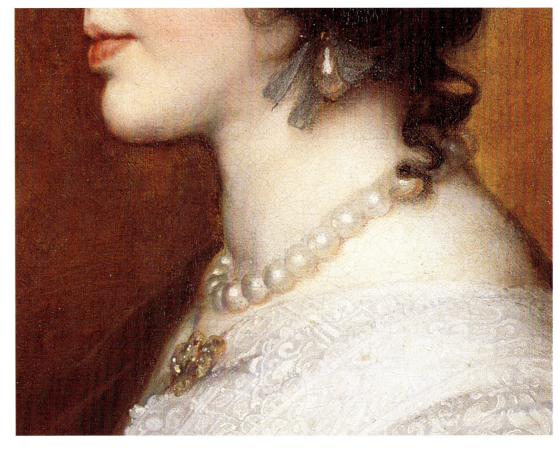

ABOVE AND RIGHT (DETAIL)
Fig. 69 Sir Anthony van Dyck (1599–1641), *Queen Henrietta Maria*, 1638.
Oil on canvas, 78.8 x 66.1 cm. RCIN 400159

FAR LEFT
Fig. 70 (detail from fig. 23)
After Anthonis Mor van Dashorst (c.1518–76), *Mary I*, 1554–9?
Oil on panel, 93.1 x 75.8 cm. RCIN 404442

LEFT
Fig. 71 (detail from fig. 12)
Juan Pantoja de la Cruz (c.1553–1608), *Margaret of Austria, Queen Consort of Philip III of Spain*, c.1605.
Oil on canvas, 204.6 x 121.2 cm. RCIN 404970

The magnificent brooches worn here include different table cut diamonds set in ornate gold mounts, but both have the pearl known as *La Peregrina* suspended as a pendant. The variation in appearance of the pearl is due to differences in painting style between the two artists.

Originally owned by the Medici family in Florence, the pearls were brought to France by Henrietta Maria's mother, Marie de' Medici, upon her marriage to Henri IV, and from there they went to England as part of Henrietta Maria's dowry.[50]

Another way to emphasise the prized pale skin of elite women during the first quarter of the seventeenth century was with fine strands of black silk which could be used in a multitude of ways – as a necklace, tied through the ear as an ear-string, or wrapped several times around the wrist and used to secure a valuable or ill-fitting ring (see fig. 25). Robert Herrick even dedicated a poem to the style, emphasising the contrast between dark and light:

> I saw about her spotlesse wrist,
> Of blackest silk, a curious twist;
> Which, circumvolving gently, there
> Enthrall'd her Arme, as Prisoner.
> Dark was the Jayle; but as if light
> Had met t'engender with the night ...[51]

Later in the seventeenth century, women are depicted wearing pearls threaded onto coloured silks, as seen for example in fig. 138.

Unfortunately it is impossible to do justice to the subject of cosmetics and hairstyles in this survey.[52] However, one subject which does deserve brief comment is that of the fashion for patches. Almost completely absent from portraits at any point during the Tudor and Stuart period, patches were fashionable from the early part of the seventeenth century and remained popular well into the eighteenth century. Cut from black fabric, usually velvet, and stuck onto the face using saliva or adhesive, like black silk strings they were designed to emphasise the creamy white skin of the truly leisured class (an effect likened to a fly in milk – the French word for a beauty spot is *mouche*). Patches were found in a variety of shapes, including crescents, flowers and animals, and as many as seven or eight might be worn at once. They were frequently used to conceal a blemish – Pepys remarks on the Duchess of Newcastle appearing with 'many black patches, because of pimples about her mouth'.[53]

A gold enamelled patch box belonging to Mary II (fig. 72) and set with diamonds is dated *c.*1694, around the year of her death (ironically from smallpox, at the age of only 32). It will have been used to hold the patches that she bought from her milliner for 1s per sheet. Mary is depicted wearing three modest circular patches on her forehead and cheek in the print of the same date after Bonnart (fig. 44; detailed in fig. 73), although this is unlikely to have been from life. By contrast, in all the paintings that Mary sat for, as either a Princess of Orange or monarch, she is shown with her skin undecorated in this manner.

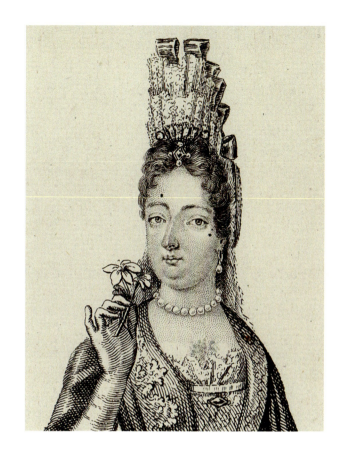

ABOVE

Fig. 73 (detail from fig. 44) After Robert Bonnart (1652–1729), *Mary II*, 1694.

Etching and engraving, 27.7 x 19.2 cm (sheet). RCIN 603312

BELOW

Fig. 72 Queen Mary's Patch Box, probably made in London, *c.*1694.

Enamel, gold and diamonds, 2.3 x 5.2 x 4.5 cm. RCIN 19133

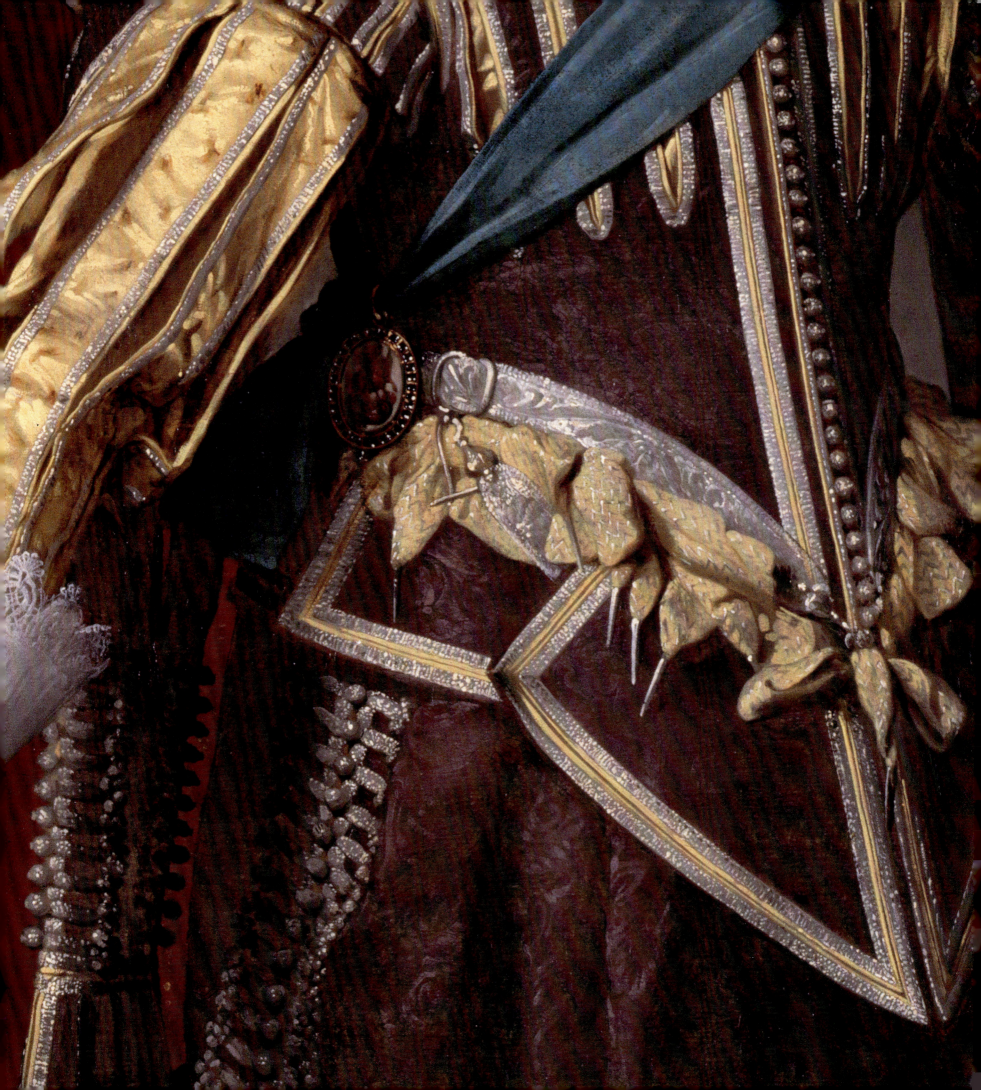

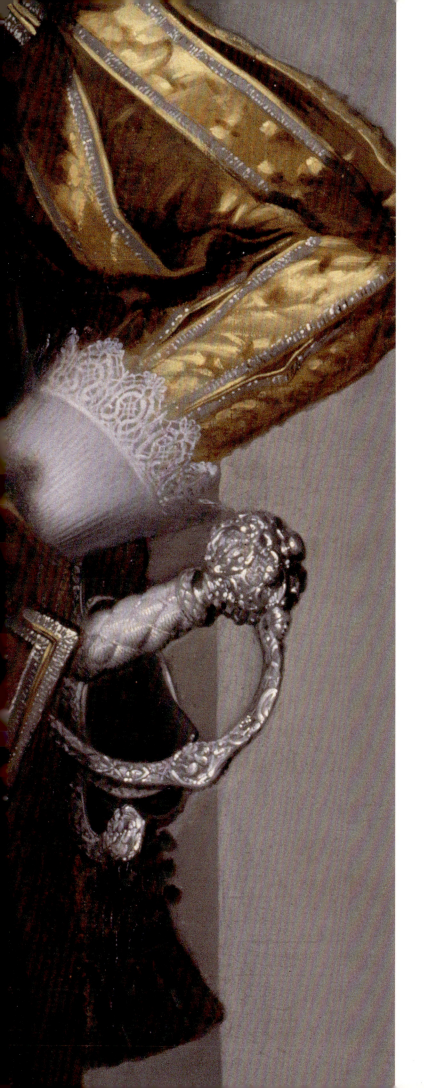

3

DRESSING MEN

Called up by my tailor, and there first put on a summer suit this year; but it was not my fine one of flowered tabby vest, and coloured camelott tunique, because it was too fine with the gold lace at the hands, that I was afeard to be seen in it; but put on the stuff suit I made the last year, which is now repaired

Samuel Pepys, *The Diary of Samuel Pepys*, 1 May 1669

WHILE there were obviously differences in terms of the component garments and silhouette, male fashions matched their female counterparts in materials, expense and complexity of design and surface decoration throughout the period. Moreover, men were subject to similar manipulations of the body to produce an idealised figure: 'We use much bumbastings and quiltings to seem better formed, better shouldered, smaller waisted and fuller thighed than we are.'[1]

Broad changes in fashions were sometimes echoed in both sexes, so when waistlines rose above the natural level during the 1620s the effects were seen in male doublets and female bodices. In Daniel Mytens's double portrait of Charles I and Henrietta Maria (fig. 75), the dress of each of the two main figures complements that of the other. Both have waistlines at approximately the same height, voluminous sleeves, a sloping shoulder line emphasised by a wide lace collar and applied vertical stripes of braid to create a sense of height (Charles I was 5 feet 4 inches tall and his wife under 5 feet). Each also wears a white-plumed hat. Preferences for colours, fabrics and surface decoration were often broadly consistent for male and female dress – so the Elizabethan preference for abundant, complex and symbolic surface decoration on textiles was seen in both sexes, while by the Caroline era plainer silks and simpler styles were worn by both, and at the end of the seventeenth century the exaggerated verticality of female dress achieved through the mantua gown and tall *frelange* headdresses was echoed in male dress by wigs raised into horns and by high heels. At other times general changes in fashions for the two sexes separated, so for example while male dress became gradually looser and more relaxed during the 1650s, by contrast female dress became more constrictive and formal.

During the fifteenth century clothing worn by men and women became increasingly differentiated and clothing became a standard indicator of gender; the differences between clothing worn by the two sexes reflected both the anatomical figure beneath and traditional differences in lifestyle. Generally those features of the male body associated with masculinity, such as broad shoulders and long muscular legs, were highlighted, although the level of emphasis naturally changed throughout the period as fashions shifted. The length of breeches varied significantly, for example, but usually revealed at least the lower leg. Although sometimes the clothing of one sex might mimic that of the other, it was not until the twentieth century that truly unisex clothing developed. The one exception to this is in children's dress, where it is occasionally impossible to distinguish the sex of a child in

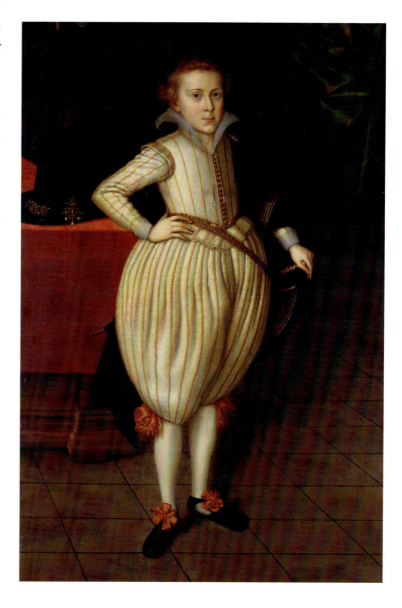

Fig. 74 Attributed to Jacob van Doort (d. 1629), *Christian, Prince of Brunswick, later Duke of Brunswick and Lüneburg*, 1609.
Oil on canvas, 187.6 x 103.9 cm. RCIN 404914

The extent of the padding used to add volume to male breeches is clearly demonstrated in this portrait. The figure's lower body is completely distorted by clothing and is in dramatic contrast to the doublet cut tight to the torso.

Pp. 78–9 (detail from fig. 93) Daniel Mytens (c.1590–1647), *Charles I*, 1628.

Fig. 75 (detail) Daniel Mytens (c.1590–1647), *Charles I and Henrietta Maria Departing for the Chase*, c.1630–2.
Oil on canvas, 282.0 x 408.3 cm. RCIN 404771

a portrait under the age of around six (when boys made the transition from skirts to breeches). Even in these cases, though, clues such as collar style are sometimes indicators and would probably have been intuitive symbols to the contemporary viewer.

SHIRTS AND NIGHTSHIRTS

For men, as for women, the layer closest to the skin was made of linen. A shirt similar in design to the female smock was the first item to be put on each day, and is visible in portraiture, both at the cuffs and neck as for women, but also in other areas, for example through the slits in doublet sleeves, and around the waistline as the doublet waistline became shorter. As well as being easily washable, the linen shirt protected the body from uncomfortable materials used to construct the outer garments, and prevented chafing, particularly at the neck and wrists. The whiteness of one's linen held a deeper meaning, that of godliness – clean in both body and soul. Finely woven pristine-white linen was also a significant sign of wealth, and at certain points, for example during the 1650s and 1660s, the voluminous shirt was pulled through gaps in the clothing above to emphasise a billowing abundance of costly fabric. The general T-shaped design of the man's shirt changed little throughout this period, but other features such as necklines, any associated embroidery and the detachable ruff/collar and cuffs could vary significantly. A wealthy man would own a sufficient number of shirts to allow a fresh shirt to be worn each day. In Shakespeare's *Henry IV, Part II* (Act II, scene ii), Prince Henry mocks Poins for owning only two shirts, 'one for superfluity, and another for use'. Even a basic linen shirt without embroidery was a significant investment.

A typical man's shirt can be clearly seen in Godfried Schalcken's painting of a raucous parlour game (fig. 76). Although the rules are now lost to us, it must have encompassed some kind of forfeit involving the removal of items of clothing. The central figure (possibly a self-portrait of the artist) has removed his doublet to reveal his linen shirt, which is gathered into the neckband and cuffs. The neckline is deep, making the shirt easy to put on, and the artist has depicted gussets inserted under the armpits for more comfortable movement – they appear here triangular, but were actually squares folded diagonally. The shirt is worn tucked into the man's breeches of flower-patterned fabric. Another white linen garment can be seen in the pile of clothes on the footstool, but its shape makes its identification difficult. The man's stockings and shoes are missing, and there appear to be too many clothes in the pile for one person to wear, although no-one else is as undressed as the main 'victim'. The top garment in the pile, of striped brown silk, might perhaps belong to the female figure beckoning behind the main protagonist – its colours co-ordinate with her blue silk bodice decorated with yellow ribbons. She appears in a state of partial undress; her linen shift is visible at the waistline, and the

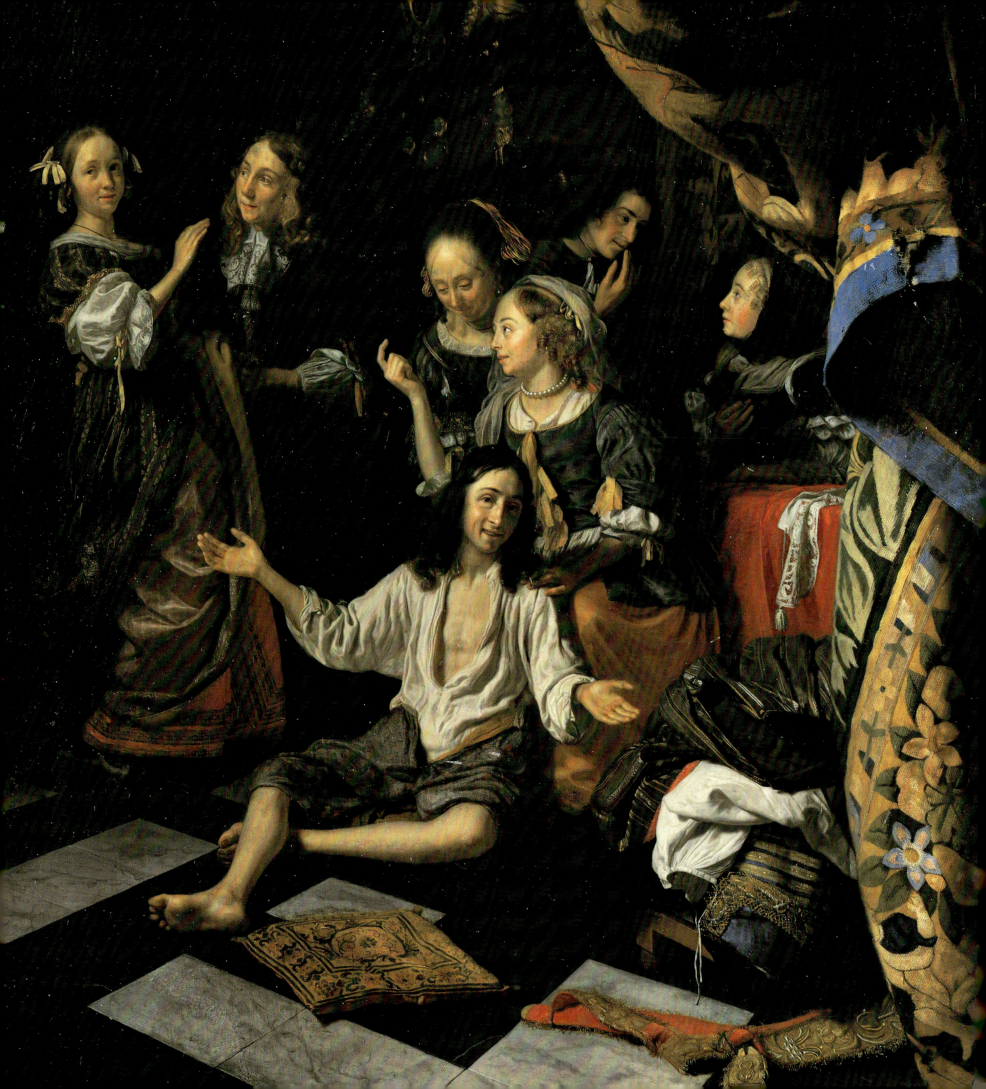

orange garment she wears is perhaps a petticoat. Another garment of blue and yellow stripes, trimmed with gold lace, together with the gold and scarlet sword belt on the floor, are additional disparate and expensive items.

During the early part of Henry VIII's reign, doublet necklines were cut fairly low across the chest and a large part of the shirt could be visible above, as in the portrait of Henry VIII by van Cleve (fig. 77). This clearly shows how the volume of the shirt has been gathered into the neckband, which in this example has been trimmed with diamonds and pearls. The shirt (or a lining fabric) has also been pulled through slashes in the cloth of gold fabric to form elliptical puffs of fabric in a geometrical pattern. Similar effects to display underlayers of white linen were created during the seventeenth century by the use of paning in the chest, back or sleeves of the male doublet.

Henry VIII's neckline is jewel-set, but more typically men's shirts were embroidered in the same way as women's smocks – and, for both, blackwork was the most popular form of decoration, whether geometric or foliate in design. The shirt visible in *Portrait of a Man in Red* (fig. 78) is open down the front and is not covered by his doublet worn above. This combination, revealing the torso, is unusual for a fully dressed figure in England (although low-cut doublets of German visitors were remarked on at the English court).[2] The floral embroidery, which becomes wider towards the base of the opening, indicates this was an intentional effect. This style might have been considered appropriate in youth – facially this young man appears to be an adolescent. The intimate miniature of Henry Fitzroy, Duke of Richmond, aged around 15 (fig. 79), shows an open shirt – although here the sitter is in informal attire, worn in the home prior to putting on the upper layers. This shirt may in fact be a nightshirt. While many men wore their normal shirts to bed, some owned separate nightshirts for sleeping. Henry Fitzroy wears a white linen nightcap (in reality a form of headwear worn informally during the day) embroidered with a geometric blackwork design, and the shirt has been deliberately left untied at the collar. Such a manner of depiction at this date is very unusual, making this a particularly personal memento. His informal dress indicates that he is of superior social standing, since etiquette dictated that it was inappropriate to appear in front of one's superiors in less formal attire. Perhaps it was intended to demonstrate that, despite Fitzroy's illegitimate birth, his status in the king's eyes was still considerable. Another interpretation is that the miniature was painted during a period of illness, and that the Duke is dressed in the manner of receiving visitors in bed, in the same way that women would receive visitors after childbirth.[3] Another idea is that it was intended as an intimate gift for his new wife, Lady Mary Howard.

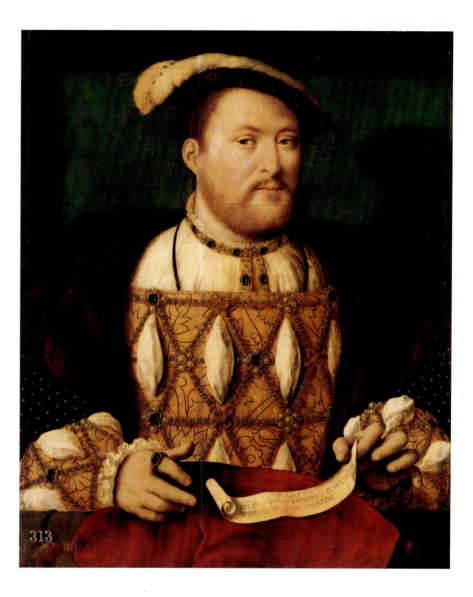

Fig. 77 Joos van Cleve (active 1505/08 – 40/1), *Henry VIII*, c.1530 – 5
Oil on panel, 72.4 x 58.6 cm. RCIN 403368

OPPOSITE

Fig. 76 (detail) Godfried Schalcken (1643 – 1706), *The Game of 'Lady, Come into the Garden'*, c.1668 – 70.
Oil on panel, 63.9 x 49.3 cm. RCIN 405343

ABOVE

Fig. 79 Lucas Horenbout (c.1490/5–1544), *Henry Fitzroy, Duke of Richmond and Somerset*, c.1533–4.

Watercolour on vellum laid on playing card, diameter 4.4 cm. RCIN 420019

RIGHT

Fig. 78 German or Netherlandish artist working in England, *Portrait of a Man in Red*, c.1530–50.

Oil on panel, 190.2 x 105.7 cm. RCIN 405752

While it is true to say that the linen shirt was customarily the item closest to the skin, occasionally it appears that an additional layer was worn beneath for warmth. King Charles I's finely knitted bluish-green silk vest, in the Museum of London (fig. 80), is an example of this type of intimate yet luxurious layer, and is commonly understood to have been worn while on the scaffold at his execution in 1649.[4] The shirt is of a particularly high quality, with a variety of patterns and knitting stitches and was probably produced in England, possibly in or around London, but knitted from imported Italian silk.

NECKWEAR

By the Elizabethan period men's shirts were usually covered by high-necked layers; the only items of linen visible were collars and cuffs. These became separate items, following the same broad changes in styles seen for women. The small decorative frill around the neckline grew in size until it formed the huge detachable cartwheel ruff at its most extreme in the 1580s. The ruff gradually transformed into the *band* (the contemporary term used for collar) that could be either a *standing band* (stiffened and raised on a wired support so that it stood up away from the shoulders) or *cloak band* (covering the shoulders, also known as a *falling band*). This is the style most commonly seen in the portraits of van Dyck, such as *Charles I* (fig. 81). An exquisite cloak band at The Bowes Museum, Barnard Castle (fig. 82), dating from approximately the same year as the painting, provides a rare opportunity to compare the three-dimensional object with the two-dimensional image. In the surviving garment the area which would be concealed by the wearer's hair is of plain woven linen, avoiding the expensive lace being exposed to grease. It is likely that the painted collar is also made in this manner, although van Dyck gives the impression of a collar completely constructed of lace. In the portrait the left-hand figure's collar is the most regular of the three – like the surviving collar, the pattern is identical within each lobe. The ability to replicate a motif perfectly in a regular pattern demonstrates the technical skill of the lace-maker. The more free-handed way in which the lace patterns for the central and right collars have been depicted might suggest they were painted later. Perhaps van Dyck was keen to get the portrait finished, or perhaps he was bored by the more precise rendering, which was less a hallmark of his style in general. Alternatively, he may not have had direct access to a garment and so let his imagination guide the pattern instead. The unusual simultaneous portrayal of the sitter from three angles is explained by the fact that the portrait was commissioned to be sent to Lorenzo Bernini in Rome; the sculptor

Fig. 80 Knitted pale green silk vest associated with Charles I, English, c.1640–9.
London, Museum of London. Acc. A27050

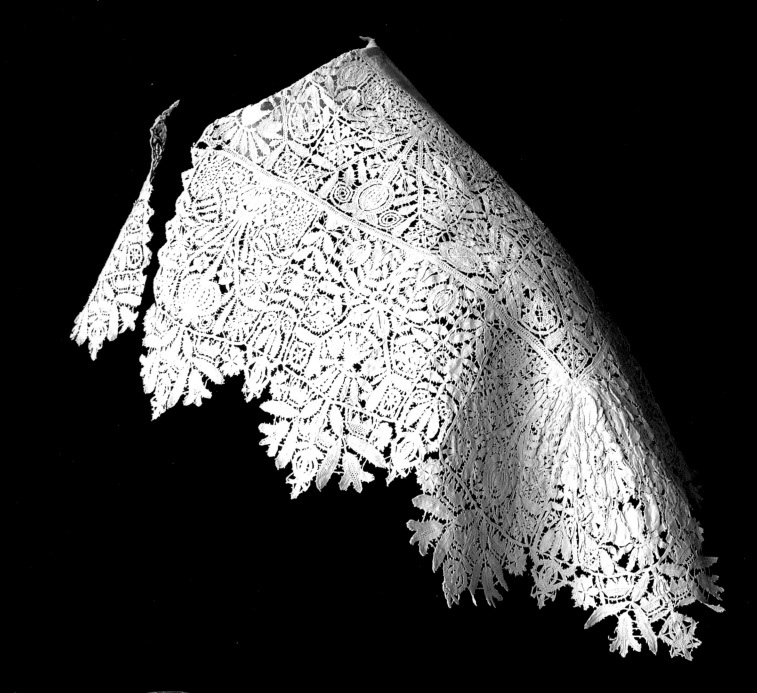

OPPOSITE

Fig. 81 Sir Anthony van Dyck (1599–1641), *Charles I*, 1635–6.

Oil on canvas, 84.4 x 99.4 cm. RCIN 404420

ABOVE

Fig. 82 Man's cloak band, English, *c*.1635.

Barnard Castle, The Bowes Museum, Blackborne Collection. Acc. 2007.1.1.28

LEFT

Fig. 83 Charles I (1600–49), *Eikon Basilike: the portraicture of His Sacred Majestie in his solitudes and sufferings*, London: Roger Daniel, 1649 (Madan 25).

Four lengths of blue silk ribbon are attached to the boards. An inscription inside the book describes these as Charles I's Garter ribbon.

RCIN 1080417

RIGHT

Fig. 84 Peter Vanderbank (1649–97), *Charles II*, 1680.

Engraving, 52.4 x 43.0 cm (sheet). RCIN 602556

BELOW

Fig. 85 (detail from fig. 15) Sir Anthony van Dyck (1599–1641), *Charles I and Henrietta Maria with their two eldest children, Prince Charles and Princess Mary ('The Greate Peece')*, 1632.

Oil on canvas, 303.8 x 256.5 cm. RCIN 405353

was to produce a marble bust of the king as a papal gift from Pope Urban VIII. This might also explain why van Dyck depicted three different lace collars, perhaps acting as a menu from which the sculptor could select his preferred pattern.

The surviving collar clearly shows that the shaping of the collar is created by pleating the lace into the corners over the shoulders. Van Dyck ignores these pleats and implies that the collar has been shaped in three dimensions during the lace-making process, an unlikely and technically demanding feat. A further point of comparison with the portrait is provided by a ribbon (fig. 83) which survives inside a copy of Charles I's book, *Eikon Basilike* ('The Royal Portrait'). An inscription inside the book claims it is Charles I's Garter riband and recent carbon dating indicates that it is likely to date from between 1631–70. The pale blue colour of this ribbon, which in the portrait is shown suspending the Lesser George garter badge, was officially decreed only in 1622 and was later replaced by a darker shade of blue, probably during the reign of George II.[5]

In many miniatures and prints of the latter seventeenth century, such as the Peter Vanderbank print of Charles II (fig. 84), lace neckwear is often the main item of clothing interest and decorative elements are concentrated in the front given that the back and sides are obscured by the styled wig. The curving thread patterns and the curving ringlets of the fashionably full-bottomed wigs proved an attractive combination. This lace is likely to be Venetian *gros point*. Like cutwork, it was made with a needle and linen thread rather than on bobbins, and is characterised by its sculptural three-dimensionality. It was particularly fashionable in England between 1660 and 1690, despite attempts to limit foreign imports (including lace) by royal proclamation. Only royalty were excluded from having to adhere to this statute, but it appears to have had little impact on fashionable courtiers who continued to buy and wear such forms of lace. In the Schalcken painting (see fig. 76), a separate lace bib-fronted band, probably of Flemish bobbin lace but in the Italian style, has been placed on the table.[6] The care with which the lace has been set aside is demonstrative of its extraordinarily high value, relative to the other garments of rich fabrics slung in a disorganised pile on a low footstool.

STOCKINGS, BREECHES AND CODPIECES

Full-length male portraits during the Renaissance period often use a rather balletic pose, with one foot in front of the other and each slightly turned out to emphasise the shapely male leg, the ideal form of which was lean, muscular and exaggeratedly elongated with a curving calf and strong swelling thigh disappearing into the trunk-hose. Stockings (also known as netherstocks, or *hose* from around 1600) covered the legs. Originally cut from woven woollen cloth or linen, and often cut on the bias (diagonal) to give more flexibility, they were fitted

individually with a seam up the back. They could be laced into the leg bands of the trunk hose or held up by garter ribbons above the knee. From the mid-sixteenth century knitted silk versions became available, initially imported from Spain but later made in England. Knitted stockings had the advantage of more stretch, which meant they were tighter fitting and could be sold ready-made. Even with this technological development, however, it is unlikely that the smooth and entirely wrinkle-free depiction of male legs in much portraiture of the Tudor and Stuart period is an accurate representation.

Van Dyck is the first artist in Britain to emphasise deliberately the wrinkling of stockings to artistic effect, in portraits such as *'The Greate Peece'* which shows the seated Charles I in lilac-coloured silk stockings gently crumpling at the knee (fig. 15, detailed in fig. 85). It is a testament to the artist's skill that despite (or indeed because of) the depiction of such imperfections he achieves such elegance and vibrancy. Charles I ordered hose in huge quantity – between 1633 and 1634, for example, he received from his hosier Thomas Robinson over 200 pairs of upper- and under- hose in linen, silk and worsted, including some specifically designed for playing tennis.[7] Under hose were worn beneath the stockings, to provide warmth, intensify the colour and conceal leg hair.[8]

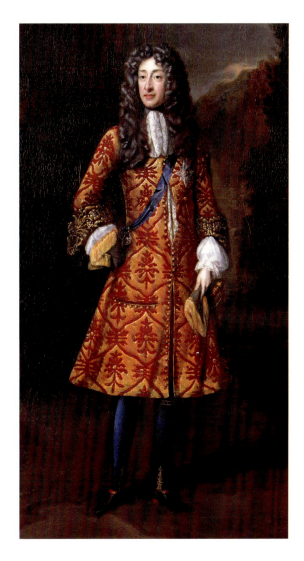

LEFT
Fig. 86 (detail) Anne Killigrew (1660–85), *James II*, 1685.
Oil on canvas, 104.8 x 86.4 cm.
RCIN 403427

BELOW
Fig. 87 Green silk stockings associated with William III, *c.*1690.
London, Royal Ceremonial Dress Collection. Acc. 3503039.a-b

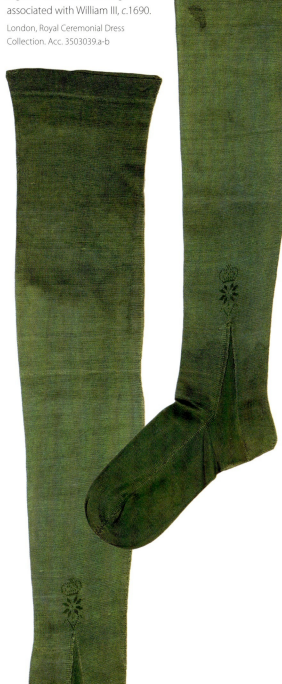

Brightly coloured silk stockings, in a variety of shades contrasting dramatically with the rest of the outfit, do not appear to have been unusual for men. In Mytens's 1623 portrait of the Duke of Hamilton, an all-black ensemble is teamed with shocking red hose (Tate Britain, London), while Arthur Capel in Cornelius Johnson's *The Capel Family* of *c.*1640 (National Portrait Gallery, London) has bright green hose that the artist has considered important enough to sneak into the picture frame. The fashion persisted. In the Royal Collection is Anne Killigrew's *James II* (fig. 86). Blue silk stockings are paired with a patterned coat of complementary orange and red; the contrast between the two items makes the colours sing emphatically against each other. An interesting comparison are the knitted green silk stockings belonging to William III, with carefully worked decorative *clocks* at the ankle and 'W' woven into the upper hem (fig. 87). William III is usually considered a reserved monarch, less interested in the oscillations of fashion than his predecessors, but these stockings indicate that he did not shirk away from eye-catching hues.

Fig. 89 Doublet and paned trunk-hose worn by Don Garzia de' Medici, c.1560.
Crimson silk velvet and silk satin with couched gold cord.
Florence, Palazzo Pitti

Drawers (the contemporary word for underwear) were optional for the fashionable gentlemen, and were usually constructed of linen. Instead of drawers, a man would usually wrap the shirt-tails of his long linen shirt between his legs.[9] Breeches, however, were ubiquitous. They varied in shape and name throughout the period, from the spherical *trunk-hose* of the Elizabethan period to the baggy knee-length *Venetians* popular in the early seventeenth century and the *petticoat breeches* worn at the early Restoration court.

In the 1563 portrait of Lord Darnley and Lord Lennox (fig. 88), the older brother wears an all-black ensemble of high-necked doublet with pumpkin-shaped trunk-hose, black stockings and black shoes. Trunk-hose in this style were stiffened with lining fabric and padded with bombast (stuffing of cotton, horsehair or other materials) to achieve the three-dimensional effect. They are often constructed in panes of fabric which sometimes reveal a contrasting lining beneath. Displaying a very similar silhouette is a suit in the Palazzo Pitti in Florence (fig. 89), belonging to Don Garzia, fourth son of Eleanora of Toledo and Cosimo I de' Medici. It probably dates from only one or two years before the painting – Don Garzia was buried in the suit when he died, aged 15, in 1562.[10] The trunk-hose are of dark crimson silk velvet, decorated with gold cord oversewn with another thread to secure it. It was in 1562 that this style of trunk-hose was the subject of new legislation in England, attempting to regulate their volume and the amount of fabric that could be used to construct them.[11]

One of the more extraordinary forms of breeches, often commented upon by contemporary writers, are *petticoat breeches* (known on the Continent as the 'rhingrave'[12]), which were extremely full, and thus bore a resemblance to female petticoats – although they reached the knee rather than the ankle. Introduced into England in 1658, according to Randle Holme,[13] they are relatively infrequently depicted in portraiture due to the tendency for men in this period to be painted in a more timeless form of dress. Charles II, for example, was most frequently depicted in armour or Garter robes. The fashion is clearly depicted, however, in contemporary popular prints – for example in one commemorating the marriage of Charles II to Catherine of Braganza in May 1662 (fig. 90). The king's breeches fall in multiple vertical folds to the knee, and are decorated with bunches of ribbons at the waist and side. Such prints would have been widely available, with features of fashionable dress immediately recognisable to the viewer. The doublet and petticoat breeches in the Verney Collection (fig. 91) follow these lines closely. Constructed of cream figured silk, the suit is trimmed with six different types of ribbon, with a total length of approximately 216 yards.[14] Petticoat breeches were worn until around 1680, by which date they were considered very old-fashioned.[15]

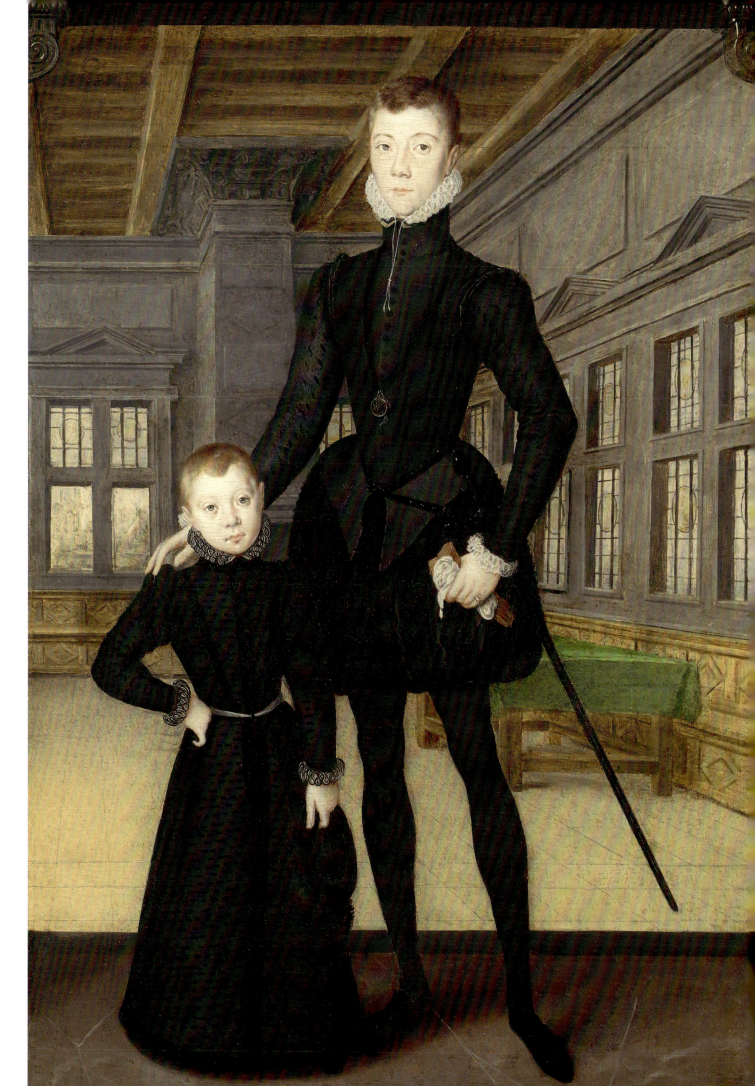

Fig. 88 Hans Eworth (active 1540–73), *Henry Stewart, Lord Darnley, and his brother Charles Stewart, Earl of Lennox*, 1563. Oil on panel, 63.3 x 38.0 cm. RCIN 403432

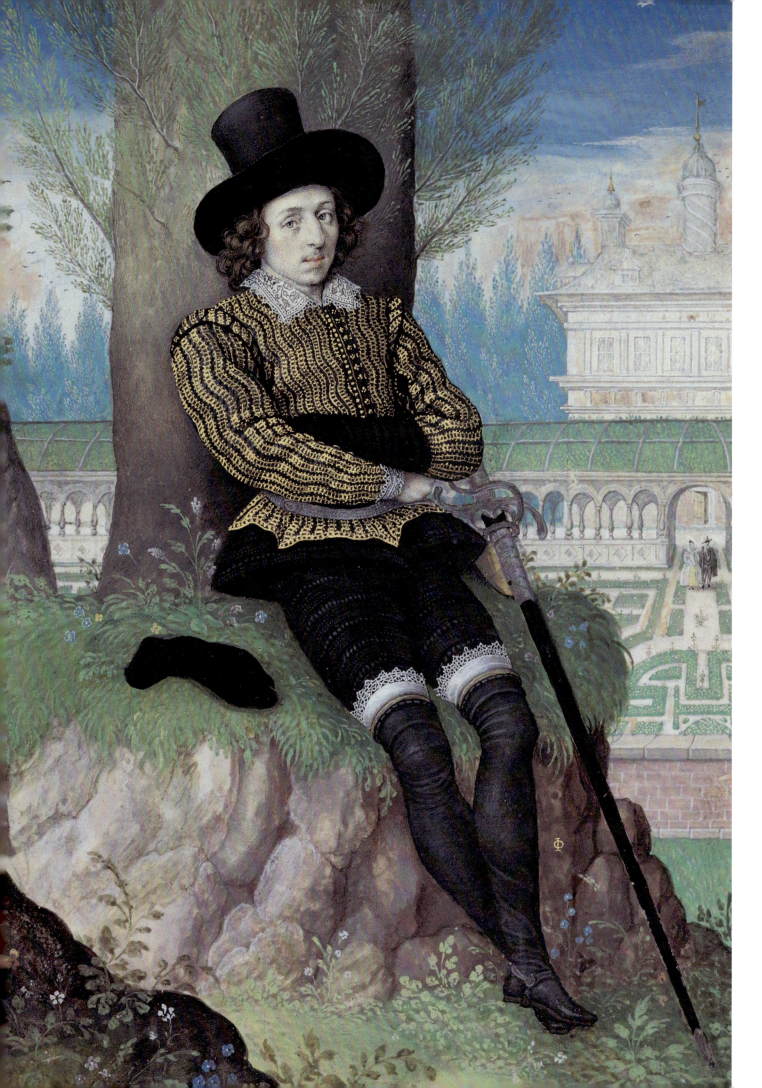

Fig. 92 Isaac Oliver (c.1565–1617), *A Young Man Seated Under a Tree*, c.1590–5. Watercolour on vellum laid on card, 12.4 × 8.9 cm. RCIN 420639

LEFT
Fig. 90 John Chantry (fl. c.1662–77), *The marriage of Charles II and Catherine of Braganza, May 1662*, 1663.
Engraving, 11.5 x 9.0 cm (sheet). RCIN 602630

RIGHT
Fig. 91 Doublet and petticoat breeches of cream figured silk.
Claydon House, Verney Collection

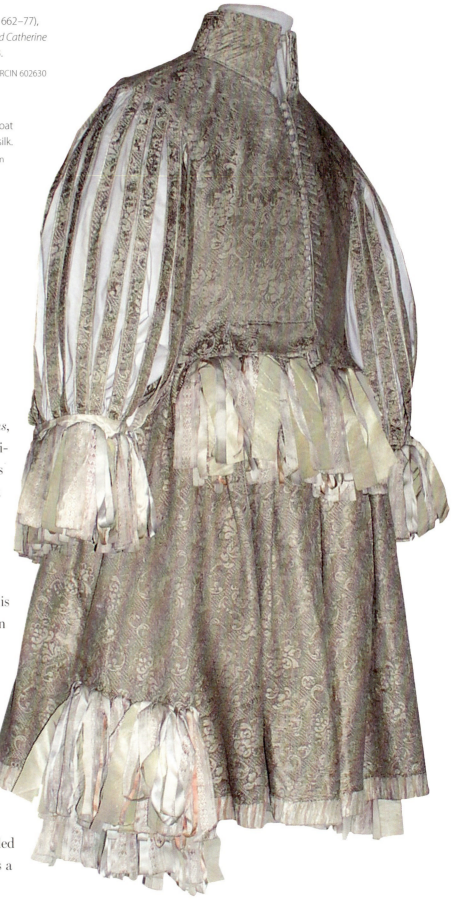

Uncommon after *c.*1620 were tubular extensions known as *canions*, attached to the trunk-hose and covering the thighs to the knee. In a miniature by Isaac Oliver (fig. 92) of *c.*1590–5, an unknown young man wears a black doublet decorated with applied gold braid, with very short black trunk-hose and matching black canions. Stockings would usually be pulled up over the canions and kept in place using garters. Rather unusually, his boots of soft black leather extend above the knee and are topped with lace-edged *boot-hose*. His collar is also surprisingly small given the date, and is apparently still attached to the shirt and decorated with blackwork. By this date trunk-hose were beginning to be replaced by longer, baggier styles in England known as slops.

The *codpiece*, a hollow but padded protuberance at the groin which is clearly depicted in many sixteenth-century portraits – such as the portrait of Edward VI by William Scrots (fig. 100) – has its origins in the flap of fabric between the two legs of the breeches, which could be folded down and then replaced up into position as nature dictated. *Cod* being a contemporary term for the testicles, its etymology is obvious. This particular component of male dress reached its maximum size during the middle years of the sixteenth century, and had disappeared entirely by the turn of the century. Padded, slashed, puffed, embroidered and bejewelled in the same way as other items of clothing of the period, the codpiece was a self-conscious and exaggerated symbol of virility.

DRESSING MEN

DOUBLETS AND COATS

Throughout most of this period a man would wear a *doublet* on the upper part of his body, over his shirt. Slashing, paning and embroidery were just some of the ways to add interest to the basic design of the doublet. Like breeches, it changed in shape over time – with, for example, significant variations in the line and level of the waistline. Pleated 'skirts' below the waistline were a feature of doublets during the reign of Henry VIII; these shortened and gradually morphed into a set of overlapping stiffened *laps*. In his 1628 portrait by Mytens (fig. 93), Charles I wears a doublet of brownish plum-coloured silk with four geometrically designed stiffened laps at the front. Based on comparison with a surviving example (fig. 94) – associated with Charles I, and of a similar design and date – there were probably six laps on the back. In the portrait the laps are edged with silver braid and gold silk satin, and a similar device is used to emphasise the panes across the chest (through which the gold silk lining is visible) and to decorate the shoulder wings projecting from the shoulder down the sleeve. These add masculine breadth to the shoulder line, and conceal the join at the shoulder seam. Here the sleeves are cut into strips of matching gold silk satin, which has apparently been stiffened so that it creates a three-dimensional effect, standing away from the arm until just below the elbow where the panes are joined together. Undersleeves of the same silk can be seen beneath.

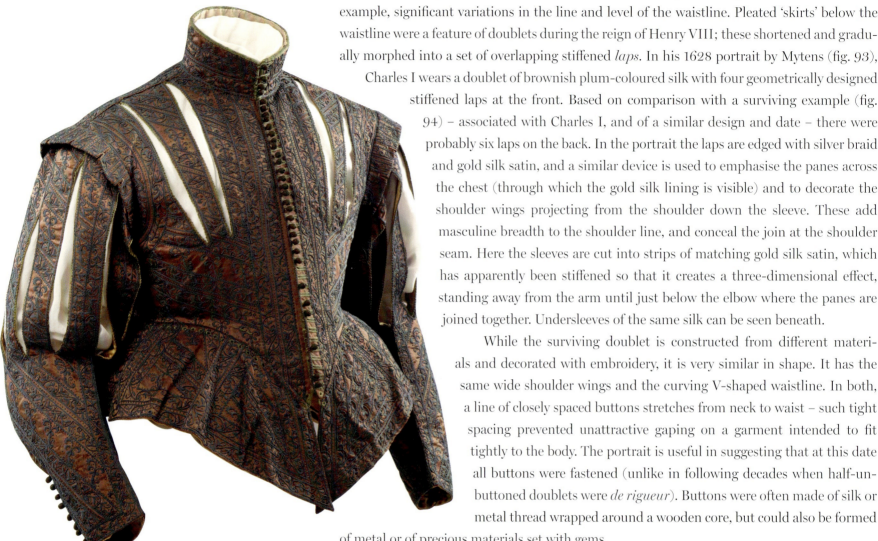

While the surviving doublet is constructed from different materials and decorated with embroidery, it is very similar in shape. It has the same wide shoulder wings and the curving V-shaped waistline. In both, a line of closely spaced buttons stretches from neck to waist – such tight spacing prevented unattractive gaping on a garment intended to fit tightly to the body. The portrait is useful in suggesting that at this date all buttons were fastened (unlike in following decades when half-un-buttoned doublets were *de rigueur*). Buttons were often made of silk or metal thread wrapped around a wooden core, but could also be formed of metal or of precious materials set with gems.

One of the most eye-catching features of the Mytens portrait is the line of bows encircling the monarch's waistline. Constructed from bows of gold and silver striped ribbons, each is tipped with an *aglet*, the metal of which would have made an attractive tinkling noise as they brushed together. Here they are probably ornamental, a vestigial feature with its origins in the fact that doublet and breeches were originally laced together through holes in the waistband of each – the aglet serving the practical purpose of aiding the threading process and preventing the ribbon or cord from fraying. Metal hooks and eyes replaced this method for holding up the breeches at around the time that this portrait was produced, and such hooks are visible inside the surviving example. Eyelet holes are also still present, and ribbons will have been used to create the effect seen in the portrait. The fact that breeches and doublet were securely fastened together in such a manner placed limitations on a man's deportment. It meant, for example, that he had to sit without bending at the waist, and that bowing during the period took the

Fig. 93 Daniel Mytens (*c.*1590–1647), *Charles I*, 1628. Oil on canvas, 219.4 × 139.1 cm. RCIN 404448

ABOVE AND OVERLEAF
Fig. 94 Doublet associated with Charles I, 1620s. Brown silk satin embroidered with blue silk cord. Private collection

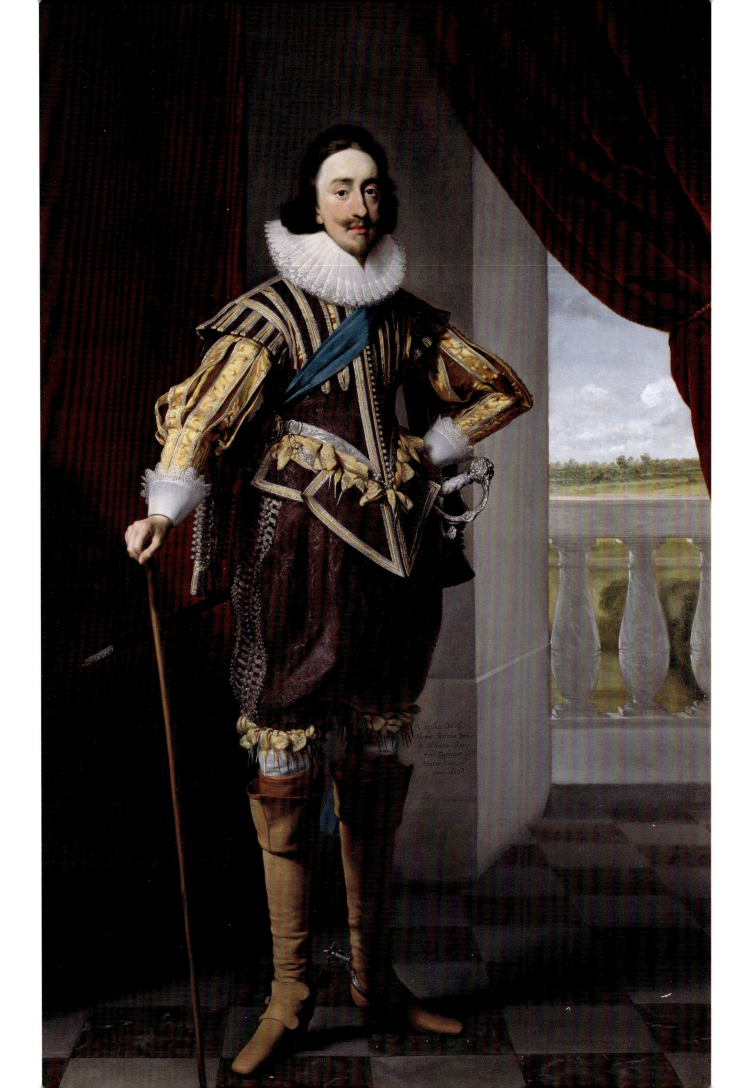

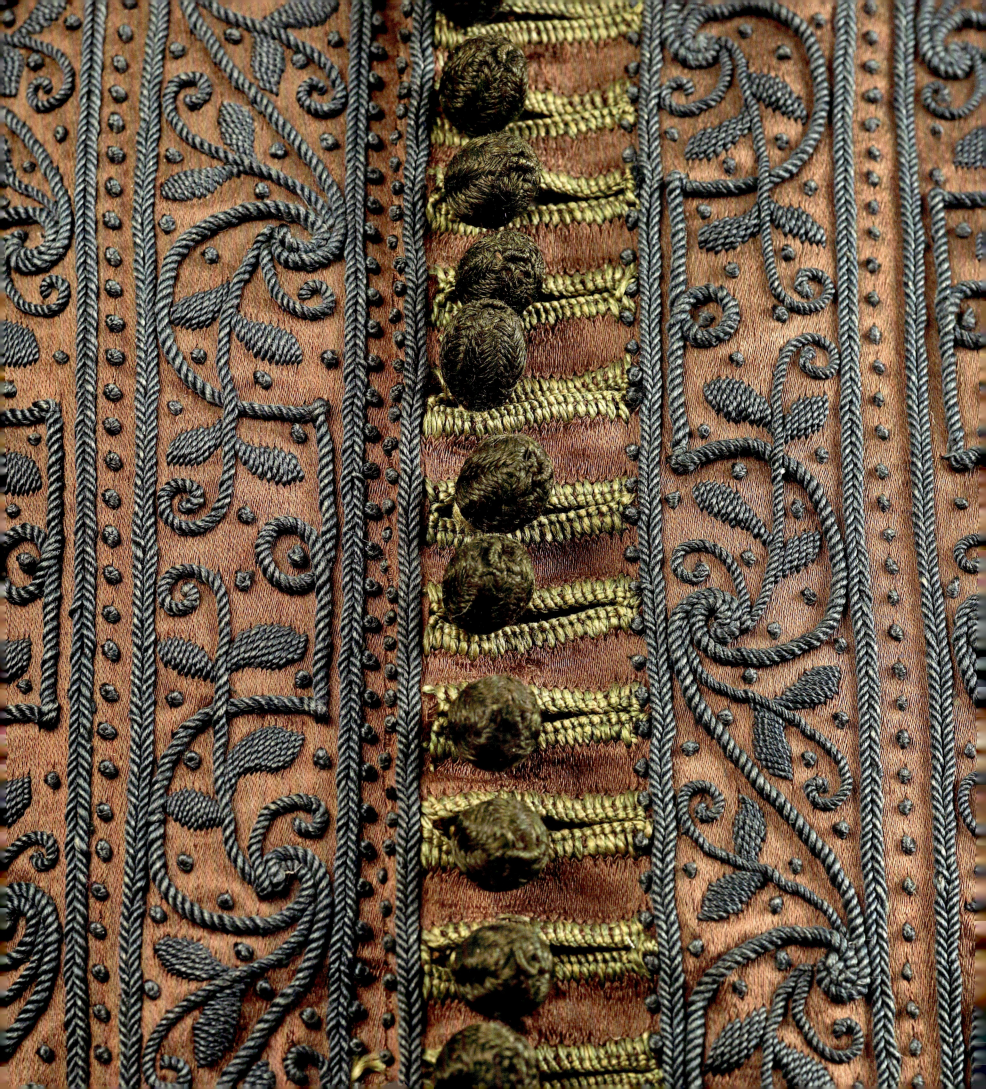

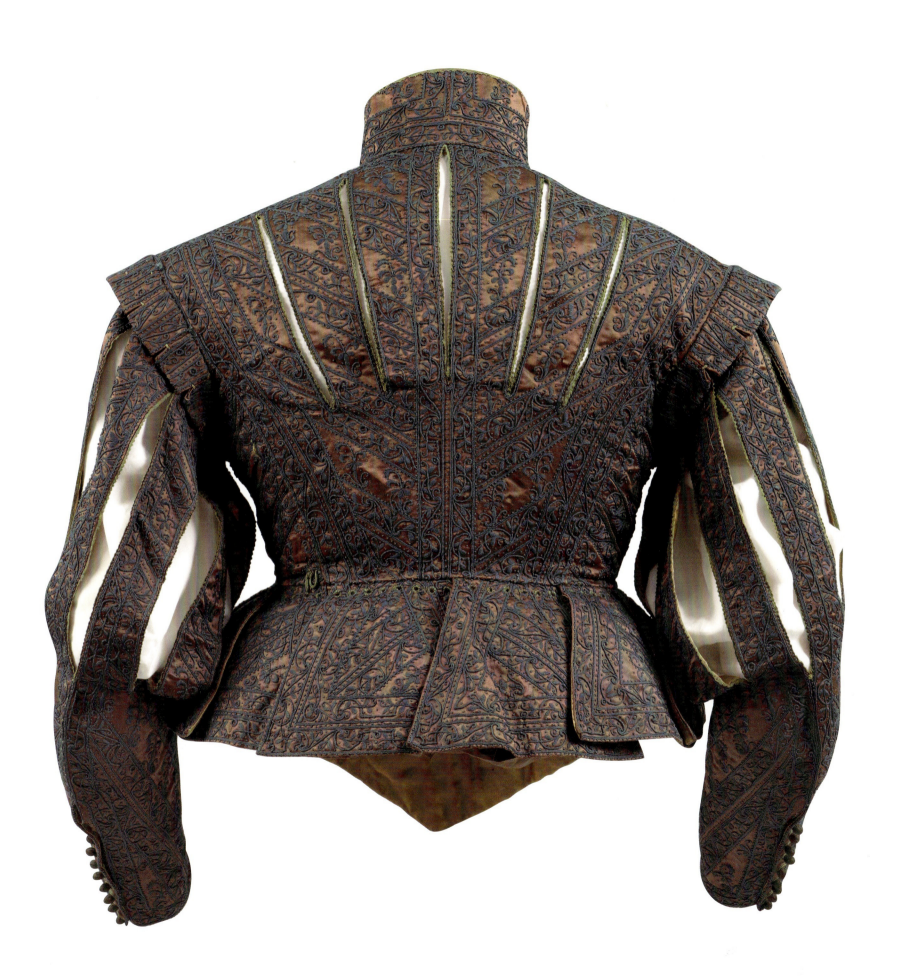

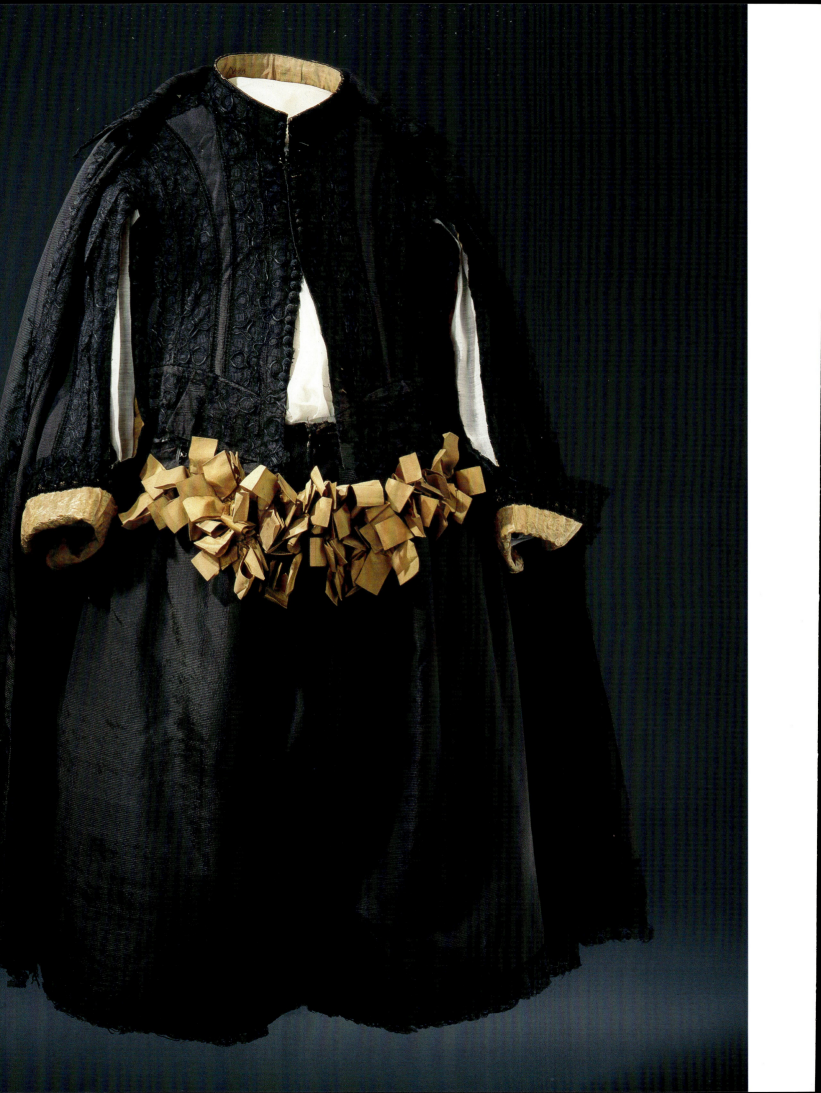

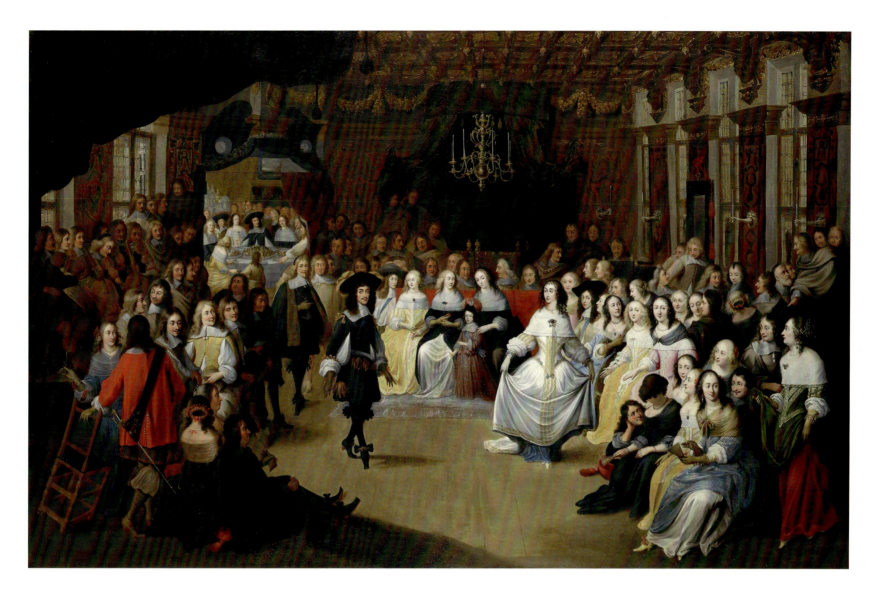

form of a knee bend rather than a bend in the back, a movement which also made keeping control of the sword and hat easier.[16] During periods of relaxation, however, a man might choose to undo some of his ribbon points for a more comfortable fit.

During the 1650s the doublet shortened considerably, so that by the Restoration it revealed much of the linen shirt at the waistline and resembled a modern bolero. Charles II wears this style of doublet in the Janssens scene of a ball, probably painted just before the monarch returned to England in 1660 (fig. 95). It is here displayed alongside a suit in the Swedish Royal Armoury dated to 1658 (fig. 96), which belonged to Charles X of Sweden. That both the English and Swedish monarchs wore costume of very similar cut and colour around the same date demonstrates the geographical spread of fashions across Europe during the period (see chapter 6). The surviving costume consists of a cloak, doublet, petticoat breeches and matching *shoe roses*, and is constructed of black silk rep (a weave effect which gives a subtle striped effect to the fabric) with yellow silk ribbon rosettes below the waistband of the breeches. Both surviving doublet and painted version have long slits in the sleeves running from shoulder to wrist to reveal the shirt beneath. The costume has been mounted on the figure as it is worn in

Fig. 95 (also fig. 14) Hieronymus Janssens (1624–93), *Charles II Dancing at a Ball at Court*, c.1660.
Oil on canvas, 139.7 × 213.4 cm. RCIN 400525

OPPOSITE

Fig. 96 Cloak, doublet and breeches, 1658.
Black silk rep with black linen lace and horsehair-covered buttons.
Stockholm, Royal Armoury. Acc. 3399 (19348, 19393-96, 25542-43)

DRESSING MEN 101

Fig. 97 The 1666 vest as drawn by the Earl of Sandwich: 'The habitt taken up by the King and Court of England, November 1666 which they call a vest.'

Reprinted in John Drinkwater, *Mr Charles, King of England*, London 1926. London, British Library. 10807.e.9 opp.pg 284 pl v

OPPOSITE

Fig. 98 British School, *Charles II Presented with a Pineapple*, c.1675–80.

Oil on canvas, 96.6 x 114.5 cm. RCIN 406896

the painting, with half the buttons left undone. The Swedish doublet is lined with yellow silk moiré, and it appears from the tiny piece of gaping fabric over Charles II's stomach that his may be lined in a similarly coloured yellow fabric, which would match the ribbons at his waist. Charles II wears comparably decorative bows to fasten his black leather, high-heeled shoes, which have a square toe and fashionable red heels.

In a rare example of a well-documented case of a fashion changing almost overnight, in October 1666 the male doublet in England was replaced by a new style – the man's coat worn over a vest. This combination was the precursor to the three-piece man's suit popular to this day. The innovation was a conscious attempt by Charles II to invent a truly English fashion, identifiably different from the fashions on the Continent and exempt from the fluctuations of fashion. Its inspiration may lie in a number of sources, including the Persian vest worn by visiting ambassadors, theatre costume, and riding coats which were traditionally cut on a longer line.[17] Samuel Pepys wrote on 8 October 1666, 'The King hath yesterday in Council declared his resolution of setting a fashion for clothes, which he will never alter. It will be a vest, I know not well how; but it is to teach the nobility thrift'. On 15 October Pepys reported:

> This day the King begins to put on his vest, and I did see several persons of the House of Lords and Commons too, great courtiers, who are in it; being a long cassocke close to the body, of black cloth, and pinked with white silke under it, and a coat over it, and the legs ruffled with black riband like a pigeon's leg; and, upon the whole, I wish the King may keep it, for it is a very fine and handsome garment

As an indication of how quickly a new fashion could be translated into garments for the courtier, the diarist himself was wearing the new style by 4 November, less than three weeks later.

A sketch by the Earl of Sandwich (Pepys's patron and Master of the Great Wardrobe) gives the clearest indication of what the new mode looked like in its earliest form (fig. 97). The coat, which at this stage apparently still retains the slit sleeves seen in earlier doublets, is worn unbuttoned over a long belted vest. Unlike the doublet, the new coat and vest were both knee-length and could apparently be worn separately, and over a variety of styles of breeches. In a painting of Charles II being presented with the first pineapple grown in England (fig. 98), possibly by the royal gardener, John Rose, the monarch wears a dark brown knee-length coat, probably of English wool, trimmed with black ribbons at the wrist and embroidered with the Garter Star. There does not appear to be a vest beneath, but the coat is worn with matching brown petticoat breeches.

GOWNS, JERKINS AND NIGHTGOWNS

During the Tudor period it was fashionable for the elite gentleman to wear a loose-fitting *gown* over his doublet. This is what Henry VIII wears in his most iconic images and what contributes to the massive horizontality of the shoulders, achieved through the use of padding and stiffening stay tapes in the upper arm. Gowns were longer in the early part of the sixteenth century, becoming shorter as the century progressed. A long gown by c.1550 would suggest a figure

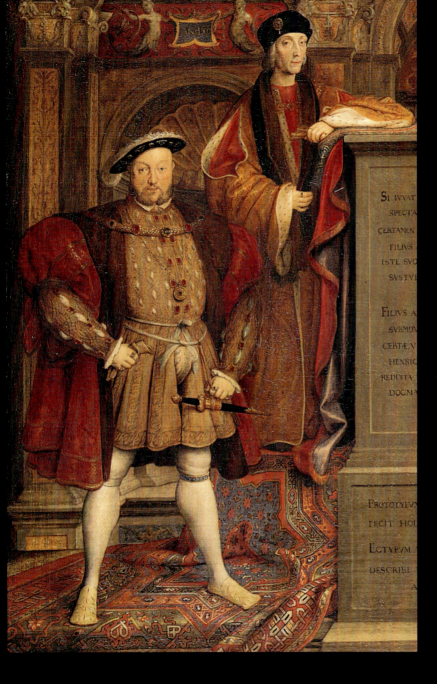 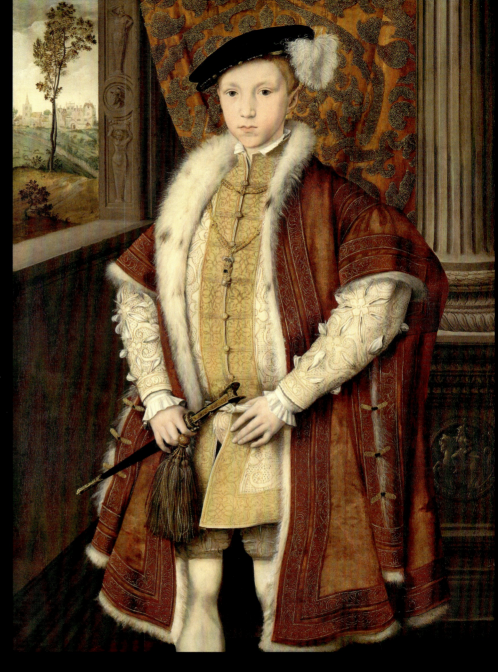

ABOVE

Fig. 99 (detail of fig. 2) Remigius van Leemput (d. 1675), *Henry VII, Elizabeth of York, Henry VIII and Jane Seymour* (copy of 'The Whitehall Mural'), 1667. Oil on canvas, 88.9 x 99.2 cm. RCIN 405750

ABOVE LEFT

Fig. 101 Alonso Sánchez Coello (1531–88), *Rudolf of Austria*, 1567.

Oil on canvas, 98.2 x 80.4 cm. RCIN 405798

ABOVE RIGHT

Fig. 102 Alonso Sánchez Coello (1531–88), *Ernest of Austria*, 1568.

Oil on canvas, 99 x 81 cm. RCIN 405797

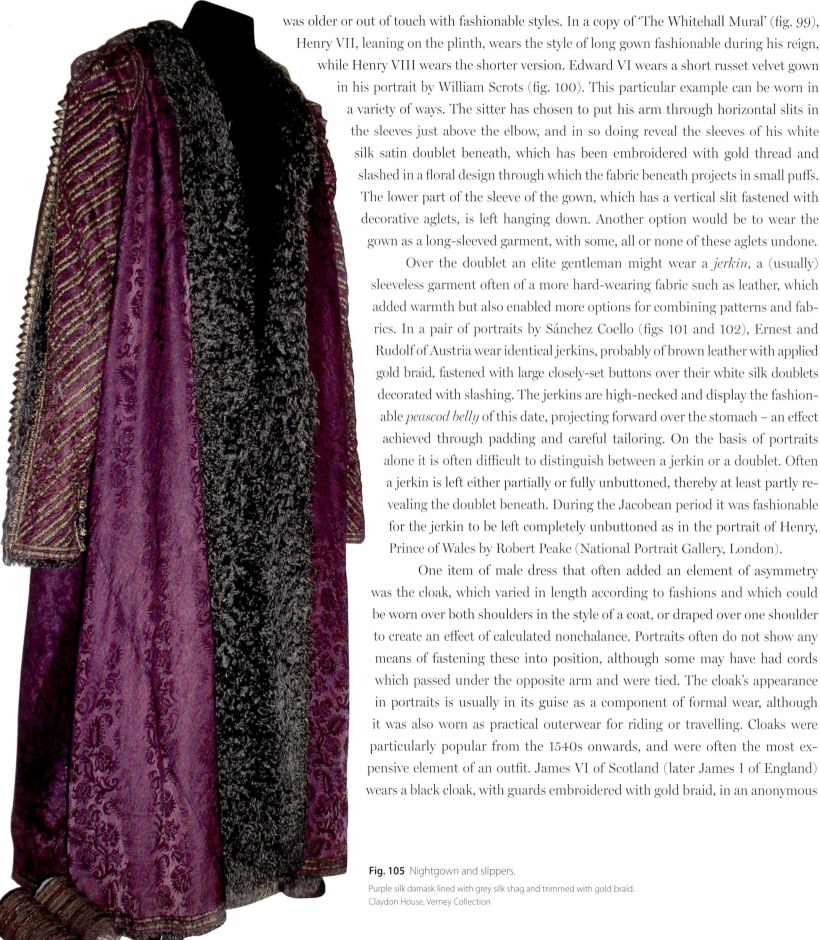

was older or out of touch with fashionable styles. In a copy of 'The Whitehall Mural' (fig. 99), Henry VII, leaning on the plinth, wears the style of long gown fashionable during his reign, while Henry VIII wears the shorter version. Edward VI wears a short russet velvet gown in his portrait by William Scrots (fig. 100). This particular example can be worn in a variety of ways. The sitter has chosen to put his arm through horizontal slits in the sleeves just above the elbow, and in so doing reveal the sleeves of his white silk satin doublet beneath, which has been embroidered with gold thread and slashed in a floral design through which the fabric beneath projects in small puffs. The lower part of the sleeve of the gown, which has a vertical slit fastened with decorative aglets, is left hanging down. Another option would be to wear the gown as a long-sleeved garment, with some, all or none of these aglets undone.

Over the doublet an elite gentleman might wear a *jerkin*, a (usually) sleeveless garment often of a more hard-wearing fabric such as leather, which added warmth but also enabled more options for combining patterns and fabrics. In a pair of portraits by Sánchez Coello (figs 101 and 102), Ernest and Rudolf of Austria wear identical jerkins, probably of brown leather with applied gold braid, fastened with large closely-set buttons over their white silk doublets decorated with slashing. The jerkins are high-necked and display the fashionable *peascod belly* of this date, projecting forward over the stomach – an effect achieved through padding and careful tailoring. On the basis of portraits alone it is often difficult to distinguish between a jerkin or a doublet. Often a jerkin is left either partially or fully unbuttoned, thereby at least partly revealing the doublet beneath. During the Jacobean period it was fashionable for the jerkin to be left completely unbuttoned as in the portrait of Henry, Prince of Wales by Robert Peake (National Portrait Gallery, London).

One item of male dress that often added an element of asymmetry was the cloak, which varied in length according to fashions and which could be worn over both shoulders in the style of a coat, or draped over one shoulder to create an effect of calculated nonchalance. Portraits often do not show any means of fastening these into position, although some may have had cords which passed under the opposite arm and were tied. The cloak's appearance in portraits is usually in its guise as a component of formal wear, although it was also worn as practical outerwear for riding or travelling. Cloaks were particularly popular from the 1540s onwards, and were often the most expensive element of an outfit. James VI of Scotland (later James I of England) wears a black cloak, with guards embroidered with gold braid, in an anonymous

Fig. 105 Nightgown and slippers.
Purple silk damask lined with grey silk shag and trimmed with gold braid.
Claydon House, Verney Collection

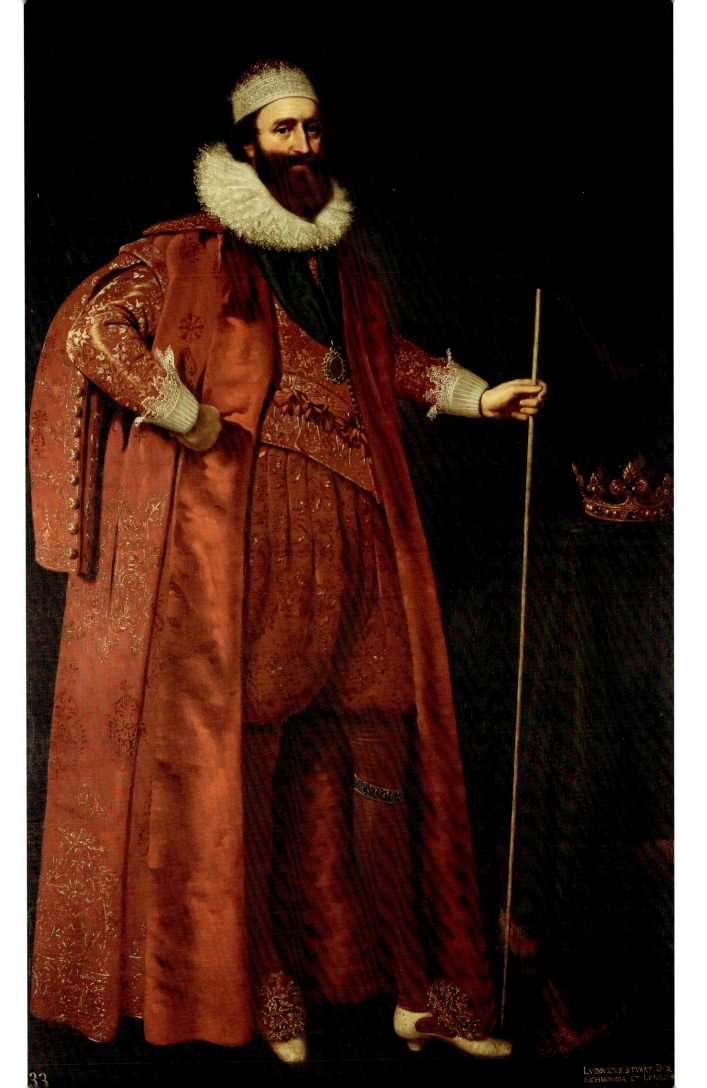

Fig. 104 Studio of Daniel Mytens (c.1590–1647), *Ludovick Stuart, 2nd Duke of Lennox and Duke of Richmond*, 1625.
Oil on canvas, 218.8 x 137.9 cm.
RCIN 405664

Fig. 103 British School, *James VI and I*, c.1587.
Oil on canvas, 86.0 x 56.2 cm. RCIN 401226

OPPOSITE
Fig. 106 (detail) Hans Holbein the Younger (1497/8–1543), *Sir Henry Guildford*, 1527.
Oil on oak panel, 82.7 x 66.4 cm. RCIN 400046

portrait of *c*.1587 (fig. 103). Cloaks were typically made of a fabric co-ordinating to the doublet and breeches (as are the matching sets described in the inventories of Charles I), or in contrasting black as in this portrait of his father. The cloak remained popular during the seventeenth century, although it was generally of a longer length, until its use was usurped by the new style of coat in the 1660s.

For informal occasions, or while in their own home, a gentleman might choose to wear a long gown or *nightgown*, which would have provided warmth and comfort (and contrary to their name, were not worn for sleeping). Henry VIII ordered 15 nightgowns between 1510 and 1545, a third of these between 1543 and 1545 – they were presumably a practical garment in old age.[18] This is apparently what Ludovick Stuart, 2nd Duke of Lennox and Duke of Richmond, is wearing in his portrait (fig. 104). He wears a voluminous long nightgown of red silk, probably embroidered with gold thread, and lined with red silk plush over his crimson cloth-of-gold doublet and breeches. The buttons along the upper part of the hanging sleeves have been undone; Ludovick's arm projects through the gap, while the remaining buttons are left fastened. A similar early example is in the Verney Collection (fig. 105). Showing how rich the fabrics could be for such an item, it is constructed from purple silk damask lined with grey silk *shag*, and trimmed with gold braid in diagonal patterns along the sleeves.

HAIR AND ACCESSORIES

Throughout the Tudor period the most popular form of headwear for men was the *bonnet*, which could be knitted (particularly further down the social scale) or sewn from a range of fabrics including wool and silk velvet. The elite might wear their bonnet decorated with ostrich feathers, jewels or aglets, and portraits show them worn at a variety of angles, presumably depending on the preferences of the wearer. Although they were most commonly black (the ideal background to set off sparkling jewels effectively), red was also popular.

Bonnets were often worn with a hat badge pinned to the turned-up brim. In his 1527 Holbein portrait (fig. 106), Sir Henry Guildford wears a hat badge depicting geometrical instruments and a clock to indicate his scholarly interests. That this hat badge was not included in the artist's original sketch for the painting (RCIN 912266) may suggest that it was not an item actually owned by the sitter, but was instead a fanciful design created by the artist in conjunction with the sitter specifically to be included in the portrait (Holbein also designed jewellery for Henry VIII's court). The geometrical instruments in the badge are also seen in Dürer's engraving *Melencolia* (1514) – prints and pattern books of this type were circulated around Europe, providing much inspiration for jewellers and goldsmiths.[19] Guildford's headwear is of a style known as a Milan bonnet, which he wears with black ribbons attached at the sides and tied over the crown.[20]

Saints and mythological figures were common sources for hat badge designs, and a rare surviving example illustrates the complexity that such pieces could achieve. The enamelled gold hat badge of *c*.1520 (fig .107) depicts St George, dressed in blue and gold on horseback holding a sword with a seed-pearl handle above his head, which he is about to strike into the blue-skinned, yellow-clawed dragon at his feet. A tiny princess kneels to one side, while in the

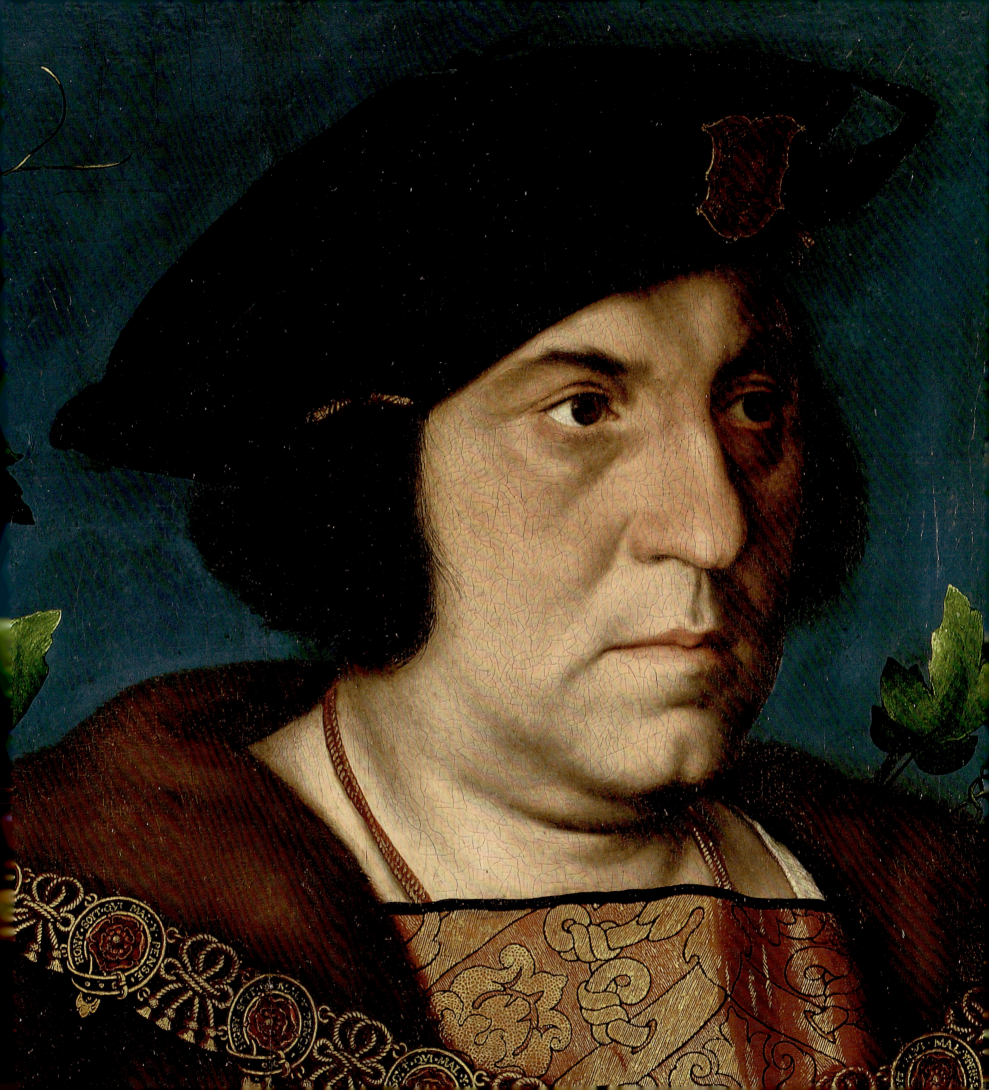

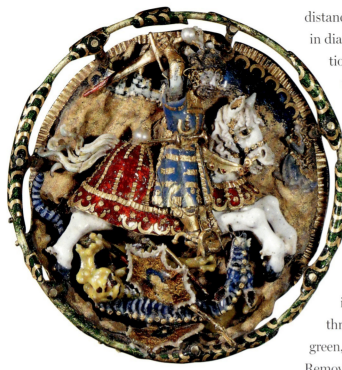

Fig. 107 Hat badge with St George and the Dragon, Flemish?, *c*.1520.
Gold, enamel and seed pearls, 4.2 × 0.9 cm. RCIN 442208

distance is a walled town. That all this is contained in high relief within a circle of only 4 cm in diameter makes its intricacy of design all the more extraordinary. This item has been traditionally associated with Henry VIII, although none of his jewellery is recorded as surviving in the Royal Collection, and it may be more likely to have belonged to Maximilian I of Habsburg (Holy Roman Emperor from 1493 to 1519), who was frequently commemorated in the guise of St George in armour.[21]

During the 1560s bonnets began to be replaced in most fashionable men's wardrobes by tall crowned black hats, the most expensive of which were constructed of beaver fur, felted and moulded into shape over a block. While such hats remained popular, their shape changed over the seventeenth century, generally becoming shallower crowned and wider brimmed.

In Robert Peake's painting of Henry, Prince of Wales, hunting (see fig. 243), one of the ways in which the artist has indicated the subservience of the Prince's hunting companion, the Earl of Essex, is through the etiquette of hat honour. The heir to the throne wears his hat, decorated with a diamond-set hat badge and an ostrich plume dyed green, while the Earl of Essex has removed his and placed it on the ground near the fallen stag. Removing the hat in the presence of superiors was a mark of deference, and hat etiquette was strictly observed at all levels of society throughout the Tudor and Stuart period. Visitors entering Elizabeth I's bedchamber in 1585 were required to remove their hats, whether the queen was present in person or not. Of all the participants in the court ball of *c*.1660 (see fig. 95), it is only the four royal males – King Charles II, dancing; James, Duke of York, visible over the king's left shoulder; Henry, Duke of Gloucester, to the right of the dancing Princess Mary of Orange; the infant William III, Prince of Orange – who wear fashionable black hats, probably of beaver fur. By this date the hat is worn with a turned-up brim, a precursor to the tricorne hat fashionable after *c*.1675 and worn (or carried) throughout the eighteenth century. The king and one of his brothers are also visible dining in another scene in the same picture, again identifiable by their headwear. Hat honour was an important element of diplomatic relations. When Charles II greeted the Spanish ambassador, the Prince de Ligne, in the Banqueting House at Whitehall in 1660, the monarch removed his hat in respect to his visitor, since the Prince de Ligne was arriving as a representative of the Spanish king. Notably, the Quakers disregarded the traditional values of hat etiquette, considering all men equal before God.

Men's hair was subject to the same vagaries of fashion during this period as their clothing. Moreover, fashions in clothing and hairstyle are often intrinsically linked – we have already seen how the trend towards hair worn longer at the back and over the shoulders shifted the focus of neckwear to the front, and this was not unique. The high-standing collars and large ruffs of the late Elizabethan period were accompanied by shorter hairstyles for men that did not interrupt the sculptural effect at the neckline, while the section of hair brushed upwards above the forehead was not disrupted by the wearing of the fashionable tall crowned hats of the same date.

Portraits of Charles I during the 1630s show the monarch with the fashionable curling *lovelock* – hair worn longer on the left-hand side than on the right. It is particularly clear in

the portrait of Charles I in three positions by van Dyck (see fig. 81), since the figure has been rotated to show both sides of the head. The hair on the figure's right-hand side reaches his shoulder, but that on his left extends past the bottom of his cloak band. The asymmetry is emphasised by his single pearl earring, also worn on the left side. While the effect may be strange to our eyes today, it is still hard to comprehend how such a fashion can have roused so much hatred amongst contemporary critics, who saw lovelocks as both effeminate and a sign of the degeneration of society as a whole. The most vocal critic, the lawyer and polemicist William Prynne (well-known for criticising most fashions of his day), devoted a whole treatise to the subject. *The Unloveliness of Love-Lockes*, published in 1628, considered the fashion a sign of 'sinful, shamefull and uncomely vanitie' derived from the Devil himself who used the locks to pull their wearers down into hell.[22] Another form of lovelock, and probably the origins of this fashion, was a smaller lock of hair (either the wearer's own hair or that of a loved one) attached to the ear as a symbolic love-token. An example can be seen in a miniature thought to represent Lord Compton (fig. 108). Unusually this sitter wears his lovelock in his right ear rather than the left.

The latter half of the seventeenth century saw the fashion for male *periwigs* (a name derived from *perruque*, the French for wig), which were to persist in various different forms for men of all classes throughout most of the following century (although wigs had been known before this time, and were worn by both men and women with thinning hair – including Elizabeth I). In the Schalcken scene (see fig. 76), the main figure still seems to be wearing his own hair, although curling or crimping has apparently been used in an attempt to add volume to its rather thin and flat natural appearance, and hairpieces might also have been added. The purchase of a wig was a convenient way to achieve a perfect hairstyle every day without such labours. Periwigs are a fashion frequently credited to Charles II, who will have come across them at the French court while in exile, but Pepys notes that neither the king nor the Duke of York adopted wigs until 1664.[23] Yet the wearing of periwigs had been criticised by Puritans in England during the 1640s and 50s showing that they were worn before the Restoration.[24]

Pepys dawdled over the decision until finally on 3rd November he took the plunge, purchasing two periwigs of different prices and having his own hair cut off, 'which went a little to my heart at present to part with it; but, it being over, and my periwigg on, I paid him 3*l.* for it'.[25] It appears he was spurred into action by overhearing the Duke of York the day before say that he was going to adopt a wig soon.[26] Nervous of the reception he would receive in his new wig, Pepys was relieved that his first excursion wearing it was not remarked upon ('no great matter made of my periwigg, as I was afeard there would be').[27] That same day he bought himself a special trunk in which to store his new purchases and from time to time would send his wigs to the barber to be cleaned and reset.

Periwigs were usually made of human hair – Pepys sold his own to the wig-maker – and concerns were raised during the plague that unscrupulous wig-makers were cutting hair from victims. While dark wigs are most frequently depicted in portraits of the seventeenth

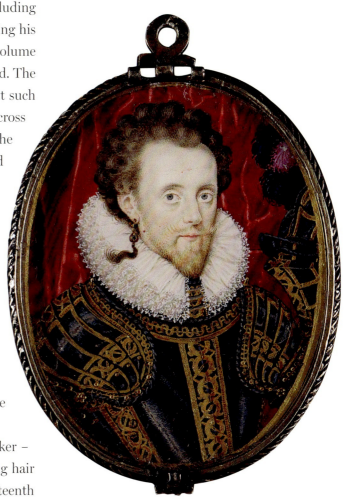

Fig. 108 British School, *Portrait of a Man, perhaps William Lord Compton, 1st Earl of Northampton*, c.1600. Watercolour on vellum, 5.1 x 4.0 cm. RCIN 420895

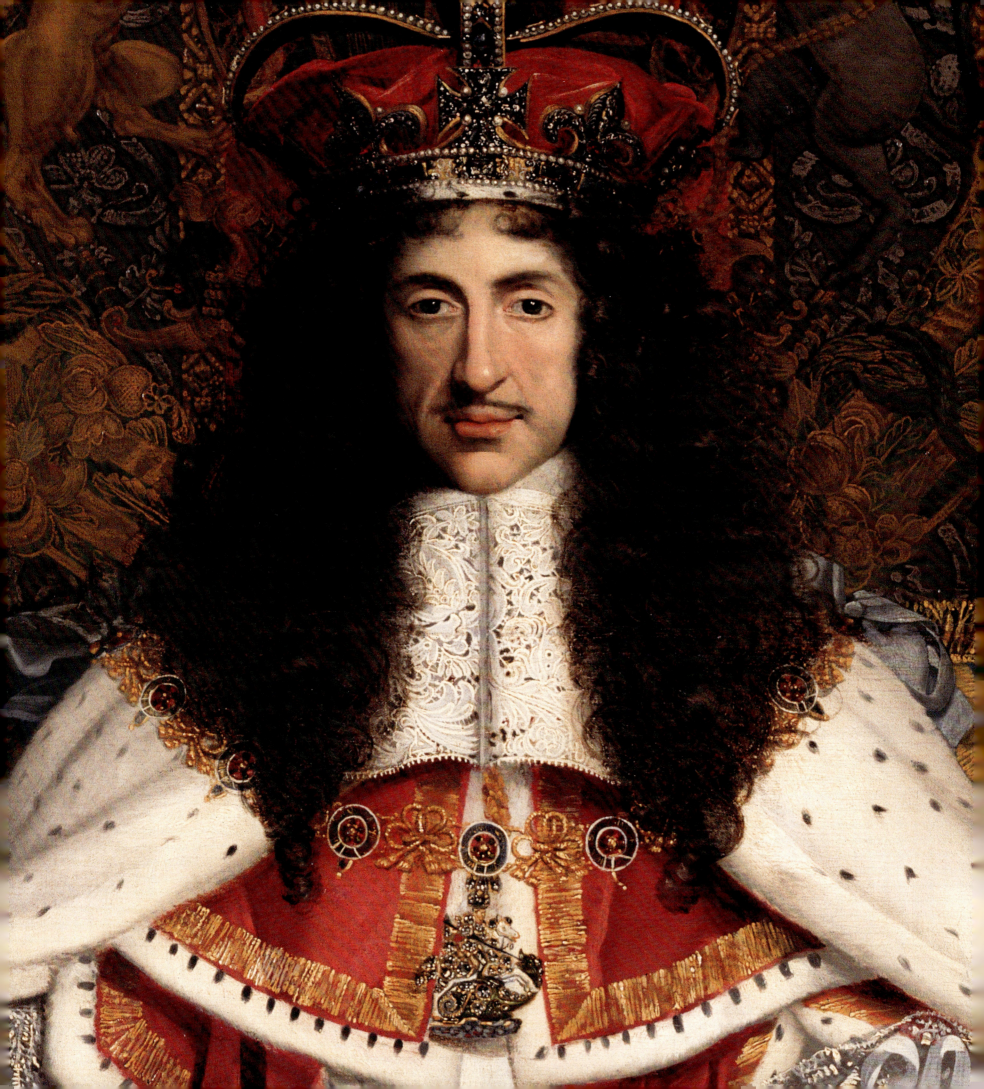

century, powder (the best of which was derived from starch) could be tinted and used to produce a range of colours. The portrait of Charles II by John Michael Wright (fig. 109) shows the monarch wearing the coronation suit ordered from Paris for his coronation in April 1661, but anachronistically with a full-bottomed wig styled with a centre parting, volume at the crown and worn with the two side pieces (known as *ladders*) forwards over the shoulders. The style of this wig is of a later date than 1661 (and we know that Pepys did not see Charles wearing a wig until 1664), which corroborates the suggestion that the portrait was commissioned *c.*1676, some years after the event.[28] By the 1680s it had become fashionable for wigs to be built up into horns on either side of the centre parting and to become longer and even fuller at the bottom, and this shift can prove helpful in dating a portrait, particularly when the clothing is of a more timeless style. Occasionally the depiction of hairstyles, when combined with documentary evidence, can help date a painting more precisely. The painting of Charles being presented with a pineapple (see fig. 98) shows the monarch without the thin moustache he had favoured during the 1660s but shaved off in 1677. If the other figure is John Rose, the royal gardener, who died in 1677, these two facts combine to suggest the picture was commissioned in that year.

Wigs were reserved for public and formal occasions, so for informal daywear at home a gentleman would often wear a *nightcap*. Both practical (they kept the head warm, particularly important when the hair was closely shaved for easier wig-wearing) and an effective way of concealing a receding hairline, these had been popular since the sixteenth century – we have already seen Henry Fitzroy wearing one embroidered with geometric blackwork, fastened with a strap (fig. 79). Ludovick Stuart, Duke of Lennox and Richmond, also wears a nightcap in his portrait (see fig. 104), and this clearly illustrates that it was not an item solely reserved for very informal circumstances. The sitter held an important position at the court of James I, as First Nobleman of the Bedchamber. In all other elements of his clothing Ludovick is wearing costly fabrics with ornate decoration. It would be a strange choice to choose to wear a nightcap with such an outfit if its status was minimal. It is clear from surviving nightcaps that they were not seen as trivial items but were highly valued and expensive objects, upon which significant expense and labour was invested, making a nightcap suitable attire for a variety of different occasions during the day.

One extant nightcap in the Museum of London is of linen embroidered with gold thread and decorated with silver-gilt bobbin lace and gold spangles (fig. 110). The pattern includes a thistle, pansies, borage and honeysuckle, as well as birds and butterflies, all worked in a variety of different stitches including plaited braid stitch, satin stitch and ladder stitch. In his portrait Ludovick Stuart is probably wearing an embroidered nightcap with a linen nightcap beneath, edged with lace that has been turned up around the brim (fig. 111). This second inner layer

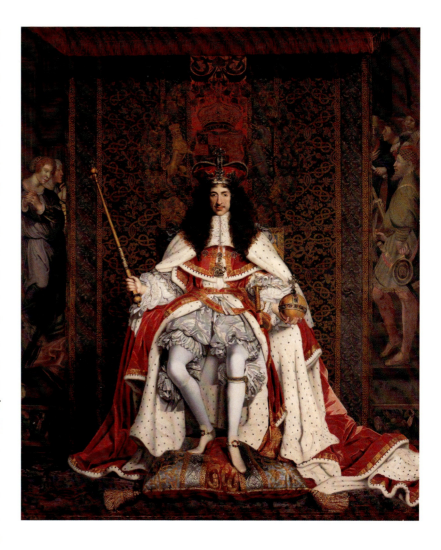

ABOVE AND OPPOSITE (DETAIL)
Fig. 109 John Michael Wright (1617–94), *Charles II*, c.1676.
Oil on canvas, 281.9 x 239.2 cm. RCIN 404951

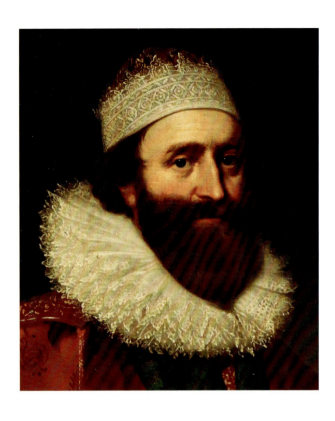

Fig. 111 (detail of fig. 105) Studio of Daniel Mytens (c.1590–1647), *Ludovick Stuart, 2nd Duke of Lennox and Duke of Richmond*, 1625. Oil on canvas, 218.8 × 137.9 cm. RCIN 405664

BELOW LEFT
Fig. 112 Linen nightcap, *c.*1600–30.
London, Museum of London. Acc. 35.147/3

BELOW
Fig. 110 Embroidered nightcap, *c.*1600–30.
London, Museum of London. Acc. 42.51

would have made the nightcap more comfortable to wear, and prevented the metal thread embroidery from rubbing the scalp. It may have been similar to another nightcap from the Museum of London (fig. 112), constructed of fine linen with a turned-up brim trimmed with needle lace. This example is believed to have belonged to Charles I, and by tradition is said to have been worn by the monarch at the wedding of George Kirke (a groom of the bedchamber) to Mary Townshend in 1646. It is part of a matching set which also includes a collar and handkerchief. The nightcap is gathered using tiny pleats at the top to achieve the shaping rather than cut into curves. This was common practice for linen items produced by seamstresses, unlike tailor-made garments which were constructed from shaped pieces of fabric.[29]

FOOTWEAR

Where men's feet are shown in full-length portraits of the sixteenth century, they are frequently encased in rather plain shoes, usually black but sometimes coloured. Despite their impracticality, shoes made from woven fabric were the predominant type of footwear at the Tudor court and were evidently frequently replaced. Henry VIII bought 89 pairs of velvet-covered shoes between 1531 and 1532, and eight of leather.[30] In the early seventeenth century Ludovick Stuart, Duke of Lennox and Richmond (fig. 113), wears shoes that are possibly of white silk since he is in formal dress, decorated with ornate *shoe roses*. These were rosettes made up of ribbons of fabric gathered into a puffed decoration, which could also be decorated with metal lace and spangles. His shoes have a moderately high heel, open sides, and are fastened with a latchet strap across the top, unlike the slip-on styles of earlier periods. All shoes throughout the Tudor and Stuart period were made straight, that is without different shaping for the left or right foot. Charles I wears similarly constructed shoes with ornate shoe roses in '*The Greate Peece*' (see fig.15). Shoes of the later seventeenth century were usually constructed of black leather.

At the Caroline court soft leather boots were another fashionable footwear option, worn for riding but also indoors. They are frequently represented in paint, as for example in the portrait of Charles I by Mytens (see fig. 93), where they are worn with the top folded down – an effect that became more exaggerated during the following decade. The most supple leather came from Córdoba in Spain, and created the softly crumpling effect that was most desirable. Butterfly-shaped pieces of leather over the instep hold the spurs in place. Invisible in this portrait, but also frequently worn, were decorative lace-trimmed linen boot-hose which sometimes appear at the top of the boots and which protect the stockings from the leather. By the Restoration period these boot-hose could reach extraordinarily large proportions (see fig. 90 where Charles II wears boot-hose with shoes).

Fig. 113 (detail of fig. 105) Studio of Daniel Mytens (c.1590–1647), *Ludovick Stuart, 2nd Duke of Lennox and Duke of Richmond*, 1625. Oil on canvas, 218.8 x 137.9 cm. RCIN 405664

JEWELLERY

Particularly in the sixteenth and early seventeenth centuries, monarchs and their courtiers invested considerable wealth on enormous jewels in complex settings. Henry VIII recognised the impact of striking jewellery, which he wore as jewelled collars, rings and as decoration on hats. Jewels were also sewn on to garments as decoration for particular occasions, and were subsequently removed and used elsewhere. James I, who in many other respects was rather careless of his appearance, was particularly fond of large gemstones, which he viewed as symbols of the Divine Right of monarchy.[31] He is often depicted in portraits wearing three of the most famous royal jewels – known at the time as the Three Brothers, the Feather, and the Mirror of Great Britain.

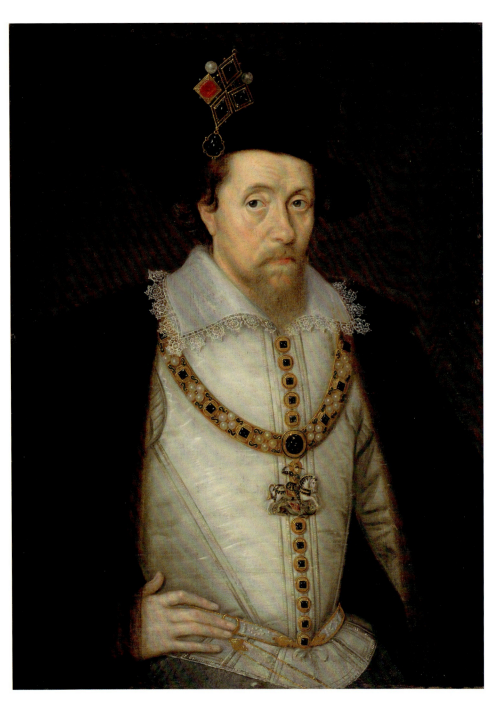

Fig. 115 John de Critz (c.1552–1642), *King James VI and I*, 1604.
Oil on canvas, 82.9 x 61.9 cm. Edinburgh, Scottish National Portrait Gallery

The Three Brothers was named after three balas rubies, combined by Duke Philip the Good of Burgundy into one extraordinary jewel with a large pointed diamond and four pearls. Its appearance is recorded in a contemporary watercolour in the Historisches Museum, Basel (fig. 114). It was subsequently acquired by Edward VI in 1551 – although Henry VIII had probably been negotiating to buy it before his death – and it appears in later portraits of Elizabeth I (such as the 'Ermine Portrait' at Hatfield House), and worn by James I as a hat badge (Gripsholm).[32] In 1623 the jewel was reset by court jeweller George Heriot to maximise the impact of the diamond upon the Spanish court during the visit of Prince Charles to Spain to try and secure his marriage to the Spanish Infanta. The jewel was pawned in 1625, and after 1650 never mentioned again.

Similar fates met the two other famous Stuart jewels, both of which were created by James I – presumably through the destruction of Elizabeth I's jewellery. The Feather consisted of 26 large diamonds of differing shapes, arranged into a series of spikes, while the Mirror of Great Britain was designed to commemorate the union of the Scottish and English crowns in 1603. The latter is depicted being worn as a hat badge in various portraits of James I, for example that in the Scottish National Portrait Gallery by John de Critz (fig. 115). In addition to a ruby, three diamonds and two pearls set into a diamond pattern, it also contained as a pendant the famous Sancy Diamond which, before being cut in 1661, was the largest white diamond then known, at 106 carats. Probably named after the original owner, the French courtier and military commander, Nicolas de Harlay, seigneur de Sancy, it was lent to various kings of France, then sold

to James I in 1604.³³ The diamond was described in the Tower of London's 1605 Inventory of Jewels as 'one fayre dyamonde, cutt in fawcettis, bought of Sauncey', and around the same time was set into its position in the Mirror of Great Britain.³⁴ Subsequently sold by Henrietta Maria while exiled in France, the diamond passed through the hands of various princes and collectors before being sold to the Musée du Louvre in 1978, where it remains to this day.

The changing tastes in jewellery at the Caroline court mimicked the shift in fashionable clothing – from an emphasis on complexity of design and dense patterns to restrained elegance and simplicity. As was the case for women, pearls became the most fashionable jewellery for men at court. Jewellery for men became less significant during the Restoration, although decorative elements of clothing such as buckles (which were first worn during the 1660s in England) and buttons could add sparkle to even the plainest of suits.

Badges associated with chivalric orders could be highly decorative, often incorporating expensive enamelwork and precious stones (fig. 116). They were important and fashionable status symbols throughout the period – male accessories that also served the purpose of identifying the wearer with an exclusive group. The wearing of such insignia was not limited to ceremonial occasions – so each Knight of the Garter for example would wear his Garter badge (either the *Great George* on a chain or more frequently the smaller, more practical *Lesser George* on a riband round the neck or over the left shoulder) with his fashionable clothing each day as well as with his ceremonial robes.

LEFT
Fig. 114 *The Three Brothers*.
Watercolour on vellum 21.2 x 18.0 cm. Basel, Historiches Museum

BELOW
Fig. 116 Robert Vyner (active 1661), *Great George*.
Gold, enamel, diamonds, 7.2 x 6.4 cm. RCIN 441924

DRESSING MEN 117

MOURNING DRESS

Perhaps it is appropriate to end with a discussion of clothing worn to signify the end of a life. Mourning etiquette was strictly observed throughout this period, and clothing formed a key element. Mourning dress demonstrated the social status of the deceased, provided reassurance to the grieving that they were responding appropriately, and freed the wearer from normal social rules. Funerals for members of the aristocracy were extravagantly expensive events, and like other forms of dress, mourning apparel was strictly regulated at the Tudor court. It was the responsibility of the head of the household to provide appropriate mourning attire in the form of black cloth for the chief mourners, family and servants – indeed fabric was often the most significant cost associated with a funeral. During the seventeenth century smaller, more private funerals became the custom for the elite, with only the close family wearing full mourning dress for extended periods. Three official levels of mourning were often obeyed, with different dress conventions required for each: full or deep mourning, followed by secondary mourning and finally half-mourning. Various factors interacted to dictate what could be worn at each stage and for how long it was to be worn – including the status of the deceased, the status of the bereaved and their relationship to each other.

The seventeenth century saw a rise in the popularity of accessories given as mourning tokens to a larger group of mourners. Commemorative mourning rings, for example, were commonly given out at funerals (at Pepys's funeral three different grades were distributed), while sashes, hatbands (known as 'weepers') and gloves were other accessories used to 'share out' grief in this way. Although large-scale expensive funerals became less fashionable during the seventeenth century, the death of a member of the royal family remained a matter of important sartorial concern for the entire court and population as a whole. Upon hearing that Catherine of Braganza was ill in 1663, Pepys temporarily put an order for a new cloak on hold – if she were to die he would be required to wear mourning dress, and by the end of the mourning period the new garment might be out of fashion.[35]

While there were some garments specific to mourning dress, in general the cut of mourning garments was similar to fashionable styles, the differences instead being in terms of colour, fabric and accessories. This became increasingly true as the period progressed. For deep mourning, black clothing was customary in England. Surfaces were to be matt – reflective fabrics and jewellery were not allowed (a convention ultimately derived from superstitions about reflections of the dead), so shoes were of black cloth rather than shiny leather and sword covers were black, while gold belt buckles and watch chains were removed. Black silk could be reintroduced during secondary mourning, while during half-mourning dull mauve and grey were allowed, together with subtle patterns. One person for whom black clothing was not deemed an appropriate mourning colour was the monarch, who instead wore royal purple or blue, an imperial colour associated with Ancient Rome and Byzantium (where it was dyed with expensive tyrian purple, extracted from seasnails). Elizabeth I's inventory reveals a set of purple mourning robes consisting of a mantle, kirtle, surcoat and bodice of purple velvet trimmed with ermine, while Charles II wore purple in 1660 upon the death of his youngest brother Henry. The colour purple was also worn by the monarch on

liturgical days of the royal calendar which commemorated the dead, including All Soul's Day and Good Friday.

As we have seen mourning dress was seen as a way to pay respect to the deceased and their family. Conversely, choosing not to obey the appropriate mourning convention could be used as a deliberate intention of offence. When Queen Mary II of England died in 1694, at the request of her father James II, Louis XIV of France refused to put his court into mourning. In return William III ordered that only secondary mourning was to be worn at the death of James II seven years later.[36] The two figures in the moving double portrait by van Dyck (fig. 8; detailed in fig. 117) are united in grief. The figure on the left is Thomas Killigrew, a royalist poet and playwright – shown in the traditional pose of a melancholic, head on hand. The other sitter has not been conclusively identified, although he is perhaps William, Lord Crofts, nephew of Cecilia Killigrew, wife of Thomas. The clothing worn by the two men has been interpreted, like the broken column and blank sheet of paper, as a symbol of their shared grief.[37] Killigrew's jewellery corroborates this view. He wears his deceased wife's wedding ring attached to a black silk band wrapped around his wrist, together with a mourning ring next to his own wedding ring on his right hand and a cross engraved with his wife's initials (which may have belonged to his Catholic wife) attached to the doublet. The black colour of both men's doublets has been viewed as signifying mourning dress, while their dishevelled appearance (buttons undone, layers showing beneath) is taken as an indicator of their distracted minds. Black clothing however was a fashionable colour and was not exclusively reserved for mourning, while a deliberately calculated dishevelment was a fashionable affectation adopted by many men, whether grieving or not. Moreover, the shiny satin fabric used to form the companion's doublet would not have been considered appropriate during the period of deepest mourning.[38]

The clothing worn by gentleman affected by the fashionable emotional state of melancholia shares many features in common with mourning dress. This affliction first became popular during the 1580s in England, and was an importation from Italy that remained fashionable until well into the seventeenth century – Robert Burton's *Anatomy of Melancholy* (1621) outlines the principles behind the notion.[39] According to contemporary literature melancholia was caused by an abundance of the melancholy humour, one of the four humours thought to regulate the functions of the human body. An excess of melancholy was associated with heightened intellectual abilities and as such led to melancholia becoming linked with the notion of genius and creativity. It subsequently became a fashionable affectation for young men in portraiture and literature of the period. Isaac Oliver's *A Young Man Seated Under a Tree* shows many hallmark features of someone in the grips of a melancholic moment (see fig. 92). He sits contemplatively in an isolated outdoor location, away from the formally tended garden visible in the distance, his arms folded with a sad, distracted expression on his pale face. Although enlivened with fashionable gold braid and lace, his clothing is black and he wears a large-brimmed hat over long, curling locks. He wears a single glove (its pair is placed beside him), perhaps as a reference to a lost love, a common excuse for a bout of melancholia. We do not know the sitter's identity, yet his clothing contributes greatly to our interpretation of his melancholic state of mind.

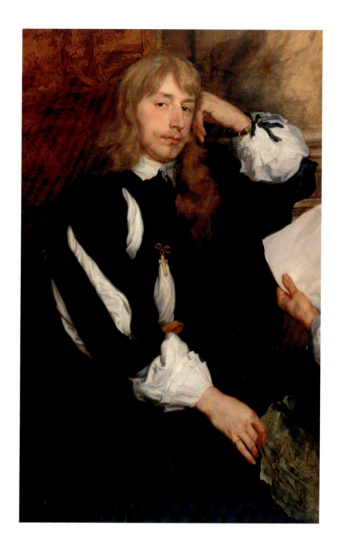

Fig. 117 (detail of fig. 8) Sir Anthony van Dyck (1599–1641), *Thomas Killigrew and William, Lord Crofts(?)*, 1638.
Oil on canvas, 132.9 x 144.1 cm. RCIN 407426

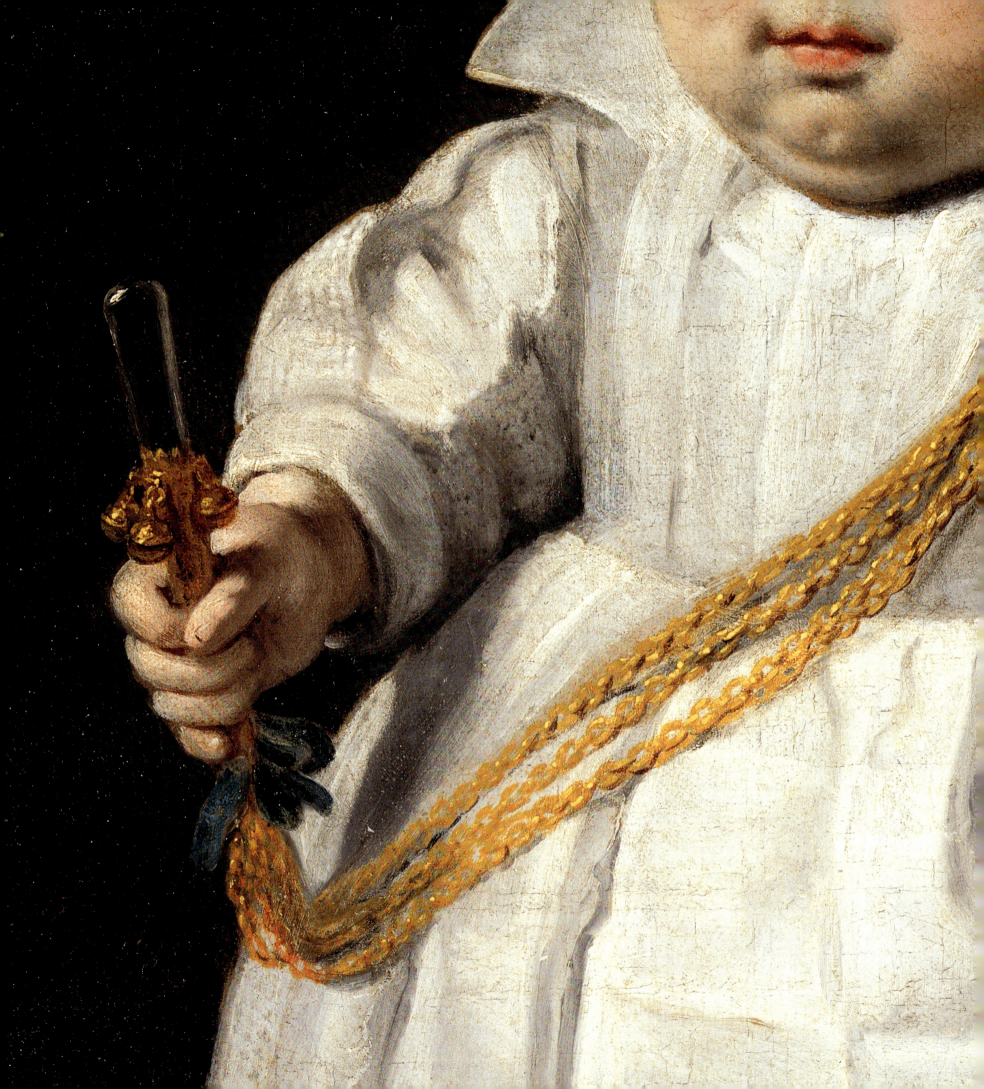

4

DRESSING CHILDREN

What a faire necke he hath! Pull off his shirt, thou art pretty and fat my darling, washe his arme-pits ... Now swaddle him again, but first put on his little biggin and his little band with an edge, where is his little petticoat? Give him his coat of changeable taffeta, his satin sleeves. Where is his bibbe? Let him have his gathered aprone with stringes, and hang a Muckinder to it. You need not yet to give him his corall with the small gold chayne, for I believe it is better to let him sleepe until the afternoon.

Peter Erondell, *The French Garden*, 1605

NEWBORN BABIES of both genders were wrapped in lengths of fabric. When they started to become mobile at the age of around one, they were 'coated', that is put into ankle-length clothes. For little girls these clothes were generally a version of adult female clothing. There were, however, subtle differences to the dress of adult women – they did not wear stays until the age of two or three (and these were of a less constrictive form than those worn by adult women), and bodices fastened at the back rather than with a stomacher in the front.

In van Dyck's *Three Eldest Children of Charles I* (fig. 118), on the far right is Mary, later Princess of Orange (1631–60), at the age of four. Her turquoise silk-satin bodice is cut along the lines of an adult bodice, with a square neckline, a slit sleeve revealing her smock beneath, and matching skirt. As is typical for a child she also wears a bib and apron of fine translucent linen over the bodice and skirt, providing both a protective and decorative function, being finished with fine lace around the hem. Her younger brother, the future James II, is aged two, and is dressed in a similar manner. At this age boys' attire is often impossible to differentiate from that worn by young girls. Van Dyck indicates that Princess Mary's bodice has leading strings attached at the shoulder, which hang down her back. These were strips of co-ordinating or matching fabric which could be worn by children of both sexes – they served the practical purpose of enhancing stability for a child not yet able to walk unaided, and/or preventing a toddler straying too far into danger, in a similar way to modern reins. A fascinating portrait at Boughton House by Pantoja de la Cruz shows such strings being used, as a woman leads the newly walking child through a curtain (fig. 119). Leading strings could be retained until a daughter's teenage years, their removal a symbolic gesture indicating the transition into adulthood. In Lely's portrait of the Duke of York and Anne Hyde with Princess Mary and Princess Anne (fig. 120), the distinct lateral view presented of Princess Mary on the far left indicates that she still wears leading strings at the age of around seven.[1] Sometimes it is difficult to differentiate between leading strings and false or hanging sleeves, which formed a fashionable element of adult dress during the sixteenth and early seventeenth century.

A 1634 portrait by Paulus Moreelse depicts a boy who will have recently made the transition into ankle-length garments, known as a 'short coat' (fig. 121). Although he is probably Flemish, the clothes he wears are typical of those worn by children in England at around the same date, as demonstrated by a similar portrait of Prince Charles at the age of four months (National Portrait Gallery, London). The Flemish boy wears a fitted bodice over a skirt, and both are protected by a bib and apron of linen. The sleeves of the bodice have slits running down their full length, a fashion also seen in adult male fashions of the same date. He wears a cap with feathers (plumes of feathers generally indicated the child was male), and holds an elaborate rattle decorated with bells, suspended from an expensive gold chain and secured with

Pp. 120–21 (detail from fig. 121) Paulus Moreelse (1571–1638), *Portrait of a Young Boy*, 1634.

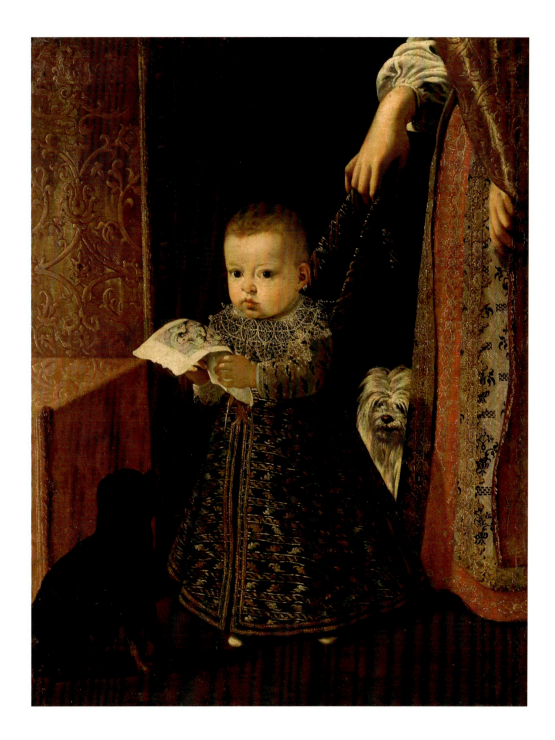

LEFT

Fig. 118 (detail) Sir Anthony van Dyck (1599–1641), *Three Eldest Children of Charles I*, 1635–6.

Oil on canvas, 133.4 x 151.8 cm. RCIN 404403

ABOVE

Fig. 119 Juan Pantoja de la Cruz (1553–1608), *Child in Leading Strings*.

Oil on canvas, 109.9 x 85.0 cm. The collection of the Duke of Buccleuch & Queensberry

DRESSING CHILDREN 125

Fig. 120 Sir Peter Lely (1618–80) and Benedetto Gennari (1633–1715), *James II, when Duke of York, with Anne Hyde, Princess Mary, later Mary II and Princess Anne*, c.1668–85.
Oil on canvas, 168.6 x 194.0 cm. RCIN 405879

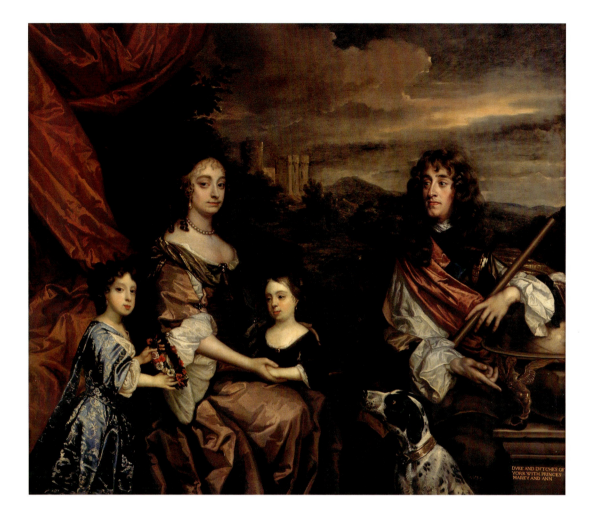

a ribbon at his shoulder, well out of reach of his pudgy young hands. Such rattles provided entertainment, but also could serve as teething aids and were believed to have protective powers. This example is made of rock crystal, believed to sooth wounds, while other common materials used in such toys included coral and wolf's tooth, both of which were ascribed supernatural powers.[2] The white apron has clearly been pressed and folded tightly for storage – the pattern of creases carefully depicted by the artist was both decorative and served as a clear indication of high standards of housekeeping.

Another portrait of a young boy who still retains the 'short coat' worn in childhood is shown in fig. 9. This portrait has been traditionally identified as Henry Frederick Stuart, Prince of Wales (1594–1612), eldest child of James I, based on the 'HF' monogram on the jewel at his chest. However, examining details of his costume, in particular the lace standing-band at his neck, enables a precise dating of this portrait to around 1615 (when such collars were fashionable for a relatively short window of time).[3] This date would make it too late for Prince Henry, given that the child is of toddler age. More likely is that it depicts Henry Frederick (sometimes called Frederick Henry), Prince of the Palatinate (1614–29) – the son of Elizabeth Stuart and grandson of James I.[4] This illustrates how costume can be an important aid for identification. Particularly unusual in this portrait is the cohesive nature of the fabric used to form the curtain, upholster the furniture and construct the child's gown. Although the furnishing fabrics

OPPOSITE

Fig. 121 Paulus Moreelse (1571–1638), *Portrait of a Young Boy*, 1634.
Oil on canvas, 87.5 x 63.3 cm. RCIN 404734

126 IN FINE STYLE

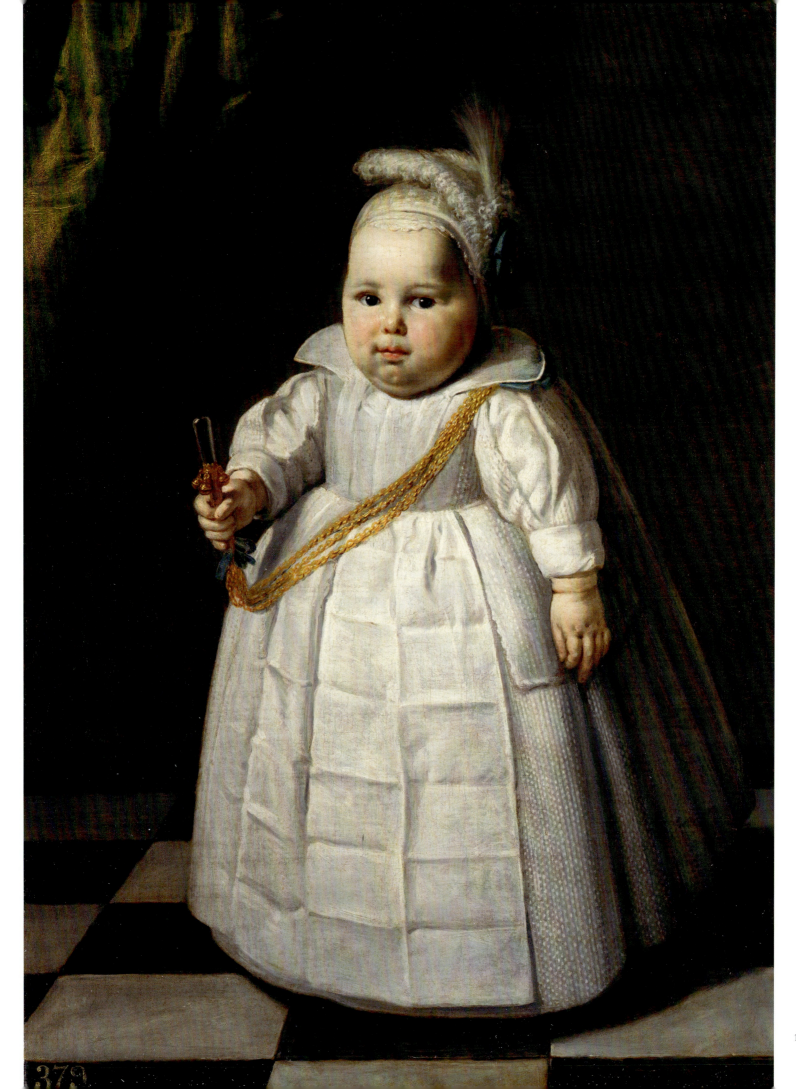

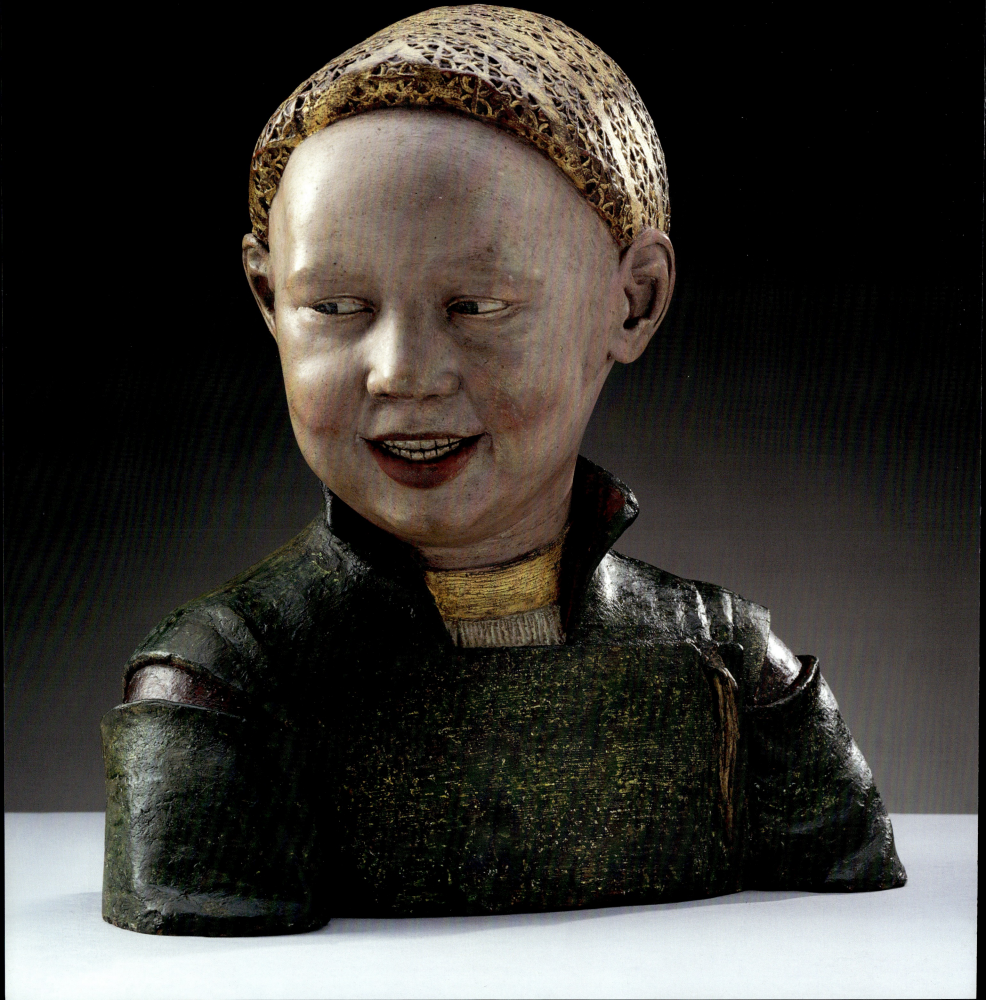

are of a different colour to those used to make up the child's clothing, both are decorated with olive branches and fleur-de-lis. The young child plays with a toy cannon, which in conjunction with the olive branch is perhaps intended to symbolise the world of a successful future ruler – filled with both war and peace.[5] The cutwork lace in this example includes motifs similar to those included in lace pattern books of the sixteenth century. However, the same styles continued for some years after.[6] At around this date cutwork was at its most sophisticated and technically skilled, a fact that is demonstrated through this painting together with a comparable example (fig. 235). The extraordinary cost of such a large piece of lace makes its use on a child's apron – an item usually deemed to serve a protective function for the fabric beneath – a particularly lavish symbol of wealth.

Referring again to the group portrait of the three eldest children of Charles I (see fig. 118), the young Prince James is wearing a long-skirted garment remarkably similar to that worn by his sister Princess Mary. Both boy and girl are wearing square-necked gowns, trimmed with lace and covered with a linen bib and apron to protect the colourful silk. One notable difference between their attire is that the little girl's hair has been dressed according to adult fashions of the 1630s and decorated with flowers while her younger brother James wears a linen cap fastened under the chin. A similar cap (fig. 124) is in the Royal Collection. Forming part of a set of christening garments traditionally associated with Charles I, the cap is trimmed with a style of lace which was not produced until after 1650 and so the attribution cannot be upheld.[7] Nevertheless, styles of cap did not change significantly over the period.

In contrast to his younger brother, the Prince of Wales has reached the landmark stage in a young boy's life of being breeched. He wears a grown-up suit of gold silk satin, decorated with matching ribbon points, ribbon bows at the knee and elaborate shoe roses on his white shoes. The cloak band over his shoulders imitates that of the fashionable courtier, and even his stance, with the classic nonchalant elbow and feet crossed at the ankle, suggests an early training in elegant deportment. An interesting point to note is that the silk of his doublet was painted first, before the lace falling band covering his shoulders. As a result, the colour of the silk shines through the holes in the lace and also slightly modifies its whiteness, just as it might have done in reality.

Sometimes a young child wears, along with his skirt, a doublet cut along the masculine lines of fashion, with a high neck, tabs at the waist and buttons down the front. Such a garment gives a fairly clear indication that the wearer is male (fig. 122). In this portrait of an unidentified young boy, probably of Flemish nationality, the fabric is of rich silk with swirling pomegranate pattern. The doublet has been deliberately cut from the fabric to ensure a symmetrical arrangement of the pattern either side of the front opening, while the two sides of the skirt are not symmetrical, but have been deliberately aligned to ensure a continuation of the pattern across the front opening of the skirt. Both these techniques will have meant

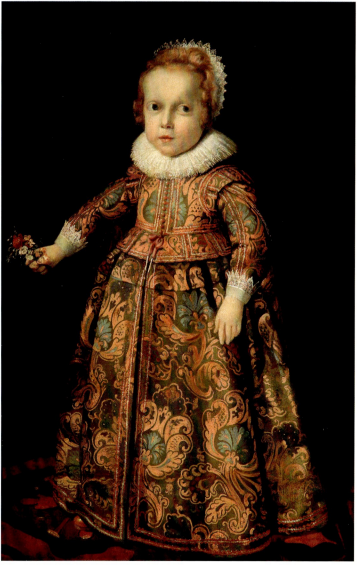

ABOVE

Fig. 122 Flemish School, *A Young Boy*, c.1620.
Oil on canvas, 88.7 x 58.4 cm. RCIN 401179

OPPOSITE

Fig. 123 Guido Mazzoni (1465–1518), *Laughing Child, possibly Henry VIII*, c.1498.
Painted and gilded terracotta, 31.8 x 34.3 x 15.2 cm. RCIN 73197

This strikingly lifelike terracotta bust portrays a young child wearing a green jacket lined with a red fabric and fastened with a ribbon point, together with a cap of gold lace. The green fabric is represented by a green glaze applied over a layer of tin foil scored in fine parallel lines with a stylus, presumably intended to represent an expensive cloth-of-gold green silk woven with silver-gilt thread.

DRESSING CHILDREN 129

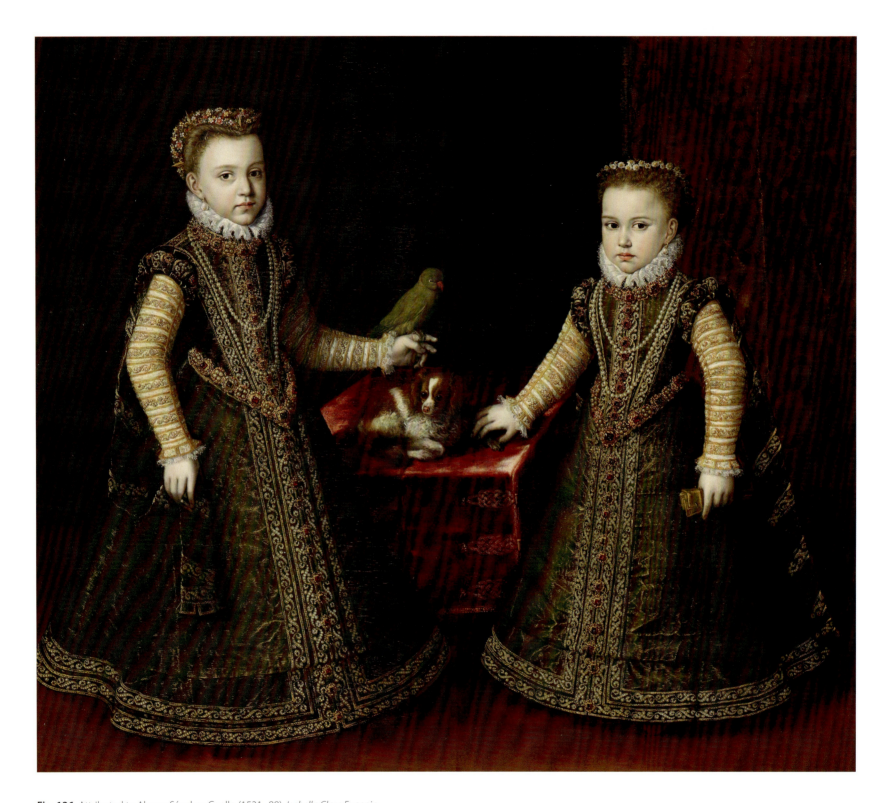

Fig. 126 Attributed to Alonso Sánchez Coello (1531–88), *Isabella Clara Eugenia and Catalina Micaela, daughters of Philip II, King of Spain*, 1569–71.
Oil on canvas, 134.0 x 145.8 cm. RCIN 404331 (pre-conservation).

Expensive jewels were family heirlooms. The girdle and collar worn by the two Spanish infantas in their portrait here for example appear again in a portrait of their mother in the Prado (Pantoja de la Cruz, c.1605). The *al forza*, a tuck of fabric around the hems of the skirts, which is a distinctive feature of dress for adult females in Spain (see pp. 206–7) is also clearly shown here.

BELOW
Fig. 125 Sir Anthony van Dyck (1599–1641), *Three Eldest Children of Charles I*, 1635.
Oil on canvas, 151.0 x 154.0 cm. Turin, Galleria Sabauda

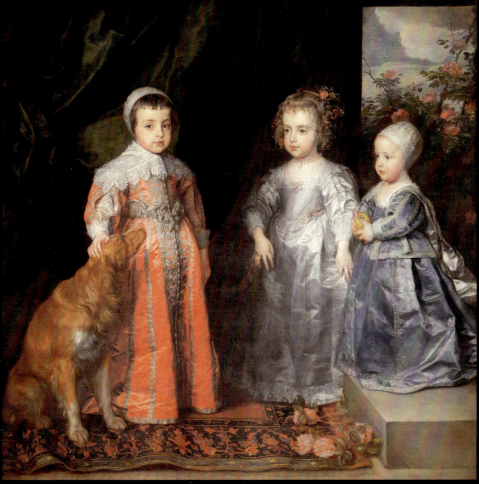

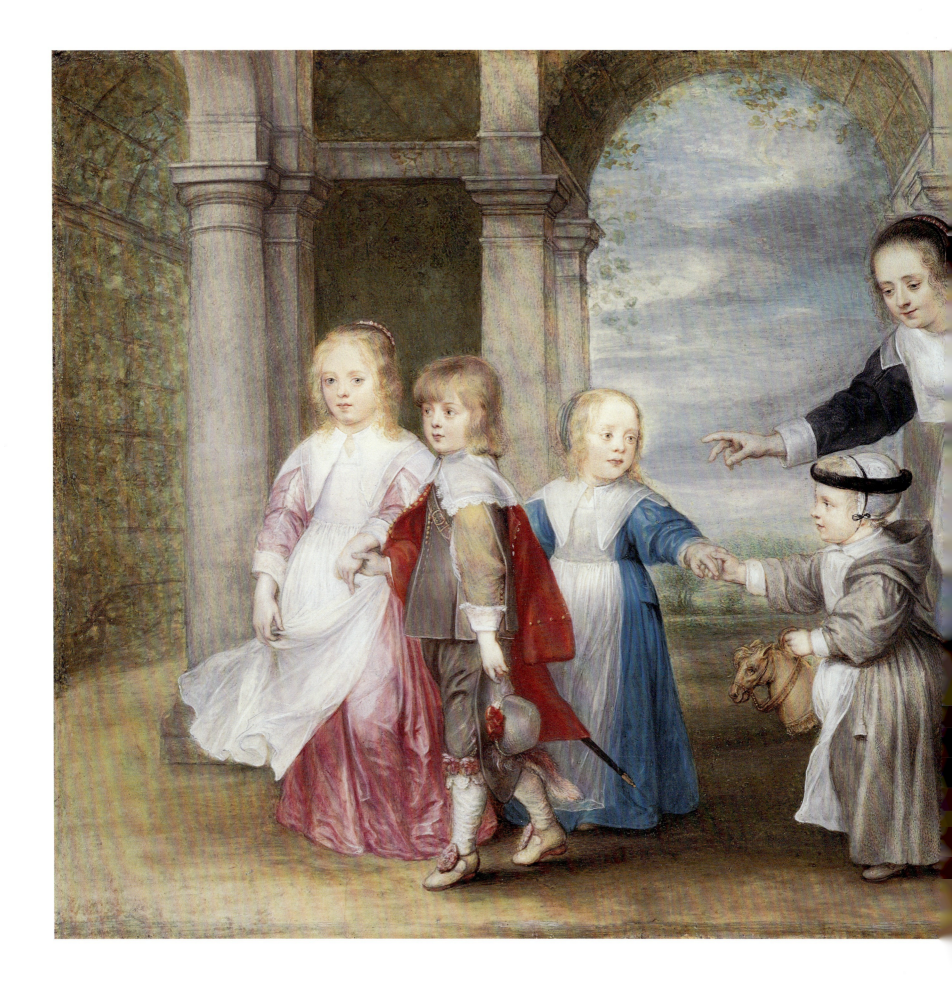

Fig. 127 Philip Fruytiers (1610–66), *Four Children of Peter Paul Rubens and Helena Fourment with two maids*, c.1638–9.
Watercolour, bodycolour and pencil, 24.6 x 33.6 cm. RCIN 452433

greater expense since a longer length of fabric will have been required when cutting out the pattern pieces. The scale of the pattern, which looks over-large for the boy's small figure, perhaps suggests it has been remade from an adult garment which would have meant more fabric available to achieve this careful alignment. Little boys, like little girls, wore a less constrictive version of adult stays until they were breeched – these were believed to help their growing bodies develop correctly.[8]

Breeching for boys was a significant rite of passage, indicating the transition from the world of the nursery (where boys were treated as children and looked after by women) to the masculine world of their fathers, where they socialised with other adults and were taught the pursuits of gentlemen including fencing, riding and dancing. The age at which a child would make this transition usually occurred around the age of six during the Tudor and Stuart periods (it became earlier during subsequent centuries), although the precise age depended on the individual child's maturity as well as parental preference. New clothes were purchased for the occasion, and the commissioning of a portrait was one way to commemorate the event. Two versions of the group portrait by van Dyck exist, the one in the Royal Collection (fig. 118) and another, earlier, picture in the Galleria Sabauda in Turin (fig. 125), which was was sent to the queen's sister, the Duchess of Savoy. Clearly the key difference between the two pictures is that in the Turin version Prince Charles still wears a skirted gown and nightcap like his younger brother. Presumably his father wanted to have his own version of the painting, and perhaps he requested that the future king, despite being only four or five, be portrayed in the breeches and doublet of a young adult. We know that Charles I was concerned with the clothing that his children were depicted wearing. It is recorded that the king was angry with the artist during the painting of the Turin version because he had not included the aprons they usually wore to protect their expensive clothes, and the queen had asked the artist to add them in.[9] This he appears to have done, although in a very translucent manner. Van Dyck has taken care to ensure lace-trimmed aprons are prominently displayed for the two younger children in the subsequent Royal Collection painting.

In the charming watercolour of Rubens's children by Philip Fruytiers of *c.*1638–9 (fig. 127), the youngest child, named Peter-Paul after his father, is probably aged around two and rides a hobby horse. He wears a distinctive type of infant headdress known as a *pudding hat*. This formed a padded circlet around the head and protected young children of both genders from head injuries when learning to walk – they are named after the pudding sausage to which they bear some resemblance (although another interpretation was that they were believed to stop the brain from turning to pudding). An example dating from the eighteenth century survives in the V&A Museum, London.[10] In this image the older boy Frans is aged around six and has been breeched – he wears a miniature version of adult male clothing including a hat, cloak and sword.

DRESSING CHILDREN 133

5
PAINTING DRESS

Taffatys and thin Silks must be full of Breaks and Flickerings; Sattens more Quick Lights, the Folds lying more soft and round; but Velvet the quickest, the deeps very dark, with Reflections on the outward parts of the Folds

Marshall Smith, *The Art of Painting*, 1692

TRANSLATING the highly three-dimensional items of clothing worn during this period into painted representations, while preserving their variable textures and patterns, presented a challenge to artists. This chapter looks at how fabrics and their accompanying surface decoration were imitated in painted form, and examines artistic practices of the period which were specific to painting clothing and jewellery.

LAYERS OF PAINT

Like the fashionable courtier, an artist builds up his image in layers. And like the most stylish sixteenth-century outfit, which gives prominence to certain layers at particular points of the body, so too the finished effect of a painting is dependent on the subtle combination of the various layers at different points over the canvas.

A painting's support – the part that provides a structure on which to hang the subsequent layers – was most frequently made from either a panel of wood or a piece of linen canvas stretched taut (although copper panels were also used). In Northern Europe, including England, during the sixteenth century panel paintings were most common; by the end of the seventeenth century canvas was the preferred support. Miniatures of this date are usually painted on vellum mounted on a playing card. One or more preparatory layers were applied to the support to make a smooth surface for painting. Then the artist would begin to apply layers of coloured pigment – these were usually ground to a powder and combined with a drying oil or paint medium. The sequence by which the artist dressed the figure in paint was dependent on a number of factors, and varied between paintings.

Some artists may have painted an unclothed figure first before dressing it in fabric, but this theory is not upheld by technical examination of paintings from the period. Instead artists often painted the body and clothing in parallel with each other – so, for example, the first layer of paint for both was completed at the same time with the background blocked out around the entire silhouette, including body and clothes. One outcome of this approach is that occasionally the figure beneath appears distorted, their clothing a mask to the anatomically improbable body below.

Similarly, the various clothing layers depicted in a finished portrait have not necessarily been completed in a sequential fashion that follows the layers as they are applied to the human body. Obviously there would be little point in the portrait painter completing a man's linen shirt when it would be almost entirely covered by a doublet. However, artists did utilise the varying opacities of different pigments to depict different layers of clothing by building paint layers on top of each other. Very effective use of this technique can be seen in the 1638 portrait of Henrietta Maria by van Dyck (fig. 128). Here the artist has clearly completed the sitter's white silk bodice before adding her accessories of a lace collar and fine silk scarf.

Pp. 134–5 (detail from fig. 138) Gerard ter Borch (1617–81), *The Letter*, c.1660–5.

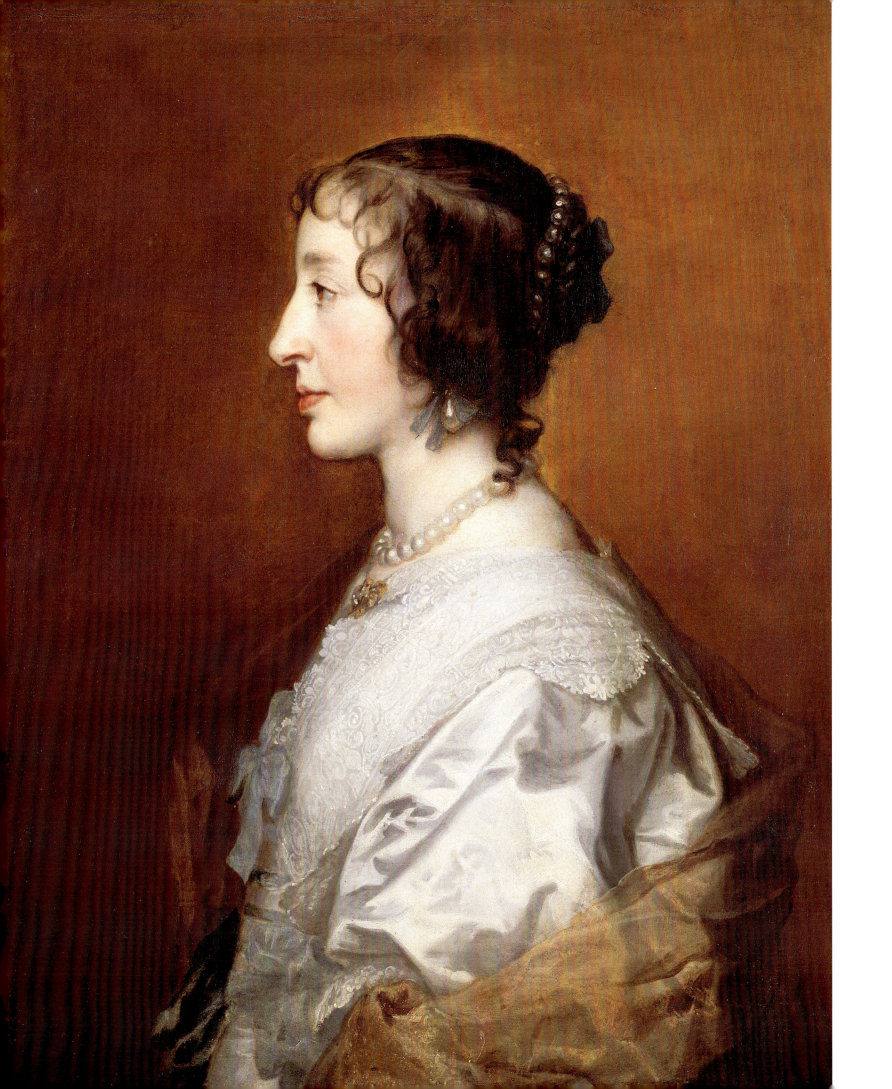

The folds in the fabric of the sleeve, and the pattern of light falling across its reflective surface, shine through the thin brown silk and add to the sense that the clothing has been built up in layers in exactly the same way as the painted image. It is possible, however, that the brown paint of the gauzy scarf has become slightly more translucent over time, revealing more of the bodice than the artist originally intended. It is also possible that the scarf was a later addition, and that the effect of layering is an unintentional side effect. But with an artist as skilled as van Dyck, it is just as likely that the subtle interaction of the two layers of fabric was a very conscious effect.

There are also cases where the artist paints the layers in the 'wrong' order – that is, they complete the *outer* layers of clothing first before adding layers beneath. For example, in his portrait of Edward VI, William Scrots painted some parts of the sitter's white silk doublet sleeves before depicting parts of the white fabric beneath, visible through the slashes in the silk and pulled through to form puffs (fig. 129). Where the white paint used for this lower fabric has

OPPOSITE

Fig. 128 Sir Anthony van Dyck (1599–1641), *Queen Henrietta Maria*, 1638.
Oil on canvas, 71.8 × 56.4 cm. RCIN 400159

BELOW

Fig. 129 (detail from fig. 100) Attributed to William Scrots (active 1537–53), *Edward VI*, 1546–7.
Oil on panel, 107.2 × 82.0 cm. RCIN 404441

OPPOSITE

Fig. 130 (detail from fig. 32) Rembrandt van Rijn (1606–69), *Agatha Bas*, 1641. Oil on canvas, 105.5 x 83.9 cm. RCIN 405352

BELOW

Fig. 131 Flemish bobbin lace, mid-sixteenth century. London, V&A Museum. Acc. 949–1907

become more translucent over time it reveals the gold embroidery of the sleeve, clearly indicating that is was applied as a later layer. Here the sequences of dressing and painting diverge. It is unsurprising that the artist has chosen to proceed in this manner – in order to know where the puffs of fabric should appear, it is first vital to know where the slits in the fabric will occur. In much the same way, embroidered shirts of the period are often only embroidered in those areas that will be seen.

To the artist, it is the sequence of clothing as it falls between them and the sitter, and how these layers occlude each other, that guides the sequencing of paint layers. In his portrait of Agatha Bas (fig. 32), Rembrandt uses this principal to guide how he portrays the lace of the sitter's collar and cuffs. By looking at this painting under magnification it becomes clear that the artist has painted the lace in two different ways. In some places he has painted the lace in a thick white paint against a dark background, and used the white to create the pattern in a traditional manner. However, in other areas (fig. 130) he has filled a broad area with white paint then used a darker paint to fill in the negative space – either black to represent the black background and the silk of the bodice, or the cream colour of the stomacher – as it shows through the open lace pattern. He also shows the effect of light falling on the curled lace, for example at the cuff, through tiny white highlights. For this style of lace, which by this date follows the prevailing baroque aesthetic for dense foliate designs and where the linen thread makes up a larger proportion of the fabric than the hole, this method is presumably quicker. A similar surviving example is in the V&A Museum (fig. 131). It takes an artist with the technical dexterity of Rembrandt however, with his unrivalled understanding of how the viewer's eye will interpret the arrangement of paint, to make the optical illusion as effective as in this example, and thereby avoid any appearance of a piece of white fabric decorated with a black pattern.[1]

Rembrandt's technique of painting in the negative space contrasts strongly with earlier artists who, in their representations of the more open lace characteristic of the sixteenth and earlier seventeenth centuries, painted in each thread rather than the hole surrounding it. This is particularly evident in the miniature format. In his portrait of Elizabeth I (fig. 132), Nicholas Hilliard used his characteristic technique of dribbling thick white pigment onto the surface of the vellum to recreate the intricate designs of the lace collar. This is clearly shown under magnification and raking light. The paint is raised above the surface of the other items of clothing, even the linen collar to which it is attached, to such an extent that it casts a shadow just as the lace itself would have done.

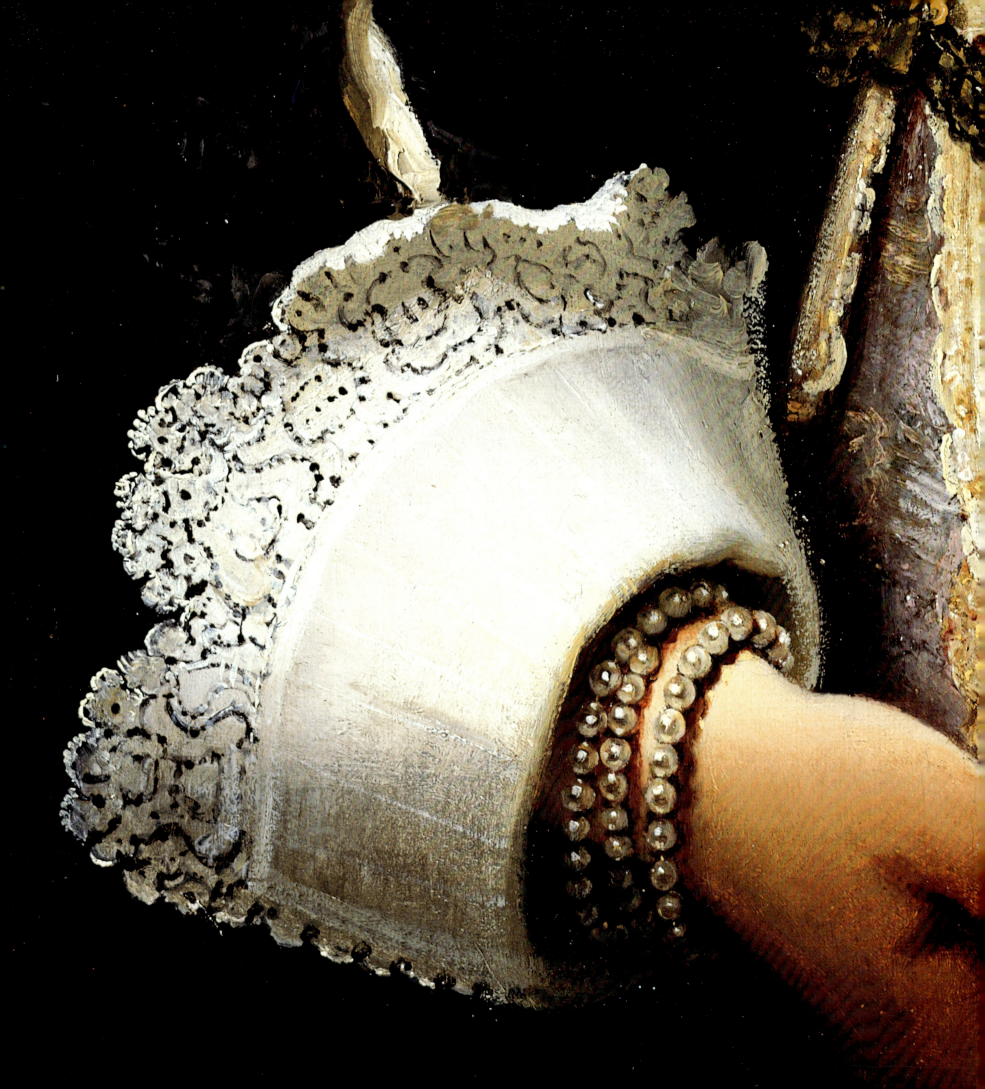

RIGHT AND BELOW (DETAIL)
Fig. 132 Nicholas Hilliard (c.1547–1619), *Queen Elizabeth I*, c.1595–1600.
Watercolour on vellum laid on plain card, 5.4 x 4.5 cm (sight). RCIN 421029

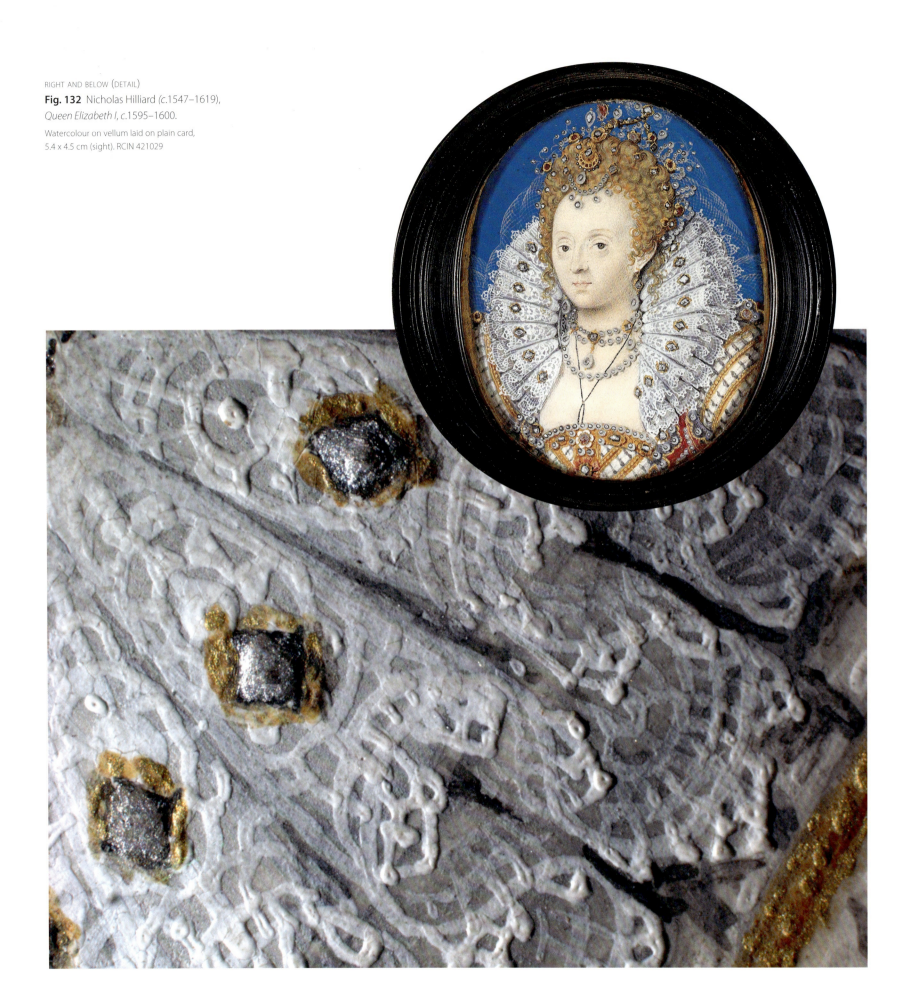

142 IN FINE STYLE

Artists frequently use several layers of paint to depict one single layer of fabric. In the *c.*1546 portrait of Princess Elizabeth, for example (fig. 27), the red silk of the sitter's gown has been represented by a paler pink lower layer to create the base colour, with the pattern of the dress created through a deeper shade of pink and then successive layers of red lake used to to add depth to the shadows. Finally the gold thread woven through the fabric, turning it from an expensive patterned silk into a cloth-of-gold, is represented by the use of short horizontal lines of lead tin yellow paint in the areas of the fabric where the metal threads catch the most light. Interestingly the artist appears to have blotted the last glaze layer of paint with a piece of fabric, resulting in a regular pattern of tiny dots across the paint surface, visible under a microscope. This was presumably a conscious process designed to enhance the textural effect of a red silk achieved through layers of paint. For a more complex fabric, the number of pigments involved and the number of layers in which they are applied can be even greater. This contrasts with the backgrounds of most portraits, which are often painted less elaborately with a simpler layer structure. As in Elizabeth's portrait, backgrounds are also frequently of a darker shade, pushing the figure and their clothing further forward into the viewer's space.

CONTRASTING PAINTING STYLES

In their approach to the depiction of dress, artists can be divided into two distinct groups. Some are meticulous in their representation of the details of fabrics and fashions, placing equal emphasis on costume, face and background, so that the portrait serves as a literal and accurate representation of the clothing. The sitter's face becomes 'an element in the arrangement of fabrics and jewels', and the sitter is 'transmuted into a jewel-encrusted icon'.[2] This style has its origins in early Netherlandish paintings by artists such as Jan van Eyck, who placed particular emphasis on the depiction of details of surface texture. This remained a characteristic feature of painting in Britain until the Baroque shift most notably associated with the arrival of van Dyck in England in the 1630s. After this date it was more frequently utilised by provincial artists working outside the immediate circle of the court. The style is particularly well represented in the work of Nicholas Hilliard, working in both miniature and full-size format, while Cornelius Johnson was a later proponent. The portraits produced by such artists are of particular value to dress historians, in whose details they often find exceptionally revealing information about dress construction, fabric design and surface decoration. In Johnson's 1624 portrait of an unknown lady, for example (see fig. 47), the bodice is decorated with black spots and the artist has taken care to indicate tiny details like the fact that the zig-zag patterns along the edges of the fabric sometimes line up and sometimes do not. It even shows the pin used to attach the ribbon point to the bodice (fig. 133). In the hands of a less skilful artist, this approach could mean that the sitter and their clothing appear to fight for the viewer's attention.

Artists in the second group use a much looser style of brushwork; rather than feeling obliged to record every detail, they rely on the spectator's eye to resolve the image in a way that makes sense. This style, achieving its difficult task in an apparently effortless manner, encapsulates the notion of *sprezzatura* so highly valued in Italy during the Renaissance, and indeed

LEFT
Fig. 133 (detail from fig. 47) Cornelius Johnson (1593–1661), *Portrait of a Lady*, 1624.
Oil on panel, 43.8 x 33.0 cm. RCIN 402978

OPPOSITE
Fig. 134 (detail from fig. 15) Sir Anthony van Dyck (1599–1641), *Charles I and Henrietta Maria with their two eldest children, Prince Charles and Princess Mary ('The Greate Peece')*, 1632.
Oil on canvas, 303.8 x 256.5 cm. RCIN 405353

is more typically associated with Italian artists than their Northern European counterparts. Titian was a particular master of this technique, and proved to be an important inspiration for later artists such as Diego Velázquez and van Dyck who would continue to work in this manner in the seventeenth century. Van Dyck's portraits of Charles I found the sense of apparently easy grace that would come to symbolise the Caroline reign (fig. 134).

Sometimes it is possible to see that an artist's painting style changes over the course of their lifetime, with a resulting change in the manner in which they paint dress. Rembrandt's earlier works of the 1620s and early 1630s are more tightly painted and more clearly delineated. By the 1650s, when he is producing works such as his 1654 portrait of Jan Six (Six Collection, Amsterdam), Rembrandt has established how much information about the sitter's clothing he is able to leave out 'for the beholder to meet him halfway'.[3] The portrait of Agatha Bas (see fig. 32), dated to 1641, is closer to the artist's earlier, more meticulous style, and subsequently displays more information about the details of the sitter's fashionable clothing.

TYPES OF FABRIC

It has long been recognised that the ability to depict different types of fabrics is a key skill for painters. Philips Angel wrote in 1642 that the artist should 'make a proper distinction between silk, velvet, wool and linen stuffs ... A painter worthy of praise should be able to render this variety in the most pleasing way for all eyes with his brushwork, distinguishing between harsh, rough clothiness and smooth, satiny evenness'.[4] The appearance and feel of the fabric is influenced by the raw materials used to produce it, the way the raw material has been woven (or knitted), the way it has been dyed, and the way its surface has been decorated. In the Tudor and Stuart period there were four main types of raw materials available to make woven fabric – wool, silk, linen and cotton. In addition, extremely expensive fabrics could be woven from threads formed from precious metals.

In England wool was derived from the coats of sheep, which once cut from the animal were usually washed to remove the natural lanolin oils. They were then combed and spun to form a thread. Wool was woven to produce woollen cloth (also known as *stuff*), an important English export throughout the period. The cloth could be fulled to make the fibres felt together, resulting in a higher quality, more waterproof fabric. The woven fabric could also be combed

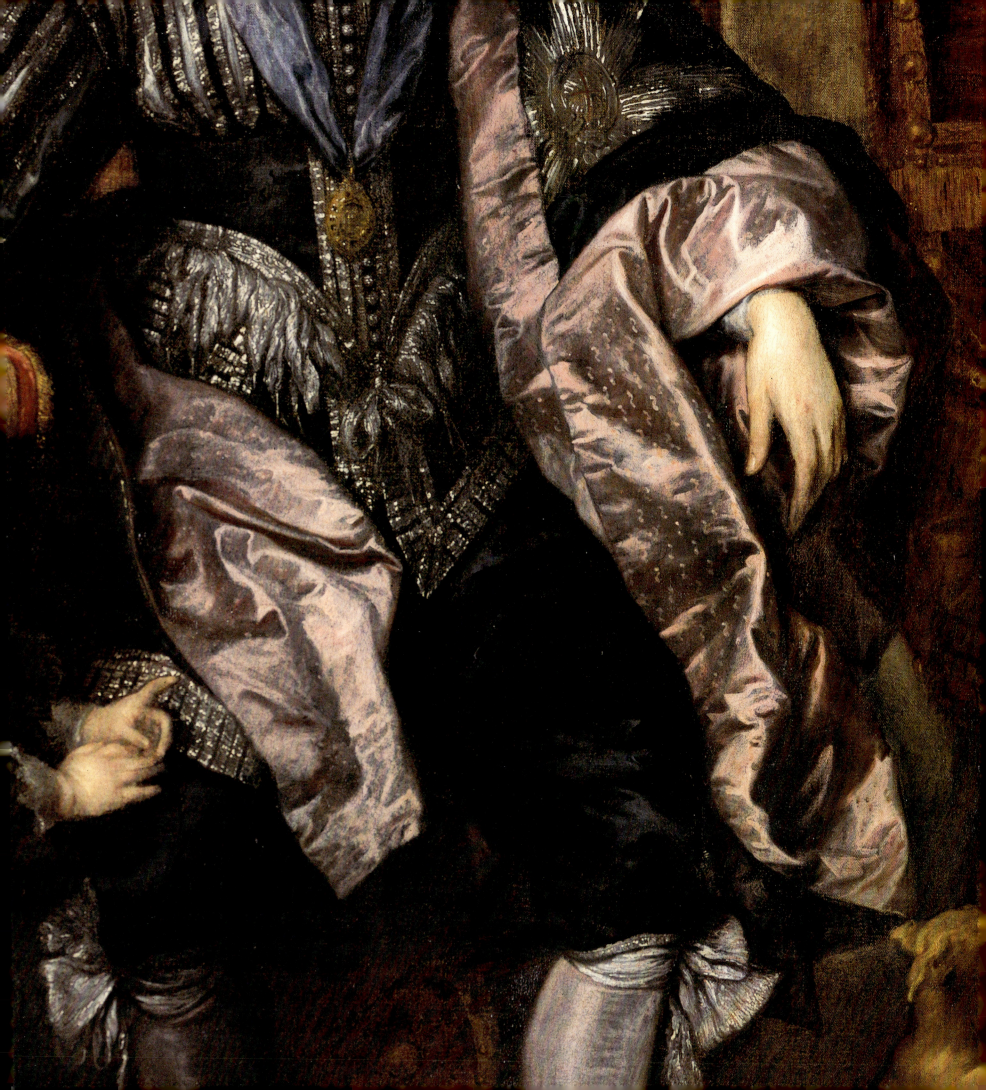

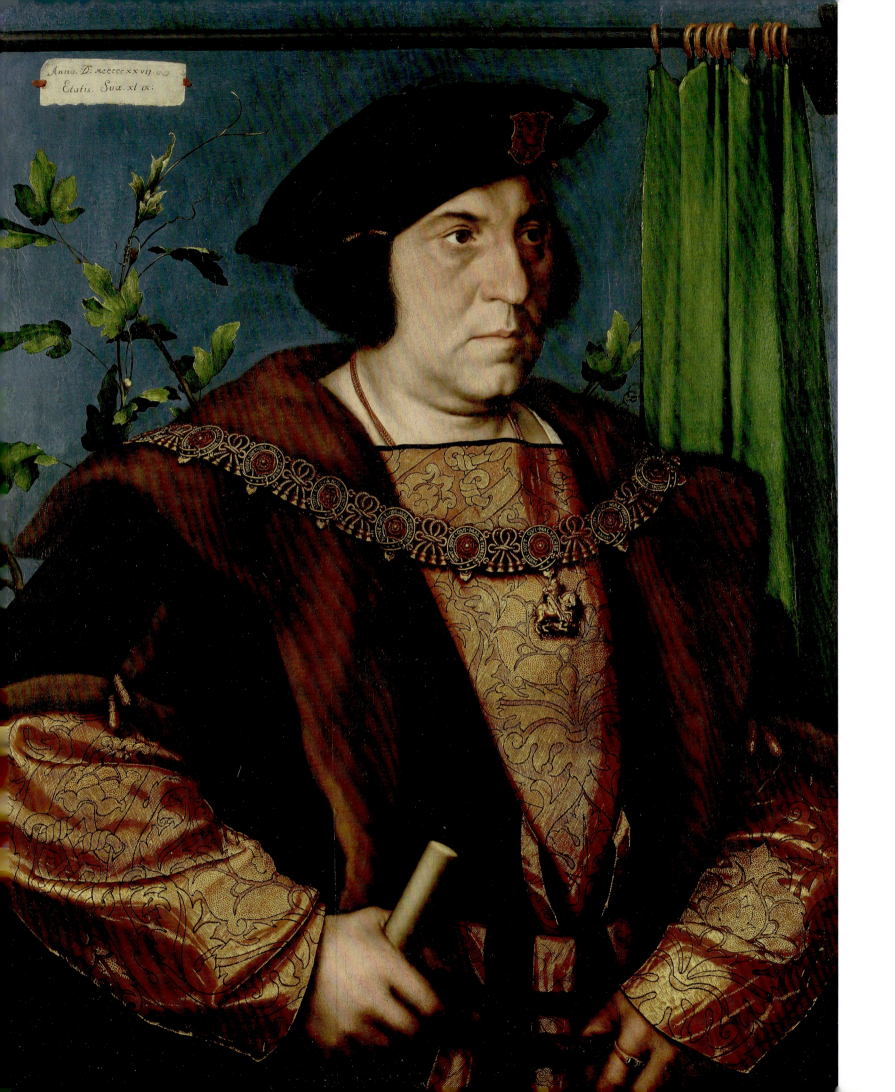

to raise the nap, and then sheared, resulting in a smoother surface. In its various forms, woollen cloth was worn throughout the period by all sections of society. Silk fabrics, however, were limited to the elite members of society, and unlike domestically produced wool were imported into England from hotter European countries, particularly Italy, or from Asia. A series by the Flemish artist Johannes Stradanus showing the silk-making process includes fig. 135, which depicts the silkworm cocoons being dried in the sun, softened in boiling water to release the sericin (natural gum), and reeled to unravel the long silk filaments. Another image in the series shows the silkworms being fed leaves from the mulberry tree, their primary food source. Silk threads are triangular in cross-section, and are gently combed with minimal twist to produce a thread that can withstand the pressures of weaving – these features account for its light-reflecting qualities and lustre. Silk is particularly good at absorbing dye, and subsequently was found in a wider range of colours than wool or linen.

Linen was produced from the flax plant, which could be grown in England. A complex series of processes included rippling (combing to remove the seed heads), retting (rotting the stalks in water for two weeks) and scutching (beating to separate the useful fibres). This resulted in the extraction of the long flax fibres from the rest of the plant.[5] These were then

OPPOSITE

Fig. 136 Hans Holbein the Younger (1497/8–1543), *Sir Henry Guildford*, 1527.
Oil on oak panel, 82.7 × 66.4 cm. RCIN 400046

BELOW

Fig. 135 Johannes Stradanus (1523–1605), *Women Winding Silk*, c.1590.
Pen and brown ink with brown and grey wash over traces of black chalk, heightened with white; indented for transfer, 17.8 × 26.9 cm. RCIN 904766

Fig. 137 (detail from fig. 136) Hans Holbein the Younger (1497/8–1543), *Sir Henry Guildford*, 1527.
Oil on oak panel, 82.7 x 66.4 cm. RCIN 400046

spun into thread and woven to produce a wide range of linens. The finest, with names such as cambric and lawn, were woven tightly using the thinnest threads, while coarser linens were produced for more practical purposes such as sails for ships or canvas for painting. Linen does not take dyes well and is usually found in its natural brown colour, or in its bleached form. Bleaching involved a process of washing, boiling and then laying out in the sun that was repeated several times.[6] Linen bleached in this way is frequently included in Dutch landscape paintings of the seventeenth century, demonstrating its economic importance to the region.

Cotton fibres are derived from the spherical fluffy capsules found around the seeds of the cotton plant. Cotton fabrics were not frequently used in England during the sixteenth century, although cotton threads were sometimes combined with other fibres such as linen to produce *fustian*. The importation of fashionable cotton clothing and accessories from India and the

Near East increased during the second half of the seventeenth century.[7] Especially popular were informal items like banyan gowns. Cottons were available at a variety of qualities and prices, and they were washable. Moreover cottons could easily be dyed, painted or printed with bright colour-fast colours – unique qualities which explained their sharp rise in popularity.

Additional metal threads could be woven through a piece of fabric, usually silk, to produce the most expensive fabrics known as *cloth-of-gold* or *cloth-of-silver* – restricted to the nobility by legislation in the sixteenth century. Metal threads were produced through a variety of techniques. Filé threads, for example, were strips of silver-gilt hammered to a very fine thickness, then wrapped around a silk core.[8] Holbein's portrait of Sir Henry Guildford (figs 136 and 137) depicts the courtier wearing a doublet of cloth-of-gold woven into a pomegranate pattern. The artist clearly demonstrates that the fabric is woven with a variety of different weave patterns. He creates the effect of the fabric by first painting the doublet with an ochre-coloured pigment, to model the folds, then delineating the outlines of the pattern with a black pigment and applying shell-gold paint to add gold highlights falling on the metal threads.

WEAVES AND PATTERNS

The simplest way to produce a length of fabric from all of these different types of threads is to weave them with a simple plain weave. *Warp* threads running from top to bottom are set up on a loom, then a *weft* thread is passed from side to side, alternating between going above then below the warp threads. This produces a plain woven fabric, also known as tabby weave. A more complex weave pattern is *satin*, whereby the weft thread passes over one warp, then under multiple (often four) threads then over one. This results in a smooth-surfaced fabric that shows mostly weft threads on one side and mostly warps on the other.

The most expensive and highly valued satin fabrics during the sixteenth and seventeenth centuries were silk satins; those portrayed in the works of Gerard ter Borch are mesmerising in their beauty and verisimilitude, and became a trademark of the artist from the 1650s onwards. In *The Letter* (fig. 138) he understood perfectly that, in order to replicate the light-reflecting effects of the smooth surface of the bodice and skirt, he needed to increase the contrast between the white of the highlights and the mid-tones and deep shadows. A more matt, less reflective fabric (such as the wool making up the servant boy's blue woollen doublet) has a much narrower range of tones between the darkest and lightest. Sometimes satins were starched and ironed before being painted, to encourage the development of stiff folds as the fabric met the floor. This is seen in this painting – a different type of more angular fold is created at the hemline. The artist has also shown that the silk fabric is so reflective that its hue is influenced by the purple velvet fabric covering the table, where the two fabrics are in close proximity. The same effect is also seen in the folds facing the floor, which reflect its brownish colour rather than the bright white of the fabric itself.[9] All these details contribute to the stunning overall effect of the silk satin garment – produced through layers of paint alone.

Weaving a patterned silk required a draw loom and was a slow process. It has been estimated that the production of a yard a day (less for more complex weaves) was typical.[10] Operating a draw loom required at least two people – a master weaver and a draw boy to

OPPOSITE

Fig. 138 Gerard ter Borch (1617–81),
The Letter, c.1660–5.
Oil on canvas, 81.9 x 68.2 cm. RCIN 405532

raise the appropriate warp threads and generate the pattern – and some of the more complex designs could require up to four draw boys. The most expensive, complex silks were velvets, in which the weaving process produced loops of thread above the surface that could either be left as loops or cut to produce the characteristic texture associated with velvet. In *Measure for Measure* Lucio is described as 'good velvet; thou'rt a three-piled piece'.[11] A velvet woven with three heights of pile was the ultimate in luxury. Where the tiny loops are of metal thread, the fabric was known as a *tissue*. At the court of Henry VIII this were restricted by law to the king and his closest relatives.[12] In William Scrots's portrait of Princess Elizabeth, massed groups of gold loops in a pomegranate pattern against a pale silver-coloured ground are clearly depicted in the fabric of the foresleeves and the triangular forepart at the front of the skirt (fig. 27; detailed in fig. 139). This type of fabric would have been known as a *cloth-of-silver tissued with gold*. By depicting such a restricted fabric, the portrait apparently makes a conscious reference to the princess's royal birth – potentially a politically charged statement when one considers that the portrait was painted in *c*.1546, only three years after the Third Succession Act had brought her back into the royal line of succession, although she was still officially deemed illegitimate. Two very similar fabrics to those in the portrait are shown in figs 140 and 141. One is a crimson silk woven with a similar floral design that even includes the same chequerboard-style filling weave for portions of the pattern.[13] The other is a crimson velvet with silver-gilt filé thread raised into loops like those in the portrait.

During the fifteenth century the most fashionable fabric pattern was the pomegranate design. In several of van Dyck's portraits of the 1630s he includes wall hangings of fifteenth-century Italian silks woven with pomegranate designs in gold thread, which are suggestive of early cloths of estate.[14] One black-and-gold example is seen in the *Three Eldest Children of Charles I* (1635–6), alternating with hangings of plain velvet (fig. 118). These early fabrics are usually painted in a more sketchy style than the contemporary fabrics worn by the sitters, and are of a more subdued colour palette, presumably deliberately designed to offset the colours of the modern shimmering silks. The design is again clearly seen in an early sixteenth-century posthumous portrait of Edward IV, whose gown is of black velvet woven with gold in a pomegranate pattern, symmetrical about the front opening (fig. 142). In general, larger patterns of this kind were more expensive than smaller ones, as they could be repeated less frequently on the loom and required a more complicated arrangement of pins. After the middle of the sixteenth century patterns typically became smaller in scale – a trend driven by the fact that garments were increasingly constructed in a more complex manner. The narrowness of the pieces which then were sewn together would interrupt any large-scale pattern.

Pomegranate patterns are the most frequently depicted of Renaissance silk designs in paintings, appearing on clothing (secular and ecclesiastical) and as furnishing fabrics. Although the designs were named after the pomegranate, which had a number of symbolic associations including fertility (due to the number of seeds they contained) and immortality (Christ is sometimes depicted carrying one as a symbol of the resurrection), the pattern came to incorporate stylistic elements from other plants, such as the thistle shown in Edward's portrait (fig. 142). The depiction of the design here does not follow the contours of the human form

BELOW LEFT

Fig. 140 Detail of the chasuble of Pope Sixtus IV. Venetian, 1470s–83.

Crimson velvet with cut and uncut silk pile, voided and brocaded with silver-gilt filé, with loops in two heights. Padua, Basilica di Sant'Antonio

BELOW RIGHT

Fig. 141 Fragment of rich crimson woven silk.

London, V&A Museum. Acc. 563.1884

OPPOSITE

Fig. 139 (detail of fig. 27) Attributed to William Scrots (active 1537–53), *Elizabeth I when a Princess*, c.1546.

Oil on panel, 108.5 x 81.8 cm. RCIN 404444

beneath. While the artist has modelled the folds at the sitter's right elbow using a darker pigment for the ground of the fabric, a closer look reveals that the black pattern does not show any foreshortening as the fabric bends and instead continues straight across the creases. The impression is of a flat piece of fabric applied onto the surface. The pattern also continues smoothly between the sleeve and the front panel, with no indication of seams or construction. The same effect is seen in the works of some early Netherlandish artists, and suggests the use of pattern drawings of fabrics rather than direct observation of the garment in the studio.[15] Artists using this method could vary the final appearance of the same pattern in different paintings by using different colour combinations and modifying the scale.

In contrast to this flat pattern technique, in the portrait of Sir Henry Guildford (see fig. 136) Holbein clearly demonstrates that the pattern becomes foreshortened around the creases at the elbow. Straight lines in the pattern move out of alignment as a result. Like earlier Netherlandish artists, Holbein re-uses a simplified version of this pattern for his later portrait of Edward VI as a child (National Gallery of Art, Washington). This suggests that, like the example of the Edward IV portrait, it may have been painted from a preliminary drawing of a sample of fabric, rather than being the actual fabric in front of him. Alternatively, Holbein might have used sketches of a doublet owned by Guildford to work up the design on the later painting. He does not appear to have modified the scale of the pattern for the child's garment, resulting in it looking over-large.[16]

A brocaded fabric is one that uses extra weft threads, in addition to the main weft forming the inherent structure and ground colour of the fabric, to add a coloured or metallic pattern on one side of the fabric. In Anne of Denmark's skirt and bodice (see fig. 1) the tiny parallel brushstrokes running horizontally across the fabric motifs are suggestive of a woven brocade. Brocaded fabrics are however sometimes hard to differentiate from embroidered fabrics in paintings, as their external appearance can be similar. Brocading threads could be limited to small areas of the fabric, which avoided wasting expensive thread across the full width of the fabric in areas where it would not be visible. Fabrics woven with metal threads are often brocaded in this manner for this reason. Small patterns like that depicted here were easier to weave than large pattern repeats, and are characteristic of the early seventeenth-century changes in textile designs from Italy.

Non-metallic weft threads can be all of the same colour, or of different colours to produce fabrics with a coloured pattern. A two-tone fabric is produced with weft and warp threads of different colours. When constructed from silk this is known as a shot silk, also known during the period as a changeant fabric. Holbein beautifully depicts the subtle colour changes of such a silk in his miniature of Henry Brandon, 2nd Duke of Suffolk (fig. 143). The young duke rests one arm on a ledge, giving prominence to his silk doublet woven from red and green silk threads, worn under a black short-sleeved gown. Unlike other types of silk, for which the direction of falling light affects the way in which they are modelled by an artist in paint, shot silks behave differently, instead appearing to switch colour depending on their angle relative to the viewer.[17] Holbein skilfully shows that this silk changes from red to green as it rotates away from the viewer around the sitter's arm at the top and bottom of the sleeve. Interestingly, examination under magnification and raking light also reveals that the artist has built up to the colours in such a way that, rather anachronistically, the first pigments to be laid down (and therefore furthest from the viewer's eye) actually represent those parts of the sleeve closest to the viewer.

Using the same colour weft thread throughout, damasks are described as self-patterning. Their design is produced by variations in the weave pattern – for example a damask might have a flower woven in a satin weave with mostly weft threads showing, and the ground pattern woven in a satin weave with mostly warp threads showing. Charles I apparently wears a doublet and breeches of a purplish-brown coloured damask in his portrait by Mytens (see fig. 93). The pattern is subtle and understated, yet expensive. Its matt effect is characteristic of these types of fabrics, and contrasts dramatically with the shining yellow silk woven with a satin weave that forms the king's sleeves. Damask fabrics are reversible, with the back of the fabric displaying the opposite pattern to that on the front.

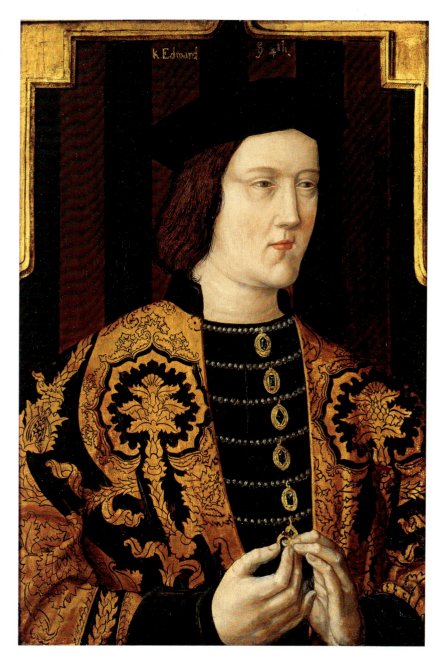

ABOVE AND OPPOSITE (DETAIL)
Fig. 142 British School, *Edward IV*, c.1520.
Oil on panel, 67.9 x 47.9 cm. RCIN 403435

ABOVE AND ABOVE RIGHT (DETAIL)
Fig. 143 Hans Holbein the Younger (1497/8–1543), *Henry Brandon, 2nd Duke of Suffolk*, c.1541.
Watercolour on vellum laid on playing card, diameter 5.6 cm. RCIN 422294

A non-woven material particularly fashionable at the court of Henry VIII was fur, frequently depicted in portraits of that period. It became less popular during the Elizabethan era, but remained in use throughout the sixteenth and seventeenth centuries, largely due to its insulating qualities. The type of fur most immediately associated with royalty is ermine, seen for example trimming the red velvet mantle of Princess Mary's ceremonial robes in her portrait by Willem Wissing, and still used to trim coronation robes today (fig. 144, detailed in fig. 146). The white fur derives from the stoat; the black spots were added separately. The stoat's coat changes from brown to white during the winter months, except for the end of its tail, which remains black. In order to create the spotted effect, the black tails – or imitation versions, of black sheep's skin – were sewn in through regular slits in the white fur, a process known as *powdering*.[18] For ceremonial robes a person's status was indicated by the density of the spotting. Close examination of Mary's portrait reveals that the artist depicted the slight dip in the flat surface of the fur that results from this process. Other popular types of fur used for clothing during the sixteenth century were miniver, sable and lynx. Miniver was derived from the white stomach fur of squirrels. The satin jacket worn by the unknown woman in *Woman at her Toilet* by Jan Steen may be trimmed with miniver (see fig. 26). Sable was one of the softest, most exclusive furs, derived from the dark brown skin of a species of marten and seen in the miniature of Katherine Howard by Holbein (see fig. 11). The skin of the lynx produced an irregularly spotted fur – it can be seen lining Edward VI's gown in the Scrots portrait (fig. 100).

Marshall Smith, who wrote *The Art of Painting* in 1692 (a quote from which opens this chapter), recognised that the weave of a fabric influences its appearance, resulting in a characteristic folding pattern. In Godfrey Kneller's portrait of Mary II from 1690, the artist appears to have used a similar method to that discussed by Smith when portraying the sitter's blue velvet Robes of State (fig. 145). We get a very clear sense of the tactile quality of the velvet fabric, largely due to the contrast in tone between the very dark blue used inside the folds of the fabric ('the deeps very dark') and the particularly pale colour which is used, as Smith advises, to create 'Reflections on the outward parts of the Folds'. Due to the structure of the pile in silk velvets, many examples demonstrate a dramatic change in appearance as they fold away from the viewer. Their pale colour at this point is the result of looking at a mass of reflective silk threads from the side rather than from the top. Another effect characteristic of velvet that has been noted in early Netherlandish paintings is that it often looks darker in the areas that catch the light, and lighter in areas that are in shadow – a reversal of the effect seen in other types of fabric.[19]

BELOW LEFT

Fig. 144 (also detailed overleaf, fig.146) Willem Wissing (1656–87), *Mary II when Princess of Orange*, c.1686–7.

Oil on canvas, 125.8 x 102.3 cm. RCIN 405643

BELOW

Fig. 145 (also detailed overleaf, fig. 147) Sir Godfrey Kneller (1646–1723), *Mary II*, 1690.

Oil on canvas, 223.2 x 148.8 cm. RCIN 405674

PAINTING DRESS

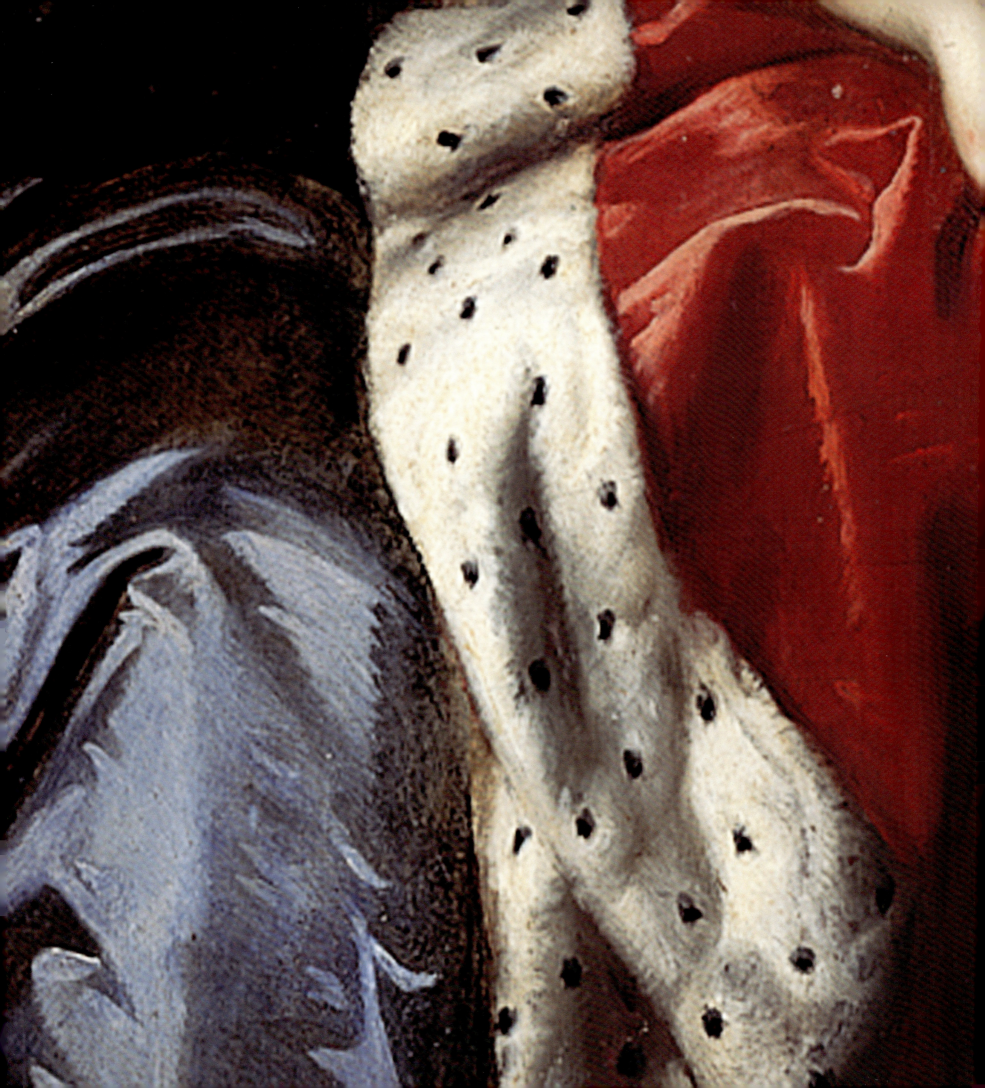

In the portrait of Henrietta Maria by van Dyck (fig. 148) it appears that the queen's white bodice may be constructed of a type of silk then known as taffeta which had a plain weave (often with weft threads slightly thicker than warp), giving it a rather flecked surface, unlike a smoothly woven silk satin.[20] The sleeve of the garment is full of the characteristic 'Breaks and Flickerings' that Smith associated with a taffeta. It does not have the 'soft and round' folds of a silk satin, but instead has rather sharp, crisp-looking creases.[21] Henry Peacham, who wrote *The Compleat Gentleman* in 1622, also specified pigments and techniques to be used by the artist, citing 29 different types of fabric including 'blacke Leather for shooes', 'changeable Taffeta' and 'Sea-water Greene Velvet'.[22]

OPPOSITE

Fig. 148 (detail from fig. 38) Sir Anthony van Dyck (1599–1641), *Queen Henrietta Maria*, c.1632. Oil on canvas, 109.0 x 86.2 cm. RCIN 404430

COLOUR

Sometimes the pigments used by an artist were the same ones used to dye fabric, although they were used in a different carrier medium. The root of the madder plant is the source for alizarin, used both as a fabric dye and also to produce madder lake pigments for painting. Similarly, indigo was used as a dye, and the floating material produced in the dye vats as a waste product could be extracted and used as a painting pigment (known as florey).[23] Cochineal and brazilwood, both imported from South America, were also used to produce dyes and pigments.[24] Minerals are not appropriate to use as dyes but are often used as pigments – the bright blue natural ultramarine derived from lapis lazuli and imported from Afghanistan via Venice is an example. The reverse could also be true – saffron (an organic compound derived from the crocus flower) was used as a yellow dye, for example to colour lace during the early seventeenth century, but was not generally considered appropriate as a painting pigment due to the fact that it quickly faded.[25] Another link between textiles and painting is the flax plant, used to produce both linen fabrics and linseed oil, the paint medium used almost invariably by artists. Linseed oil however tended to yellow slightly, so in areas where it was important to avoid this effect – blue or white clothing, for example – artists usually used walnut oil instead.[26]

Colour is one of the most impactful elements in both clothing and portraiture. While a wide range of colours was worn throughout the period, at different times certain colours were more fashionable than others. Portraiture can both provide a good indication of which colours were most popular, and be misleading. The wardrobe accounts of Henry VIII indicate that he owned clothes in a wide range of colours, with black, white, various shades of red, purple and green being particularly well represented, although he also owned clothes in orange, yellow and the intriguingly named 'horseflesh'.[27] As we have seen, however, his portraits show a limited range of colours to emphasise those shades most associated with monarchy, in particular red and gold.[28] Names for colours frequently drew on nature for inspiration, and a milliner's bill of 1638 provides an evocative sense of the colours in style for that particular year, 'primrose green, sea greene, lemmon colour, straw colour, willow colour, grasses greene, orange colour, aurora'.[29] The sale of the contents of Peter Lely's studio after his death in 1680 included satins described as 'blosseme' (peach), 'pearle-coloured', 'livered' (dark red/brown), 'feville (feuille) mort' (dead leaf), and 'sky'.[30]

Black was a popular and fashionable colour throughout the period; contrary to popular opinion it did not necessarily signify one particular religious conviction (in the seventeenth

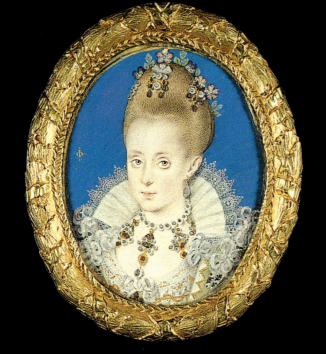
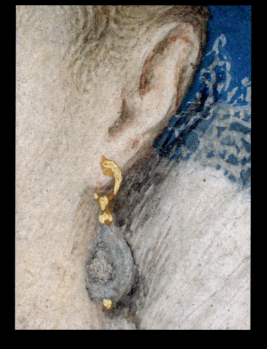

ABOVE AND ABOVE RIGHT (DETAIL)
Fig. 149
Isaac Oliver (c.1565–1617), *Princess Elizabeth, later Queen of Bohemia*, c.1610.
Watercolour on vellum laid on card, 4.9 x 4.1 cm.
RCIN 420031

century it was popular amongst Spanish Catholics, Dutch Calvinists and English Anglicans). Rather, it indicated sobriety but also wealth – to produce a true black fabric was an expensive and labour-intensive process, requiring multiple dyeings. It was also difficult to maintain the colour of black garments as the dyes used were fugitive, fading with exposure to light or washing. In many seventeenth-century portraits (and photographic reproductions) it is difficult to discern that black garments are often adorned with surface decoration of the same colour, including black lace, embroidery and slashing. Unfortunately, the metallic mordant used to fix the black dye to fabric during the process of dyeing is corrosive, so relatively few black garments have survived, and black embroidery and lace on garments have frequently deteriorated. Black garments in paint are often represented using a variety of pigments. Royal physician and scientist Théodore Turquet de Mayerne recommended that black draperies be painted first using lamp black mixed with a little lead white, and then using ivory black mixed with verdigris to deepen the colour in certain areas.[31] Technical analysis has revealed that this corresponds closely with the method used by Frans Hals to depict black fabrics.[32] The verdigris acted as a siccative to help the slow-drying black pigments to dry between layers.

The traditional method to imitate gold fabrics, embroidery and jewellery in painting was by the mordant gilding process. After the rest of the painting was complete, the artist applied an adhesive or mordant and then small pieces of thin gold leaf were placed on top. These would stick only to the adhesive and any extra was brushed off.[33] However, by the fifteenth century this method was deemed increasingly archaic, and artists instead sought to imitate gold using paint. Leon Battista Alberti, in his 1435 treatise *On Painting*, wrote that 'to represent the glitter of gold with plain colours brings the craftsman more admiration and praise'.[34] In *The Compleat Gentleman* (1622), Henry Peacham recommended that gold on armour be painted using masticot (lead-tin yellow) for the highlights and umber for the shadows, all laid over a ground of red lead. Likewise silver should be imitated using charcoal and a 'bold and sudden stroke' of white lead to represent a highlight.[35]

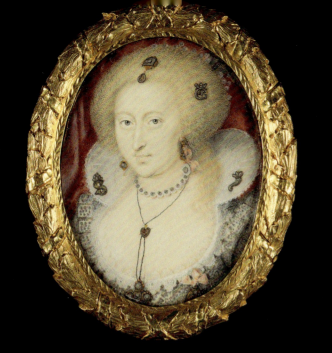

ABOVE LEFT AND ABOVE (DETAIL)
Fig. 150 Isaac Oliver (c.1565–1617), *Anne of Denmark, c.1611–12.*
Watercolour on vellum laid on playing card, 5.3 x 4.2 cm. RCIN 420041

Miniaturists, however, continued to use powdered gold – also known as 'shell gold' since it was mixed in a mussel shell – combined with gum arabic throughout the Jacobean period and occasionally later. It is no coincidence that Nicholas Hilliard, one of the earliest masters of the craft, was originally trained as a goldsmith. Shell gold was usually applied over an ochre-coloured ground pigment to imitate gold jewellery. Hilliard also developed a particular technique for painting pearls. In *The Art of Limning* he recommends:

> the pearls laid with a white mixed with a little black, a little indigo and a little massicot ... That being dry, give the light of your pearl with silver, somewhat more to the light side than the shadow side and as round and full as you can; then take a good white, delayed with a little massicot, and underneath at the shadow side give it a compassing stroke, which shows the reflection that a pearl hath'[36]

The areas of precious metal were burnished with a small tooth to make them shine.

These techniques were copied by Hilliard's pupil, Isaac Oliver. In his miniature of Princess Elizabeth, later Queen of Bohemia (fig. 149), the earring clearly shows the use of real shell gold to imitate the gold setting. The pearl is produced by dribbling thick white lead paint onto the surface, then finishing it with a touch of real silver. Unfortunately silver used in this way often oxidises over time through exposure to the air, turning it dark grey and creating an effect that can sometimes be misleading, suggestive of dark stones surrounded by white mounts, as in another Oliver miniature, that of Anne of Denmark (fig. 150). To create the effect of coloured gemstones, Hilliard developed a technique in the 1570s of applying transparent resins over a burnished silver ground.[37] This technique is clearly seen in the diamonds sewn into Elizabeth's ruff in fig. 132. On one occasion he even included a real jewel on the surface alongside painted examples (*Queen Elizabeth in Robes of State*, Welbeck), apparently as a deliberate demonstration of his skill and a challenge to the viewer to detect the difference.

PAINTING DRESS 163

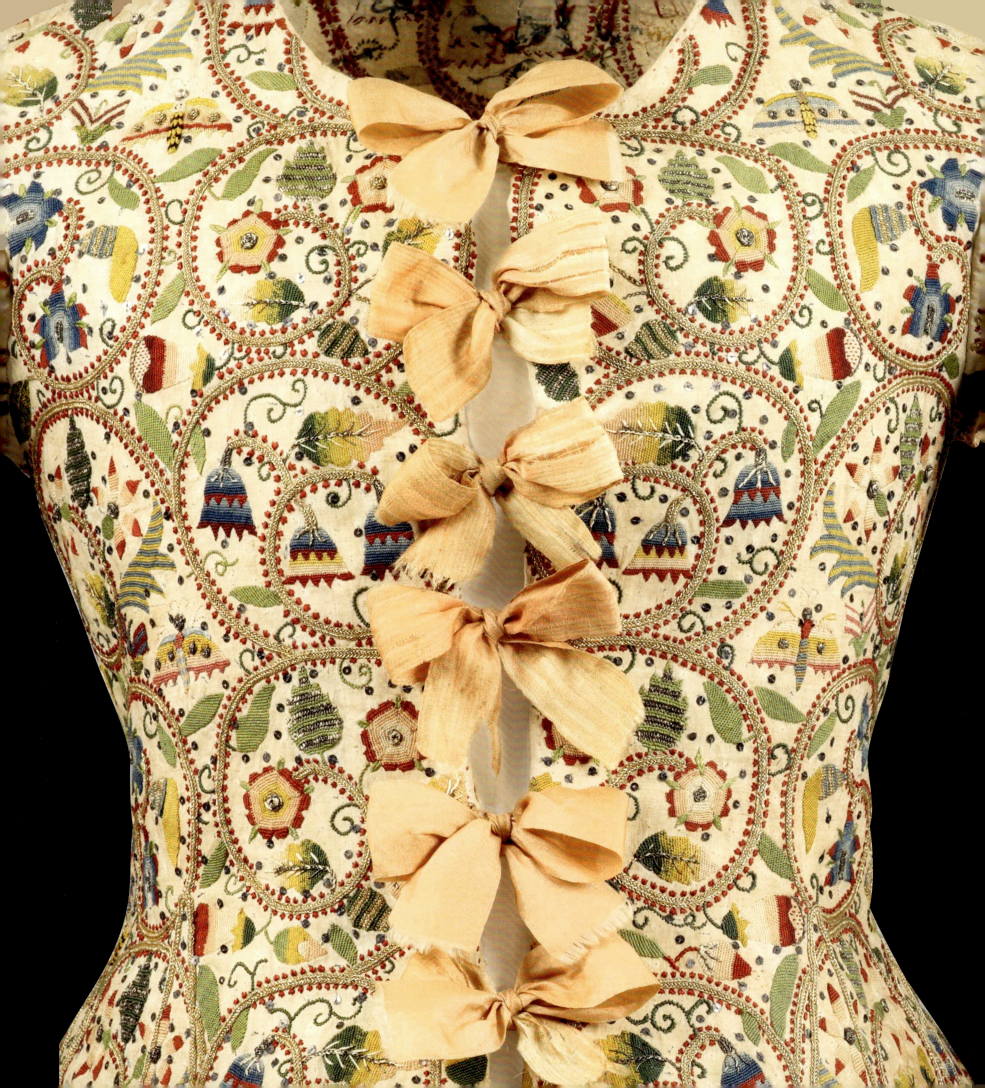

SURFACE DECORATION

During the Elizabethan and Jacobean periods, a focus on surface decoration and complexity of pattern piled on pattern was highly fashionable. Some artists took particular pleasure in depicting the small details of surface pattern in paintings. While the extreme simplicity of the elegant clothing at the Caroline court that appears in some portraits by van Dyck may be in part an exaggeration of the artist, surviving garments do indicate that by this date the focus on surface decoration and pattern had diminished in favour of a more restrained approach, emphasising plainer, more lustrous silks, left relatively undecorated.

Embroidery was expensive, and embroidered garments for men were generally limited to royalty and the nobility. Embroidered clothes for women however, many of which were made within the home, were also worn by the middle classes. Needlework was an essential part of a woman's education in the seventeenth century, and considered a highly appropriate pastime for females of all social classes within a household. Individual garments could either be embroidered directly or decorated with separately embroidered pieces of fabric, which could then be transferred between garments. For example, *guards* were strips of embroidered fabric applied around the edge of a piece of clothing and over seams.

The embroidered waistcoat of the unknown woman in fig. 41 (detailed in fig. 151) is clearly decorated in a similar manner to a waistcoat in the Fashion Museum, Bath (fig. 152). Whereas

OPPOSITE AND OVERLEAF
Fig. 152 Woman's waistcoat, *c*.1610–20.
Bath, Fashion Museum. Acc. BATMC 1.13.132

BELOW
Fig. 151 (detail from fig. 41) British School, *Portrait of a Woman*, *c*.1620.
Oil on canvas, 89.7 x 80.6 cm. RCIN 406064

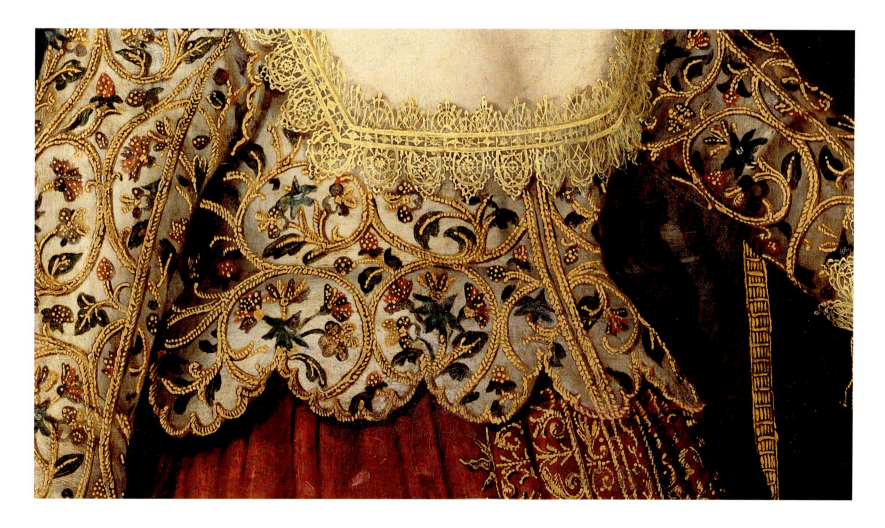

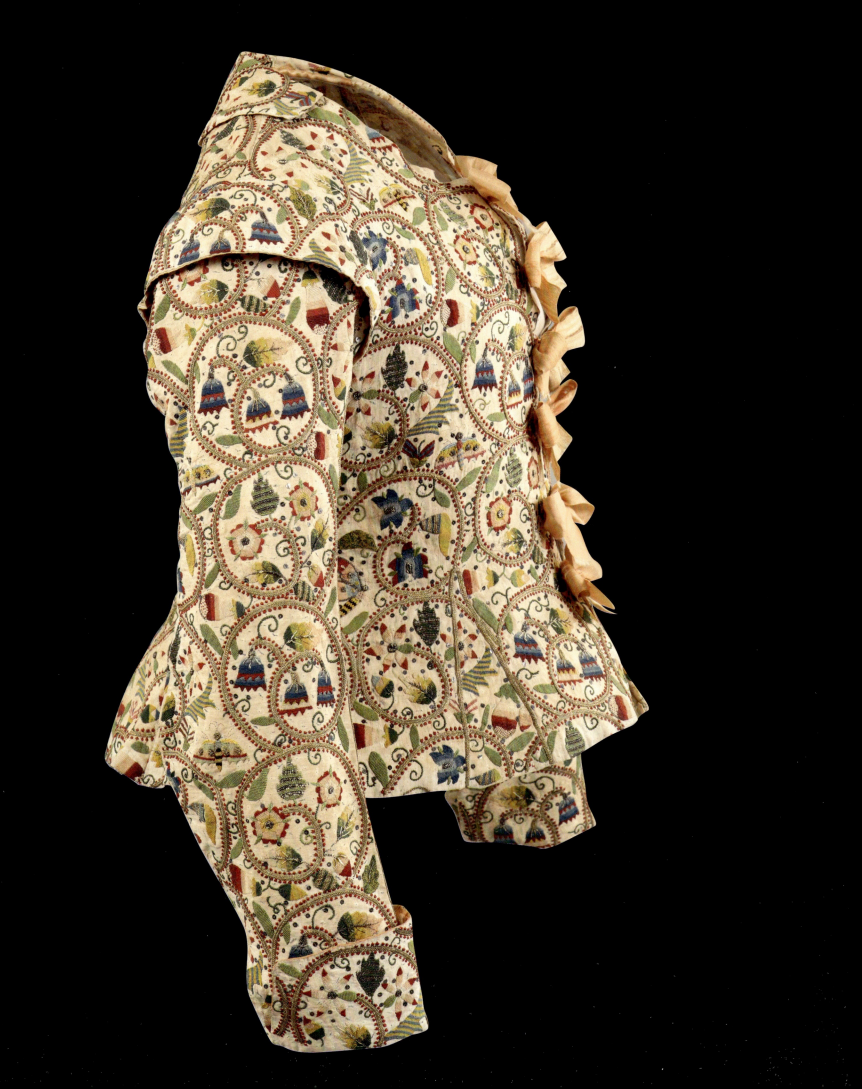

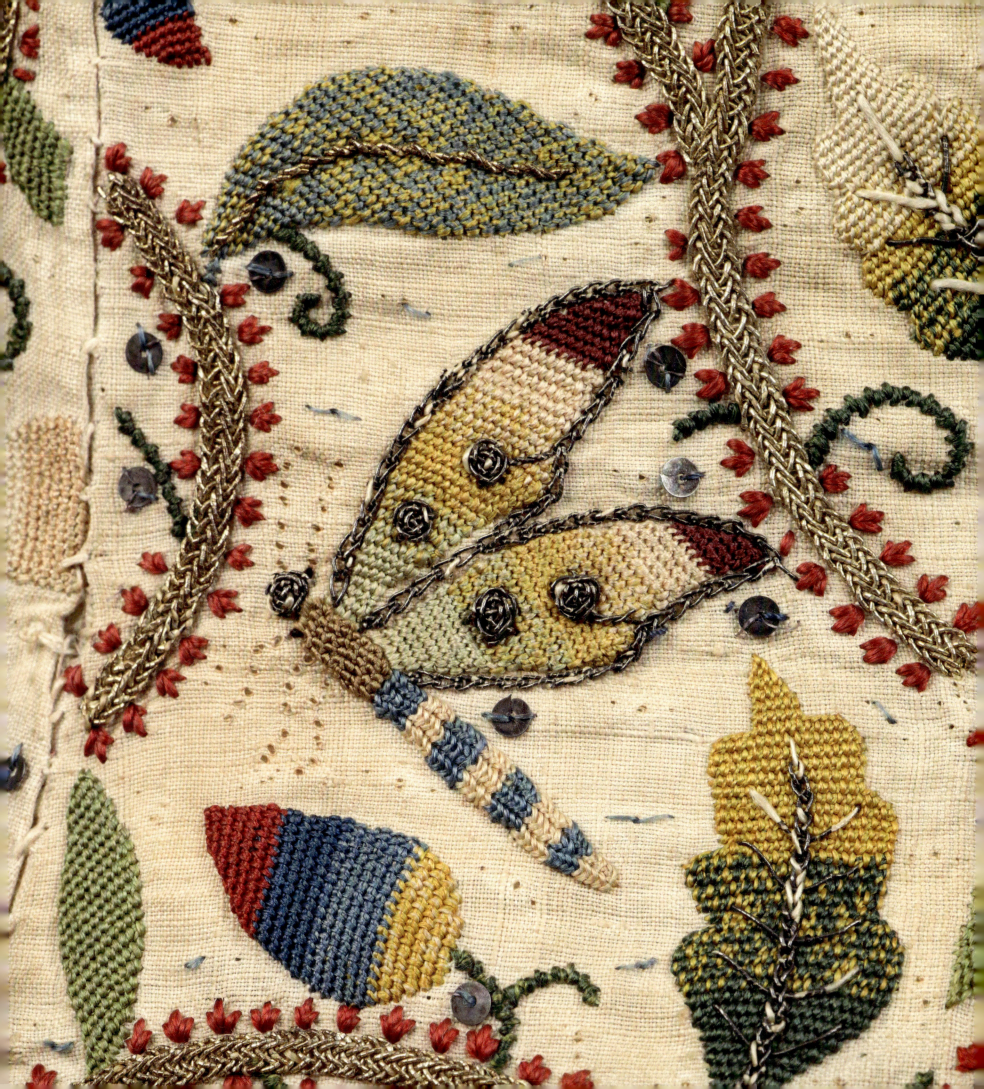

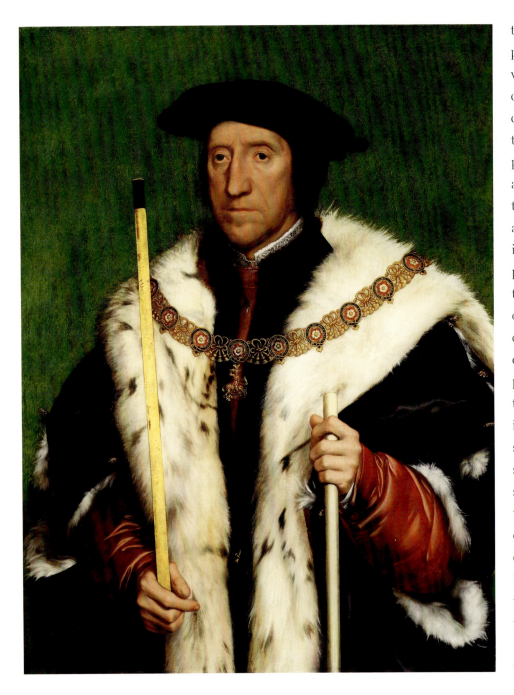

ABOVE AND OPPOSITE (DETAIL)
Fig. 153 Hans Holbein the Younger (1497/8–1543), *Thomas Howard, 3rd Duke of Norfolk*, c.1539.
Oil on panel, 80.1 × 61.4 cm. RCIN 404439

the surviving waistcoat fastens down the front with ribbons, the painted version gives no indication of a method of fastening and would probably have been pinned together. Embroidery on waistcoats of this type was completed before the pieces of fabric were cut out and sewn together, so needed to be carefully planned from the first stitch. The portrait indicates that the embroidery on the pieces used to make up each sleeve was designed deliberately to align as far as possible across the straight seam running down the inside of the arm. In practice this was very difficult to achieve and required considerable skill. The artist has depicted the curving lines of gold embroidery using tiny diagonal strokes of yellow paint to indicate the light catching on individual stitches. Although the painted waistcoat gives the appearance of applied gold braid, on surviving garments this type of pattern is most frequently created through a complicated double-plait stitch, all with a needle threaded with silver-gilt filé. Even in this apparently precisely painted depiction the artist has still simplified the appearance of the stitch, although from a distance it is effective at suggesting its appearance. The narrower tributary branches appear as a single line and were perhaps chain-stitched. The artist has clearly shown how this gold embroidery was used to conceal the straight seam line of the sleeves along the inside of the arm, and to outline the edge of the fabric around the scalloped bottom edge. This effect is also seen in the surviving garment – to cover the seams of the shaping gores inserted into the bottom edge, for example. Each motif is usually outlined in backstitch, then filled with buttonhole stitches in shading colours which sit above the surface of the fabric.

As we have seen in chapters 2 and 3, another distinctive type of embroidery popular at the court of Henry VIII, and which remained fashionable during the Elizabethan period, was blackwork. It is also known as *Holbein stitch* due to the frequency with which it appears in his work – the portrait of Thomas Howard, 3rd Duke of Norfolk, is a good example (fig. 153). This type of embroidery was most frequently executed in black silk threads on linen shirts and smocks, although examples in other single colours also exist. It is usually depicted as a single continuous black line without individual stitches delineated. This accurately reflects the double backstitch used, which required the embroiderer to go over the design a second time to fill the spaces between the stitches. This resulted in a neat and reversible version of the same design on both sides of the fabric, useful in areas like collars and cuffs where the back of the fabric is on display and not hidden against the skin or hidden by lining fabric.

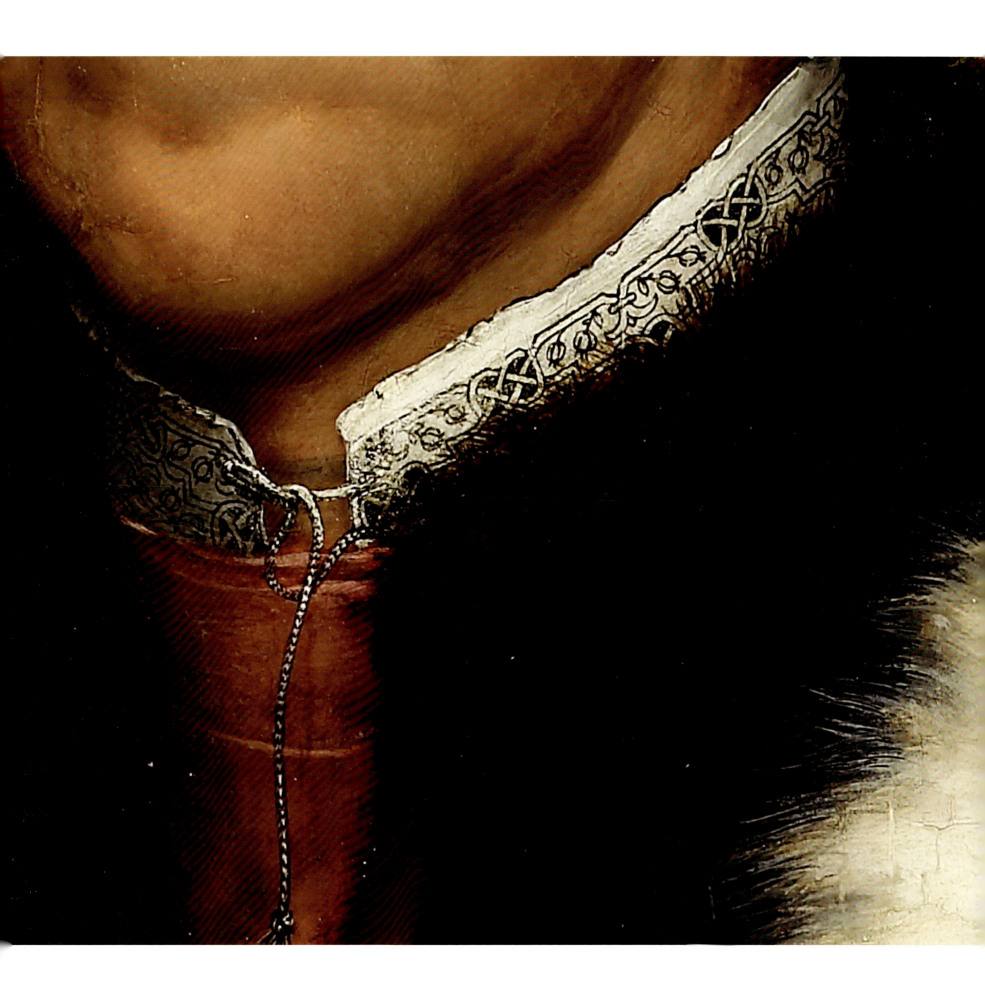

PAINTING DRESS 169

LEFT AND FAR LEFT (DETAIL)
Fig. 154 Marcus Gheeraerts the Younger (c.1561–1635), *Portrait of an Unknown Woman*, c.1590–1600.
Oil on canvas, 216.2 x 135.5 cm.
RCIN 406024

OPPOSITE
Fig. 155 After Anthonis Mor van Dashorst (c.1518–76), *Philip II, King of Spain*, 1558.
Oil on panel, 98.2 x 66.5 cm.
RCIN 406044

While metal or silk threads could form the embroidered decoration itself, they were also used to attach other objects to fabric, including *spangles* (an early form of sequins, also described as *oes*). Frequently oval in shape, they were cut from sheets of silver or silver-gilt, and often punched with an off-centre hole so that when sewn onto the garment the spangles would stand at different angles and catch the light to create a flickering display. The unknown woman in Marcus Gheeraerts the Younger's portrait of c.1590–1600 (fig. 154) wears a finely woven silk veil wrapped around her body, decorated with spangles. These are visible covering the surface of the dress and are particularly obvious when standing away from the embroidered mantle beneath. The artist has indicated the reflective nature of the metal through touches of white paint at different points on each spangle to indicate that they stand at different angles. Spangles also cover the yellow dress of Lady Bowes, painted in 1630 (see fig. 36) – they are depicted in a similar manner, some grey and some white, to demonstrate how their light-reflecting properties vary depending on their angle. Two different styles of spangles can be seen on the nightcap in the Museum of London (see fig. 110). A small circular type is sewn directly onto the linen ground, while a larger teardrop-shaped type is incorporated into the bobbin lace edging the turned-up brim.

Another way to provide a decorative surface effect was to cut into the fabric itself. Known as *pinking* if the cuts were up to around 6 mm long, and *slashing* if longer, this was a popular technique throughout the second half of the sixteenth century. Fabric to be cut was often first brushed with a layer of animal size to prevent fraying, although the edge of each slit could be reinforced with embroidery, and tightly woven fabrics would not necessarily require any extra support.[38] In portraiture, pinking and slashing most frequently appear on garments constructed from silk, although surviving garments and accessories show that it was a practical technique to add flexibility to leather in areas requiring some degree of stretch.[39] Slashing was often used to decorate an area of plain fabric in between bands of braid, as is clearly portrayed in a portrait of Phillip II after Mor (fig. 155). The Spanish king wears a white silk doublet beneath a black short-sleeved jerkin. Both garments are decorated with vertically applied bands of silver-thread embroidery with the same woven design. Diagonal slashes in the white silk cause it to twist in a manner characteristic of fine silk, revealing another white layer beneath, perhaps the linen of the shirt, but more likely a silk lining. The thicker structure of the black fabric, perhaps velvet, is suggested by the more regular nature of the slashes on the jerkin.

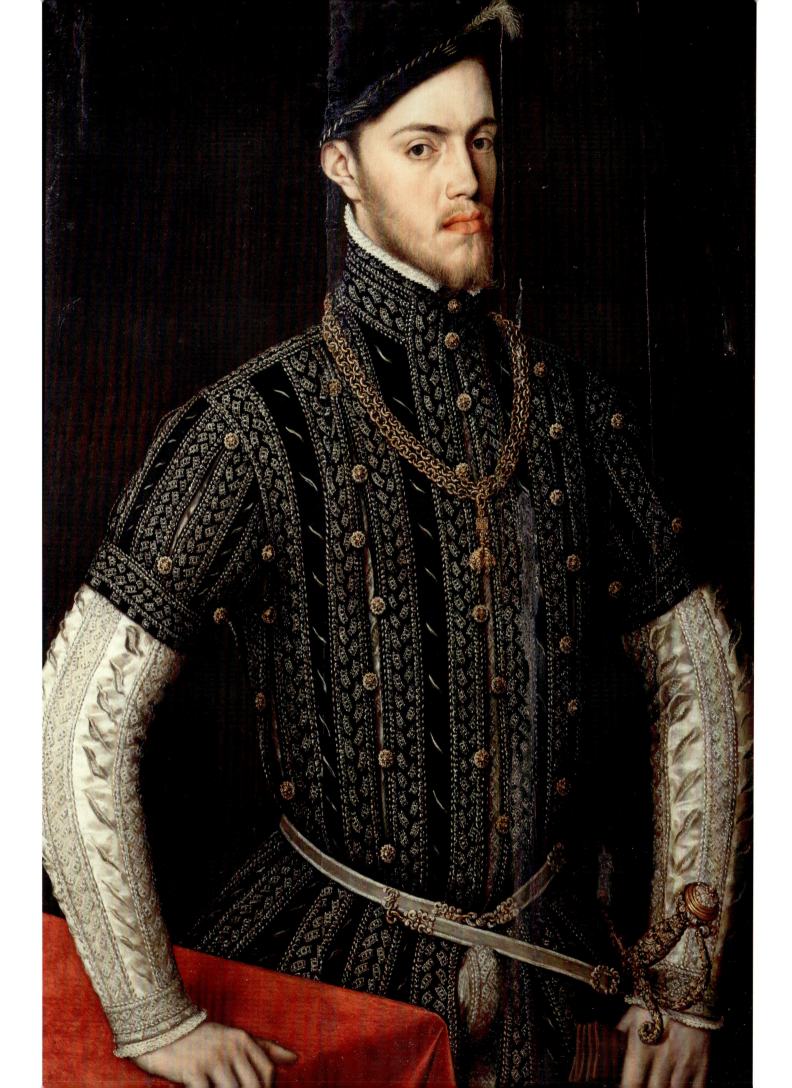

171

The white silk fabric of the doublet shows beneath the jerkin through the long vertical slits in the chest. It is just possible to discern that the slashing on the white doublet continues across the body and is not just limited to the sleeves.

By the early seventeenth century in England, slashing was considered a rather outmoded decorative technique. But a sumptuary edict in France of 1625, which prohibited the use of braid or embroidery, encouraged the resurrection of slashing as a way to enliven plain fabrics – the fashion may have returned to England through the arrival of Henrietta Maria. Chapter 2 describes how the appearance of small wavy cuts across the surface of the fabric worn in a *c*.1632 portrait of the queen by van Dyck (fig. 38) is also seen in a surviving bodice of a similar date. For men, slashing was replaced by long slits in the sleeves and chest of doublets, serving the same purpose of showing expensive layers beneath.

TIMELESSNESS

While perceptive portraits can reveal much about a sitter's personality, it is fair to say that portraits of elite men and women of the sixteenth and seventeenth centuries are typically characterised by a self-composed stillness of pose with the sitter's face displaying limited emotion. Facial expressions are often solemn – beaming smiles, grimaces and mouths in activity (speaking or eating) are instead reserved for figures in genre scenes of everyday life and for depictions of people further down the social scale. In so doing, portraitists are attempting to achieve a sense of timelessness that will outlast a lifetime.

This sense of timelessness has analogies in clothing. At certain points during the seventeenth century the most popular artists were those who depicted their subjects wearing clothing designed to outlast the whims of fashion. This is in direct contrast to other portraits when the specifics of the clothing associated with a particular event (a wedding or masque for example) might be the reason for a portrait being commissioned. The difficulties associated with a portrait going 'out of date' were recognised by contemporaries – as social commentator Joseph Addison summarised in 1712, 'Great Masters in Painting never care for drawing People in the Fashion; as very well knowing that the Head-dress or Periwig that now prevails and gives a Grace to their Portraiture at present, will make a very off figure and perhaps look monstrous in the Eyes of Posterity'.[40] It is easy to imagine the fashionable courtier flinching at themselves in the 'monstrous' fashions of earlier years as many of us do today.

From about 1630 in England it became increasingly fashionable for women to be depicted in a style of dress that differed from fashionable clothing. Firstly van Dyck and subsequently Peter Lely were the leading proponents of the style. Although the two artists took different approaches in their attitude to depicting female attire, each played the role of a stylist, modifying the dress of the sitter for its portrayal in paint.

While later commentators wrote that van Dyck was 'the first Painter that e're put Ladies dresse into a careless Romance',[41] the effect was not a conscious attempt by the artist to place the sitter outside their epoch and thus achieve 'timelessness'. Instead it was a means by which the costume would best fit into van Dyck's preferred aesthetic during this period – one that emphasised simplicity, informality and elegance over fussiness and detail. By removing certain

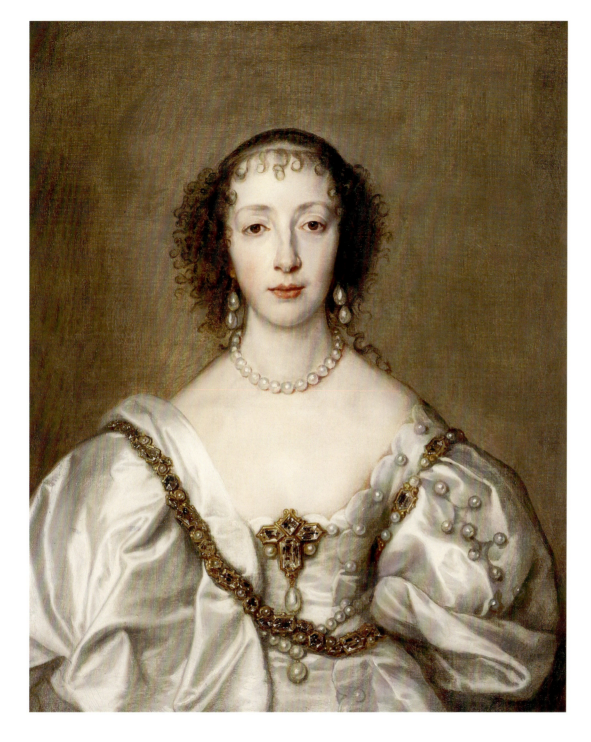

LEFT
Fig. 156 Sir Anthony van Dyck (1599–1641), *Queen Henrietta Maria*, 1638.
Oil on canvas, 78.8 x 66.1 cm. RCIN 400158

BELOW
Fig. 157 Sir Anthony van Dyck (1599–1641), *Queen Henrietta Maria*, c.1632.
Oil on canvas, 109.0 x 86.2 cm. RCIN 404430

elements of fashionable clothing such as lace collars and cuffs, and deliberately choosing plainer silks, van Dyck softened and simplified the dress of his sitters, focusing on colour and balance to achieve an overall effect of harmony rather than recording every detail of fashionable dress and accessories.[42]

The effect is more commonly seen in his later work – the portrait of Henrietta Maria in 1638 is a characteristic example (fig. 156). While the sitter's dress does bear some resemblance to the fashionable bodice in fig. 39, particularly in the neckline and the shaping, in day-to-day life this garment would always have been worn with a falling collar of lace that here is notably absent.

PAINTING DRESS 173

OPPOSITE AND ABOVE (DETAIL)
Fig. 158 Sir Peter Lely (1618–80),
Elizabeth Hamilton, Countess of Gramont, c.1663.
Oil on canvas, 124.5 × 101.2 cm.
RCIN 404960

Van Dyck also added jewels in places where they were not worn, for example as fastenings on sleeves and around the shoulder seam. He leaves off fashionable accessories such as fans and muffs in favour of softly fluttering scarves, often arranged asymmetrically across the body – in this portrait, a voluminous scarf in the same fabric as the bodice apparently covers the sitter's right sleeve. The painting is very different to his c.1632 portrait of the queen (see fig. 38). This version is much more accurate in its depiction of the lace collar and spiky cuffs, the embroidery on the bodice, the pinking on the silk and the ribbon details. As a result of this simplification process, van Dyck's later paintings can give the erroneous impression that fashions in England became dramatically simpler during the 1630s. Portraits by other less successful artists suggest that this was not the case.

While van Dyck focused on imaginative accessorising, Lely took a different approach. The clothes worn by women in his portraits show a greater departure from fashionable styles during the 1650s and 1660s. His sitters wear increasingly unstructured lengths of plain silk fabric over their white linen shift. The portrait of Elizabeth Hamilton, Countess of Gramont, is a beautiful example (fig. 158). Here the silk gives an initial impression of outer layers of clothing, but it is actually a piece of silk fastened at the shoulder. To have been wearing the shift alone would have been one step too far in terms of modesty, and yet the low neckline and use of clinging fabric reveals the natural curves of the sitter's breasts and legs far more than fashionable styles allowed. Moreover, the slippery silk and its scarf of gold brocade are apparently captured in an instant of precarious balance aided by the sitter's hand – at any moment the fabric might slide off the shoulder to reveal more than intended. The flexibility of drapery made it a flattering mode. It can conceal those parts of a figure considered less attractive and highlight a sitter's assets, unlike fashionable dress which tends to flatter particular body shapes more than others at any point in time. The other advantage of drapery which contributes to its timeless appeal is that it encourages the eye to fill in the figure beneath with the viewer's own vision of perfection, even as society's vision of perfection (in terms of the ideal figure) changes over time.

It is tempting to suggest that the garments in portraits by Lely are simply lengths of silk fabric that the artist was known to keep in his studio.[43] However, while the artist does not provide any visual information about how the clothes have been constructed, they are rarely completely untailored. In some, the fabric is cut to resemble a woman's nightgown, a fashionable garment that could be worn without stays inside the home, for informal occasions (see fig. 43).

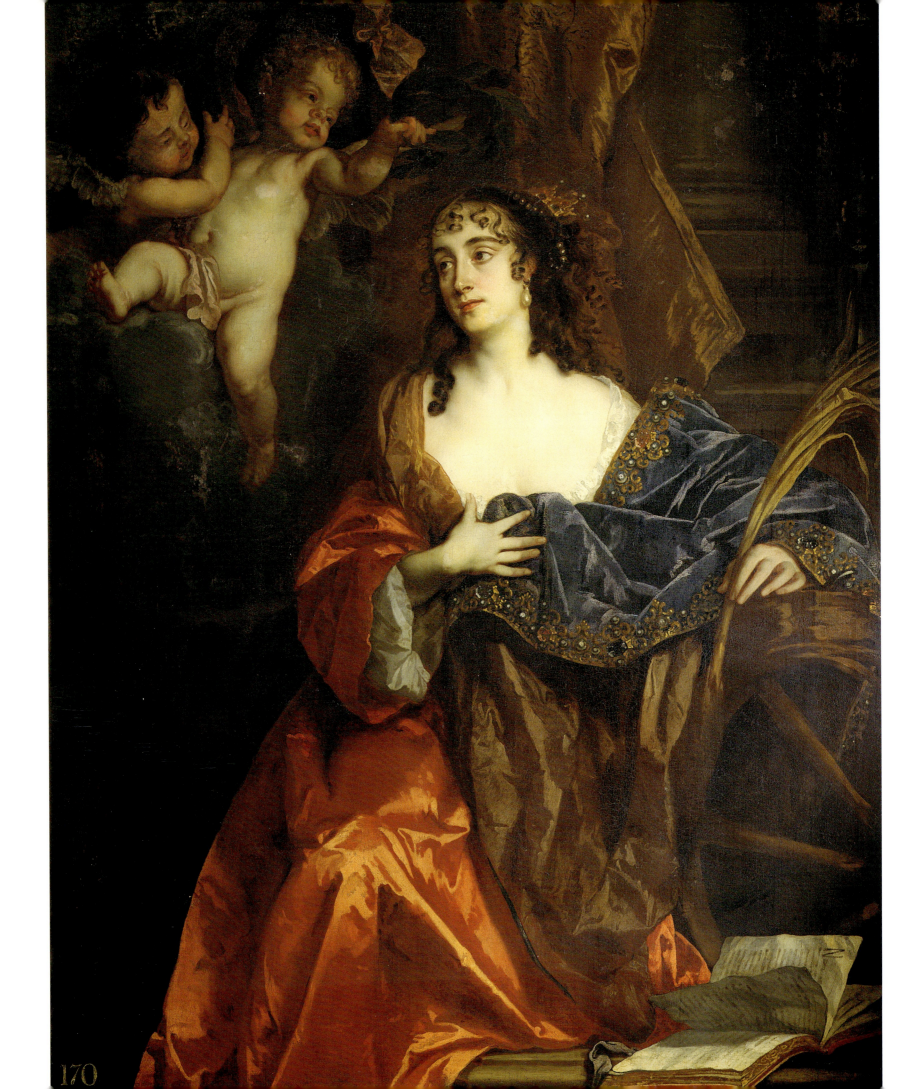

Draped fabric arranged along fashionable lines was also suitable for women adopting the guise of a religious or historical figure – for example, Eleanor Needham, Lady Byron, appears as St Catherine of Alexandria (fig. 159). This was a popular guise for female courtiers during the 1660s as it was intended as flattery towards Queen Catherine of Braganza, who was born on Catherine's feast day and was herself painted by Jacob Huysmans as St Catherine in 1664 (RCIN 405880). Accordingly, Lady Byron is depicted with the martyr's palm, leaning against the wheel upon which the St Catherine was tortured. In her hair she wears a coronet depicting the saint's aristocratic lineage, while her clothing is in Lely's characteristic style of this date. Shimmering orange silk with voluminous sleeves reveals the smock beneath, accessorised with two different pieces of fabric – a brown silk scarf is arranged around the neckline, while thrown over one shoulder is a blue velvet mantle, lined with silk and bordered with embroidery and jewels. Given that this portrait was probably painted to commemorate the sitter's marriage in 1663, the guise of St Catherine, spiritually married to Christ, is an appropriate one.

Godfrey Kneller followed the convention for depicting women *déshabille* in the last decade of the seventeenth century. The constantly changing and often highly patterned modes of high fashion during the late seventeenth century are not shown in his series of eight paintings known as the 'Hampton Court Beauties'. During Lely's time, to be painted in such a form of luxurious negligence would have been seen as a provocative statement – by the end of the century it was so common that it was adopted by Mary II when Princess of Orange in her portrait by Wissing (fig. 160) and in the hands of the artist, the Princess's ceremonial robes have been given the same 'timeless' treatment and very low neckline.

OPPOSITE
Fig. 159 Sir Peter Lely (1618–80), *Eleanor Needham, Lady Byron*, 1664?
Oil on canvas, 159.4 × 127.9 cm. RCIN 404089 (pre-conservation).

ABOVE
Fig. 160 Willem Wissing (1656–87), *Mary II when Princess of Orange*, c.1686–7.
Oil on canvas, 125.8 × 102.3 cm. RCIN 405643

DRAPERY ARTISTS

While the use of studio assistants within a workshop environment was an established practice used by many artists, and a valuable means of training apprentices, a new development was the rise of the drapery painter. These were studio assistants who specialised in painting the clothing and accessories in a portrait. They had been employed on the continent during the sixteenth century – Sánchez Coello, for example, had occasionally worked as a drapery painter for Sofonisba Anguissola during his early years at the Spanish court in the 1560s.[44] The use of drapery painters in England, however, appears to have been a new development during the seventeenth century. The master artist would paint the head and an approximation of the clothed figure, which would then be completed by the drapery artist either based

PAINTING DRESS 177

on pre-existing studies or in front of the sitter's clothes, arranged in the studio for this purpose. Everhard Jabach, a Parisian art dealer who sat to van Dyck on three occasions, describes how the artist:

> drew the figure and clothes with a great flourish and exquisite taste for about a quarter of an hour. He then gave these drawings to his skilful assistants for them to paint the sitter in the clothes which had been sent at the special request of van Dyck. His pupils, having done all they could from the life with the drapery he [van Dyck] passed his brush lightly and quickly over what they had done.[45]

Van Dyck probably enlivened the work of the drapery artist by adding flickering lights and areas of shadow.[46]

Lely continued the use of drapery painters, partly as a means of achieving the prolific output that patrons demanded from his busy studio, and developed a strong working partnership with John Baptist Gaspars (1620?–91). Some patrons, however, insisted on their portrait being completed in full by the master himself. The use of drapery painters continued throughout the eighteenth century although certain artists (William Hogarth for example) preferred to retain complete control of their output. The existence of drapery painters could suggest that painting drapery was thought to require less skill and so did not need direct involvement from the master artist. Another interpretation would be that drapery was considered important enough to justify a separate artist who specialised in that one particular style of painting. Evidence for this second view is provided by the fact that several of the assistants entrusted with the task were talented people who would go on to become important artists in their own right.[47] The importance of clothing is also emphasised by the fact that, in workshop versions of portraits, sometimes the clothing is treated with more care than the face.[48] For an important commission, however, it was considered vital for the master artist to complete at least the face, while the background, drapery and even hands were considered appropriate tasks for delegation.

Anne Digby, Countess of Sunderland is the portrait from the 'Windsor Beauties' series by Lely believed to have had the least involvement from the master himself (fig. 162). It is apparently a second version of a higher quality version at Althorp. While the face is certainly less flattering than the others in the series, it is the rather mechanical passages of painting in the fabric that particularly mark this out as largely the work of a less competent drapery artist. In Lely's earlier works, believed to have had less workshop involvement, the draperies are built up in a more idiosyncratic sequence of thick and textured layers, whereas his later paintings show a thinner and more systematic sequence of layers, with folds produced by calligraphic brushstrokes which would have been

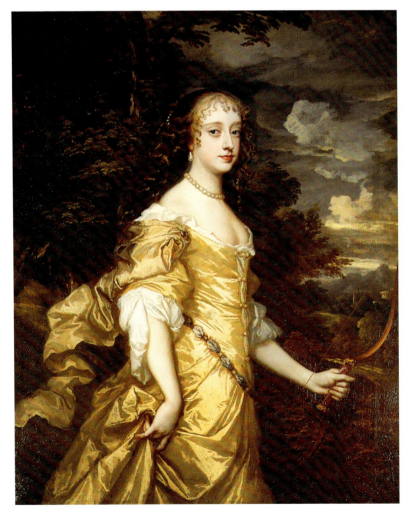

Fig. 161 Sir Peter Lely (1618–80), *Frances Stuart, later Duchess of Richmond*, c.1662.
Oil on canvas, 125.8 x 102.7 cm. RCIN 404514

In addition to being painted wearing a riding habit and buff coat (see figs 222 and 244), Frances Stuart was also depicted in a more conventional manner for a beautiful woman at court. This image, which forms one of the 'Windsor Beauties' series, shows the sitter wearing clothing which, while bearing some resemblance to fashionable garments (particularly in terms of the waistline) has been loosened as in many of the artist's portraits.

LEFT AND BELOW (DETAIL)
Fig. 162 Studio of Sir Peter Lely (1618–80),
Anne Digby, Countess of Sunderland, before 1666.
Oil on canvas, 124.9 x 101.8 cm. RCIN 404515

quicker to produce and easier for assistants to replicate.[49] Paintings by van Dyck show this same dichotomy – those believed to have had the involvement of studio assistants show a more economical treatment of the draperies. In these works the base colour of the fabric is created through a mixture of different pigments, and it is the slight change in the proportions of each of these pigments that creates the effect of folds and modelling. By contrast, in van Dyck's portraits with less studio involvement the drapery is built up using more subtle and complex paint layers, including glazes.[50] In addition, the simplification of clothing that van Dyck embraced during the 1630s, a convention which was extended by Lely in the 1660s, made the costume of their sitters quicker to complete and easier for drapery artists or copyists to replicate.

As we move into the later seventeenth century it is no surprise that drapery painters are most frequently associated with painting just that – drapery, rather than fashionable clothing, and it coincides with the phenomenon of women being painted in loose fabrics. For those artists (such as John Michael Wright) who continued to paint their sitters wearing more complex patterned fabrics with a closer approximation to fashionable styles, the use of drapery painters appears to have been less of a common practice. Their artistic output was less prolific, but more individual, as a result.

PAINTING DRESS

BELOW

Fig. 164 (detail) Sir Peter Lely (1618–80), *Barbara Palmer (née Villiers), Duchess of Cleveland with her son, Charles Fitzroy, as Madonna and Child*, c.1664.
Oil on canvas, 124.7 x 102.0 cm. London, National Portrait Gallery. NPG 6725

BOTTOM LEFT

Fig. 165 (detail) Sir Peter Lely (1618–80), *Mary II when a Princess*, c.1672.
Oil on canvas, 123.2 x 98.3 cm. RCIN 404918

BELOW RIGHT

Fig. 163 (detail) Sir Peter Lely (1618–80), *Elizabeth Wriothesley, Countess of Northumberland*, c.1666.
Oil on canvas, 144.3 x 121.8 cm. RCIN 404962

BORROWING CLOTHES

Even for the quickest of painters a portrait in oil took a long time to complete, due to the number of sittings required to execute the painting and also to allow the various different layers of paint to dry in between. Given that clothing covered such a large proportion of the canvas, it was one of the most time-consuming parts of the painting. Some sitters had busy schedules – others, such as James I, simply found the process of sitting for a portrait tedious. As a result, various studio practices were developed which enabled sitters to sit to an artist for the minimal length of time, when the artist would focus on capturing the essence of a sitter's facial likeness and character. A time-saving strategy would be for the sitter's clothes, armour or jewellery to be sent to the artist's studio after the initial session in person. These would then be worn by someone in place of the sitter, allowing the rest of the portrait to be painted at leisure by the artist. It has been conjectured that Elizabeth I, who was not fond of sitting for portraits, used

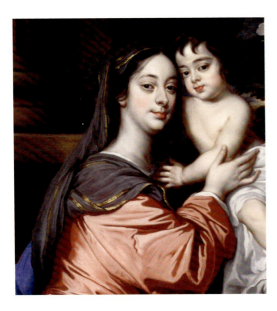

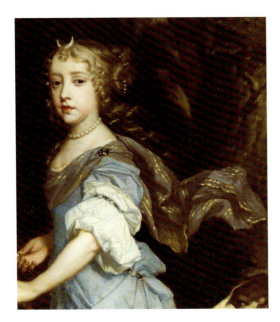

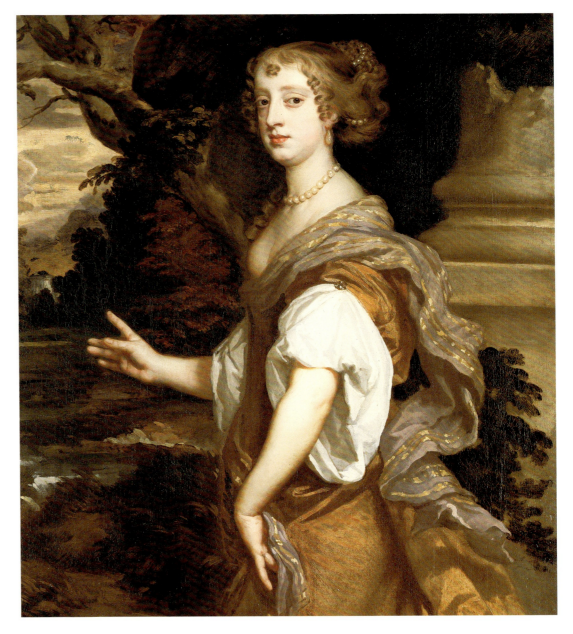

this process – a Hilliard drawing in the V&A, for example, appears to show a lady-in-waiting wearing the queen's clothes, jewellery and collar of state.[51]

Given the way that fabrics move with the movement of the wearer, and the subsequent difficulty in recreating a particular pattern of folds in fabric from one sitting to the next, some artists began to drape clothing or a piece of fabric over a manikin so that it would remain undisturbed. Gerard ter Borch, when living in London in 1635, received a manikin from his artist father, who instructed his son to 'Use the manikin and do not let it stand idle, as it has done here, but draw a lot: large, dynamic compositions'.[52] It seems likely that artists made studies of textiles draped onto a manikin and that these were then worked up into a final painting. This could result in the same arrangement of fabric appearing in more than one painting. Van Dyck appears to have speeded up the portrait-painting process by using the same drawings or pattern types for the arrangement of the drapery for different sitters. The drapery in his portraits of Lady Clanbrassil (Frick, New York), Lady Buckhurst (Knole) and Lady Isabella Rich (private collection) is almost identical.[53]

Surprisingly few accounts of the process of sitting for a portrait and choosing the clothing exist. One rare piece of documentary evidence is provided by Pepys, who reveals that he hired the Indian gown of brown figured silk in which he was depicted by John Hayls (National Portrait Gallery, London), despite owning several himself.[54] Some artists presumably played more of a role in selecting a sitter's clothing than others, and it seems fair to assume that as an artist became more successful he may have been able to exert more influence on the choice of clothes. Titian, for example, decided what colour clothes the Duchess of Urbino should wear for her portrait.[55] Another clue is provided by inventories of artists' studio contents, revealing that many artists kept costumes or lengths of fabric in their studio – this could have been for the purposes of adorning their sitters, or for studying the fall of drapery, which could perhaps be worked up into a final painting. The inventory of Vermeer's household goods drawn up after his death records that he owned a 'yellow satin mantle with white fur trimming', which is probably the one depicted in several of his paintings such as *Girl with a Pearl Necklace* (Gemäldegalerie, Berlin).[56] Casper Netscher and Rembrandt had significant collections of fabric in their studios, as did Peter Lely.[57] The suggestion that Lely used these lengths of fabric to adorn his sitters is upheld by the reappearance of the same fabric in portraits of different sitters. One scarf of taupe-coloured silk with a gold stripe running through it is particularly distinctive, and is used in portraits of the Countess of Northumberland (fig. 163), the Duchess of Cleveland (fig. 164) and Mary II when a Princess (fig. 165). amongst others. Lely has apparently played the role of stylist, using this flexible accessory as a loose fluttering scarf, a silk collar fastened at the neckline and the veil-like headdress of the 'Madonna'. Is it perhaps the piece of fabric described as 'Isabella [greyish-yellow, light buff] Cloth of Gold' in the Executor's Account Book of his studio contents compiled after his death?[58]

Regardless of who had the final say about how their clothing was depicted, a sitter would nevertheless have played a major role in the creation of their outfit in the first place. Few garments during this period were bought ready-made, and the process of producing clothing and jewellery was often the work of a variety of craftsmen with choices dictated by the final

recipient. Fabric was purchased from a draper or mercer, given to the tailor to be made into a garment based on individual measurements, then passed to an embroiderer or furrier for embellishments or trims. Henry VIII personally selected cloth for his clothing from Italian merchants.[59] Elizabeth I was shown embroidery samples from which she could make a choice.[60] Pepys determines what modifications are to be made to his clothing in conjunction with his tailor. The wearer would also need to decide how the multiple interchangeable elements of dress (such as sleeves) might be combined each day. While the artist may have played the role of stylist, to some extent the wearer acted as their own couturier.

PORTRAIT DRAWINGS

Another technique to record the various fabrics, colours and textures of a sitter's clothing was for an artist to make notes on a sketch during an initial sitting. This strategy was adopted by Holbein, many of whose exquisite drawings are dotted with hasty jottings and are evidently working documents intended to be worked up into final portraits in oil. As seen in chapter 1, his portrait of William Parr, later Marquess of Northampton, has extensive notes (fig. 166). It includes the comments *wis felbet* (white velvet) on the front of the doublet, *burpor felbet* (purple velvet) on the upper sleeve of the gown and *wis satin* (white satin) on the lower sleeve. In addition the letter 'w' for *weiss* (white) has been included five times to label the jewellery sketch, while *Gl* (gold) is included twice. The number of comments suggests that an oil painting in colour was planned, although it is not known whether it was ever executed. The medallion hanging from the chain around the Marquess's neck is left blank, as is the hat badge.[61] Presumably one was intended to be filled with the enlarged design in the top left of the drawing which shows a figure in classical armour with a sword (perhaps St George and the Dragon), and was perhaps made after the sitting was over under close observation of the original. Holbein also sketches links of a chain and possibly buttons or aglets. One of these has the inscription *MORS* (death), which was presumably part of the sitter's personal motto.

Some of van Dyck's sketches are annotated in a similar manner. His sketch of Sir Robert Shirley (British Museum) includes the comments *drapo doro* (gold cloth) and *le figure et gli fogliagi de colori differenti de veluto* (the figures and foliage in different colours to the brocade). Van Dyck also annotated the colours of fabrics and draperies in sketches he made of other paintings by other artists, including Titian, during his time in Italy.[62] Rubens produced a costume study of Robin, a dwarf in the Earl of Arundel's household (Nationalmuseum, Stockholm), in which the clothing is labelled with multiple annotations about the colours and fabric, including that the doublet can be red satin while the breeches can be of red or tawny velvet.'[63]

Several of Holbein's drawings show his sitters wearing informal dress that may not have been considered appropriate for the more permanent medium of oil paint – indeed, sometimes an associated portrait in oil shows the sitter more formally dressed.[64] This discrepancy suggests the artist had access to the costume after the initial sitting, which may have been worn by a courtier standing in for the sitter or mounted as described above. Artists sometimes also produced drawings of fabric, or details of a pattern, which could then be worked into a finished painting under less time pressure. To one side of his drawing of Lady Ratcliffe

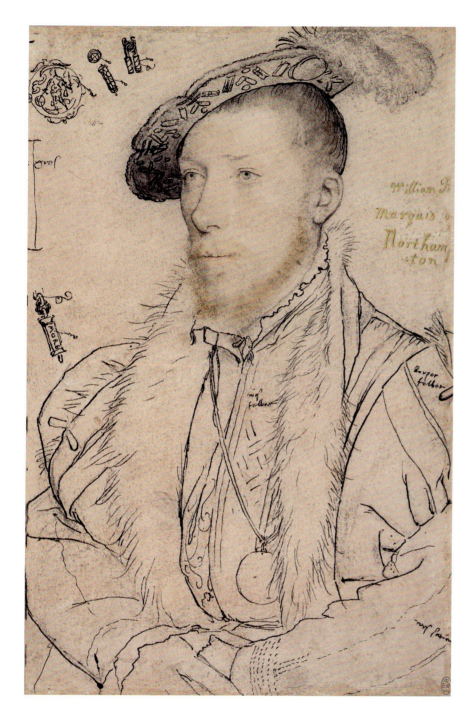

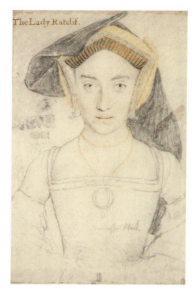

(fig. 167), Holbein included a detail of an embroidery design, which probably refers to blackwork decorating the sitter's smock at the neckline or at the cuffs. The artist has captured just enough information (a full pattern repeat of the design) for it to be worked up in a more complete form. Just above this sequence Holbein includes another detail, probably referring to the criss-crossing pattern of the yellow fabric making up the sitter's hood, with some kind of jewel represented at each intersection point. A very faint indication of this pattern can be seen on the fabric, and a clearer idea of the final result can be gauged from his 1536–7 portrait of Jane Seymour (Kunsthistorisches Museum, Vienna), where she wears a near identical hood with a similarly decorated fabric.

ABOVE LEFT

Fig. 166 Hans Holbein the Younger (1497/8–1543), *William Parr, later Marquess of Northampton*, c.1538–42.

Black and coloured chalks, white bodycolour, pen and ink, and brush and ink on pale pink prepared paper, 31.7 x 21.2 cm. RCIN 912231

TOP RIGHT AND ABOVE (DETAIL)

Fig. 167 Hans Holbein the Younger (1497/8–1543), *Lady Ratcliffe*, c.1532–43.

Black and coloured chalks, pen and ink, brush and ink, and metalpoint on pale pink prepared paper, 30.1 x 20.3 cm. RCIN 912236

PAINTING DRESS 183

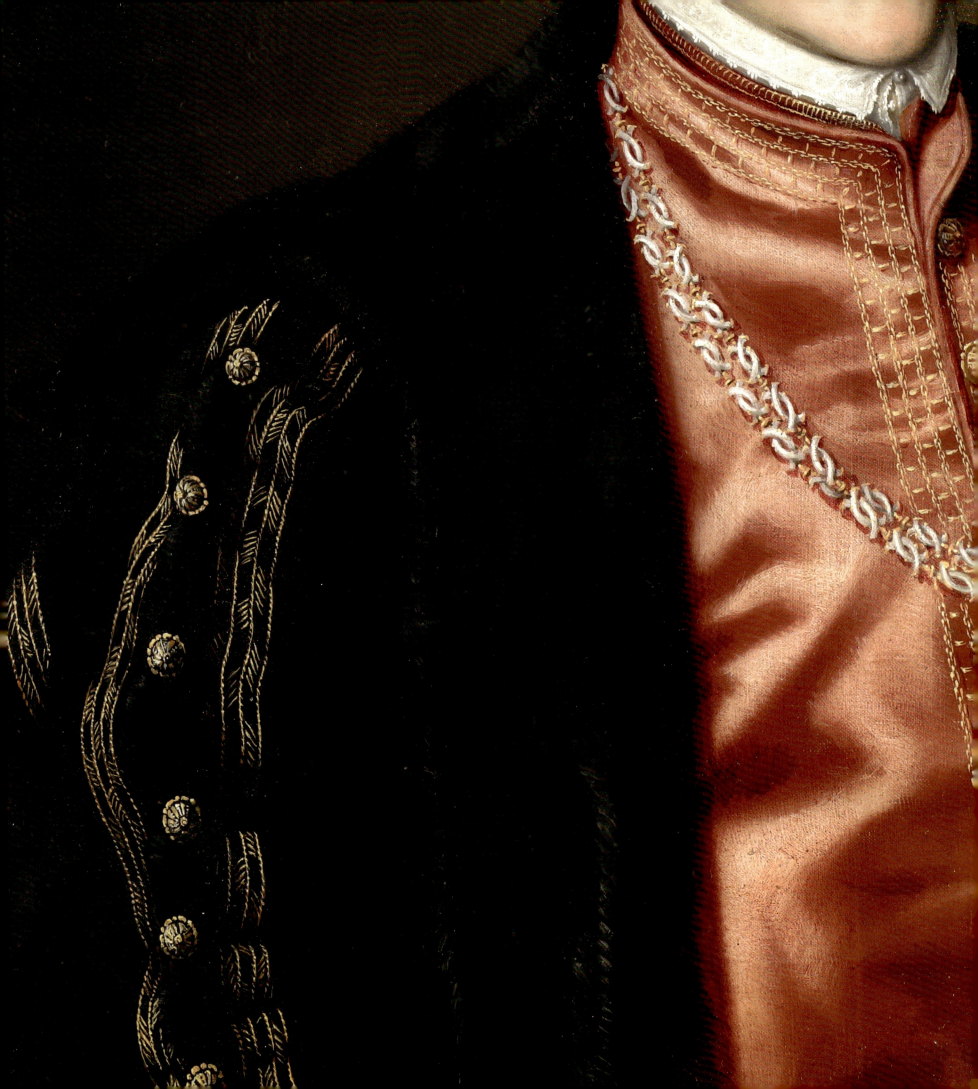

6

FASHION ACROSS THE BORDERS

I am an English man, and naked I stand here
Musing in my mind what raiment I shall wear
For now I will wear this, and now I will wear that
Now I will wear I cannot tell what
All new fashions be pleasant to me;
I will have them, whether I thrive or thee

Andrew Boorde, *The Fyrst Boke of the Introduction of Knowledge*, 1547

CLOTHING from European countries drew on many of the same raw materials, and an efficient trade network distributed these from their country of origin throughout the Continent. The finest silks from Italy, and later France, were used throughout Europe, while fine woollens came from England, and high-quality linen from Flanders.[1] The close relationships between the various European courts, and the spread of styles through the mediums of print and portraiture, as well as pattern books, were all ways in which fashions spread from country to country. Despite this sharing of raw materials and ideas about fashionable dress, however, there were also distinct differences. Clothing and fabrics from beyond Europe also became increasingly influential, and were brought into England by travelling courtiers and visiting ambassadors.

FASHION AND ENGLISHNESS

Andrew Boorde's indecisive Englishman, depicted in his 1547 publication *The Fyrst Boke of the Introduction of Knowledge* as a naked figure carrying tailor's shears and a piece of cloth, characterises the popular image of the English approach to fashion throughout the sixteenth century and into the seventeenth (fig. 168). As he stands 'Musing in my mind what raiment I shall wear', his difficulty stems from the fact that 'All new fashions be pleasant to me'.[2] The English were viewed as chameleons, adopting various elements of fashionable clothing from other countries and combining them in a strange manner, often mixing different styles and fabrics simultaneously. So in *The Merchant of Venice*, Portia mocks her suitor, the English baron Falconbridge, 'How oddly he is suited! I think he bought his doublet in Italy, his round hose in France, his bonnet in Germany and his behavior every where'.[3] The English were also satirised for the frequency with which they changed their fashions; other countries, such as Spain, were seen as far more constant in their clothing from year to year. With no equivalent of traditional folk dress of the type seen in other countries on the Continent, it was noted by visitors that even members of the lower social order aspired to fashionable (and thus changeable) clothing.[4]

The adoption of fashions from other countries was frequently criticised in English contemporary literature, where it was seen not as simply an importation of particular fabrics and garments but also contamination by what were considered foreign attitudes and deficiencies. It was thus part of a wider anti-foreign sentiment. So the adoption of French clothing styles in the early seventeenth century in England was also linked to immorality, effeminacy and Catholicism. Jonson's description of the 'French disease' in 'On English Monsieur' was an allusion to both venereal disease and an obsession with fashionable clothing.[5] The adoption of foreign clothing was seen as a deliberate disruption to the notion of 'Englishness', and was considered by many to be a particularly grievous sin when committed by the ruling monarch,

Fig. 168 *Naked man with shears*, reproduction of a woodcut, p.116 in Andrew Boorde (*c.*1490–1549), *The Fyrst Boke of the Introduction of Knowledge*, London: N. Trübner & Co., 1870, first published 1547.
RCIN 1095018

Pp. 184–5 (detail from fig. 180) Workshop of Anthonis Mor van Dashorst (*c.*1518–76), *John, Prince of Portugal*, *c.*1552–4.

an emblem of national identity. That this concern was not unique to England is demonstrated by Baldassare Castiglione, writing in 1516: 'Our exchange of Italian dress for foreign clothing seems to me to symbolize that all those by whose dress we were transformed must come to rule over us'.[6]

ENGLISH STYLE

One element of the clothing industry that was considered particularly English throughout the period was the production of woollen cloth (known as *stuff*, or simply *cloth*). England had been a leading manufacturer and exporter of wool since the Middle Ages. In 1500, two-thirds of English exports were of woollen cloth.[7] During the sixteenth century English cloth was often dyed in Antwerp, then exported back to England, but increasingly weaving and dying were done on English soil.[8]

The association of woollen cloth with England was frequently noted in contemporary pamphlets bemoaning the disregard of such a sensible, patriotic staple in favour of fashionable foreign imports like silk. Because of the importance of wool to the English economy, some monarchs made deliberate attempts to stimulate the domestic market. Elizabeth I established

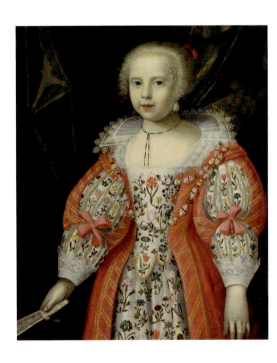

ABOVE AND RIGHT (DETAIL)
Fig. 169 British School, *Portrait of a Young Girl*, c.1630.
Oil on canvas, 65.2 x 53.5 cm. RCIN 401363

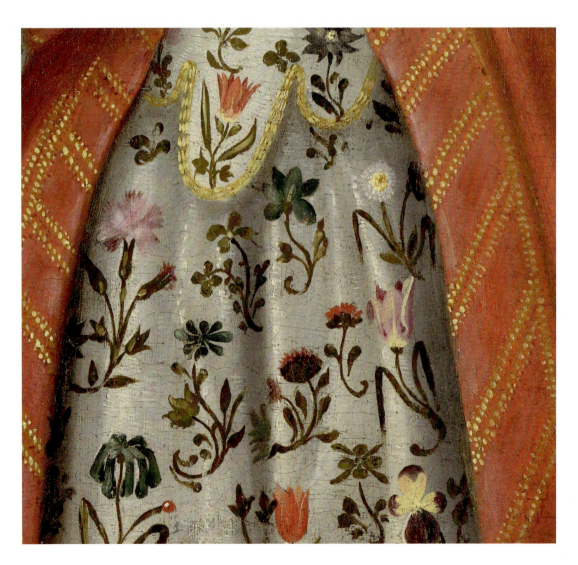

an Act of Parliament in 1571 that required all males over the age of six – except the most wealthy – to wear a wool cap on Sundays. Charles II's deliberate effort to revive the industry by announcing that 'he has resolved henceforth to wear none but English manufactures, except linen and calico'[9] was somewhat undermined by his subsequent actions, although he did introduce an act for 'Burial in Woollen' in 1666, fining anyone found to have buried their relatives in materials other than plain English woollen cloth. In *Charles II Presented with a Pineapple* (see fig. 98) – a rare depiction of the monarch in fashionable clothing rather than ceremonial robes or armour – he is wearing a brown wool coat. With low-set pockets and a peach-coloured silk lining, it is trimmed at the cuffs with black ribbons, matching those on his petticoat breeches. A second figure, possibly representing the royal gardener John Rose, presents the king with the first pineapple grown in England. His coat is cut in a similar style to the king's and is probably also of wool, this time dyed dark blue instead of brown. These dark neutral colours were known as 'sad colours', and were particularly fashionable during the 1670s. They are very appropriate for wool, which does not absorb brightly-coloured dyes as well as silk.

Another fashion very much associated with England was a characteristic type of embroidery inspired by the natural world, with scrolling serpentine stems often in silver-gilt filé thread, encircling accurately depicted flowers and (by the 1590s) insects and birds.[10] This embroidery is a common feature of portraiture during the late Elizabethan and Jacobean period (see fig. 41), and many examples of garments decorated in this manner survive in museum collections (see the waistcoat from the Fashion Museum, Bath, fig. 152). The particular popularity of this form of decoration in England was linked to the English love of gardening and nature, and coincided with changing approaches to cultivation that formed the beginnings of what has been termed a 'gardening revolution'.[11] It was also linked to the broader interest in the symbolism of flowers during the Renaissance – for example, Elizabeth I was characterised as the 'Empresse of Flowers' by John Davies in his poem 'Hymnes of Astraea' (1599), while flower imagery frequently appears in her portraits. In 1600 Queen Elizabeth received from Baroness Burghley 'one wastecote of white sarcenett, embrothered with flowers of silke of sondry colors' as a New Year's Gift.[12]

The Jacobean period saw an increase in the number of garments and accessories decorated in this style of naturalistic embroidery with metal thread – after legislation banning the wearing of garments embroidered with metal threads by anyone under the level of a baron was rescinded in 1604.[13] Accordingly, garments embroidered in this manner become a more common feature of portraiture at around the same time, and start to appear being worn by

Fig. 170 *Hearts-ease, or pansies*, woodcuts with hand-colouring, pp. 854–5 in John Gerard (1545–1612), ed. Thomas Johnson c.1600–44), *The Herball, or, Generall Historie of Plantes*, London: Adam Islip, Joice Norton & Richard Whitakers, 1636, first published 1597.
RCIN 1057110

women of the gentry classes – including the wives of two well-known miniaturists.[14] It was a style that transcended class boundaries. The unknown sitter in *Portrait of a Young Girl* (fig. 169) wears a bodice and skirt embroidered with flowers, many native to England, such as daisies and daffodils. However, the painting is an interesting record of variations in embroidery styles – it does not include scrolling encircling stems, and each flower is represented upright, with a the curl at the base of each indicating that they are slips, cuttings of flowers taken for cultivation. Moreover the majority of the motifs are unique.

Contemporary herbals – botanical encyclopedias containing descriptions, images and recipes – were an important source of inspiration for embroiderers. One of the most popular in England was John Gerard's *The Herball*, first published in 1597 (fig. 170). A botanist, medic and collector of rare plants, the author makes an explicit comparison between gardens and fashion in his introduction: 'what greater delight is there than to behold the earth apparelled with plants, as with a robe of embroidered worke, set with Orient pearles and garnished with great diversitie of rare and costly jewels?'[15] Pattern books translated the detailed illustrations in these herbals into appropriate designs for the embroiderer. Often the flowers chosen for embroidery conveyed specific symbolic messages, particularly on intimate items intended as gifts – unfortunately the meanings are sometimes lost to us. Thus, while the strawberry-embroidered handkerchief given to Desdemona in Shakespeare's *Othello* is open to multiple symbolic interpretations, one trait associated with strawberries in contemporary emblem books was treachery, since poisonous serpents sometimes hide beneath the leaves of its temptingly sweet fruit.[16]

SHARING FASHION

While there were certainly distinctive features associated with the different regions across Europe during the sixteenth and seventeenth centuries, there was also much commonality. The fashion for ruffs, for example, was seen across the entire continent at approximately the same period. Upon arriving in London in 1522, Henry VIII and the visiting Emperor Charles V entered 'not only like brothers of one mind, but in the same attire'.[17] The courts in particular played an important role in spreading new fashions, and styles spread relatively quickly, even to the more peripheral courts like Sweden and Poland. As a result, the origins of particular fashions were often misunderstood, even by contemporary commentators, and items of clothing named after their presumed country of origin (for example, Venetian breeches) should be treated with caution.

Fashions spread throughout Europe in a number of ways, one of the most important being the printed image. The first costume books appeared during the sixteenth century, and were widely circulated and collected. One well-known example was *Habitus Variarum Orbis Gentium (Costume of the Various People of the World)* with engravings after designs by Jean Jacques Boissard. 65 plates, each showing three figures from various levels of society, depict the regions across Europe, Asia and Africa (fig. 171). Such images propagated stereotypical (and not always reliable) views of the dress associated with particular regions, but also provided a wealth of source material for artists and designers (see chapter 8). During the seventeenth

century Hollar's prints of women in fashionable clothing from various different countries continued to circulate national styles of dress between countries. 60 plates were made between 1642 and 1644 and published as two related series *Theatrum Mulierum* and *Aula Veneris* (fig. 172), with some later plates made after Hollar moved back to Antwerp in 1644.[18] Hollar must have been familiar with sixteenth-century costume books, and his work continues in this tradition, delighting in the variations of regional costume.

The natural successor to Hollar's etchings were fashion plates, the first of which were produced in France from the 1660s and which were colloquially known as *Les Modes*. These provided a relatively cheap and portable means to circulate ideas about dress styles, and sometimes included samples of fabric attached to the figure. A woman would be able to take a French fashion plate to her English tailor and ask him to reproduce the style. They were also collected as artworks in their own right – Pepys collected fashion plates as part of his broader collection of prints. It has been argued that fashion plates played an important role in stimulating the market for luxury French goods outside France.[19] A print of Mary II after Robert Bonnart (see fig. 44) has more in common with a fashion plate than a portrait from life. The queen is dressed in a highly fashionable mantua, depicted in a stylised manner to show clearly the decoration of the petticoat and the folding of the skirt at the back.

Pattern books were another means of circulating printed information throughout Europe. These provided the source material for embroiderers, silk weavers and lace-makers, and contributed to some similarity in styles across different geographical areas. An example of

ABOVE LEFT

Fig. 172 Wenceslaus Hollar (1607–77), *Mulier Nobilis Hispanica* from *Aula Veneris*, 1649.
Etching, 10.0 x 6.4 cm (sheet). RCIN 804075

ABOVE RIGHT

Fig. 171 After Jean Jacques Boissard (1528–1602), *Nobilis Virgo Francica*, engraving, pl. 28 from *Habitus Variarum Orbis Gentium*, Mechelen: Caspar Rutz, 1581.
RCIN 1075214

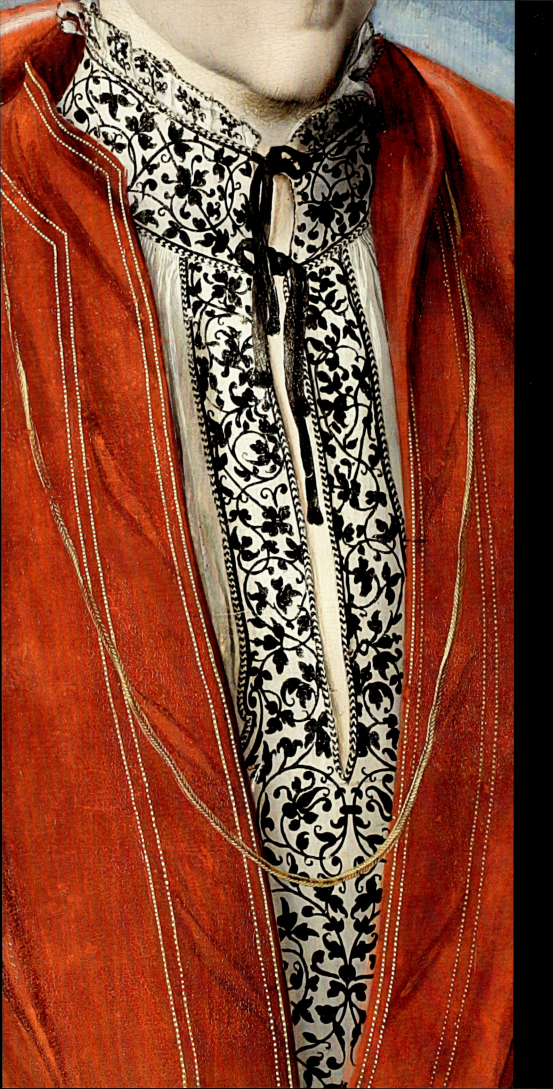

LEFT
Fig. 173 (detail from fig. 78) German or Netherlandish artist working in England. *Portrait of a Man in Red*, c.1530–50.
Oil on panel, 190.2 x 105.7 cm. RCIN 405752

ABOVE
Fig. 174 Thomas Germinus (1495–1562), *Morysse and Damashin, renewed and increased, very profitable for Goldsmythes and Embroderars*, 1548.
Engraving, ink on paper, 4.3 x 7.6 cm. London, V&A Museum. Acc. 19013

the influence of such pattern books can be seen in the blackwork embroidery on the linen shirt worn in *Portrait of a Man in Red* (fig. 173), which bears a strong similarity to an engraving by Thomas Germinus (fig. 174) and which itself demonstrates the importance of Islamic styles of ornament across the decorative arts during the period. Fashion dolls dressed in miniature versions of fashionable clothing were also used to spread ideas about different styles. A pair of dolls known as 'Lord and Lady Clapham' in the V&A Museum are seventeenth-century dolls probably used for this purpose (fig. 175). Each has a choice of both formal and informal outfits, together with the appropriate undergarments and accessories fashionable during the 1690s. The survival of such items is limited by the fact that many were presumably subsequently used as children's toys.[20]

The strong familial connections between the courts of Europe were another factor influencing the similarity of styles across the various countries. King Charles II of England and King Louis XIV of France were first cousins, for example, while the French king was also double first-cousin to the Spanish Infanta María Teresa, who would in 1660 become his wife. Such dynastic marriages between families were a feature of the sixteenth and seventeenth centuries, and the arrival of a foreign spouse, together with their entourage, provided an opportunity for the cultural exchange of ideas about clothing. As we have seen, Catherine of Aragon's arrival in England in the early sixteenth century is thought to have influenced the adoption of the Spanish farthingale and blackwork embroidery. Upon her marriage to Charles I in 1625,

Fig. 175 *Lord and Lady Clapham*, English.
Turned, carved, gessoed and painted wood, wool, linen, human hair on net and ribbon. London, V&A Museum. Acc. T.847-1974 and T.846-1974

Henrietta Maria brought with her French fashions (she had 13 dresses in her *trousseau*)[21] and French talent – in the form of a tailor, embroiderer and dresser. Henrietta Maria was a French princess with Italian heritage (through her mother, Marie de' Medici). She continued to write to France for fashionable accessories throughout her time in England. A century earlier, when Eleanora of Austria married the French king Francis I in 1526, she maintained elements of her Spanish style of clothing as a deliberate and politically motivated attempt to preserve her Habsburg identity at the French court. In her portrait by van Cleve (fig. 176), the hairstyle and shape of the fur sleeves can be considered particularly Spanish. After 1537, however, she conceded to wear French styles, and cultivated a new image of a 'French queen' through the patronage of French court artists such as Corneille de Lyon.[22]

In 1660 the Spanish Infanta María Theresa adopted French styles upon her marriage to Louis XIV. In England, too, foreign princesses wore the clothing of their adopted country. When Catherine of Braganza arrived in England as the intended bride for Charles II in 1661, her distinctive Portuguese dress prompted much ridicule (Charles is said to have remarked 'they have brought me a bat!') and she swiftly abandoned it in favour of English styles. The dramatic shift in her appearance can be seen in two miniatures, painted only a year or so apart (figs 177 and 178). The earlier portrait is a copy taken from a three-quarter length portrait by Dirck Stoop (sent to England in *c*.1660–1 as part of the marriage negotiations), in which the princess wears the distinctive wide hairstyle frequently depicted in the paintings of Velázquez, and a severe black court dress worn over a wide farthingale.[23] Farthingales had been dropped in England over forty years earlier. In the second miniature, probably dating from the following year, Catherine has adopted the wired and curled hairstyle fashionable for women at the English court. Pepys informs us that this could be supplemented with 'a pair of peruques' – locks of hair which were pinned into place – either of the wearer's own hair or from another head.[24] Although this miniature is unfinished, it shows that by this date the queen wears a fashionable English bodice with its low round neckline and a pearl necklace. It is interesting to note that she is wearing an almost identical outfit and hairstyle to that of her husband's mistress, Barbara Palmer, née Villiers, later Duchess of Cleveland (fig. 179).

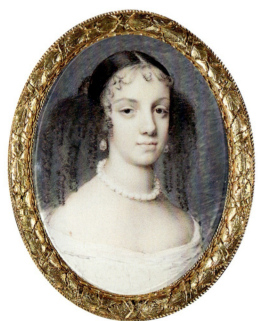

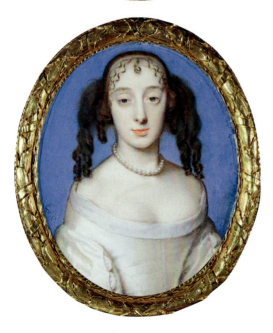

TOP
Fig. 177 Attributed to David des Granges (*c*.1611–*c*.1675), *Catherine of Braganza*, 1661.
Watercolour on vellum laid on card, 5.6 × 4.4 cm.
RCIN 420101

ABOVE MIDDLE
Fig. 178 Samuel Cooper (1609–72), *Catherine of Braganza*, *c*.1662.
Watercolour on vellum laid on card, 12.3 × 9.8 cm.
RCIN 420644

LEFT
Fig. 179 Samuel Cooper (1609–72), *Barbara Palmer (née Villiers), later Duchess of Cleveland*, 1661.
Watercolour on vellum laid on card, 8.0 × 6.5 cm.
RCIN 420088

OPPOSITE
Fig. 176 Joos van Cleve (active 1505/08–1540/1), *Eleanora of Austria*, *c*.1531–4.
Oil on panel, 71.3 × 58.7 cm. RCIN 403369

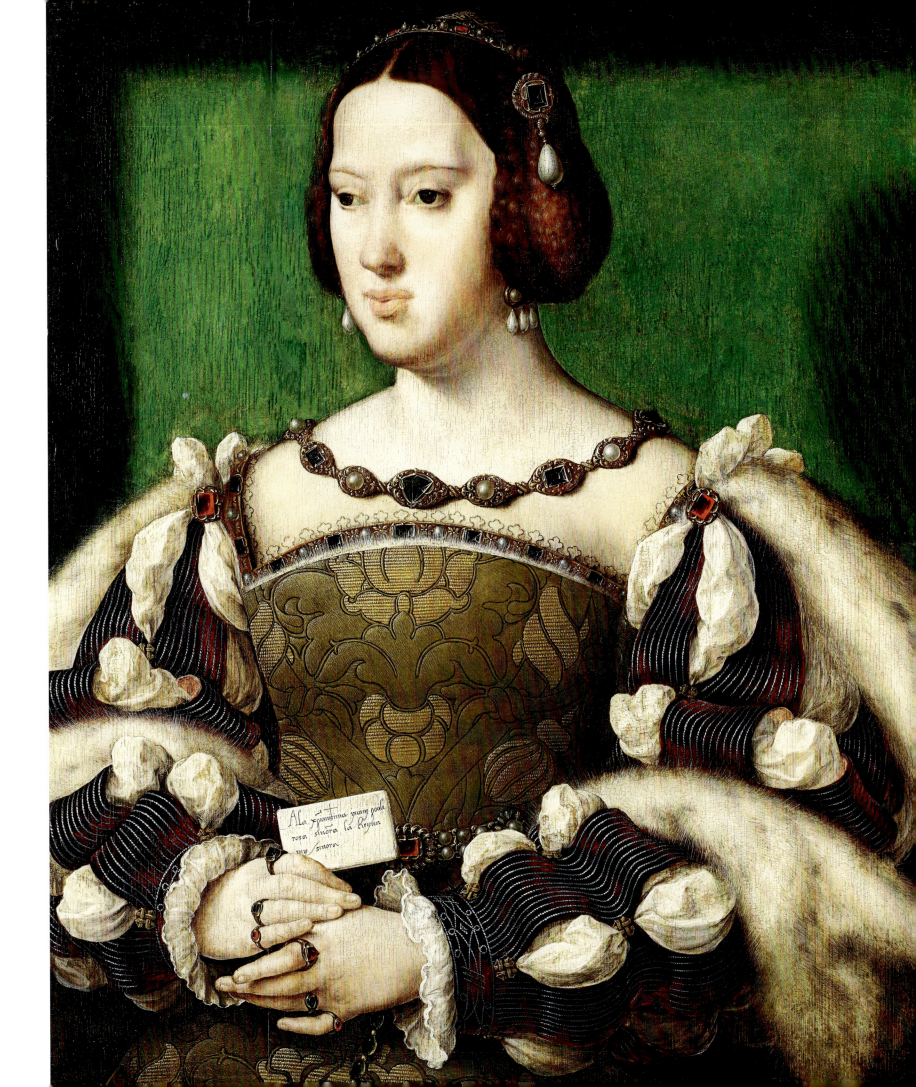

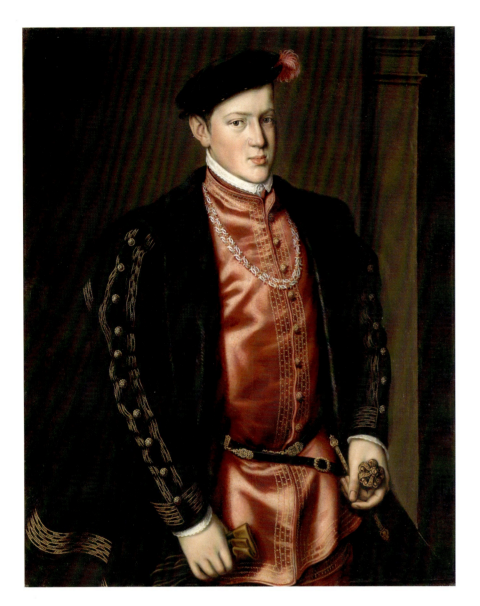
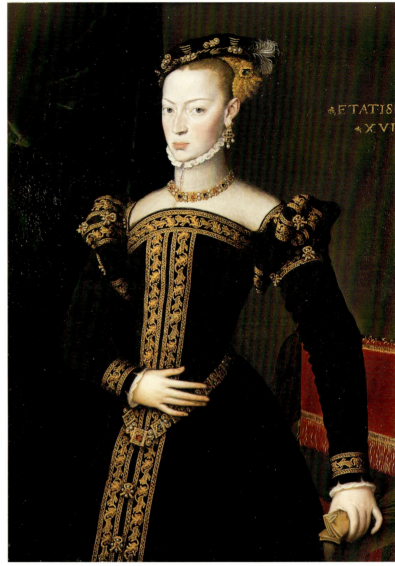

Fig. 180 Workshop of Anthonis Mor van Dashorst (*c.*1518–76), *John, Prince of Portugal, c.*1552.
Oil on canvas, 99.7 x 81.2 cm. RCIN 403953

Before their marriage by proxy in 1552 John, Prince of Portugal and Joanna of Austria exchanged portraits. While little is known of the portrait sent by Joanna this is believed to be the portrait of John, which was hung in Joanna's bedroom. She was said to 'change her way of dressing' after its arrival.[25]

Fig. 181 Follower of Anthonis Mor van Dashorst (1518–76), *Joanna of Austria*, 1552.
Oil on canvas, 95.6 x 69.1 cm. RCIN 407223

Marriages between people of different nationalities at levels below the monarch also provided scope for the transmission of dress information across borders. The French nobleman Philibert comte de Gramont, for example, married Elizabeth Hamilton, a noted beauty at the Restoration court. Maintaining his love of French fashion, he frequently sent his valet on shopping trips to Paris to bring back the latest garments and accessories. Foreign tailors also set up businesses within London, and had regular communications with their Continental counterparts. Both Henry VIII and Charles II employed foreign tailors (John de Paris and Claude Sorceau respectively) while Elizabeth I sought a French tailor able 'to make her apparel both after the Italian and the French manner' in 1567 but was unsuccessful.[26] Ready-made gowns were however brought from France to England for Elizabeth I, which could have been unpicked in order to generate a pattern for a foreign style.[27]

The attire of foreign visitors at court attracted much discussion; these visitors also passed information back about the fashions at the court abroad. Sebastian Giustinian, Venetian ambassador at the court of Henry VIII, wrote frequent dispatches making reference to the

attire of the king and his courtiers. Members of the courts would write letters of a less official capacity back to their relatives, providing information about the latest fashions, sometimes including fabric samples or patterns. A surviving letter from Mary Tudor, sister to Henry VIII, thanks her aunt Margaret of Austria, Regent of the Netherlands, for sending a Flemish dress pattern as a gift which she has had made up in England. 'I have long desired to know how the attire and the dress which are worn there [in Flanders] would become me and now that I have tried them on I am delighted with them.'[28] Letters were also used to spread fashions from court to countryside within England.

Gifts of portraits were an established component of dynastic marriage negotiations, providing an opportunity to gauge the appearance of a future spouse before meeting them in person (see figs 180 and 181). Henry VIII's court artist, Hans Holbein, was despatched to Düren, near Cologne, to paint his fourth potential wife, Anne of Cleves. The two portraits with which he returned – a full-length oil painting in the Louvre and a miniature in the V&A Museum – have often been discussed in the context of their flattery of the sitter. However, it is also interesting to imagine how the sitter's Flemish clothing will have been interpreted and analysed by the English court. Portraits were also exchanged as symbols of friendship, while clothing too was considered a suitable gift from one monarch to another. Such exchanges will have encouraged the flow of information about novel fashions from abroad.

That the region with the most political power at any particular period tended to have the most influence over fashions is a fair generalisation. Accordingly, Spain exerted a particularly strong influence on fashionable styles during the sixteenth century, coinciding with its political dominance across much of Europe, while France achieved supremacy in both politics and fashion in the seventeenth century under the rule of Louis XIV and the court of Versailles. Associated with this, we see the vehement criticism of Spanish influences on English fashion in literature of the early seventeenth century exchanged for particularly intense criticism and satire of French influences by the end of the century.[29]

A look at some of the most characteristic features in dress worn in Italy, Spain, France and the Low Countries (as well as further afield), now follows, together with the main ways in which they influenced the fashions in England. This transmission of ideas gives some sense of the difficulties in ascribing a certain feature of dress to a certain geographical region at any particular point in time. But while fashions across Europe shared many similarities during the sixteenth and seventeenth centuries, there were important geographical variations too.

ITALY

The leading producer of highest quality silks during the sixteenth and early seventeenth centuries in Europe was Italy – the country had exported high-quality silks since at least the thirteenth century, with major centres initially established in Palermo and Lucca.[30] The earliest designs were heavily influenced by the Byzantine tradition. Persia had a long history of silk-weaving, and had introduced sericulture to Sicily. Italian weavers, however, soon began to develop their own designs, the most popular of which was the pomegranate pattern, seen in both velvets and damasks and used for clothing and furnishing fabrics.

Fig. 183 A panel of large-scale raised needle lace, Venetian, 1670–90.

40 x 23 cm. Barnard Castle, The Bowes Museum, the Blackborne Collection.
Acc. 2007.1.1.127

Fig. 182 Silk velvet with a pattern of pomegranates, Italian, 1450–1500.

73.0 x 62.9 cm. London, V&A Museum. Acc. 555-1884

Italy's European reputation for the production of woven silks and its monopolisation of the industry was in large part influenced by its central position in the key trade routes via both sea and land, in much the same way that Venice became the centre for the trade of artists' pigments. The well-established trade routes between Italy and the Middle East remained important for silk-weaving throughout this period – although some silk cocoons were produced in Italy, the majority of raw silk thread was imported from Persia, Syria and Palestine. By the sixteenth century, individual cities became associated with the specialist and innovative production of a particular type of fabric. Florence was known for its gold brocades, while Venice was known for voided silk velvets like that in fig. 182. Genoa was famed for its figured velvets and damasks – so much so that 'Genoa' was used as a generic adjective for the two fabrics in the English royal accounts.[31] Henry VIII was supplied with very expensive Italian silks by a small group of Italian merchants.[32] In fact silks and velvets from Italy were the second most important import into England after wine.[33]

Fig. 184 Lorenzo Lotto (c.1480–1556), *Andrea Odoni*, 1527.

Oil on canvas, 104.6 x 116.6 cm. RCIN 405776

While Andrea Odoni was an important member of the Venetian citizen (*cittadini*) class, here he is not shown wearing a *vesta*, the traditional official dress for civilian men in Venice above the age of 25. Instead, he wears a fur-lined black silk gown of a style also worn by Holbein's sitters in England during the 1530s – demonstrating the similar styles worn across much of Europe at this date.

The two European centres associated with the earliest production of lace are Italy and Flanders. Venice, in particular, was a centre for early needle lace; the first lace pattern books were published there in the late sixteenth century. *Punto in aria* ('stitch in the air') lace was the first to be produced without using a piece of woven fabric as its base. Italian terms like this reflect their early origins in the region. The patronage of the Catholic church, using Italian lace as both clerical clothing and church decoration, was a key factor driving the expansion of the lace industry in Italy. While many of the most fashionable laces of the mid-seventeenth century were made in the Low Countries, Venice retained its position of prominence with the introduction of *gros point* lace at the end of the century – a bold and highly three-dimensional type of lace, able to withstand competition from the extravagant styles of the Baroque. As is demonstrated by the surviving examples, this type of lace carefully balances density and complexity with open space (fig. 183).

Garments cut in styles particularly associated with Italy were adopted in England. Elizabeth I, for example, had five gowns in the 'Italion fation' made between 1568 and 1569. Characteristic features that appear to indicate Italian origin are long vertical slashes in the front of the bodice revealing a second bodice worn beneath, together with tabs at the waist.[34]

Generalisations in styles of dress within Italy are made difficult by the persistence of the Italian city-state system of the medieval period – the country was still run as a collection of independent regional territories, under the control of different groups. As a result, Italian dress remained highly idiosyncratic depending on the region in question. Fashions in the southern

OPPOSITE AND BELOW (DETAIL)
Fig. 185 Agnolo Bronzino (1503–72), *Portrait of a Lady in Green*, c.1528–32.
Oil on poplar panel, 76.6 x 66.2 cm. RCIN 405754

part of Italy for example, including Naples, were heavily influenced by Spain, since this region was under the control of the Spanish Habsburgs.

Costume historians have found it difficult to attribute the clothing worn in *Portrait of a Lady in Green* (fig. 185) to a precise geographical region in Italy, and vary in their opinion as to whether it is north Italian or Florentine. The debate has been part of confirming or discrediting the attribution of the painting to the Florentine artist Agnolo Bronzino. The relatively small size of her round, padded headdress is unusual – portraits of Italian women of this date (*c*.1528–32) often show a larger headdress, balancing the voluminous sleeves.[35] The linen garment covering the sitter's décolletage is possibly a high-necked *camicia* (smock), or more probably a separate partlet pinned into position. It is decorated with blackwork embroidery similar to that depicted by Holbein in England at around the same date. The artist has beautifully depicted the fine pleats gathering the volume of the linen into the neckband. One cuff of the camicia is just visible at the sitter's left wrist and is also decorated with blackwork, although in a different pattern to that at the neck, which lends credence to the fact that the linen at the neck and that at the cuff belong to two separate garments. Interestingly the artist originally intended that the collar be completely circular with the two sides fastened together at the centre front. He evidently decided that the more informal appearance lent by gently folding sides at the neck would be more appropriate. The gown is of a particularly vivid shade of green and is decorated with bands of fabric in a contrasting shade of white. It apparently laces up the side or at the back, although some Italian portraits of this date show front lacing. Her lower sleeves are of white silk decorated with long slashes to reveal probably a lining fabric beneath. The sitter's clothing overall is expensive but relatively restrained.

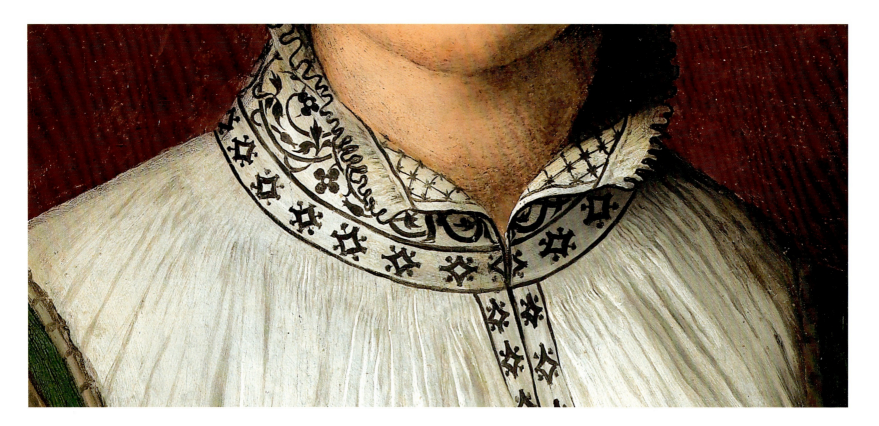

200 IN FINE STYLE

SPAIN

Spain exerted a powerful influence over dress worn in other countries across Europe – particularly after *c*.1530 when the country developed a characteristic national style, driven by the taste of the monarchy.[36] This coincides with the rise of Spain as the most powerful political force in Europe. The dress of King Philip II (reigned between 1556 and 1598) together with that of his four queens and four surviving children was highly influential, and a style of 'Spanish' dress was established under the early years of his reign that would continue throughout the century. Philip II took a keen interest in the attire depicted in portraits of his family members, and made numerous visits to the studios of the court artists Anthonis Mor and Alonso Sánchez Coello. While elements of Spanish dress were adopted throughout much of Europe, it was modified by the other countries.[37] The influence of Spanish styles was greater during the sixteenth century; Spanish portraits of this period are particularly well represented in the Royal Collection due to the close links between the two courts.

Spanish clothes are notable for their precise geometric cut, austerity in style and distinctive silhouette. Spanish clothing in general gives a sense of the wearer being buttoned-up and encased in their attire – for women, the clothing completely covered the skin except for the face and hands. This had an effect on the wearer's deportment. Slow, solemn movements and an erect head gave the wearer a rather detached and haughty appearance, often conveyed through portraiture, which would have contributed to the reputation abroad of Spaniards being proud and arrogant.[38] Spanish styles were, however, praised in England during the seventeenth century as unchanging, particularly in contrast to the novelty-seeking sartorial culture of the English and French courts.

Given the complexity of cut in Spanish dress during this period, for which Spanish tailors were renowned throughout Europe, it is no coincidence that the first tailoring manual was produced by a Spanish master tailor. Juan de Alçega first published *Libro de geometría, práctica y traça* (*The Practice of Tailoring, Measuring and Marking Out*) in Madrid in 1580, with a second print in 1589. The tailor's trade was traditionally a rather secretive closed industry, passing skills directly from master to apprentice via the workshop system. This was

Fig. 186 Juan de Alçega (fl. 1580s), *Libro de Geometría, práctica y traça (The Practice of Tailoring, Measuring and Marking Out)*, Madrid, 1580.
London, National Art Library.

the first publication on the subject; it included 135 patterns for making male and female fashionable clothing, as well as specialist garments such as mantles for various chivalric orders. The manual specified how pattern pieces should be laid out in the most efficient manner on the fabric, while ensuring that the nap (weaving pattern) matched up where necessary (fig. 186), and also included tables to calculate how much fabric would be required for different garments. These helped the tailor to minimise the amount of fabric required and avoid the wastage of expensive fabric. Notably, however, the manual does not include instructions about how the pieces should be sewn together. It would not be until 1796 that the first manual of this type was published in English.[39]

It has been speculated that one purpose of Alçega's manual (which its author notes required the approval of the Spanish Royal Council before publication) may have been a conscious effort by the Spanish monarchy to help spread Spanish fashions throughout the rest of the country to form a characteristic national style of dress, as well as throughout the rest of Europe.[40] The consistency of distinctive Spanish fashions across such disparate regions as Southern Italy, the Spanish-ruled Netherlands and Austria can be interpreted as a symbol of the country's political power, particularly during the second half of the sixteenth century, and was a highly visual means of emphasising the familial connections between the various courts. Fashion served as political propaganda.

Given Mary I's ardent Catholicism, together with her unpopular and short-lived marriage in 1554 to Philip II of Spain – making her queen consort of Spain for two years – it is unsurprising that her clothing showed a distinctive Spanish influence, a feature which permeated throughout the English court. The portrait of Mary I (fig. 187) is after an original version by Anthonis Mor (Prado, Madrid), commissioned by Philip II in 1554 and sent to Spain as part of the marriage negotiations. It shows her wearing a dark-coloured gown and matching partlet concealing her shoulders and neck, that was in keeping with more modest styles in Spain at this date.[41] Mary would presumably have wanted to demonstrate her affinity with her proposed new kingdom through her choice of attire. The gown depicted here is probably the 'Frenche Gowne of Murrey vellat' listed in Mary's Wardrobe Accounts of 1554.[42] She also wears the diamond and pearl pendant sent by the Spanish king as a betrothal gift. The Duke of Mantua visiting England in 1557 remarked that the English were adopting Spanish fashions instead of Italian.[43] The popularisation of the so-called Spanish

Fig. 187 After Anthonis Mor van Dashorst (c.1518–76), *Mary I*, 1554–9.
Oil on panel, 93.1 × 75.8 cm. RCIN 404442

FASHION ACROSS THE BORDERS 203

Fig. 189 *Jubón*, *basquiña* and *ropa*, Spanish, late sixteenth century.

Silk and linen. New York, Metropolitan Museum of Art. Acc. 25.118a-c

cloak (a short garment, often made with a decorative hood always worn folded back over the shoulders) in England is credited to the arrival of Philip II in 1554 as husband of Mary I.

Fashionable men in Spain wore a *jubón*, a stiffened doublet often lined and decorated with horizontal lines of backstitching across the torso and sleeves. It is worn beneath a sleeveless jerkin (*coleto* or *cuera*) in the portraits of Ernest and Rudolf of Austria (see figs 101 and 102). The enclosed effect of these garments covering the torso imitates a military breastplate – this tight-fitting style, which became standard attire for Elizabethan courtiers in England, is a fashion first associated with Spain. The initial protective purpose of the jerkin is indicated by the fact that they were usually made of leather or suede.

Women depicted in Spanish portraits of this period are shown wearing either a combination of *jubón* (bodice) with *basquiña* (overskirt) or a *saya* (gown).[44] The portrait by Frans Pourbus of the Infanta Isabella Clara Eugenia (fig. 188) depicts the first of these options – a high-necked bodice and skirt with the characteristic triangular shape created by a conical Spanish farthingale worn beneath, which was adopted in various countries throughout Europe including England. Women's bodices were often designed along the masculine lines of the male doublet, with tabs at the waist and a high neckline, which concealed the natural shape of the feminine torso beneath. Spanish women during the sixteenth and seventeenth centuries never adopted the extremely low round necklines seen in England. Over the top Isabella Clara Eugenia wears a long formal surcoat known as a *ropa* – this example is fur-lined throughout. The extended length of Isabella's body from waistline to the ground is probably exaggerated by the use of platform-like *chapines* (with soles constructed from wood or cork), completely hidden by the long skirt above. These apparently were not widely adopted in England, although they are mentioned in literature of the period.

A set of similar extant garments (*jubón*, *basquiña* and *ropa*) survive in the Metroplitan Musuem (fig. 189). Both the painting and the three-dimensional clothing show a similar elaborate form of decoration covering

OPPOSITE AND OVERLEAF (DETAIL)
Fig. 188 Frans Pourbus the Younger (1569–1622), *The Infanta Isabella Clara Eugenia, Archduchess of Austria*, c.1598–1600.

Oil on canvas, 217.5 × 131.0 cm. RCIN 407377

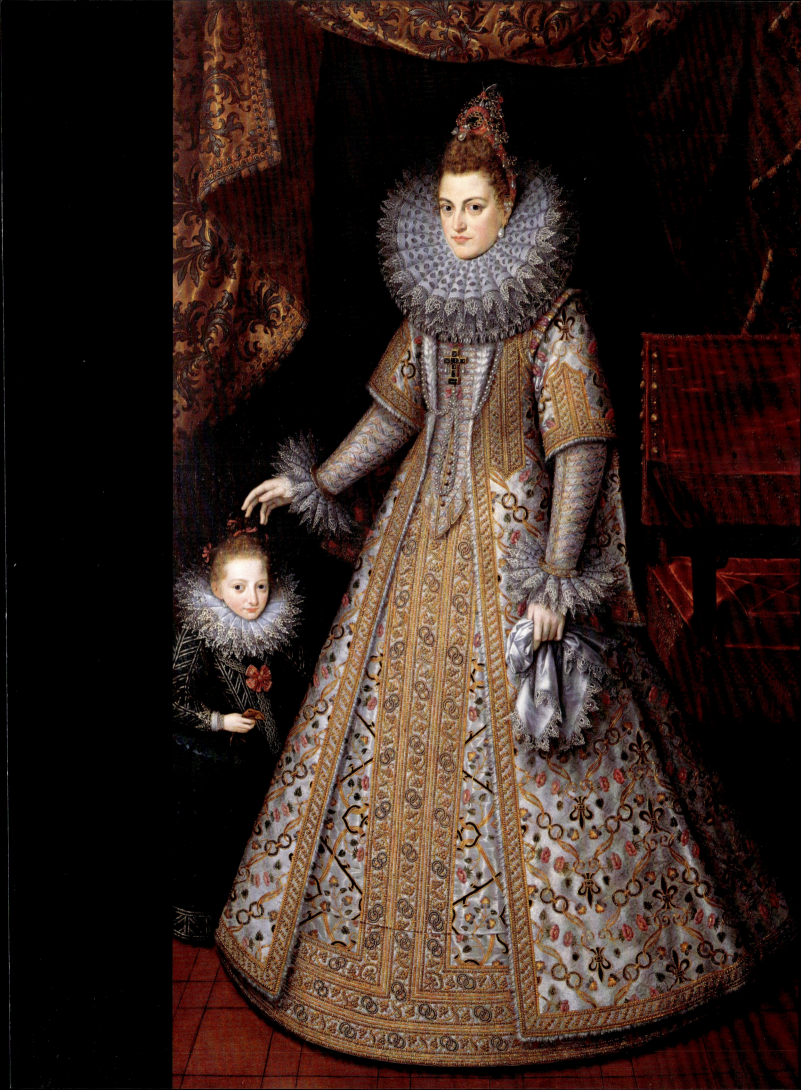

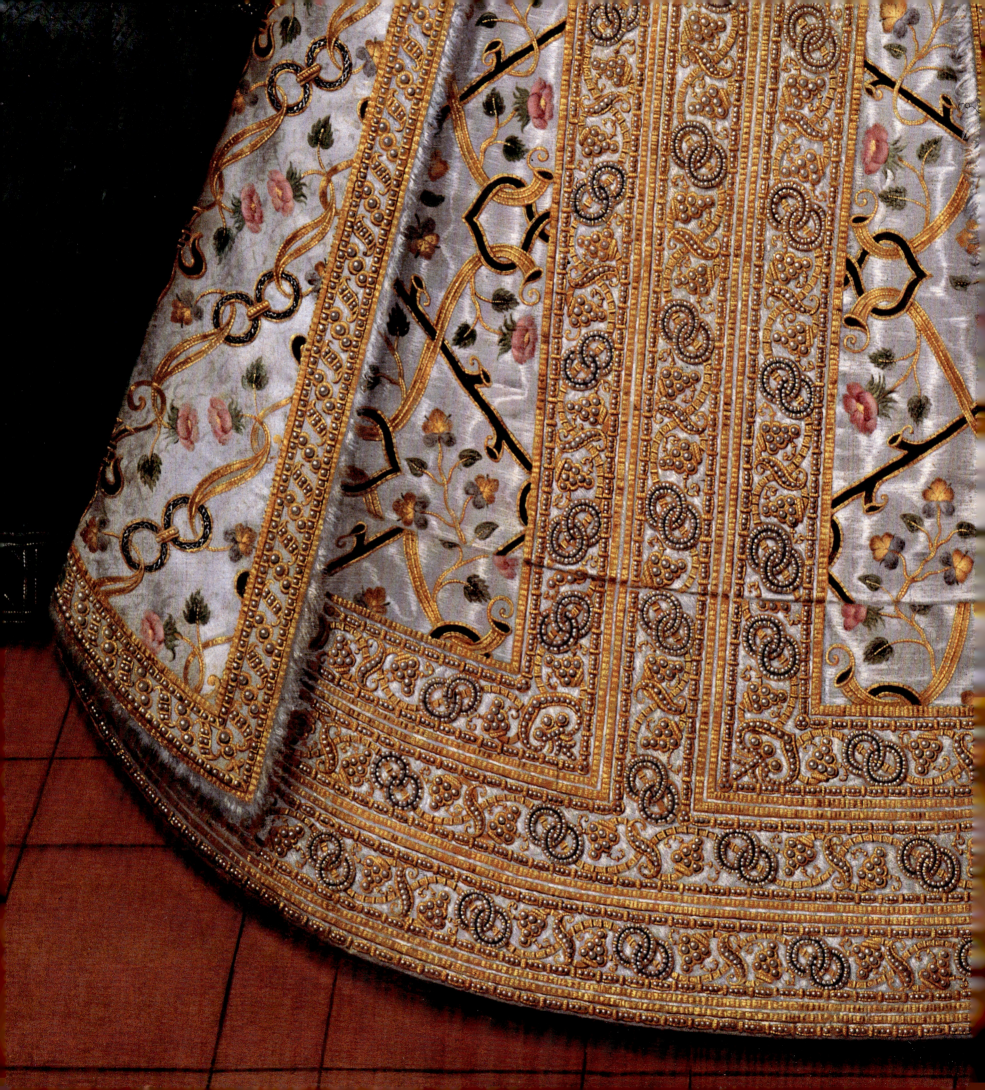

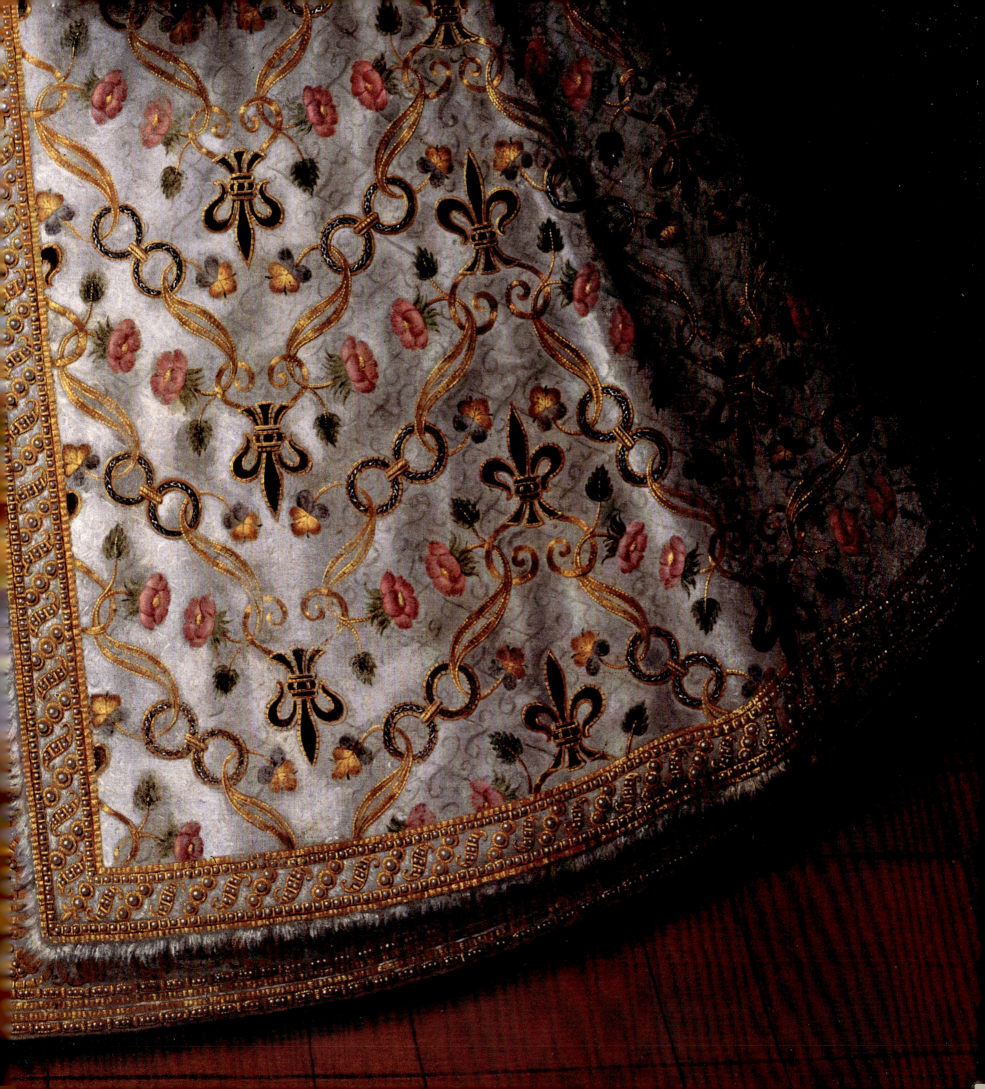

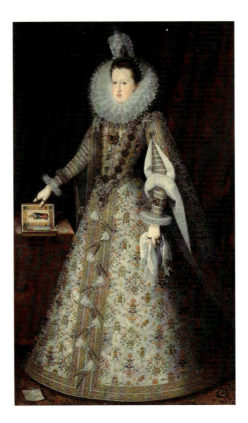

ABOVE LEFT

Fig. 190 Juan Pantoja de la Cruz (c.1553–1608), *Philip III, King of Spain*, 1609.
Oil on canvas, 184.4 × 118.5 cm. RCIN 404969

ABOVE RIGHT AND OPPOSITE (DETAIL)

Fig. 191 Juan Pantoja de la Cruz (c.1553–1608), *Margaret of Austria, Queen Consort of Philip III of Spain*, c.1605.
Oil on canvas, 204.6 × 121.2 cm. RCIN 404970

the entire surface, and both are trimmed with braid running down the centre front of the skirt and around the hem.[45] A particularly characteristic feature of Spanish sleeves is that they are often cut with a round edge at the back and straight edge down the front. This style (termed '*mangas redondas*' in the tailor's books) remained in fashion at the Spanish court well into the seventeenth century. It was also adopted by some women in England – Anne of Denmark, for example, wears a bodice with Spanish sleeves in her portrait by van Somer of 1617 (see fig. 242), left unbuttoned and hanging behind her shoulders.

The second style of court dress available for elite Spanish women was a gown known as a *saya*. Early examples were made in one piece, but by the end of the sixteenth century they were cut in two independent pieces of the same fabric. Margaret of Austria wears a saya in her portrait (fig. 191), believed to have been commissioned by the sitter in 1605, which was sent over as a diplomatic gift for the English court as a mark of the new alliance between the two countries.[46] It is surely deliberate that Margaret is shown wearing the *joyel rico* at her chest – a priceless square table-cut diamond that she is documented as wearing during the signing of the London Treaty in 1604. From it hangs the famous *La Peregrina* pearl that Mary I of England had been given by Philip II as an engagement gift, but which had reverted to the Spanish crown upon her death. In his register, Pantoja de la Cruz records completing a portrait of Margaret wearing her wedding robes from her marriage to Philip III some years earlier in 1598. These were of 'spring fabric bedecked with the coats of arms of Castile-León, and Austria, and bespangled with pearls'.[47] This is apparently that portrait. The front of the skirt section is fastened with ribbon bows trimmed with pairs of huge aglets in gold and enamel, arranged in alternating diagonals. Although aglets were fashionable in England they never reached the size of those in Spain.[48] The sleeves of the saya could be cut in the round style as described earlier, or could be long and pointed as shown here ('*mangas de punta*'). To create an interesting asymmetric effect Margaret wears each sleeve differently – her left arm projects through the lowest opening while her right arm exits through the upper slit.

During his visit to Spain in 1624 as part of the negotiations for a proposed marriage to the Spanish Infanta, Prince Charles of England was especially taken with the formality of dress and etiquette at the Spanish court. The year before, King Philip IV of Spain had introduced a style of formal court dress for men as part of a complete set of sumptuary laws outlined in his *Chapters of Reformation*, which for the first time were obeyed by the population following the leadership of the king himself.[49] That the king himself adhered to his own rules is illustrated in his portraits, for example the full-length painting by Velázquez in the Metropolitan Museum (fig. 192). The new court dress consisted of a plain unadorned black doublet, breeches

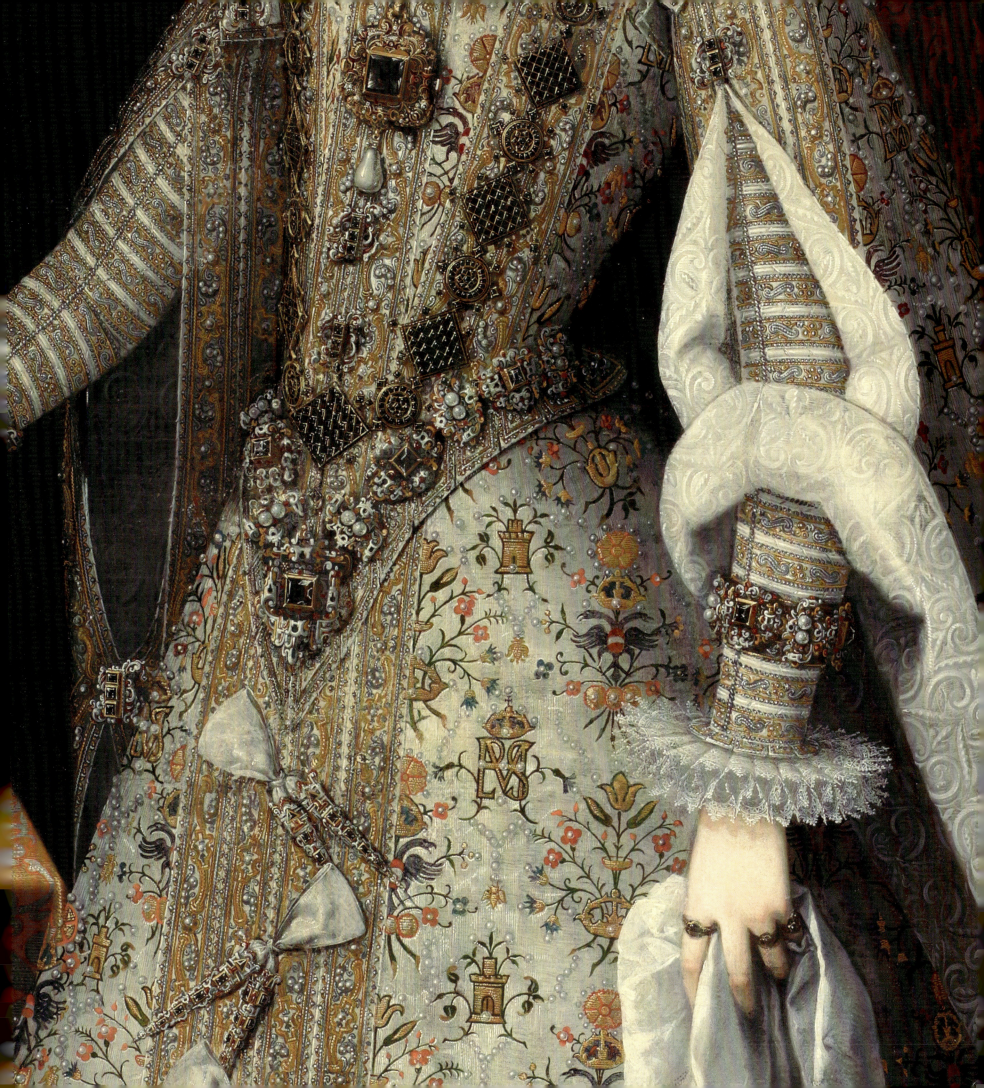

Fig. 192 Diego Velázquez (1599–1660), *Philip IV, King of Spain*, c.1624.
Oil on canvas, 200.0 x 102.9 cm. New York, Metropolitan Museum of Art. Acc. 14.40.639

and cloak. The only interruption to the monotone black is the small white standing collar known throughout Europe as a *golilla* (although in fact this refers to the cardboard support holding up a plain starched linen collar known as a *valona*). The *golilla* became a characteristic feature of Spanish dress for the next 80 years, and contemporary writers remarked frequently on how uncomfortable it was to wear.[50]

The range of laws introduced by Philip IV included the prohibition of imported silk and fabrics woven or decorated with silver or gold. They also specified the maximum size of ruffs and cuffs allowed. The strict rules were relaxed, however, for the state visit of the English Prince Charles, so as to represent the Spanish court with appropriate splendour. The Spanish king wore black or brown set off with metal thread embroidery and expensive jewels throughout the visit. Prince Charles does not appear to have been aware of this revocation in the laws, and upon arriving in Spain with clothing that he deemed to be insufficiently magnificent he embarked on a spending spree. During his seven-month soujourn in Madrid, Prince Charles spent 80,382 Spanish *reales* (approximately £440,000 in today's money) on textiles and accessories, and also received a number of gifts of clothing including a dressing gown and one hundred pairs of gloves from the Spanish king and queen.[51] He also ordered clothes from England, many of which were in the English fashion – in vivid shades of fabric with elaborate embroidery. Letters were written to King James requesting the most important jewels be sent over from England to Spain. For the various events during the visit Charles adopted both Spanish and English styles, depending on the nature and formality of the occasion, and appears to have been sensitive to Spanish protocol – choosing Spanish dress for public appearances.[52]

According to his wardrobe accounts, for a brief time after his visit to Spain Charles appears to have developed a preference for relative simplicity in his clothing. However, he would have been wary of appearing too Spanish in his styles, given the widespread hostility across England to the marriage and the fact that by the end of 1624 England was at war with Spain. The shift appears to have been a temporary change – the arrival of the French Henrietta Maria as his wife

in 1625 apparently had a greater influence on the king's adult clothing style, and the portraits of the 1630s for which Charles I is most famous portray the king in bright or pale coloured silks. This reflects a shift in influence on fashion throughout Europe as a whole, which was increasingly dominated by France. Spain however remained largely immune to the dictates of French fashion, retaining its national style of dress until the end of the reign of the last Habsburg king in 1700.[53]

FRANCE

As Spain became less powerful on both the political and fashion stage during the seventeenth century, France was ready to take over the leading role. King Louis XIV (reigned 1643 to 1715) insisted on magnificence at his court, and the fashionable clothing of his courtiers was of major concern. In moving the centre of court from Paris to Versailles he cultivated a concentrated centre in which the courtiers, removed from the diversions of the city with little to do other than gamble and gossip, attempted to outdo each other in their search for novel and ostentatiously expensive fashions that would suitably reflect the grandeur of the king and draw his attention.

The strong links between the French court and the court in England ensured that its influence was keenly felt across the Channel. As we have seen, Henrietta Maria maintained a love of French fashions throughout her life (fig. 193). Charles II had first-hand experience of the French court at various points during his exile in the 1640s, and while living there between 1651 and 1654. It is unsurprising, therefore, that the court in which various close relations were such important tastemakers had a major influence on the fashion culture at the Restoration court in London. Louis XIV was first cousin to Charles; Charles's beloved sister Henrietta was married to Louis' brother, Philippe, duc d'Orléans. The importance of French fashion plates as a relatively cheap means of disseminating new styles throughout Europe has already been highlighted. France was also responsible for producing the first magazine to convey information about fashionable dress. *Le Mercure Galant*, a monthly periodical first published in 1672, included articles on a variety of subjects relating to elegant society, including fashion. The arrival of French fashions on the bodies of stylish young women raised at the French court such as Frances Teresa Stuart and Louise de Kérouaille (both of whom immediately caught the eye of Charles II) also heightened their appeal.

While French styles infiltrated the court through the seventeenth century, it was really from the 1660s onwards that France's new position as the key centre for European fashion was most keenly felt in England. French tailors were regarded as the best in Europe, and were thus much in demand. French words for items of dress began to enter the English vocabulary, and the obsessed fop who adopts French fashions with alacrity makes a frequent appearance in Restoration comedies. In an apparent dichotomy French luxuries were considered highly desirable but the influence of France was satirised in the theatre and print. According to one commentator 'Ribbands, Lace and Looking-Glasses are the three things without which the French cannot live'.[54]

A key drive behind France becoming the leading exporter of fashionable luxury consumer goods during the second half of the seventeenth century was the involvement of the French

Fig. 193 Anonymous, *Henrietta Maria when a Princess?*, c.1622.
Oil on canvas, 69.3 x 59.4 cm. RCIN 400961

The sitter in this portrait has traditionally been identified as the French princess Henrietta Maria, later consort of Charles I. Her clothes, with their formal sleeves set in rolls, are distinctively French and suggest a date of *c*.1622 when Henrietta Maria would have been around thirteen years old.

OPPOSITE

Fig. 194 After Pierre Mignard (1612–95), *Elisabeth Charlotte, Princess Palatine, Duchess of Orléans, with her son Philippe, later Regent of France, and daughter, Elisabeth, later Duchess of Lorraine,* c.1678–88.

Oil on canvas, 204.4 × 171.0 cm. RCIN 404410

BELOW

Fig. 195 (detail from fig. 196) After Pierre Mignard (1612–95), *Louis, the Grand Dauphin of France with his Family,* c.1687.

Oil on canvas, 115.4 × 160.4 cm. RCIN 404490

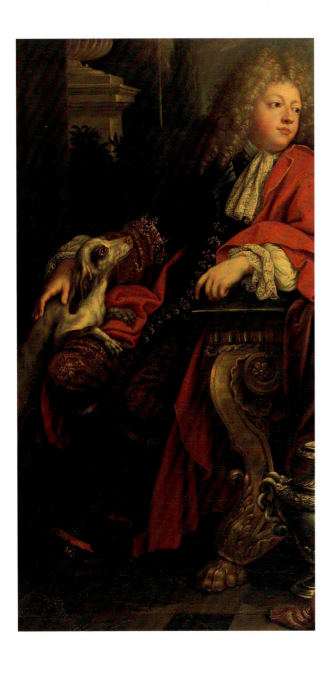

government, headed by the minister of finance, Jean-Baptiste Colbert. Coming from a family of textile merchants, Colbert recognised the economic potential of textiles, understanding its value as an easily circulated, highly visual form of currency. In a systematic approach designed to develop the French luxury goods market, Colbert encouraged foreign artisans with expertise to set up businesses in France, and established a system of financial incentives for new luxury goods entrepreneurs and their investors including tax reductions, tariff protection, subsidies and loans.[55] Strict quality control regulations were imposed during the 1660s, and competition within France was minimised by encouraging each regional weaving area to become a specialist in a certain type of pattern or weave. Colbert also instigated sumptuary laws designed to increase the demand for domestic fabrics, lace and silks – for example, the law of 1667 which forbade the importation of foreign silks into France.

By the end of the seventeenth century France was producing the highest quality woven silk fabrics in Europe. The centre of its silk industry was Lyon, where the most complex and luxurious silks were created and where seasonal fashions in silk designs were set. Due to its position at the confluence of two important rivers, Lyon had long been a centre for merchants importing silks from Italy, and all raw silk had to be brought through the city to be weighed for government duty. But as improvements to the draw loom in the early seventeenth century enabled more complex designs, alongside an influx of foreign talent including many weavers from Italy, a domestic weaving industry was able to flourish in Lyon during the seventeenth century.

The portrait of Elisabeth Charlotte, Duchess of Orléans, demonstrates that by the late 1670s this German princess had fully adopted French fashions (fig. 194). Elisabeth Charlotte ('Liselotte') arrived from the Rhineland to France in 1671. She and her two children are depicted at the height of fashion, wearing luxurious silk woven with gold thread and lace in the style of Venetian *gros point*.

Louis XIV's revocation of the Edict of Nantes in 1685, making Protestantism illegal, forced an exodus of skilled Huguenot craftsmen from France to more tolerant countries including England and the Northern Netherlands. Many of the French silk-weavers arriving in London settled in the area around Spitalfields market, and their skills encouraged its development into a key silk-weaving centre.

One particular feature of male French court fashion that was adopted in England (and throughout Europe) was bright red block heels on shoes (*talons rouges*). In France they were only allowed to be worn by those of noble birth – their impracticality was a clear sign of the leisured lifestyle of the wearer. These were not men who got their feet dirty. This led to *talons rouges* becoming a derogatory expression symbolising an aristocratic futile existence. Red heels are often prominently displayed in portraits. In the group portrait of Louis the Grand Dauphin with his family, the artist takes care to show the Dauphin's red heels (fig. 196, detailed in fig. 195). The position of his feet, with one foot in front of the other, mimics that seen in many portraits of standing figures – a pose deemed as most elegant, and taught by the dancing master. The dauphin wears a blue velvet coat, cut close to the body (known in France as the *justaucorps*), with the blue sash of the Order of Saint-Esprit and a red cloak prominently embroidered with its star.

Fig. 196 After Pierre Mignard (1612–95), *Louis, the Grand Dauphin of France with his Family*, c.1687.
Oil on canvas, 115.4 x 160.4 cm.
RCIN 404490

Despite the profusion of French fashions, accessories and fabrics in England, there were differences between the two countries, which remained throughout the period. The court at Versailles was more formal and more strictly regulated. Throughout his reign Louis XIV insisted on the *grand habit* for women at court (even for those who had recently given birth).⁵⁷ It comprised a rigid boned bodice with wide low neckline revealing bare shoulders, short capped sleeves and large lace frills known as *engageantes* at the elbows. This was worn over a hoop to give width and had a trained skirt, the length of which was dictated by a woman's social position. However, the loose, unboned *manto* – worn for activities such as the theatre and promenades – was much preferred by the women of the court, for its comfort and warmth. In England the *grand habit* was rarely worn under the Stuart monarchs, its use limited to highly formal occasions such as royal weddings. Formal regulations for court dress did not exist until the end of the eighteenth century, and elite women adopted the more informal mantua (as the manto was known in England), even for court occasions. Princess Anne, for example, wore a mantua for William III's birthday ball in 1696 and no objections were raised.⁵⁸ But the *grand habit* was adopted across many of the courts of Europe, as far as Russia, and continued to be

worn throughout much of the eighteenth century. The process of dressing was also more formalised in France, with the king's *levée* (dressing) and *coucher* (undressing) elevated to daily state activities in front of the court, with increasing numbers of courtiers present as more clothes were added to the royal body. While the English court under Charles II was much more informal, upon his accession to the throne James II deliberately attempted to model his court on Versailles, reviving much of the ceremony and etiquette that had existed previously.

THE LOW COUNTRIES

Defining what is meant by the 'Low Countries' during this period is complicated, but the political situation had an important influence on fashionable dress in the region, so a brief overview may be helpful. The Netherlands of the sixteenth century encompassed the present-day Netherlands plus Belgium, Luxembourg and parts of France. The Netherlands were brought under Habsburg rule (along with the Holy Roman Empire, Spain and parts of Italy), but the rebellion of the Dutch people against the oppressive and remote leadership led to the Eighty Years' War (1568–1648) and resulted in a split between the northern and southern provinces. The northern Netherlands, which included the city of Amsterdam, formed a separate group known collectively as the 'United Provinces'. These were officially recognised as the Dutch Republic in 1648 with the Treaty of Münster, ending the Eighty Years' War.

The south (which encompassed the important sixteenth-century trading city of Antwerp) was ruled by a series of appointed governors reporting to the king of Spain. The north was led by Staadtholders of the House of Orange and grew in prosperity and influence during the seventeenth century (a period which is now known as the Dutch Golden Age). The north was particularly known for its unique social hierarchy in which rich regents and merchants held more power than the long-established nobility. The 'Low Countries' is here used to encompass both regions, although the terms Dutch and Flemish will also be used to refer to the Northern and Southern regions respectively.

One characteristic feature of seventeenth-century Dutch portraits is the sombre monochromatic fashions of the sitters. In one sense the colour black represents the legacy of Spanish rule in the region, but it remained the colour of choice for the emerging merchant class in the north. These were the economic elite, the ruling classes who held the most important government positions and who had made their money trading goods including textiles and dyes. This rising middle class valued black clothing for its simplicity, formality and understated suggestion of wealth, without the ostentation of complex surface decoration and eye-catching colour. Despite their apparent simplicity, the sitter's clothes in Frans Hals's *Portrait of a Man* (fig. 197) demonstrate that he was a wealthy and successful merchant. The process for dyeing black fabrics was labour-intensive and expensive, and his garments, dyed with the deepest and most intense of blacks, consist of shining silks contrasted with more matt textured fabrics. Artists like Frans Hals and Rembrandt were masters at depicting the subtle and nuanced effects resulting from different black fabrics. The sitter wears a black cloak over his left shoulder, which wraps around his waist. Of his doublet beneath only the right arm is visible; the striped effect appears to be from decorative braid applied onto shiny silk satin.

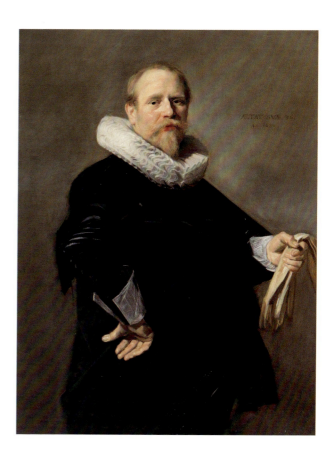

BELOW AND OVERLEAF (DETAIL)
Fig. 197 Frans Hals (c.1580–1666), *Portrait of a Man*, 1630.
Oil on canvas, 116.6 x 90.1 cm. RCIN 405349

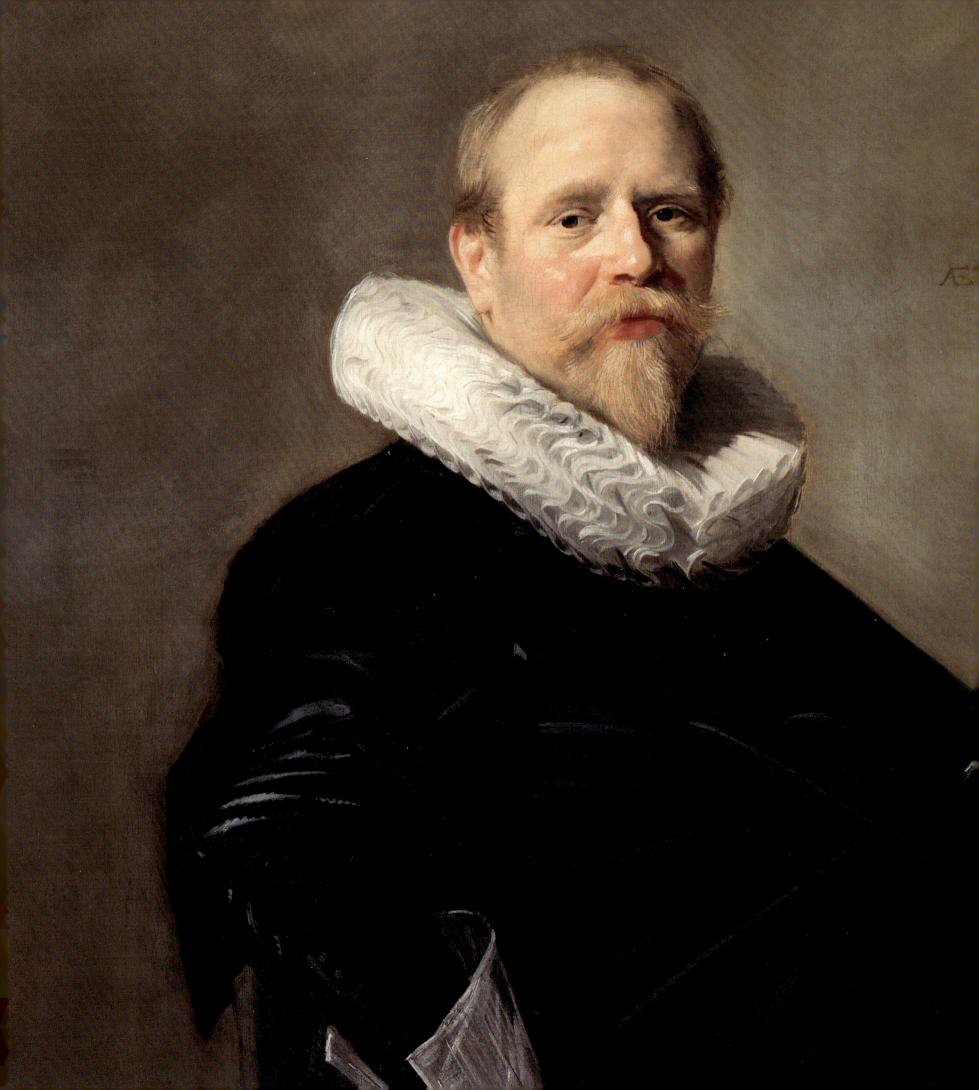

One of the most prominent features of this unknown man's clothing is his multi-layered ruff, constructed of crisp fine linen, together with his *ponjetten* (cuffs). Alongside black clothing, it was for high-quality linens that the Low Countries were particularly famous. Linen was widely used during the sixteenth and seventeenth centuries to make smocks, shirts, ruffs, caps, collars, kerchiefs – and more. Although a domestic flax industry in England did develop at the end of the sixteenth century, the finest linens were imported from the Low Countries throughout the period. *Holland* was used widely as the name for one of the most finely woven types of linen. The area was famous for the initial production of the raw materials (which could then be exported – linen thread was exported to Italy for lace-making, for example), and also for its involvement in the various stages in the manufacture of fine linen objects, including weaving, bleaching and starching.

Woven linen in its natural form is light brown. To achieve the level of white that was such a mark of pride and respectability, amongst even the poorer sections of society, bleaching was vital. As we have seen, the bleaching process involved a complex series of steps; it could take up to seven months to produce the brightest whites. Haarlem was the most important centre for the bleaching of linen in Europe, and many countries including England and Scotland sent their woven linens to Haarlem to be bleached. The location was ideal – water from the sand dunes nearby was of the perfect mineral content for bleaching, while local dairy farms provided buttermilk, a vital component to the bleaching process, as a waste product. The dunes themselves, covered in natural grass vegetation, made ideal bleaching fields for laying out the fabric. Other important ingredients, such as potash and soap, were easily imported due to Haarlem's location on the coast.[58] Linens were packed and prepared for trade in the same area then exported via the same waterway system.

Flemish émigrés from the south introduced superior techniques of bleaching to Haarlem and also provided much of the workforce.[59] Immigrants from the Low Countries also settled in England – many were artisans working in industries associated with clothing, including weaving. In his play *The Devil is an Ass* (1616), Ben Jonson refers to this immigrant community: 'To Shoreditch, Whitechapel and so to St Katharine's, To drink with the Dutch there and take forth their patterns'.[60] They introduced English craftsmen to new techniques and high standards of manufacture, producing a range of objects including hats, thread, bobbin lace and jewellery. As outlined in chapter 5, starch and heated poking sticks were required to set a linen ruff or piece of lace into the complex arrangements of pleats so frequently depicted in portraits of the period. Starch was produced from cereal grains like wheat, and its production was a month-long process in itself. The region was particularly recognised for its starching from an early date. A Flemish woman, Mistress Dinghen van der Plasse, set up the first starching business in England in 1564, while Elizabeth I appointed the Dutch-woman Gwillam Boone to the position of starcher by appointment.

Some of the most prominent elements of dress in English portraiture of the Caroline period are the wide, scalloped collars (falling bands) that spread over the shoulders. By the 1630s they had replaced other forms of fashionable neckwear for both men and women. This style of falling band was also worn in the Netherlands, although some members of the regent

FASHION ACROSS THE BORDERS 217

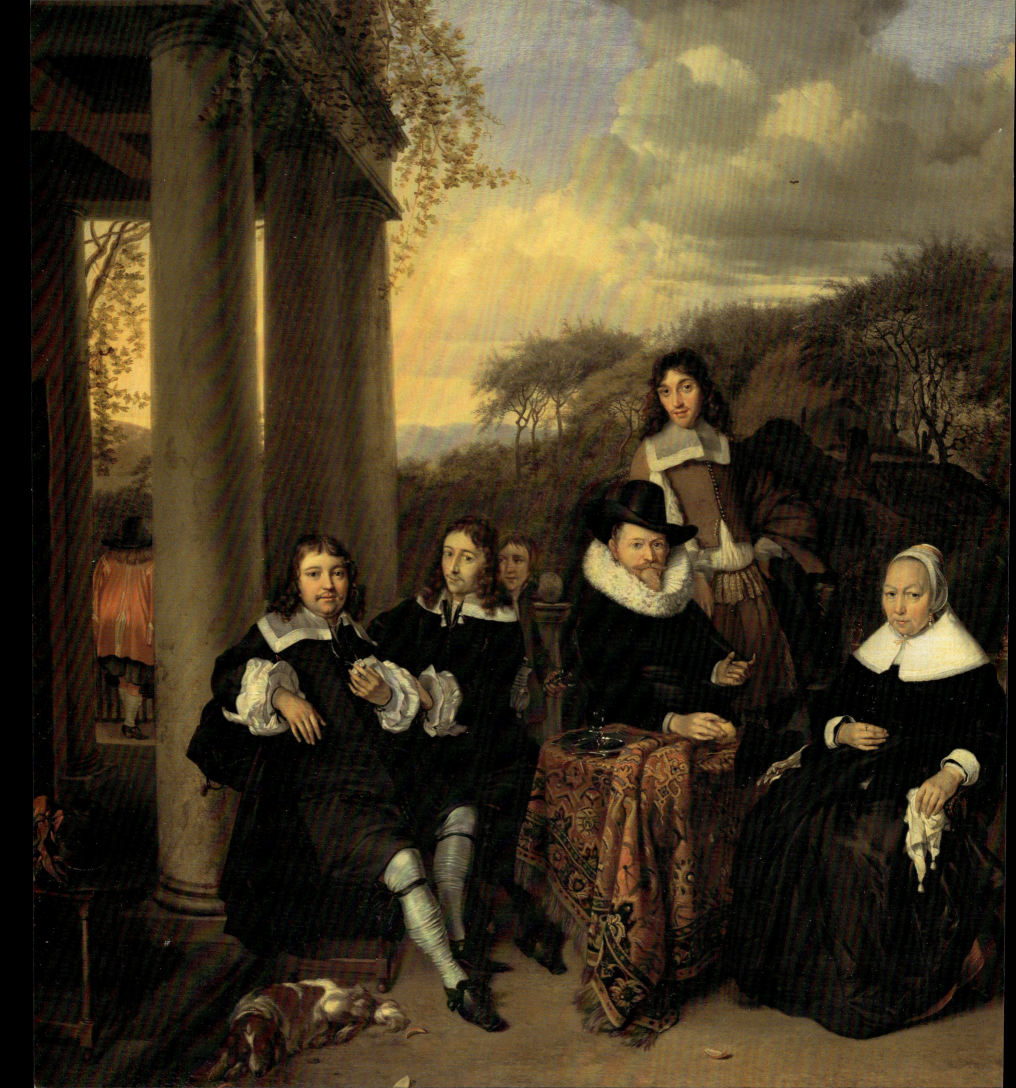

class continued to wear millstone collars – which grew progressively larger in size – until the middle of the century. While Italy had been producing the most desirable needle lace during the early part of the seventeenth century, it was the bobbin lace from Flanders that gained ascendancy by the late 1620s and was imported to England (and other countries in Europe). This Flemish bobbin lace was perfectly suited for falling bands. Its extraordinary lightness and delicacy, due to the open nature of the designs and the very fine linen thread used, provided a beautiful contrast against the fashionable unpatterned silks. The lace worn in the portrait of Agatha Bas (see figs 32 and 130) exemplifies the qualities of this lace perfectly, its whiteness delivering a dramatic contrast against the deep black silk of the bodice, and a softly sculptural effect at the cuffs. The lace-makers in Flanders, due to their proximity to Paris (by this date becoming a key centre for setting fashions), were able to produce lace that responded to and best complemented new styles of clothing.[61] Other countries responded by producing needle laces that imitated the laces produced by the bobbin technique; differentiating between the two in a portrait alone can be difficult. Flanders remained the most important centre for the production of fashionable lace during the seventeenth century until the 1670s, when Venice returned to prominence with the development of *gros point* needle lace.

While English fashions were influenced by the Low Countries, particularly with regards to linen and lace, there were characteristic features of dress in the Low Countries which remained specific to the region and which were never adopted in England. In Hendrick Avercamp's depiction of a fashionable young couple on skates (fig. 198), the man wears the tall crowned hat, standing band, tight doublet and voluminous breeches worn throughout much of Europe at around this time. The woman, however, wears a style of dress believed to have originated in the Netherlands. Worn by unmarried women and girls, the tight-waisted black dress with a fitted bodice fastened at the front was known as a *bouwen*.[62] Both married and unmarried

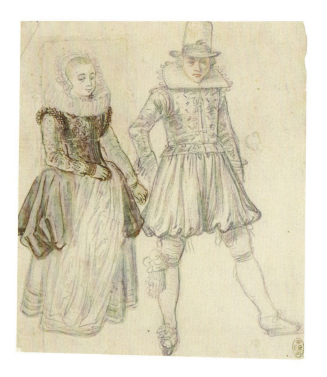

LEFT

Fig. 198 Hendrick Avercamp (1585–1634), *An elegantly dressed couple on skates*, c.1620.

Pen and brown ink over graphite with some watercolour on the female figure, and graphite with red chalk on the male figure, 14.5 x 13.0 cm. RCIN 906484

FAR LEFT

Fig. 199 (detail) Barent Graat (1628–1709), *A Family Group*, 1658.

Oil on canvas, 57.9 x 67.1 cm. RCIN 405341

women kept their heads covered, and this drawing also demonstrates the lace-trimmed linen cap frequently seen in Dutch portraiture during the first half of the seventeenth century. The curving front of the cap was shaped by a *hooftijsertgen* (head iron) which, as one English traveller wrote, 'so nipt in their Cheeks, that you would think some Faiery, to do them a mischief, had pincht them behind with Tongs'.[63] In the early years of the seventeenth century these caps were constructed of two separate layers of linen, one tight to the hair and the other shaped to flare over the ears, but it gradually lost one layer and was increasingly worn further back on the head.[64] By the mid-1630s this form of headdress had become so diminished that it took the form of a tiny cap covering a bun at the back of the head, as can be seen in the 1641 portrait of Agatha Bas (see fig. 32).

After *c*.1650 fashionable Dutch and Flemish women were more frequently painted wearing more brightly coloured bodices and skirts, that followed the lines of fashions seen in France and England rather than the black fashions of the first half of the century. Low square necklines increasingly reveal more of the décolletage, something not seen in the first half of the century due to the continuing influence of high-necked Spanish styles. This shift in fashion is clearly illustrated by the two unidentified female figures in Barent Graat's *A Family Group*, which was probably painted in Amsterdam and is dated 1658 (fig. 199). While the matriarch retains the black *vlieger* gown and linen cap that had been fashionable during her youth, her daughter wears a low-necked bodice and skirt of blue silk, together with a white silk petticoat. Unlike the older woman, whose hair is completely concealed by her linen cap, the younger woman's hair is set into a topknot hairstyle with curls falling over the shoulders and arranged around the forehead – a style seen in England at the same time. The most fashion-conscious of the three sons has adopted the short doublet and ribbon-trimmed petticoat breeches, a style of garment which first arrived in England from the French court during the same year this painting was produced. All the sons wear their hair longer than their father, and have not followed his rather outmoded preference for a pointed beard and moustache.

The French taste for a contrived negligence and casual nonchalance in dress also affected male fashions in the Low Countries during the 1640s, just as it did in England. By the latter years of the seventeenth century, Dutch and Flemish women – like their English contemporaries – were often painted in loose-fitting draperies, by artists such as Caspar Netscher. The style bore little relationship to the specificities of fashionable clothing.

BEYOND EUROPE

It would be a mistake to ignore the fact that areas further afield also had an impact on English customs, and there are many examples of how cultural exchanges across the globe influenced dress. In the mid-seventeenth century, William Feilding, 1st Earl of Denbigh, travelled around India and Persia for three years. When he returned to London in 1633, he brought with him jewellery and clothing from those regions. His position as Master of the Great Wardrobe for Charles I, coupled with his wife's position as Lady of Her Majesty's Robes in the household of Henrietta Maria, meant that clothing worn in other parts of the world would no doubt have been a subject for discussion with the king, his wife and other courtiers. Van Dyck's portrait of

the earl (fig. 200), painted soon after his return, certainly draws attention to foreign fashions. The sitter's clothing is a hybrid interpretation of eastern- and western-style trousers, based on the Indian 'paijama', and a coat cut with a much longer line than doublets fashionable in England at this date. Both are woven of pinkish-red silk with a gold stripe. The manner in which the coat is worn, however, with a short turn-down collar and lower buttons undone to reveal a voluminous white shirt, is evocative of contemporary styles in England (see fig. 8, for example). He wears European shoes.[65] It has been speculated that dress of this sort, seen by travelling courtiers such as William Feilding but also being worn by ambassadors to the English court, was one of the influences behind the development of the long man's vest, first seen in 1666.

To give just one more example of the growing taste for the 'exotic' amongst fashionable members of society in the seventeenth century – India became an increasingly important trading partner during the period. Textiles were by far the largest import, accounting for 84 percent of the English trade with India in 1684.[66] Brightly coloured and washable cotton fabrics (often called *callicoes*) were popular for Indian gowns, worn for example by the fashionable gentleman in his home before dressing to leave the house. The social-climbing Monsieur Jourdain in Molière's 1670 play *Le Bourgeois Gentilhomme* is dressed by his tailor in 'calico, because people of quality were like that in the morning'.[67] The importation of these fabrics via the East India Company produced such vociferous opposition, with the impact on domestic industries being of such concern, that the English parliament banned their importation in 1701. Similar legislation was also seen in France and Spain at around the same time.

During the Tudor and Stuart period England was both a melting pot of fashion ideas from abroad, and a purveyor of styles and commodities overseas. English courtiers throughout the period were open to new fashions, and were certainly not so nationalistic as to limit themselves to traditional 'English' styles constructed from home-produced fabrics.

Fig. 200 Sir Anthony van Dyck (1599–1641), *William Feilding, 1st Earl of Denbigh*, c.1633–4.
Oil on canvas, 247.5 x 148.5 cm. London, National Gallery. NG 5633

FASHION ACROSS THE BORDERS 221

7

PAINTED FOR BATTLE AND THE HUNT

All furnish'd, all in arms; All plumed
like estridges that with the wind;
Baited like eagles having lately bathed;
Glittering in golden coats, like images

Vernon to Hotspur, *King Henry IV Part I*, Act IV, scene i

FOR many men, to be painted wearing the clothes intended for battle was a means by which their dress could achieve a sense of timelessness, intended to transcend the specificities of fashions and tastes popular in any particular year. Arms and armour were also powerful emblems of personal identity, which could be engraved with personal mottoes or monograms and passed down from one generation to the next. Moreover, such a manner of dressing, with its historic associations of heroism and bravery, was following in the footsteps of an artistic convention which looked back to Ancient Greece and Rome for inspiration – like so much Renaissance art, literature and material culture. The exact form of the 'heroic' dress adopted varied considerably, and could consist of contemporary armour, historical armour (based either on classical forms or more recent styles), or other garments worn in battle such as the buff coat, together with other military attributes including the sword, commander's baton and helmet.

This chapter discusses some of the ways in which armour was used in sixteenth- and seventeenth-century portraiture, and demonstrates some of the close links between fashion and armour that may not at first glance be immediately obvious. Military dress exerted a strong influence on male civilian costume during the period.

MONARCHS AND ARMOUR IN PORTRAITURE

During the sixteenth century, it became increasingly common for artists on the Continent to represent monarchs and military leaders wearing armour – either standing, or mounted on horseback in the tradition of Roman equestrian sculpture. Titian's portrait of *Charles V* (fig. 201), painted in Augsburg in 1548, was particularly influential. In its brooding intensity it ensures the armour (which survives in the Royal Armoury in Madrid) is no mere afterthought but an integral part of the overall scheme of the painting, helping to set the sitter's mood of quiet determination and to illustrate his military might as Holy Roman Emperor of the hugely powerful Habsburg empire.

In England, however, although armour had been used to dress figures since the middle ages on brasses and funerary effigies, the fashion for monarchs to be painted in armour did not become widespread until the early seventeenth century. According to

Pp. 222–3 (detail from fig. 228) Adriaen Hanneman (1604–71), *William III when Prince of Orange*, 1664.

Fig. 201 Titian (1485/90–d. 1576), *Emperor Charles V on Horseback at Mühlberg*, 1548. Oil on canvas, 335 x 283 cm. Madrid, Museo del Prado

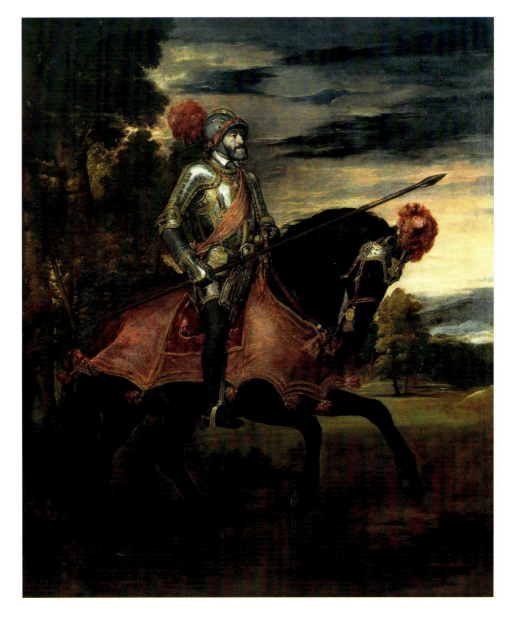

surviving portraits, in the sixteenth century Henry VIII chose instead to be painted with all the trappings of fashionable magnificence (jewellery, furs and metallic fabrics), despite his personal participation in battles abroad – although he is shown with swords and daggers. It seems that his son Edward VI was also never painted in armour. Both monarchs owned magnificent armour, some of which still survives today, yet apparently they never appeared wearing them in paint. Henry VIII's interest in armour is also demonstrated by the fact that he was responsible for establishing the Royal Almain Armoury at Greenwich by bringing armourers and craftsmen from the continent.

Unsurprisingly, the convention to be 'painted for battle' was not applied to women, since they did not participate in active warfare and did not commission armour. In some later sources Elizabeth I is said to have worn a breastplate while addressing the troops at Tilbury in 1588, although there is no contemporary evidence that she did so.[1] Elizabeth's military achievements are instead demonstrated in portraiture through the use of allegory and symbolism. In *The Armada Portrait* (*c*.1588, Woburn Abbey), for example, two different battle scenes representing the defeat of the Spanish armada are shown in the background, while her hand rests on a globe demonstrating the English dominance of the seas.

While several English noblemen (such as Nicholas Carew) chose to be painted wearing armour during the sixteenth century, the first English prince to embrace fully the convention was Henry, Prince of Wales (1594–1612), first son of James I. Both full-length oil paintings and miniatures show him dressed in this manner to emphasise his physical strength and martial abilities. In a large format miniature by Isaac Oliver (fig. 202), Henry wears armour decorated with embossed classicising motifs, including termes and symmetrical foliage all contained within gilded bands of decoration. Between these bands the steel has been blued – a process which uses heat to change the colour of the steel to a blue/black – and the fall of light across the curving surfaces has been beautifully rendered by the artist. Such contrasts of colour, in particular blues, blacks and russets in combination with the bright white of polished steel, were particularly characteristic of armours produced at the Greenwich armouries, although they incorporated design elements from Italian, Flemish and German armour.

Surviving armour that can be positively identified with that worn in a portrait is the French cuirassier armour of *c*.1607 (fig. 203), presented to the Prince of Wales by French nobleman, Claude de Lorraine, Prince de Joinville (1578–1657). Its small size reflects the fact that it was made for a prince aged around 13. Armour could be a huge investment, the highest quality examples costing far more even than a suit of the most expensive silk. It was an ostentatiously extravagant diplomatic gift – even more so when, like this example, it was for an adolescent prince who would soon outgrow such a gift. Nicholas Hilliard executed a miniature (also dated 1607) showing the armour as it would have appeared originally (fig. 204). The shape of the patterns across its surface make the armour recognisable, however it shows that the plain straight bands of undecorated metal which run parallel to the gilded sections would originally have been white and not blue/black as they are today.

That it is the armour which has changed and not the pigments of the miniature is corroborated by the inclusion of the miniature in Abraham van der Doort's inventory of the

OPPOSITE
Fig. 202 Isaac Oliver (*c*.1565–1617), *Henry Frederick, Prince of Wales*, *c*.1612.
Watercolour on vellum laid on card, 13.2 x 10.0 cm.
RCIN 420058

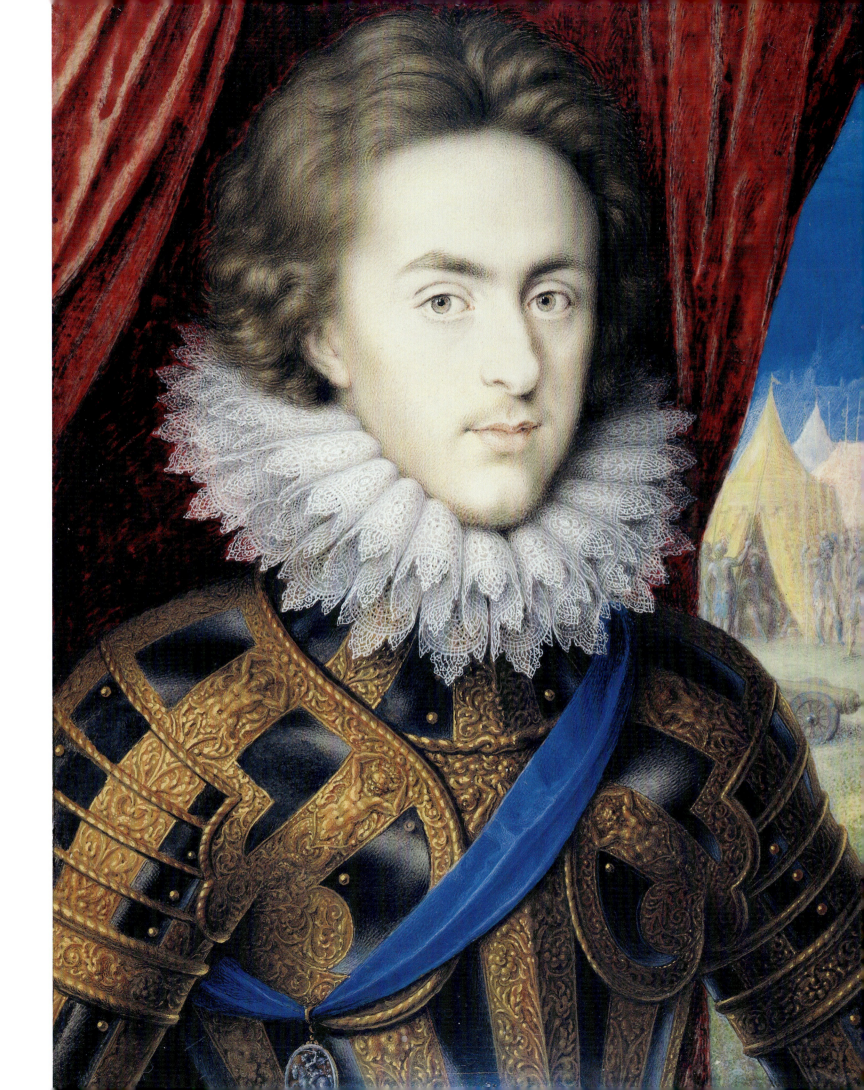

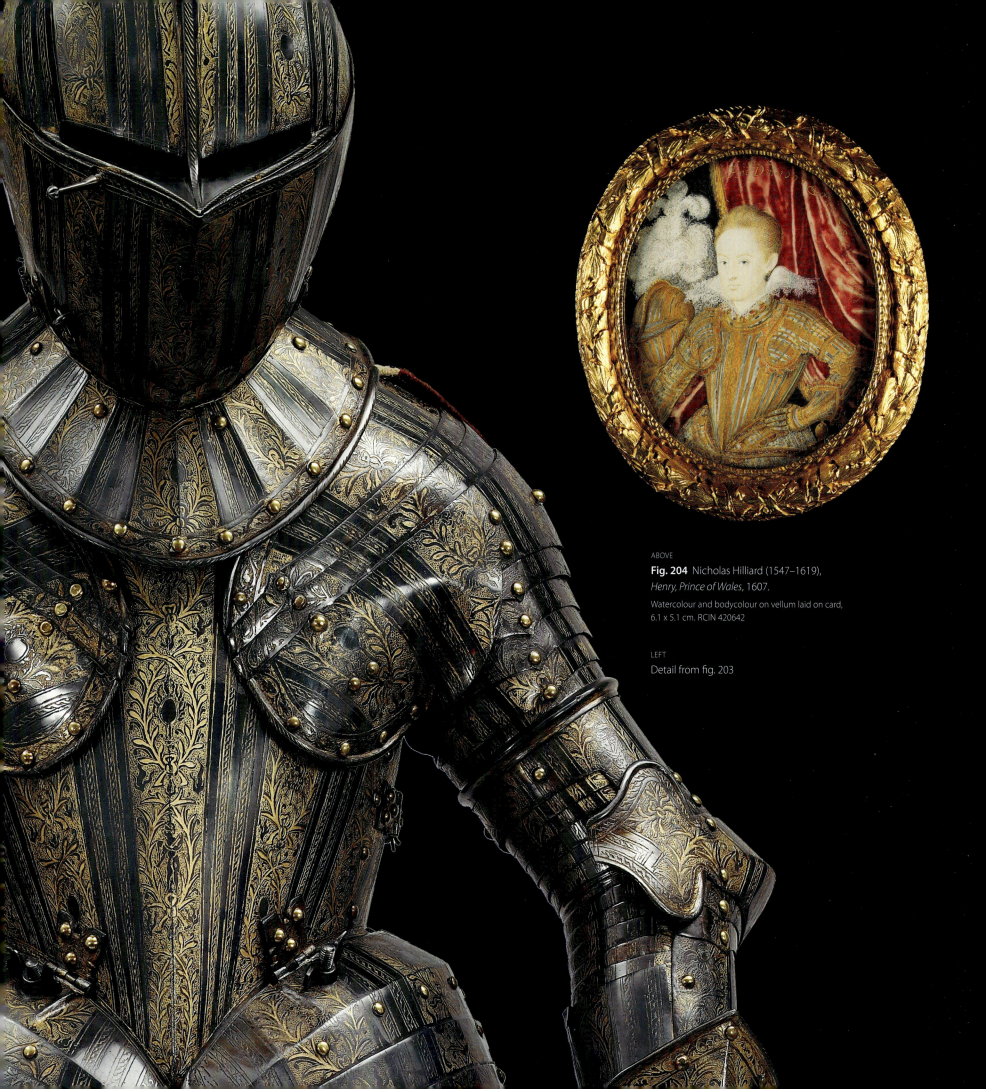

ABOVE

Fig. 204 Nicholas Hilliard (1547–1619), *Henry, Prince of Wales*, 1607.

Watercolour and bodycolour on vellum laid on card, 6.1 x 5.1 cm. RCIN 420642

LEFT

Detail from fig. 203

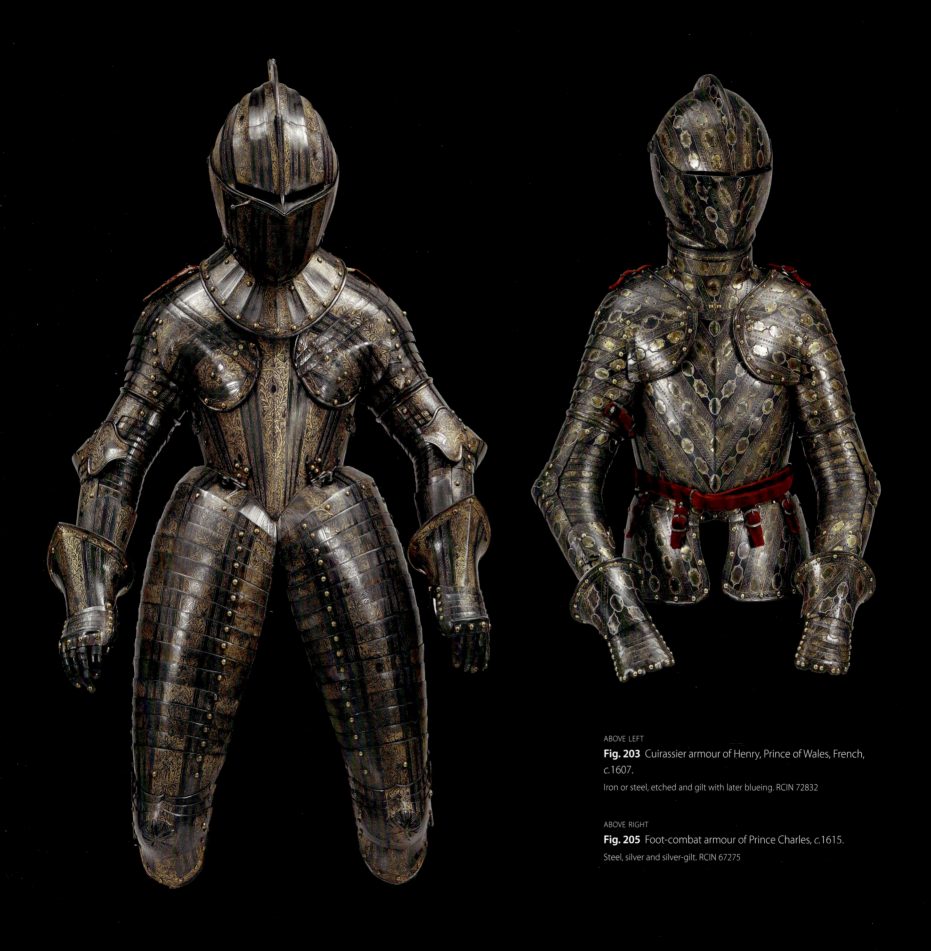

ABOVE LEFT
Fig. 203 Cuirassier armour of Henry, Prince of Wales, French, c.1607.
Iron or steel, etched and gilt with later blueing. RCIN 72832

ABOVE RIGHT
Fig. 205 Foot-combat armour of Prince Charles, c.1615.
Steel, silver and silver-gilt. RCIN 67275

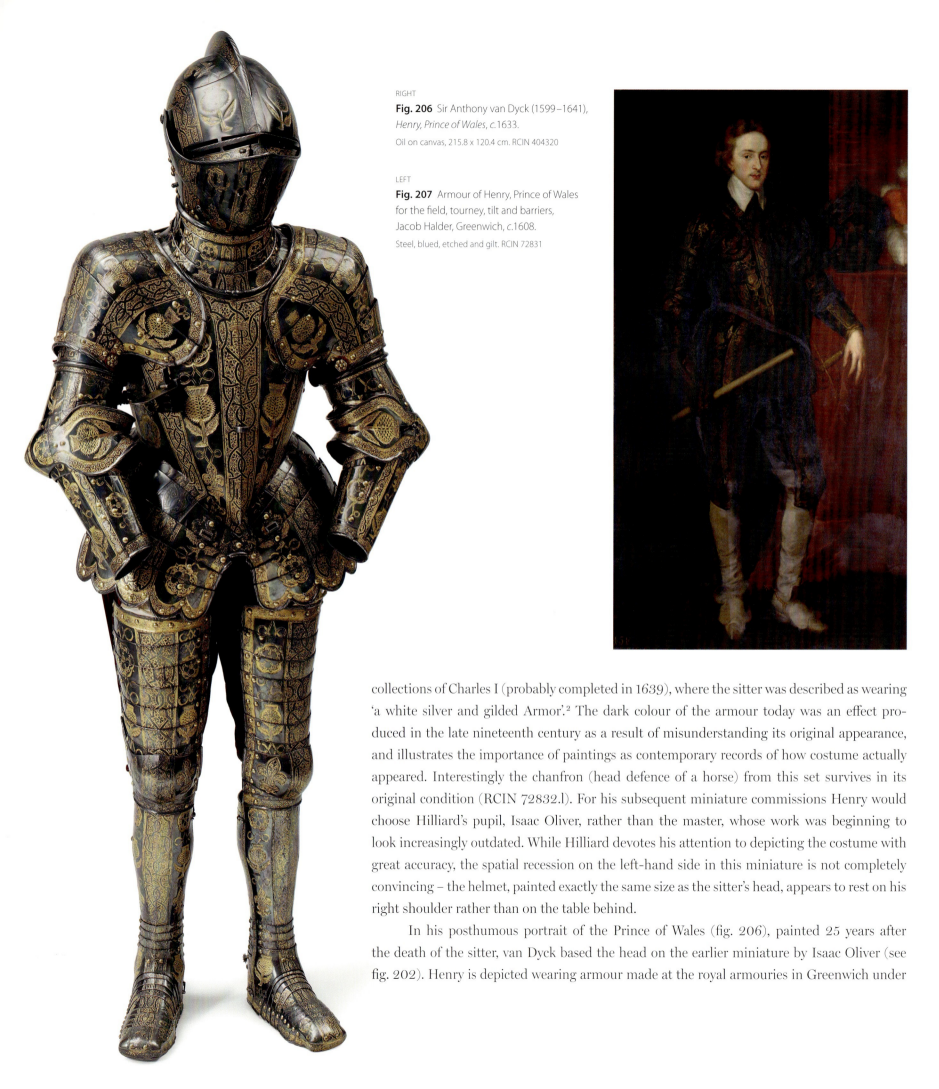

RIGHT
Fig. 206 Sir Anthony van Dyck (1599–1641), *Henry, Prince of Wales*, c.1633.
Oil on canvas, 215.8 x 120.4 cm. RCIN 404320

LEFT
Fig. 207 Armour of Henry, Prince of Wales for the field, tourney, tilt and barriers, Jacob Halder, Greenwich, c.1608.
Steel, blued, etched and gilt. RCIN 72831

collections of Charles I (probably completed in 1639), where the sitter was described as wearing 'a white silver and gilded Armor'.[2] The dark colour of the armour today was an effect produced in the late nineteenth century as a result of misunderstanding its original appearance, and illustrates the importance of paintings as contemporary records of how costume actually appeared. Interestingly the chanfron (head defence of a horse) from this set survives in its original condition (RCIN 72832.l). For his subsequent miniature commissions Henry would choose Hilliard's pupil, Isaac Oliver, rather than the master, whose work was beginning to look increasingly outdated. While Hilliard devotes his attention to depicting the costume with great accuracy, the spatial recession on the left-hand side in this miniature is not completely convincing – the helmet, painted exactly the same size as the sitter's head, appears to rest on his right shoulder rather than on the table behind.

In his posthumous portrait of the Prince of Wales (fig. 206), painted 25 years after the death of the sitter, van Dyck based the head on the earlier miniature by Isaac Oliver (see fig. 202). Henry is depicted wearing armour made at the royal armouries in Greenwich under

Jacob Halder in *c*.1608 at a cost of £340 – approximately £33,000 today.³ Presented to the prince by Sir Henry Lee, who served as Master of the Royal Armoury from 1590 to his death, it survives in the Royal Collection today (fig. 207). It is decorated with etched and gilded bands decorated with strapwork, and the HP monogram together with the fleurs-de-lis, thistles and the Tudor rose – emblems of the Union of the Crowns which occurred with the accession of James VI of Scotland to the English throne in 1603.

The portrait was probably commissioned by Charles I as part of a collection of historic portraits for the Cross Gallery at Somerset House. The armour was presumably worn by a member of the royal household with similar stature to the deceased prince while the portrait was being painted. Paintings like these, depicting actual surviving items of armour, provide an opportunity to examine how the artist translates the three-dimensional form and surface decoration into a flat image. In the case of this example, the unusual level of specificity with which van Dyck has depicted the armour (perhaps under express command from the king) means that it rather overpowers the rest of the figure. Perhaps this is not surprising, given that the subject himself never appeared in front of the artist in person. Since van Dyck is not able to focus on the personality of the sitter, he instead devotes more attention than he would usually to the details of the costume.

Unlike his son, James I appears never to have embraced the convention of being painted in armour. The closest he gets is being depicted next to a pile of armour in a portrait by Paul van Somer of 1618. He wears just the *gorget* (metal collar), which is decorated with the initials 'IR' for *Iacobus Rex* (King James) (fig. 208). By this date it was becoming increasingly common for men to combine pieces of armour with civilian clothing, wearing them almost like fashion accessories, and this pattern of wear appears more frequently in portraiture. A gorget and reinforcing beaver of Greenwich armour in the Tower of London have been associated with the armour in this portrait, however the pile on the floor bears a remarkable resemblance to Henry's armour (see fig. 207). Is it included here as a conscious reference to his deceased son? Instead of wearing the full armour the king instead has chosen to don a sombre black doublet and breeches – perhaps as a sign of continued mourning for the beloved Prince Henry, although by this date the official mourning period would have finished. The armour provides an interesting complement to the traditional regalia of kingship (crown, orb and sceptre), which have been positioned on a carpet-covered table on the right. Perhaps the inclusion of each is intended to indicate the dual role of the monarch as both head of the state and head of the military.

Throughout the rest of the seventeenth century, to be painted in armour became a particularly popular means for the Stuart kings, together with other members of the nobility, to assert their bravery and heroic qualifications – whether they were recognised for their military successes or not. A man with more of a claim to military success than most was the Protestant

Fig. 208 Paul van Somer (*c*.1576–1621), *James VI and I*, 1618.
Oil on canvas, 269.6 × 139.1 cm. RCIN 401224

PAINTED FOR BATTLE AND THE HUNT 231

OPPOSITE
Fig. 209 Willem Wissing (1656–87),
William III when Prince of Orange, 1685.
Oil on canvas, 124.6 x 102.5 cm. RCIN 405644

RIGHT
Fig. 210 Lesser George, known as 'The Strafford George'
c.1675–1700.
Onyx: brown, light grey, dark grey; gold, silver, enamel,
Dutch rose-cut diamonds, 8.0 x 4.8 cm. RCIN 441379

BELOW
Fig. 211 Sir Anthony van Dyck (1599–1641),
Charles I with Monsieur de St Antoine, 1633.
Oil on canvas, 370.0 x 270.0 cm. RCIN 405322

William III, who both before and after his accession to the English throne in 1689 remained an active participant in the wars against Catholic France. In the majority of his portraits William chooses to wear plain armour with minimal surface decoration – as in the 1685 painting by Wissing (fig. 209). With baton in hand (the traditional insignia of command), and wearing full plate armour of highly polished steel, William is the archetypal commander – serious and authoritative, seemingly with little concern for the frivolities of fashion. It is interesting to notice, however, that his cravat is of the most expensive and fashionable Venetian *gros point* lace, and he wears a Lesser George (the badge of the Order of the Garter) set with large rose-cut diamonds. Very similar is the example in fig. 210. Traditionally associated with Thomas Wentworth, 1st Earl of Strafford (1593–1641), it probably dates instead from the second half of the seventeenth century. It is centrally set with an onyx stone carved with St George slaying the dragon, and includes rose-cut diamonds, while the reverse is enamelled with a miniature painting of St George and the dragon, and surrounded by the Garter motto. The Lesser George was a more practical form of the Garter regalia than the Great George and Garter chain and, as such, was more suitable to be worn with armour – and also while hunting, usually tucked under one arm (as displayed here). In contemporary accounts of goldsmiths, the Lesser George was sometimes described as a Hunting George.

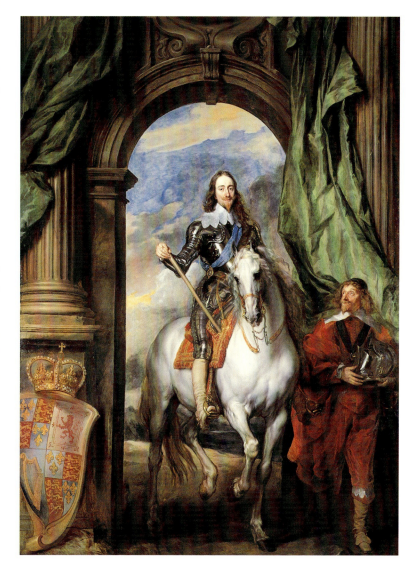

The style of armour worn by William in this portrait is almost identical to that worn by his grandfather, Charles I, in the well-known equestrian portrait by van Dyck, *Charles I with Monsieur de St Antoine*, painted over 50 years earlier (fig. 211). Like William, Charles wears his Garter badge on a blue silk ribbon passing over his left shoulder. While the armour and Garter badge have changed little over the 50 years, each man's lace collar is highly distinctive of its own period in terms of both design and technique. In hairstyle, too, each man betrays the styles of his own era – Charles wears his natural hair with his asymmetric lovelock over his left shoulder, together with the pointed beard and moustache. Given the date of the painting William's long wavy hair is likely to be a wig, although in its styling it looks rather less artificial than others of this period and is surprisingly flat on the crown – perhaps this is a deliberate attempt to suggest that the helmet by his side has been recently removed, and is perhaps also a reference to the lack of vanity of its wearer.

PAINTED FOR BATTLE AND THE HUNT 233

ABOVE

Fig. 213 (detail from fig. 2) Remigius van Leemput (d. 1675), *Henry VII, Elizabeth of York, Henry VIII and Jane Seymour* (copy of 'The Whitehall Mural'), 1667.

Oil on canvas, 88.9 x 99.2 cm. RCIN 405750

BELOW

Fig. 212 Sabatons from Henry VIII's armour for the field and tilt, Erasmus Kyrkenar, Greenwich, c.1539.

Steel. RCIN 72834

BELOW RIGHT

Fig. 215 Jacob Halder, *Design for Sir Christopher Hatton's Armour* from *Almain Armourers Album*.

Pen, ink and watercolour on paper, 43 x 29.2 cm. V&A, London. Acc. D.600A-1894

OPPOSITE

Fig. 214 Armour of Sir Christopher Hatton for the Field, Tourney Course, Tilt and Barriers, Jacob Halder, Greenwich, 1585.

Steel, blued, etched and gilt. RCIN 72835

ARMOUR AND FASHION

While being painted in armour was a means of achieving a sense of timeless heroism, to suggest that styles of armour remained consistent in terms of shape and style throughout the period under examination would be misleading. A deeper look reveals that the shape of armour closely follows the prevailing silhouette of contemporary dress, and armour manufacturers were evidently very aware of the fashionable styles of the day. An overall similarity in silhouette is perhaps unsurprising, since armour needed to fit comfortably over clothing, so as shoulders widen around the middle of the sixteenth century this effect is echoed in the armour of the period.[4] Likewise the waistline of the breastplate (whether high, natural or low), its shape (straight or pointed) and the volume of the *tassets* (leg coverings) follow the fluctuations of their analogous items of clothing, namely the doublet and trunk hose. So too the fashionable shape of civilian shoes influences the shape of the *sabaton* – the piece of armour covering the foot. The transition from the long, pointed and highly impractical sabatons of the fifteenth century, which echoed the pointed *poulaines* of medieval dress, to the square-toed examples increasingly found on armour during the first half of the sixteenth century is clearly indicated by fig. 212. Henry VIII wears shoes of this square shape in the 'Whitehall Mural', the original of which was commissioned in 1537 (detail in fig. 213).

Even the codpiece and peascod belly find their equivalent in metal form – in armour, both served an important protective function. The strong vertical line down the front of a breastplate echoed the buttonholed centre-front of the doublet; it became exaggeratedly extended into a point over the stomach after 1560, just as the peascod shape did in male doublets. The V-shape of the projecting breastplate added strength to the armour, and encouraged the point of an attacking weapon to be deflected rather than pierce the metal. The armour shown in fig. 214 is of blued and russetted steel, and was made in 1585 for Sir Christopher Hatton (1540–91), politician and favourite of Elizabeth I. It can be identified by its appearance in the 'Almain Armourer's Album' (fig. 215), a manuscript probably produced by armourer

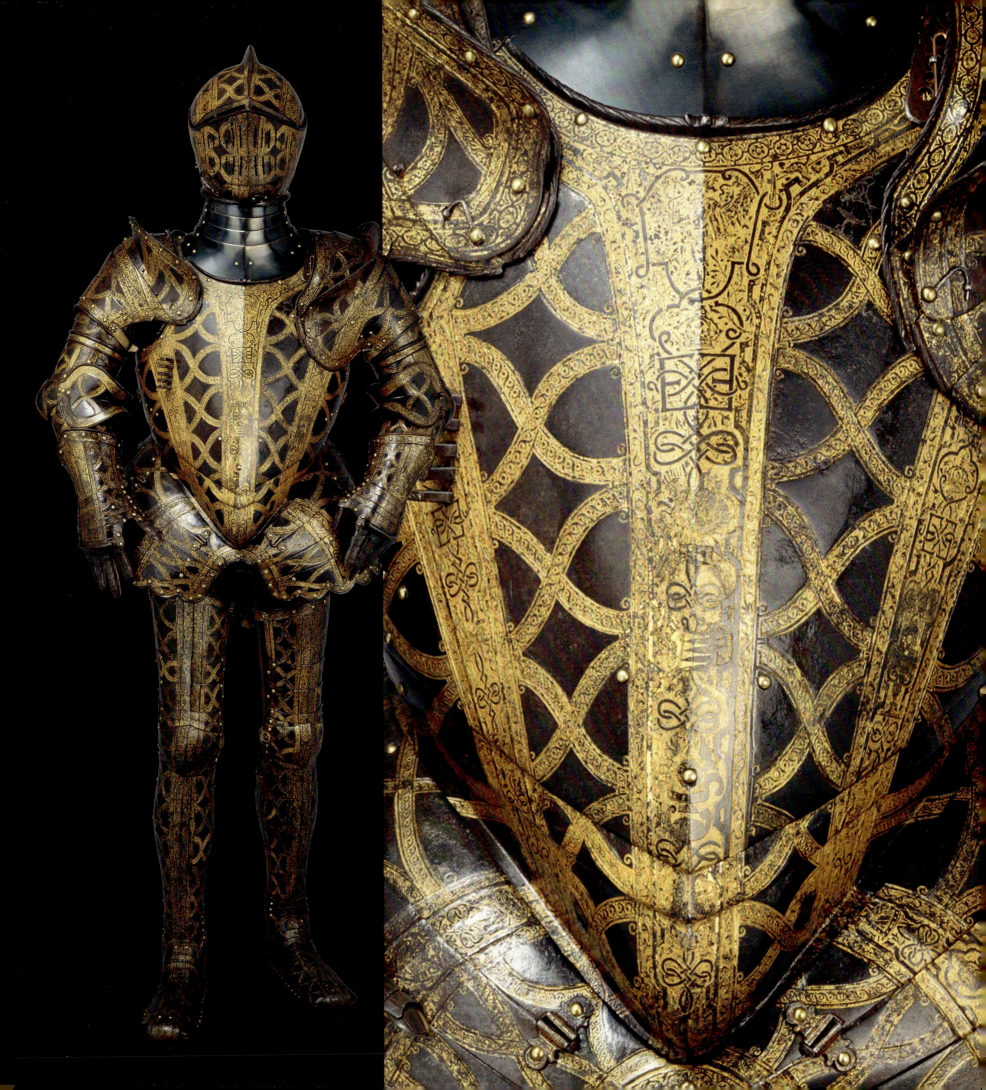

Fig. 216 Daniel Hopfer (1493–1536), *Five German Soldiers*, c.1520.
Berlin, Deutsches Historisches Museum

Jacob Halder, containing design drawings for the armour of 23 high-ranking Elizabethan courtiers. The shape of the breastplate in this armour reflects the peascod belly, which by the end of the sixteenth century had begun to fall from favour amongst the fashionable elite.

While fashionable civilian dress exerted a strong influence on military clothing, the inspiration was not one-directional. The fashion for slashing and puffing in sixteenth- and seventeenth-century clothing – the creation of cuts in an upper layer of fabric, through which contrasting layers were pulled from beneath – had its origins in the clothing worn by the *Landsknechte*, the highly paid Swiss and German mercenaries who fought in a variety of wars across Europe throughout the sixteenth century (fig. 216). Exempt from clothing legislation, these troops became known for their mismatching and elaborate brightly coloured attire. Looted scraps of fabric (trophies of war taken from the clothing and tents of the dead) were attached to their clothes, creating a deliberately tattered appearance; the fashion was copied by civilians in the form of slashing and had spread to England by the 1490s. Henry VIII hired a substantial number of Landsknechte soldiers during the 1540s to fight in the wars against France and Scotland,[5] but his portraits demonstrate that he adopted puffing and slashing well before this date (see fig. 217, for example), and so would have been aware of the influence of the style on continental fashions. Puffing and slashing was one way for the rich to demonstrate their wealth and ability to afford multiple layers of excess fabric.

Perhaps more surprising than the similarities in silhouette between clothing and armour are the similarities in their decorative surface effects. The fashions for slashing, puffing, pleating and paning were replicated in armour through a variety of metalwork techniques. One example is clearly shown in armour dated to 1525 in the Kunsthistorisches Museum, Vienna

LEFT
Fig. 217 Joos van Cleve
(active 1505/8–40/1), *Henry VIII*, c.1530–5.
Oil on panel, 72.4 x 58.6 cm. RCIN 403368

RIGHT
Fig. 218 Armour for field and tilt,
made for Wilhelm Freiherr von Roggendorf
by Kolman Helmschmid, 1525.
Vienna, Kunsthistorisches Museum

(fig. 218). This extraordinary costume armour has arm sections designed to look like strips of fabric, gathered into puffs at four points down each arm and slashed with crescent shaped slits. The gaps in between these 'panes' have been etched with classical ornament, while the dark background of these areas encourages them to recede and appear as a layer below the smoother sections. Armour could also be decorated with a fluted effect, imitating pleated fabric on doublets and breeches found in the late fifteenth and early sixteenth century, although on the greaves (pieces below the knee covering the shins and calves) the metal was left plain so as to reproduce the effect of smooth unwrinkled stockings. Gilding on armour was also used to imitate fabrics woven with metal threads. Etching could imitate embroidery, and indeed sometimes used the same sources for inspiration, such as John Gerard's *The Herball*. It is interesting to note that Holbein designed both jewellery and armour.

While armour often has simple fabric linings the inherent structural properties of the metal from which it is formed mean it has no need for the padding or *bombast* of surviving garments, whose final appearance on the body must partly be conjectured through the examination of similar garments in portraits. Armour also has a higher survival rate than that of fashionable dress of the sixteenth and seventeenth centuries. A single hawking glove in Oxford's Ashmolean Museum[6] is the only surviving item of clothing associated with Henry VIII, yet armour worn by the monarch covering a period of approximately 30 years is

OPPOSITE
Fig. 219 Sir Peter Lely (1618–80), *Sir John Lawson*, c.1665.
Oil on canvas, 127.6 × 102.2 cm. RCIN 405153

BELOW
Fig. 220 Buff coat, British, 1640–60. Leather, with whalebone stiffening and silver-gilt braids.
London, V&A Museum. Acc. T.34-1948

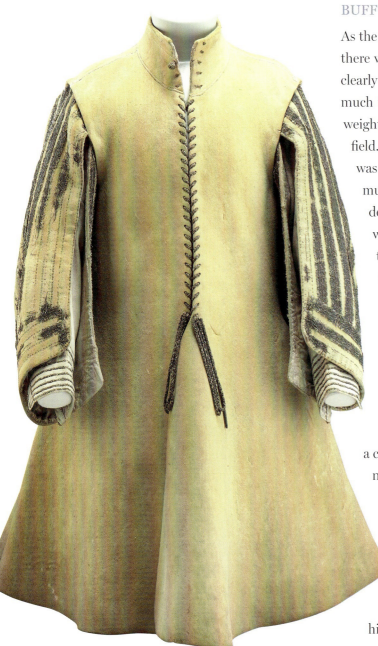

still in existence. It ranges from the Flemish 'silvered and engraved armour' of c.1515 (Royal Armouries) – decorated with the letters 'H' and 'K', thought to commemorate Henry's marriage to Katherine of Aragon in 1509 – to the Wilton Anime armour of c.1544 (Metropolitan Museum, New York). By this time the monarch's waist circumference had reached around 50 inches, compared to 34 inches at the age of 23. Since armour was made-to-measure and had to fit precisely for it to be comfortable, the sequence provides a fascinating documentation of Henry VIII's changing weight and body shape. There was little capacity for making adjustments as the owner's silhouette changed over time, unlike clothing which could be let in or out – although interestingly one of Henry VIII's armours (RCIN 72834) has been let out at the backplate and has three settings on the waist clasps. Moreover, armour was not subject to the potential flattery that the paint medium allowed in portraiture.

BUFF COATS

As the nature of warfare became more focused on gunpowder during the seventeenth century, there was a shift in the type of clothing that would best protect its wearer, and this change is clearly reflected in portraiture. Increasingly efficient firearms meant that armour needed to be much thicker in order to protect against shot from muskets. The accompanying increase in weight made armour more cumbersome, and allowed its wearer less mobility on the battlefield. A lighter alternative that became increasingly popular during the seventeenth century was the buff coat, which could protect against bad weather, sword cuts and possibly even musket shot at long range. The term *buff* indicates that this was a form of leather originally derived from the skins of European buffalo, although by the seventeenth century buff was a more generic term, covering hides from cow, elk or deer.[7] The buff coat covered the vital organs and was often worn with a back and breastplate for additional protection. They are a common element of dress in portraits of the nobility painted during the Civil War (1642–1651), and both Parliamentarian and Royalist cavalrymen and officers wore them. Their expense (up to £10 for a high-quality example, equivalent to approximately £860 today) made them unaffordable for the majority of infantrymen. The deer parks raided during the Civil War probably provided a new source for buff leather to clothe soldiers.[8]

The shift from armour to buff coats is clearly reflected in portraiture. A typical buff coat is shown in Lely's portrait of Sir John Lawson (fig. 219). By the 1660s Lawson was a committed royalist although during the Civil War he had fought for the Parliamentarian navy, reaching the rank of Commander-in-Chief of the fleet by 1659. This was one of a set of 13 portraits commissioned by James, Duke of York, who commanded the English fleet, to commemorate the 13 'Flaggmen' in the battle of Lowestoft in Suffolk, 1665. A scene depicting the English victory is depicted in the background.[9] In 1665 Lawson died from a knee injury inflicted at the battle, and this portrait may have been painted while he was dying of the infected wound or as a posthumous tribute.

Lawson wears his buff coat with a breastplate and bright red sash around his waist. As the portrait indicates, sleeves for high-ranking officers could sometimes be

SIR JOHN LAWSON. LELY.

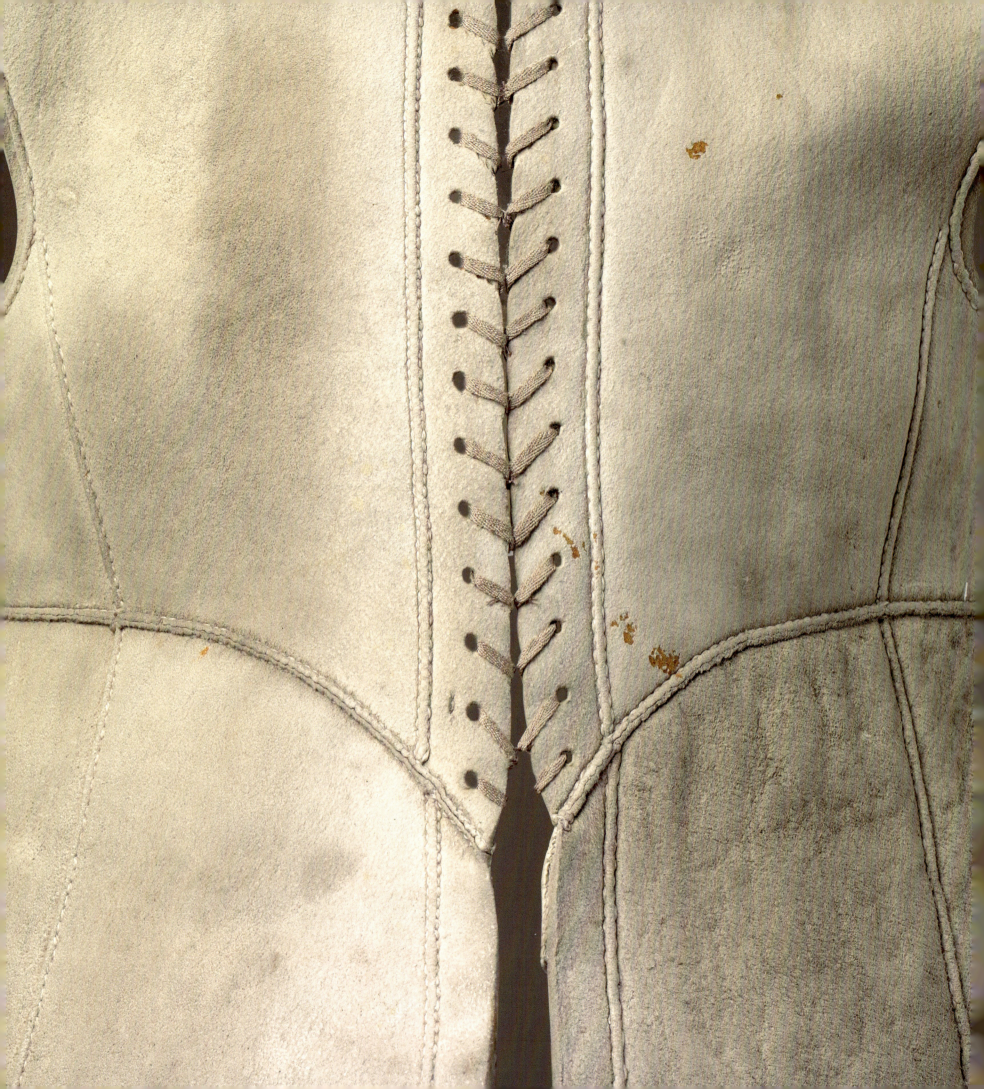

decorated with applied metal braid. In a similar example in the V&A (fig. 220), the sleeves are made of a softer type of leather than the body, which would have made the practical process of attaching this applied decoration much simpler. To sew through standard buff leather was a laborious process, requiring holes to be pierced first with an awl for the needle to be passed through. These sleeves of thinner leather would also have made it easier to move the arms. Surviving buff coats and portraits demonstrate that styles both with and without sleeves were popular.

A more detailed examination of a sleeveless buff coat is revealing (fig. 221). This example is associated with Charles I, and its small size (86 cm around the waistline) would fit with the monarch's petite build. Although a practical, very much worn item, this coat is not purely utilitarian in construction. It is lined in areas with finer quality leather, and rows of stitching add subtle decoration in the form of false butt seams. The best buff coats were skilfully constructed so that the thickest part of the hide was used to cover the most important parts of the body, and this is clearly evident in this example, for which the buff is much thicker on the front tabs which cover the thighs than on the back tabs, since the thighs would be exposed while riding a horse. Diagonal patterns of wear on both sets of the front lacing holes, together with evidence of rusting on the interior along these edges, indicates that cord laces were wrapped through the holes as decoration but that the doublet itself was fastened with metal hooks and eyes. This would have made the buff coat much quicker to put on and remove than if it had to be laced up each time and was a standard feature of buff coats during this period – an element of their construction that is not evident through an examination of portraiture alone, which suggests they are fastened by laces.

Interestingly, while most portraits of the Civil War period show buff coats with waistlines cut straight across the front, this example has the pointed shape typical of the 1620s. It is conceivable that this was a buff coat originally used for riding rather than warfare in the years before the Civil War, and indeed during the seventeenth century buff coats became fashionable items of everyday wear for gentlemen. There is a large uneven hole in one of the tabs at the centre back – this piece was presumably taken by souvenir hunters, perhaps in the nineteenth century when Charles I's reputation was almost martyr-like.

The buff coat was a quintessential item of male dress, which makes its appearance in a portrait of the highly fashionable female courtier, Frances Teresa Stuart, a rather perplexing choice (fig. 222). While the sitter was known to have owned riding habits (fashionable items of female dress influenced by male tailoring), and was painted wearing that style in a miniature by Samuel Cooper (see fig. 244), there are no records or descriptions of Frances Stuart ever having appeared in public wearing in a buff coat. On 26 August 1664 Samuel Pepys records seeing in the studio of Huysmans portraits including 'Mayds of Honour (particularly Mrs Stewart in a buff doublet like a soldier) as good pictures, I think, as ever I saw'.[10] This quote demonstrates that the sitter's attire was atypical enough for it to be worthy of note, and that it was immediately associated in the diarist's eyes with soldiers. The Restoration period saw the rise of female actresses on stage,

ABOVE AND OPPOSITE
Fig. 221 Buff coat, English, *c.*1640. London, the family of Lord Acton, cared for at Hampton Court

PAINTED FOR BATTLE AND THE HUNT 241

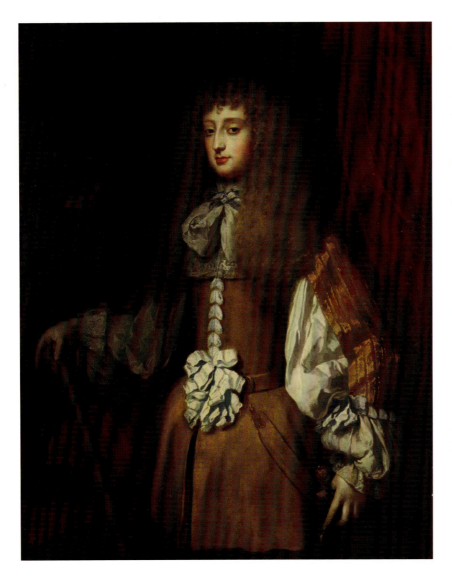

ABOVE AND OPPOSITE (DETAIL)
Fig. 222 Jacob Huysmans (c.1633–96), *Frances Stuart, later Duchess of Richmond*, 1664. Oil on canvas, 127.7 × 104.4 cm. RCIN 405876

and some became famous for playing boys in breeches (particularly sensational due to the resultant exposure of the ankle and leg). However Frances Stuart never appeared on stage and is not playing any known fictional character here. By adopting the traditional pose for a military officer, clasping the baton of command and sword, and with her hair styled to resemble a fashionable male periwig of the period, she very deliberately adopts a masculine persona.

The front tab below the waist of the jacket has been depicted by the artist from the side and clearly demonstrates the thickness of the leather as seen in surviving garments. The gold braid-trimmed sleeves in this example may be attached to the buff coat or alternatively may instead be the sleeves of a doublet worn beneath, since they are open down each arm in the style of fashionable male doublets, revealing the sleeves of the billowing linen smock beneath. The coat is trimmed with multiple bows of wide pale blue ribbon; the same ribbon is wrapped around the lower edges of the sleeves.

A clue that indicates the sitter is female lies in the shape of the torso – it reflects the fashionable conical line of the stiffened bodice around this date (see fig. 31), not seen in portraits of men in buff coats. Despite the masculine attire this emphasises her narrow waist, and it is interesting to speculate whether this small detail would have immediately indicated the gender of the sitter to the contemporary viewer. Why she chose to be depicted in this manner must for now remain a question for conjecture, but it adds another interesting dimension to what must surely have been a very conscious self-fashioning of her image. The portrait was presumably painted for Charles II, who greatly admired Frances Stuart, but who never apparently persuaded her to become one of his mistresses. Whether he also had some input into the decision about her wearing a buff coat for the portrait is another matter for speculation – but as a private picture for the king, perhaps the rather suggestive manner in which the tabs of the buff coat open vertically at the front over the groin (together with the proximity of the baton, and the ribbons suggesting pubic hair) may be intended as a private joke that the rather lascivious Charles would have enjoyed.

CUIRASSIER ARMOUR

The style of three-quarter length cuirassier armour seen in seventeenth-century portraits such that of Charles, Prince of Wales (fig. 223), was a direct descendant of the armour worn by medieval knights on horseback, and as such it evoked ideals of chivalry and virtue. The tradition of portraying monarchs, generals and other nobleman in this type of armour persisted into the nineteenth century. The armour was named after the *cuirassier* – highly paid cavalry, historically drawn from the noble classes, who were trained to charge at the enemy and so needed

242 IN FINE STYLE

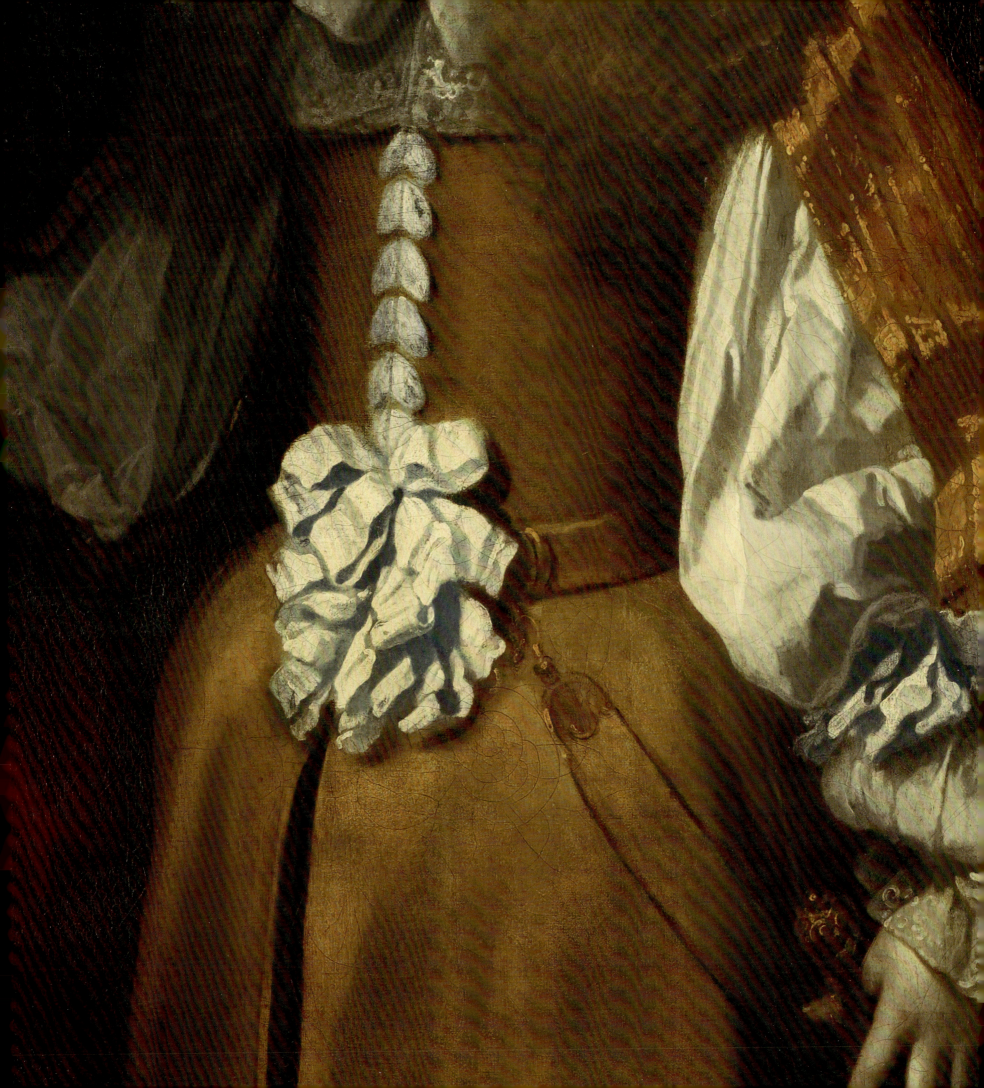

(and could afford to purchase) maximum protection from their armour including the cuirasse covering the torso. The multiple components of this type of armour can be seen in the illustration taken from *Art militaire a cheval* (fig. 224), a military manual first published in 1616 by Johann Jacob von Wallhausen, Director of the first European Military Academy in Siegen (present-day Germany).

Whether or not monarchs and noblemen actually wore this armour during the seventeenth century is debatable – its appearance in portraiture could simply have been intended as a purely historicising gesture. As we have seen, full plate armour was becoming increasingly outdated for modern warfare, and by the time of the Civil War it was recognised that cuirassier armour was an impractical solution for the wearer, hampering mobility. And not only was it difficult to find horses strong enough to carry the additional weight, but the armour was financially out of reach for the increasingly large number of soldiers drawn from the lower social classes. Soldiers started to leave off certain components of armour – Sir Edmund Verney, a Royalist officer writing in 1639 to request new, lighter armour, said, 'it will kill a man to serve in a whole Curass. I am resolved to use nothing but back, brest and gauntlet'.[11] While two cuirassier cavalry regiments did serve during the Civil War (the most famous of which was Sir Arthur Haselrig's 'London Lobsters', nicknamed after the appearance of their armour – the helmets were known as 'lobster pots'), they were progressively replaced by the more lightly armed harquebusiers, wearing breastplates and helmets.

Individual cavalrymen however continued to wear cuirassier armour, and it had the advantage of allowing princely commanders and generals to be able to survey the whole battlefield from horseback with relative safety from distant fire.[12] Charles I is reported to have worn full

BELOW LEFT
Fig. 224 *Components of Armour*, etching, fig. 2, between pp. 24 and 25, in Johann Jacob von Wallhausen (c.1580–c.1627), *Art militaire a cheval: instruction des principes et fondements de la Cavallerie*, Zutphen: Andre d'Aelst, 1621, first published 1616.
RCIN 1082182

BELOW RIGHT
Fig. 223 Studio of Sir Anthony van Dyck (1599–1641), *Charles II when Prince of Wales*, 1637–8.
Oil on canvas, 154.0 x 132.1 cm. RCIN 404400

LEFT AND OVERLEAF (DETAIL)
Fig. 225 William Dobson (1611–46), *Charles II when Prince of Wales*, 1644.
Oil on canvas, 122.5 x 99.3 cm. RCIN 404921

Fig. 226 Armour of King Charles I as a boy, and subsequently worn by Charles II as Prince, Dutch, c.1616.
Royal Armouries. Acc. II.90

cuirassier armour on occasion – for example, when he appeared at Leicester 'on horseback, in bright armour',[13] although this was probably restricted to ceremonial occasions and not during battle. At the battle of Edgehill Charles I wore a black velvet coat lined with ermine and cap of velvet-covered steel rather than full armour.[14] At the age of 12 the future Charles II commanded a troop in York in 1642, wearing what was described as 'a very curious guilt armour'.[15] This is probably the cuirassier armour in which he is portrayed in a portrait by William Dobson of 1644 (fig. 225), and which still survives in the Tower of London. It is of an earlier date than the painting, having been originally made for Charles I in 1616 (fig. 226). Unlike most cuirassier armour, it includes pieces covering the lower leg and feet. The distinctive 'S'-shaped breathing holes in the helmet's visor have been accurately depicted by the artist. Skilfully depicted too is the pattern on the bands of gilt decoration, through the sparing using of bright yellow highlights as it is illuminated by light falling from the right, without painstakingly including every detail of the engraved design. The effect of shining steel and gold is extraordinary, given that each is solely produced with non-metallic pigments. It is likely that the actual armour was originally as shiny as the artist has indicated here.

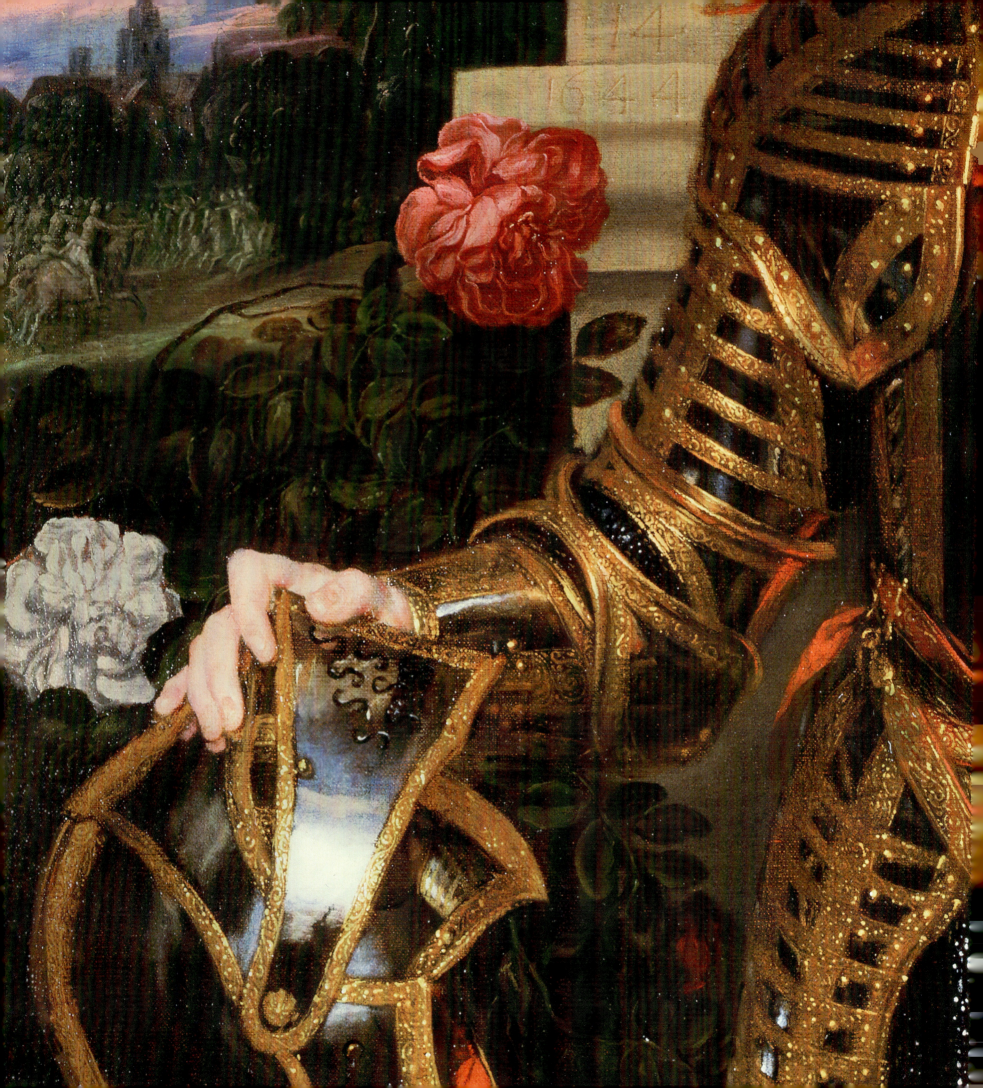

Fig. 227 William Dobson (1611–46), *Charles II when Prince of Wales, with a Page*, c.1642.
Oil on canvas, 153.6 x 129.8 cm.
Edinburgh, Scottish National Portrait Gallery. Acc. PG1244

Dobson must have had regular access to the armour in order to study the exact manner by which the light falls across each section. The portrait was therefore probably painted in Oxford, while the artist was in residence there with the exiled court. This painting is particularly interesting when compared to a similar work by the same artist in the Scottish National Portrait Gallery, dating from two years earlier and also painted in Oxford (fig. 227). It shows Prince Charles wearing only the breastplate from the same armour, while his page passes his helmet. It is possibly a more accurate depiction of what the young prince would have worn at the Battle of Edgehill, in 1642, accessorised as it is with a buff coat and sash.

UNIFORMS

One of the popular misconceptions about dress worn during the Civil War and Interregnum is that of an obvious difference in attire between Parliamentarians and Royalists. The words 'roundhead' and 'cavalier' were infrequently used during the period in question, and the stereotype of the plainly dressed Parliamentarian with shortly cropped hair versus the long-haired cavalier, foppish in his French-influenced fashions, was largely an exaggeration promoted by the populist press. This was further propagated by the fashion for 'history' painting during the nineteenth century. The word 'roundhead' is rumoured to have its basis in either the pot helmets worn by Parliamentarians on the battlefield or the short hairstyles of the Puritans. In reality these practical helmets were worn by soldiers on both sides, and although extreme Puritans did cut their hair very short, men with more moderate Parliamentarian persuasions certainly did not forgo the fashion for longer hair.[16] Moreover, the social distribution across the two warring factions was remarkably similar; divisions in politics were not necessarily based on class difference.[17] Some of van Dyck's most luxuriantly dressed sitters during the 1630s – for example Philip Herbert, 4th Earl of Pembroke (whose 1635 family portrait remains at Wilton House) – became prominent supporters of Parliament. As an example of the popularity of extravagant clothing amongst people on both sides, Major General Harrison, one of the Parliamentarian commanders who signed the death warrant for Charles I, advised his colleagues in parliament to wear plain black clothing to greet the visiting Spanish ambassador in 1650, but Harrison himself arrived wearing 'a scarlet coat and cloak, both laden with gold and silver lace, and the coat so covered with clinquant that scarcely could one discern the ground'.[18]

This similarity in appearance led to the development of certain distinctive features in dress so as to enable identification of the enemy in the smoke-filled and confusing battlefield. Coloured silk sashes were worn by officers and cavalry as a mark of rank, and are frequently depicted in portraiture of the period, either tied at the shoulder to extend diagonally across the body or tied around the waist. Occasionally they are worn tied around the upper arm, as in the portrait of William, Prince of Orange, of 1664 (fig. 228). The traditional assumption is that red

(sometimes called 'rose' in seventeenth-century descriptions) sashes were worn by Royalists while orange/tawny sashes were adopted by Parliamentarians, however this is a simplification and orange sashes were probably only worn by Parliamentarian troops under the Earl of Essex's direct command.[19] It is interesting that such similar colours were chosen – presumably these colours were particularly easy to spot in the chaos of the battle. John Lawson wears a bright red sash in his portrait (see fig. 219), indicative of his Royalist persuasion by this date, although in some portraits the distinction between red and orange/tawny is less obvious.

Portraits also reveal that many other colours were used for sashes, which may have related instead to the heraldic colours or livery of the colonel for the troop in question, or simply have reflected the availability of fabric. A particularly rich sash of purple silk in the V&A (fig. 229), densely embroidered with silk and silver-gilt threads, is traditionally associated with Charles I. Said to have been worn by the king at the Battle of Edgehill in 1642, it suggests that the monarch did not necessarily adhere to the tradition of wearing a crimson sash like his troops – although it is possible that the purple colour is instead a result of fading dyes. Similarly, in his portrait by Robert Walker (now in the National Portrait Gallery), Oliver Cromwell is portrayed with the pale grey sash he adopted as General rather than the stereotypical tawny sash of Parliamentarians. In portraits sashes are usually of plain silk, although a beautiful version embroidered with intertwined letter 'B's is worn by Christian, Duke of Brunswick and Lüneburg, in his portrait of 1624 (fig. 230). Here the sash also serves as a sling – the sitter lost his left arm in 1622. For the ordinary soldier a coloured sash was not an option, but coloured hat bands, field signs (such as a sprig of rosemary worn in the hat) or passwords were also used to differentiate friend from foe.

Henry VIII's retinue of soldiers and sailors wore specific livery colours. These were initially green and white, but changed to red and yellow in c.1544 for the invasion of France. The new livery colours would have been more expensive and were thus an emphatic demonstration of the English king's wealth and confidence. Fragments of this fabric survive on gun-shields in the Royal Collection and Royal Armouries. While livery of this kind, as well as matching coats to identify members of

Fig. 228 Adriaen Hanneman (1604–71), *William III when Prince of Orange*, 1664. Oil on canvas, 127.1 x 105.0 cm. RCIN 405640

PAINTED FOR BATTLE AND THE HUNT 249

OPPOSITE
Fig. 230 (detail) Daniel Mytens (c.1590–1647), *Christian, Duke of Brunswick and Lüneburg*, 1624.
Oil on canvas, 220.6 x 140.0 cm. RCIN 405885

RIGHT
Fig. 229 Sash associated with Charles I, British, 1635–42.
Silk, embroidered with silks, silver and silver-gilt threads, trimmed with silver and silver-gilt lace, 266.7 x 68.6 cm. London, V&A Museum. Acc. 1509-1882

BELOW
Fig. 231 *John Churchill, 1st Duke of Marlborough (1650–1722) at the Battle of Blenheim with his coat of arms as a Prince of the Holy Roman Empire above*, watercolour and bodycolour with gold leaf on vellum, c.1704, f.37r in Sir Thomas Wriothesley (c.1460–1534), *The Wriothesley Garter book*, manuscript on vellum, c.1530 with later additions.
RCIN 1047414

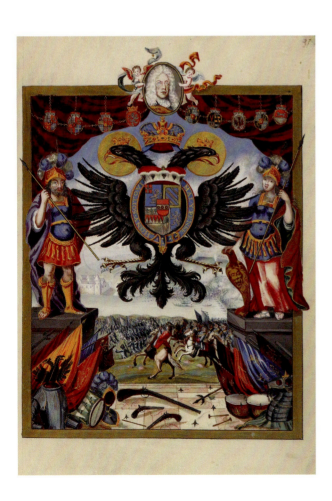

individual regiments, had been in existence earlier, the introduction of a formalised uniform for soldiers is credited to the New Model Army, formed in 1645 under the command of the Parliamentarian Sir Thomas Fairfax, whose foot soldiers were issued with red wool coats lined with different colours to indicate individual regiments. The use of differently coloured facings (visible at the cuffs, lapels and collar, and as decorative braiding) to identify different groups of soldiers was retained as a key feature of military dress throughout the eighteenth century. Officers, who during the seventeenth century were still drawn mostly from the noble classes, were slower to adopt uniforms, usually distinguishing themselves instead by higher quality fabrics, often in a different colour to the troops. However, John Churchill, 1st Duke of Marlborough, responsible for leading the army of the Grand Alliance against France, specified in 1702 that officers commanding troops for the upcoming military campaigns should 'be all clothed in red, plain and uniform, which is expected they shall wear on all marches and other duties as well as days of Review'.[20] An anonymous watercolour depicts the duke wearing this red coat to command his blue-uniformed troops (fig. 231). The artist uses aerial perspective in the form of an increasingly blue-hued colour palette to add to the suggestion of distance, which may overemphasise the predominance of blue uniforms. However, the nearer cavalry depicted in more accurate colour combinations show that some of these soldiers definitely wear blue coats and that the officer is attired in a different manner. All ranks wear the broad-brimmed black tricorne hat, which had by now replaced the helmet as the headdress worn in battle. It is interesting that alongside this depiction of contemporary uniforms the artist also includes classically influenced armour worn by the two framing figures, and medieval-style full armour for both soldier and horse on the ground.

The colour red remained associated with the British army (although not exclusively) until the early twentieth century, when khaki clothing – to camouflage with the surroundings – was adopted for battle. The earliest red coats for foot soldiers were dyed with madder, a relatively cheap dyestuff that produced a less vivid shade than the kermes or cochineal used by the elite to dye fashionable clothing scarlet. Coats dyed with madder faded relatively quickly, resulting in a duller, browner hue.

ABOVE
Fig. 232 (detail from fig. 209) Willem Wissing (1656–87), *William III when Prince of Orange*, 1685.
Oil on canvas, 124.6 × 102.5 cm. RCIN 405644

RIGHT
Fig. 233 Cravat end, large-scale needle lace, Venetian. 1670–90, 21.5 × 79.0 cm, reconstructed with modern linen and silk ribbon.
Barnard Castle, The Bowes Museum, Blackborne Collection. Acc. 2007.2.1.1.124

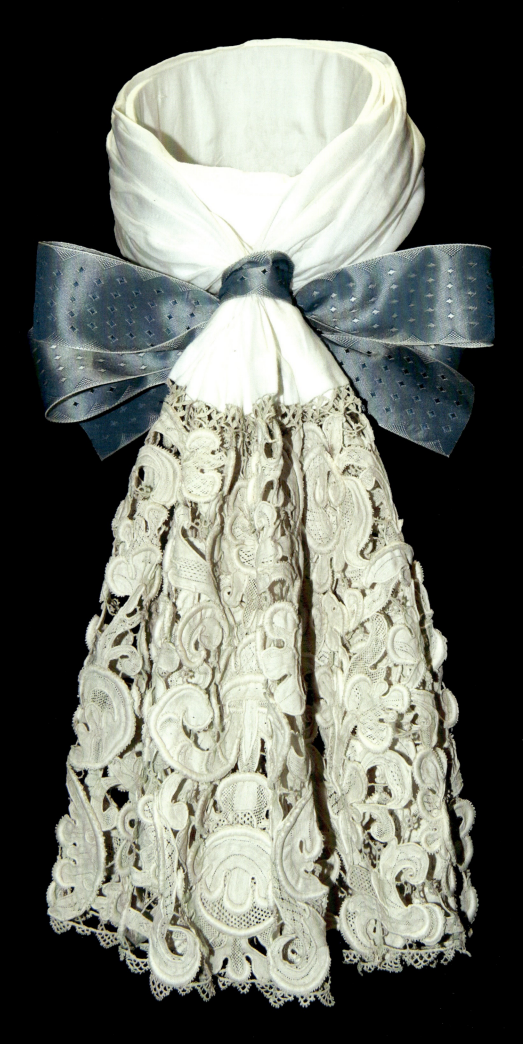

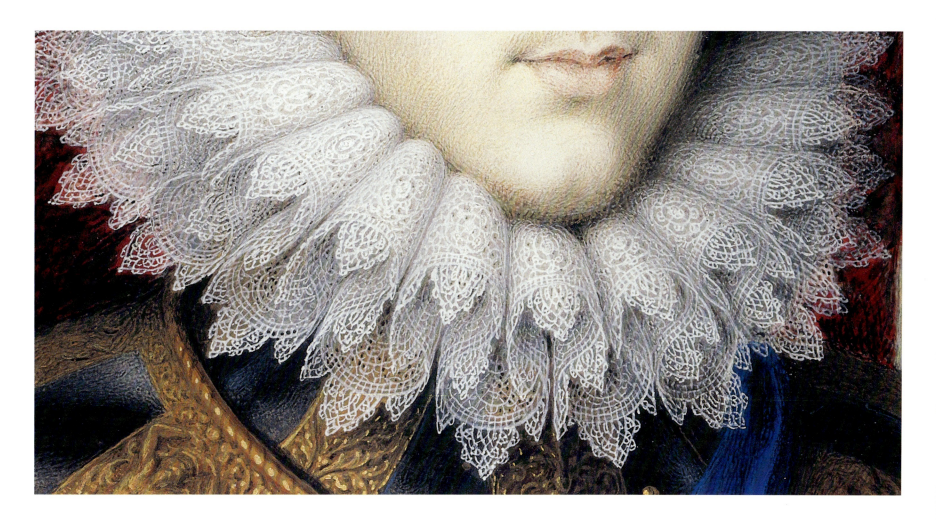

ACCESSORISING FOR BATTLE

Portraits of elite figures in armour usually depict it being worn with fine linen and lace. William III, for example, wears a cravat of Venetian *gros point* lace in the Wissing portrait of 1685 (fig. 209, detailed in fig. 232). This type of lace was particularly popular in the latter decades of the seventeenth century. As is clear from both the portrait and a similar surviving example from The Bowes Museum (fig. 233), this lace is extraordinarily three-dimensional, with raised crescent shapes and a variety of filling stitches. William's cuffs are plain, although some portraits display similarly extravagant lace cuffs worn with armour. To give an indication of the value of such items, in 1685 Charles II ordered three cravats of Venetian lace at a total cost of £194 – equivalent to over £16,000 today.[21] Equally, the most expensive style from much earlier in the century is seen in Isaac Oliver's miniature of Henry, Prince of Wales (fig. 202, detailed in fig. 234), and the surviving example shown in fig. 235. The ruff is constructed of fine geometric needle lace with a repeating pattern of circles, which has been starched and set into soft pleats.

Whether this lace was actually worn with armour in the battlefield is questionable. The high value of these items, together with the great level of maintenance required to keep them looking as pristine as this, suggests that they would not be appropriate attire for a muddy battlefield. Particularly ornate armour and accessories would also single out a high-ranking person as a valuable target for the enemy to capture or kill. However, a more practical plain

ABOVE

Fig. 234 (detail from fig. 202) Isaac Oliver (*c*.1565–1617), *Henry Frederick, Prince of Wales, c*.1612.

Watercolour on vellum laid on card, 13.2 x 10.0 cm. RCIN 420058

BELOW

Fig. 235 Geometric needle lace on a plaited grid (Reticella), early seventeenth century.

Barnard Castle, The Bowes Museum, Blackborne Collection. Acc. 2007.1.4.335

Fig. 236 (detail from fig. 14)
Hieronymus Janssens (1624–93),
Charles II Dancing at a Ball at Court, c.1660
Oil on canvas, 139.7 x 213.4 cm. RCIN 400525

linen falling band attached to the shirt, or a simple linen neckcloth tied around the neck, would have provided useful protection against the chafing of a buff coat or breastplate. Oliver Cromwell wears a plain linen collar with his armour in the majority of his portraits – for example Samuel Cooper's iconic miniature of 1649 (National Portrait Gallery, London). Presumably when armour was worn for ceremonial occasions however, these expensive and luxurious lace accessories would have set off the outfit in an appropriately ostentatious manner.

Even when a nobleman or monarch is depicted in fashionable civilian clothing, a military element is often evident in that he is shown with a sword (usually the narrow-bladed *rapier*) and sometimes also a dagger. The rapier was the first type of sword made to be worn with civilian dress – medieval swords had only been worn when travelling or when engaged in battle.[22] The origin of the word probably derives from the Spanish *espada ropera* – a sword of the robe, literally a dress sword.[23] By around 1520 the rapier had developed into a highly fashionable accessory worn by gentlemen in urban environments. These weapons were often highly decorative, carefully designed to co-ordinate with the wearer's clothing and jewellery. The sword carried in *Portrait of a Man in Red* (see fig. 78) exemplifies how scabbards could be covered with the same fabric as a suit, and metalwork decoration could match buttons or buckles. The rapier required a thrusting method of attack rather than a cutting action – to use it effectively required specialist training from an early age in the noble art of fencing. It therefore became a symbol of a gentlemanly leisured lifestyle, with time to devote to this courtly pursuit (which, throughout the sixteenth century, became progressively more theoretical and focused on mathematical principles of geometry). While expensive and ornate swords became increasingly important status symbols for the fashionable elite during the sixteenth century, for most people they also served a practical role of self-defence and as a weapon for duelling in urban areas during times of peace (their narrow blades meant they were largely ineffectual during warfare). The most powerful members of society, however, would not usually have been exposed to such risks, and for them the rapier was more a symbolic object, allowing it to become ever more ornamental and akin to a piece of jewellery, constructed of precious metals rather than steel and inset with jewels.[24]

Portraiture indicates that the sword was usually worn on the left side, suspended from a sword belt, while the dagger was worn on the right – as modelled by Rudolf in the Coello portrait (see fig. 101). The dagger appears on the left hip if no sword is worn. The sword belt suspended the sword, usually diagonally, in a comfortable balanced position. In many portraits this results in the hilt of the sword being shown in detail, while the practical blade, the killing element, is hidden in the dark shadows behind. In the left foreground of the painting *Charles II Dancing at a Ball at Court*, a courtier has pulled his sword belt round so that the sword is tucked completely behind his back and does not interfere with his flirtation (fig. 14, detailed in fig. 236).

The most decorative section of the sword was usually the hilt. In portraiture the sitter often rests a hand on the sword hilt, thus drawing attention to one of the most expensive components of his dress. This stance also suggests that he is prepared for danger, and can give a sense of action. Rapier hilts are often constructed with elegant and sculptural sweeping curved bars to protect the hand (like those seen in *Man in Red*, fig. 78), since rapiers were used

without armour. While the pommel on the end of a rapier serves a practical function – acting as a counterweight to the blade, and providing the means by which the blade is fastened to the hilt – it is also often ornate. The pommel on the end of John Lawson's sword hilt consists of a gold lion (see fig. 219). Usually concealed in portraiture by the scabbard, blades could also be highly decorative, as an example, by tradition associated with Charles I, demonstrates (fig. 237). This blade is gilded, blued and etched with the Royal Arms of England and the coronet and feathered badge of the Prince of Wales, as well as mottos in Latin. An ornate blade like this implied that the sword was drawn frequently in order that it be admired. The hilt is English and of a slightly later date (c.1660), but like many early examples is wrapped in wire – here designed to imitate a woven fabric. The blade is dated to 1616 and stamped with a unicorn's head, the mark used by the cutler Clemens Horn (1580–1630) as a play on his surname.

Horn was based in Solingen in central Germany, a region renowned for producing high-quality swords during the sixteenth and seventeenth centuries, many for export. During the sixteenth century, however, Milan was the city most synonymous with the production of the highest quality Renaissance rapiers along with other types of arms and armour. A key factor in its development was the fact that the city was also a major centre for the production of textiles; close links developed between jewellers, goldsmiths, silkmen and sword-makers, enabling them to produce extraordinary objects.[25] In England the most important cutler was Robert South (1572?–1650), who produced swords (along with all the associated accessories such as scabbards, spurs and belt-fittings) for Henry, Prince of Wales, and James I and Charles I.[26]

CLASSICAL ARMOUR

Instead of wearing contemporary armour, or that from recent history, sitters might choose instead to be painted wearing classical forms of military dress. This convention had been adopted in sixteenth-century Italy in sculpture format, for example in Cosimo I's bronze bust by Cellini of c.1547 (Bargello, Florence). In painting the use of the Roman military habit was initially limited to history subjects or portraits depicting a sitter in the guise of an allegorical or historical figure. The allegorical group portrait of *The Four Eldest Children of the King and Queen of Bohemia* (1631) shows the sitters as a group of hunters in an Arcadian woodland setting (fig. 238). They wear fancy dress costume inspired by both classical dress and the notion of the pastoral – a growing interest in rural life was a theme found both in the Netherlands and England during the early seventeenth century. Prince Rupert is shown as a classical soldier, wearing a tunic decorated with *pteruges* (strips of leather or fabric) and a red cloak (known as a *sagum*) fastened at the right shoulder. This was a symbolic garment of war during the Roman republic. For officers it was coloured with expensive bright red dye and was made of unwashed wool, which was relatively waterproof due to the presence of natural lanolins. Prince Rupert also wears knee-length buskins and has a laurel wreath atop his head. His older brother,

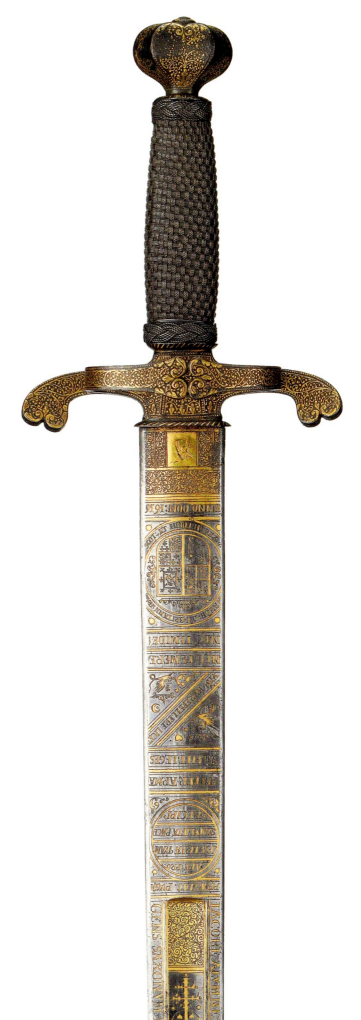

Fig. 237 Dress-sword of Charles I. Blade by Clemens Horn, German; hilt, English, c.1616. Iron, steel, gold and silver. RCIN 67125

Charles Louis, is depicted likewise in a classically inspired red tunic and buskins, while his younger brother Maurice is dressed in costume inspired by the notion of Arcadia – he carries a shepherd's crook and wears a knee-length vest that buttons up the front. The fabric is however far too extravagant for a true shepherd, and is cut with fashionable panes in the torso. The three brothers pay homage to Princess Elizabeth, who in her role as Diana represents the goddess of the chase.

By the second half of the seventeenth century, the Roman habit had become an appropriate style of clothing to be worn for a state portrait, where it was seen as an antidote to frequently changing fashionable styles and was also viewed as a way of demonstrating a wearer's esteemed social status, associating them with victory and imperial success. Louis XIV is depicted in this manner in the ceiling paintings of Charles Le Brun decorating the Galerie des Glaces at the Palace of Versailles, and was sculpted by Coysevox and Bernini wearing the same style. In England the fashion was adopted by Charles II, depicted as a Roman general in an equestrian statue sculpted by Grinling Gibbons and cast in bronze by Josias Ibach in 1679 (fig. 239). It stands in the Upper Ward at Windsor Castle, and was presented to the monarch by Tobias Rustat, Yeoman of the Robes from 1650 to 1685. While the king wears classical

Fig. 238 Gerrit van Honthorst (1590–1656), *The Four Eldest Children of the King and Queen of Bohemia*, 1631.

Oil on canvas, 173.5 x 214.8 cm.
RCIN 404971

LEFT
Fig. 240 Antonio Verrio (1639?–1707),
The Sea Triumph of Charles II, c.1674.
Oil on canvas, 224.5 x 231.0 cm. RCIN 406173

BELOW
Fig. 239 Grinling Gibbons (1648–1721),
Cast by Josias Ibach (fl. 1679–96), *Charles II*, 1679.
Bronze, portland stone and marble. RCIN 31958

armour without modern spurs or stirrups, he also has the classical shortly-cropped hairstyle seen on statues of Julius Caesar and is crowned with a laurel wreath. This is an unusual feature – as hairstyles usually betray the era in which someone lives even if their clothing does not. Antonio Verrio's *Sea Triumph of Charles II* (fig. 240), dating from *c*.1674, depicts the monarch wearing classical armour together with the fashionable periwig and moustache of the day. In all these representations, Charles wears scale armour known as *Lorica squamata*, which was worn by the Roman military during the Republic. It has also been moulded deliberately to imitate the muscles of the torso beneath, like Roman cuirass armour that was reserved solely for Roman commanders. Pteruges hang around the sleeves and beneath the breastplate to form a decorative skirt, and the monarch also wears classical buskins. Verrio has imbued the sagum cloak with a sense of life so that it floats like the delicately fluttering draperies of van Dyck and Lely.

Other Stuart monarchs also adopted the convention for classical military dress in several of their portraits, and its use spread down the social scale. Despite its popularity with the Catholic Louis XIV, classically influenced courtly attire was considered appropriate for the staunchly Protestant elite in the Dutch Republic, as demonstrated in a portrait by Jan de Baen of

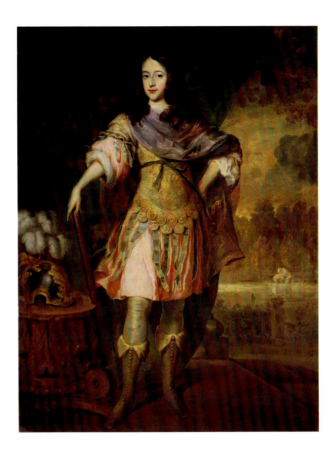

ABOVE
Fig. 241 Jan de Baen (1633–1702),
William III when Prince of Orange, c.1667.
Oil on canvas, 180.3 × 133.1 cm. RCIN 404779

OPPOSITE
Fig. 242 Paul van Somer (c.1576–1621),
Anne of Denmark, 1617.
Oil on canvas, 265.5 × 209.0 cm. RCIN 405887

the future William III, aged 17 and living in the Hague (fig. 241). Again the sitter wears a stylised version of Roman dress, and the classical theme is continued through the sculpture in the background depicting the struggle between Hercules and the Nemean Lion. William III was to base much of the rebuilding of Hampton Court on the theme of Hercules, as Versailles is based on the sun-god Apollo.

RIDING AND HUNTING

Elite gentlemen were expected to become proficient riders at a young age and, like fencing, riding was considered a suitable sport for the leisured classes as well as vital preparation for times of war. Roger Ascham, tutor to Elizabeth I, wrote of the pastimes suitable for a courtly gentleman: 'to ride cumlie: to run faire at the tilte or ring: to plaie at all weapons: to shote faire in bow, or surelie in gon … to Hawke: to hunte … conteining either some fitte exercise for warre, or some pleasant pastime for peace'.[27] Hunting in particular was deemed to be of special value as a training ground for battle, and for young boys it would 'increaseth in them bothe agilitie and quicknesse, also sleight and policie to fynde such passages and straytes, where they may prevent or intrappe their enemies'.[28] More than this, a horse and its trappings was an obvious symbol of status, explaining the enduring popularity of the hunting portrait. Maintaining stables with horses, dogs and staff was expensive. Hunting too necessitated land ownership in the form of a deer park, and a gentlemanly lifestyle without the need to work for a living. Accordingly it was a sport embraced by many monarchs during the Tudor and Stuart reigns, but was not limited to the male domain – Elizabeth I, for example, loved hunting and hawking like her father, while Anne of Denmark is depicted alongside her horse and hounds ready for the hunt at Oatlands in a portrait by van Somer (fig. 242).

Clothes worn for hunting and riding during the Tudor and Stuart period were often specially constructed, usually along the lines of fashionable clothing but often in different colours and of more hard-wearing fabrics. Henry VIII spent many hours a day on a horse, either for pleasure or for the more utilitarian purpose of transport. His inventories reveal that new riding coats were ordered regularly, the majority of which were of green woollen cloth rather than silk.[32] Green was a popular colour for outdoor clothing (perhaps for reasons of camouflage, or simply to seem more at one with nature) and was considered particularly appropriate for hunting. The tradition continued in the seventeenth century. Robert Peake depicts Henry, Prince of Wales, in a green doublet cut along the line of contemporary fashions with matching Venetian breeches (fig. 243). He is shown hunting with Robert Devereux, 3rd Earl of Essex, having just delivered the ceremonial *coup de grace* to the dying stag. As befits a prince, his suit is heavily embroidered with gold thread – his companion, of a lower status, has less impressive embroidery, largely confined to the seams. Anne of Denmark wears green in her portrait by van Somer. Hunting clothes were not exclusively green however – a description of Elizabeth I hunting in 1557 describes her being accompanied by 12 ladies clad in white satin.[30]

During the seventeenth century the riding coat was a garment quite different from a fashionable doublet, being cut on a looser, longer line for warmth and practicality. One type worn from the 1650s with a central slit at the back was known as a jump, and its popularity

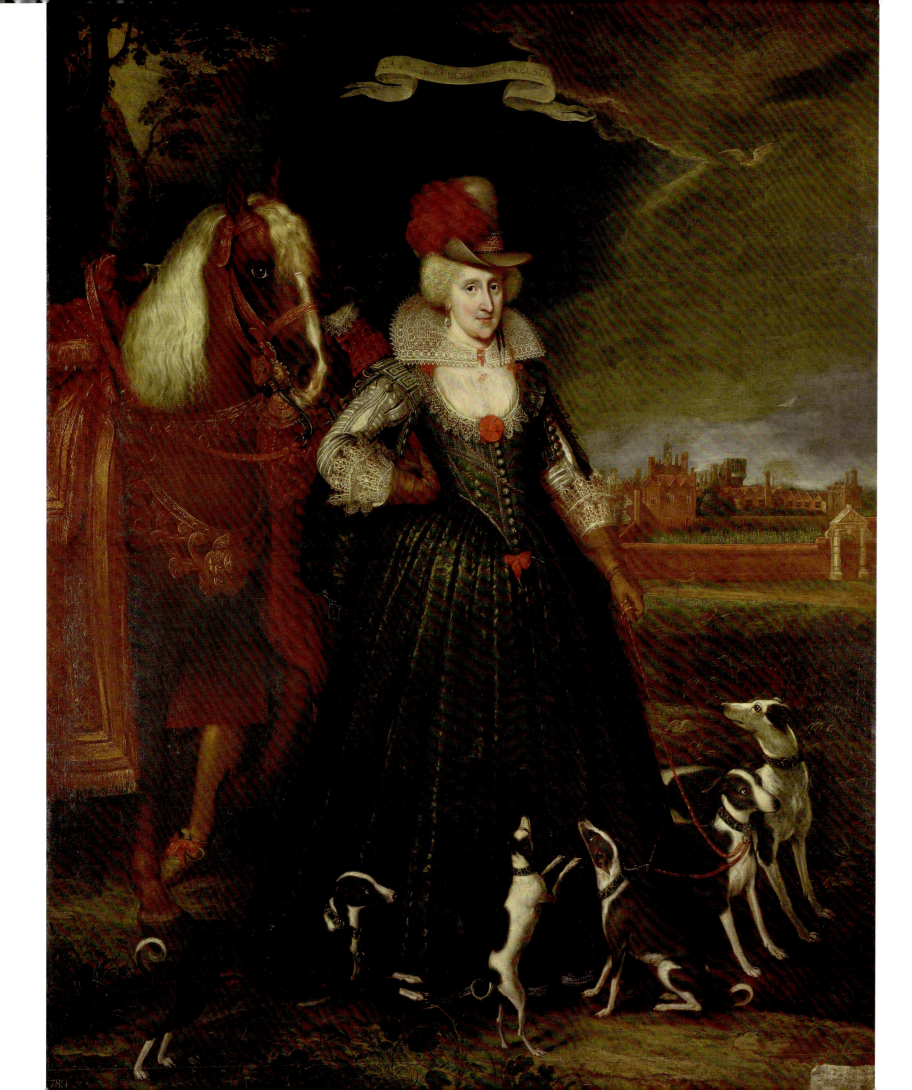

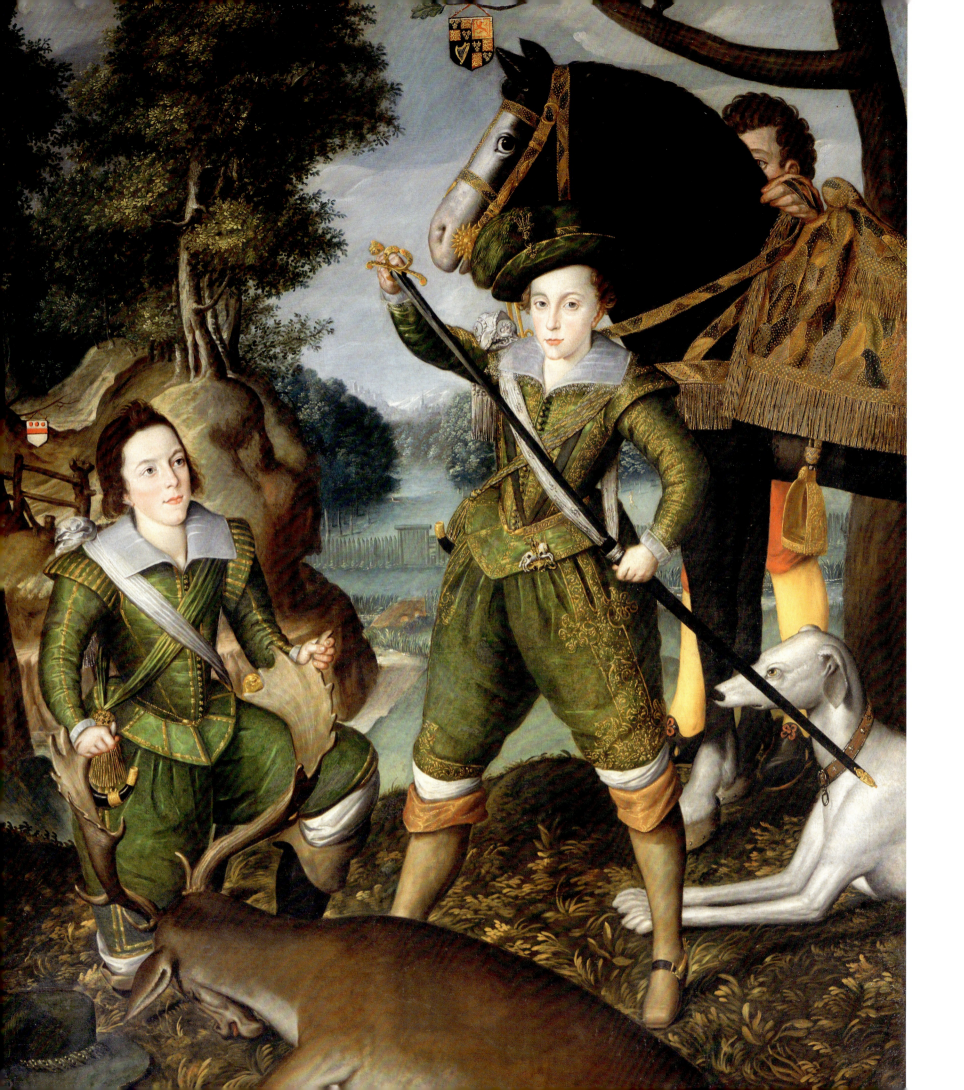

may have been one of the influences on the development of the male coat in the 1660s. Like his father James I before him – who it has been estimated spent half his reign at hunting lodges or on progresses – Charles I had a passion for hunting.[31] Charles I's wardrobe accounts reveal that during the period 1633–5 eight riding coats were made for him, five of which were of grey woollen cloth.[32] He also ordered a number of riding cloaks, all of which were of scarlet. Practical grey was a popular colour for riding coats during the seventeenth century because it did not show mud, but linings could be of a more vivid hue – several of Charles' riding habits were lined in green fabric, perhaps reflecting the colour's traditional associations with the sport.

The female riding habit became increasingly popular as a fashionable style of clothing for women during the seventeenth century. Initially viewed as a more utilitarian form of dress reserved for outdoor activities, it gradually developed into an indispensible informal style within the fashionable woman's wardrobe, remaining popular throughout the eighteenth century. The jacket of the riding habit took its influences from fashionable male styles in both form and decoration – the development of the man's suit in 1666 may have been a specific inspiration – although it was always worn with a skirt that followed the lines of female fashion. This masculine influence on women's dress (which extended to wearing hats and adopting traditionally male hairstyles), and the perceived resulting gender confusion, was not new to the Restoration period – women had been wearing masculine-inspired clothing including doublet-like bodices and men's beaver hats since the 1580s, and the topic was a subject for fierce criticism. The publication of the pamphlet *Hic Mulier* (The Man-Woman) in 1620 is notable in both its anxiety and desire at the sexually provocative sight of women dressed in masculine-style clothing. In the same year the matter of 'the insolencie of our women, and theyre wearing of brode brimd hats, pointed dublets, theyre haire cut short or shorne' was also raised during sermons by the clergy under the express wishes of King James I.[33] Portraits show, however, that Elizabeth I, Anne of Denmark and Henrietta Maria all wore clothing influenced by masculine styles – their bodices cut in the style of male doublets, often paired with large hats decorated with ostrich plumes.

Anthony à Wood, in 1665, writes that Queen Catherine's maids of honour (of which Frances Stuart was one – see fig. 222) were responsible for popularising the fashion:

> 'women would strive to be like men, viz., when they rode on horseback or in coaches weare plush caps like monteros, either full of ribbons or feathers, long periwigs which men used to weare, and riding coate of a red colour all bedaubed with lace which they call vests, and this habit was chiefly used by the ladies and maids of honor belonging to the Queen, brought in fashion about anno 1663'.[34]

In a Samuel Cooper miniature of Frances Stuart (fig. 244), the torso is covered by a garment cut along the lines of a male doublet in its final form, before being replaced by the longer line of the coat. It is likely that she is wearing the top half of a riding habit. The garment is striking in its similarity to the doublet portrayed in another miniature by Samuel Cooper, of an unknown man (fig. 245). Both garments utilise a red-and-gold colour scheme, and have slit sleeves revealing a grey silk lining and billowing white linen beneath. The similarity is so close as to suggest that it may in fact be the same garment. Perhaps it is an artist's prop? Or was it

OPPOSITE

Fig. 243 Robert Peake (active 1580–1635), *Henry, Prince of Wales with Robert Devereux, 3rd Earl of Essex in the Hunting Field*, c.1605.
Oil on canvas, 190.5 x 165.1 cm. RCIN 404440

ABOVE

Fig. 244 Samuel Cooper (1609–72), *Frances Teresa Stuart, later Duchess of Richmond*, c.1663.
Watercolour on vellum laid on card, 9.6 x 7.5 cm. RCIN 420102

BELOW

Fig. 245 Samuel Cooper (1609–72), *Unknown Man, perhaps Anthony Ashley Cooper, 2nd Earl of Shaftesbury*, 1666–70.
Watercolour on vellum, 8.4 x 6.6 cm. London, V&A Museum. Acc. P.66-1968

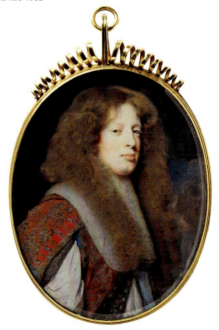

PAINTED FOR BATTLE AND THE HUNT 261

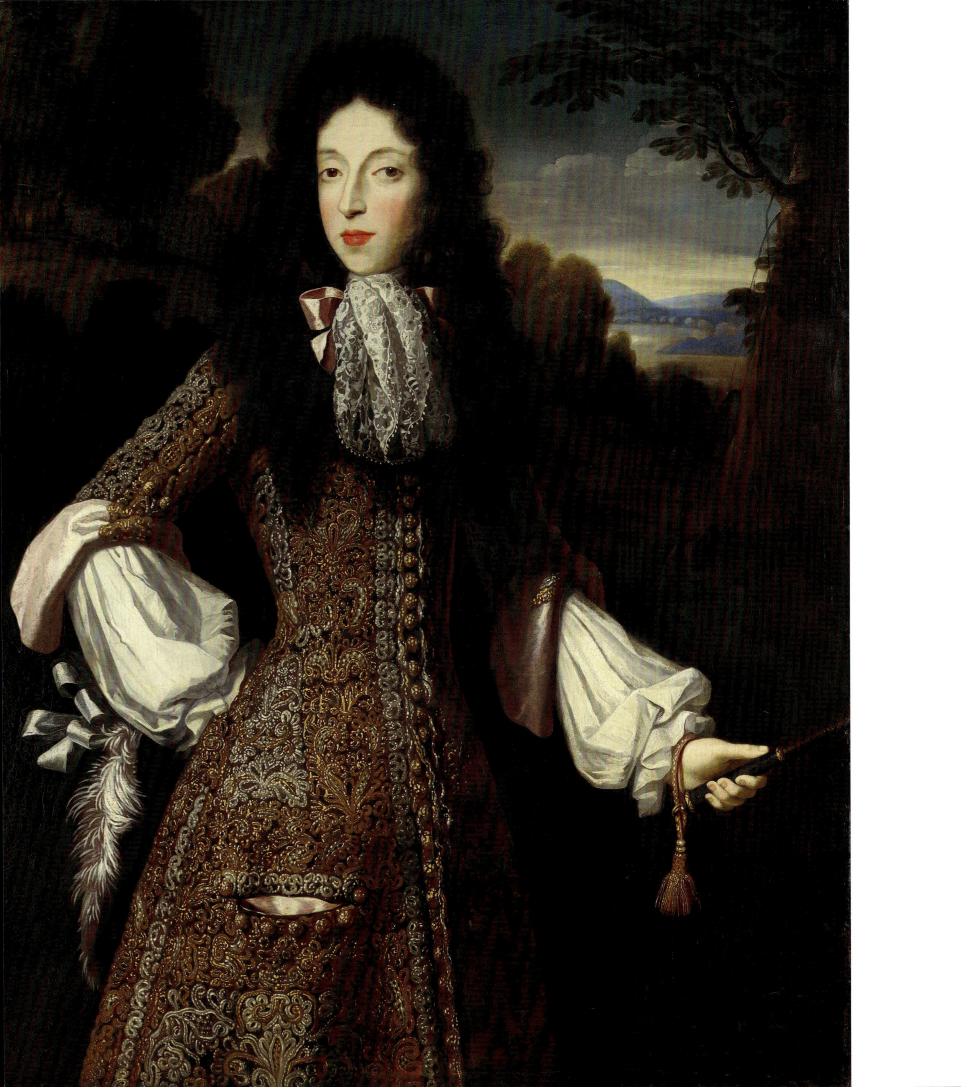

loaned to Frances after she expressed admiration of the male miniature? Another miniature by Cooper shows her again in a riding habit, this time accessorised with a feathered hat (Mauritshuis, The Hague). Such a self-conscious portrayal in masculine-inspired clothing in different portraits by more than one artist is perhaps suggestive of a deliberate choice on the part of the sitter, rather than reflecting the preferences of a particular artist or patron. Whether the choice was driven by comfort or a personal aesthetic preference is also a matter for conjecture.

Initially Samuel Pepys was not a fan of women dressed in this manner, and reports that the queen's ladies of honour appeared in the galleries at Whitehall wearing 'their riding garbs, with coats and doublets with deep skirts, just for all the world like men, and buttoned their doublets up the breast, with perriwigs and with hats; so that, only for a long petticoat dragging under their men's coats, nobody could take them for women in any point whatever – which was an odde sight, and a sight did not please me'.[35] A year later, however, he has grown accustomed to the fashion, writing 'it was pretty to see the young pretty ladies dressed like men; in velvet coats, caps with ribbands, and with laced bands just like men'.[36] While John Evelyn notes, 'The Queene was now in her Cavaliers riding habite, hat & feather & horsemans Coate, going to take the aire', Catherine of Braganza does not appear to have been painted wearing the style.[37]

A clearer depiction of a riding habit is seen in the portrait of Mary of Modena, who in 1673 had become the second wife of the Duke of York (fig. 246). The elegant jacket of her riding habit follows exactly the lines of the male coat at this date (1675), reaching to the knee and flaring from the waist. The brown wool surface is entirely covered in silver and silver-gilt embroidery, in a dense foliate design, and the large turn-back cuffs and pocket reveal a lining of pink silk. It is tempting to suggest that the design was influenced by the wedding suit of Mary's husband from two years earlier, which survives and is decorated in a very similar manner (fig. 247). The tarnishing of the metal thread makes the differences between the silver and silver-gilt less obvious than in the painting, where the silver is used to pick out details along the seamlines and around the pockets. Like the wedding suit, the stylised design on Mary's jacket shows few pattern repeats, and may have been drawn freehand by the embroiderer rather than being transferred by a pattern. Perhaps the same craftsmen were involved in producing the two garments. James II's wedding bed at Knole, which probably arrived from Whitehall after the Glorious Revolution in 1688, is also decorated with a similar form of embroidery, and it is not inconceivable that the king envisaged a set of garments and furnishings designed en suite. Mary carries her black beaver hat decorated with a blue ribbon and white feather, and wears a periwig with a lace cravat of needle lace – both items traditionally associated with male clothing.

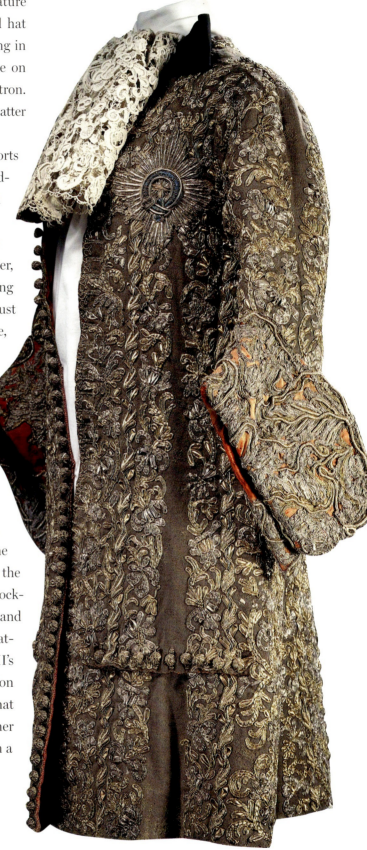

OPPOSITE
Fig. 246 Simon Verelst (1644–1721), *Mary of Modena, when Duchess of York*, c.1675.
Oil on canvas, 126.6 × 103.4 cm. RCIN 404920

Fig. 247 Wedding suit worn by the Duke of York, later James II, English, 1673.
Wool, embroidered with silver and silver-gilt thread and lined with red silk, length 91.4 cm. London, V&A Museum. Acc. T.711:1, 2-1995

PAINTED FOR BATTLE AND THE HUNT

Fig. 248 British School, *Set of Mica Overlays and Miniature of Queen Henrietta Maria*, c.1650.
Oil on copper, mica. RCIN 422348

The mid-seventeenth century saw a vogue for an unusual type of miniature which could be dressed in a variety of different outfits by placing painted transparent overlays on top of the master image. Constructed from very thin slices of mica, the 19 overlays seen here include both male and female outfits, and several can be identified with well-known figures or character types of the period.

The long skirt was wrought with lace, waved round about like a river, and on the banks sedge and seaweeds all of gold. Their shoulders were all embroidered with the work of the short skirt of cloth of silver, and had cypress spangled, ruffed out and fell in a ruff above the elbow.

Samuel Daniel, *Tethys' Festival*, 1610

THE ENGLISH court was far more than the centre for management of the royal household and for the administration of government legislation. It was also the centre of entertainment. Courtly sports like tennis, football and fencing, together with theatrical productions, were just some of the ways in which the leisured classes spent their free time. It has been convincingly argued that these pastimes were intrinsically bound up with court life, and were not simply diversions from the more official components.[1]

Many of these diversions required specially made items of clothing. The opening quotation, for example, is a description of garments worn by Queen Anne and her ladies dressed as marine goddesses in 1610. The majority of this chapter focuses on the elite courtly masque of the late Elizabethan and early Stuart reigns, an era when costume was of particular importance to the theatrical production and was directly relevant to both fashionable clothing and to portraiture of the period. The elite nature of masque productions is then contrasted with costumes in the more populist Restoration theatre and finally the symbolic significance of military dress on stage is highlighted.

THE MASQUE

In contrast to other forms of popular theatre, such as the plays of Shakespeare performed at the Globe, the masque was an exclusive form of courtly entertainment in which members of the elite court circle made up both the spectators and the participants, alongside professional actors. Masque performances incorporated music and dancing into specially created scripts by celebrated dramatists, whose complex and allegorical storylines served to glorify the court and celebrate the achievements, policies and personalities of the monarchy. It was thus an exclusive form of court propaganda. They were often held to commemorate particular events, such as a marriage or birth. The pairing of the writer Ben Jonson with the set and costume designer Inigo Jones between 1605 and 1634 was the most important combination of artistic talent. Traditionally the audience members were invited to participate in the formal dancing during the final scenes, blurring the line between the reality of the court and the illusion of the performed production – an effect that was consciously amplified through imaginative set designs and dramatic lighting.

The origins of the masque in England lie in the Italian *intermezzi* (masque-like productions performed between the acts of a play which encouraged guests to mingle with the actors) and in the French *ballet de cour*. Inigo Jones had travelled to Italy and experienced court productions in Florence, and his designs betray the influence of Italian designers like Bernardo Buontalenti. The first masque to be performed in England occurred at the court of Henry VIII on Twelfth Night in 1512, and the monarch himself played a role in the production. Masques were performed under the other Tudor monarchs, but it was under the early Stuart monarchs

Pp. 266–7 (detail from fig. 256)
Adriaen Hanneman (1604–71),
Mary, Princess of Orange, 1655?

(James I and Charles I) that the masque reached its artistic apogee and evolved into spectacular productions for which the English form of the art is notably renowned.

The masque is of particular interest to costume historians due to the prominence given to the specially designed and increasingly elaborate costumes, produced at huge expense. Unfortunately, due to its highly ephemeral nature (each masque was usually performed only once) no English masque costume survives. We therefore rely on visual imagery and contemporary descriptions to piece together the key features of clothing worn during the productions. Masque dress is fairly frequently represented in Jacobean portraiture, but is much more rare in portraits of the Caroline era. Approximately 450 costume designs by Inigo Jones (the most important of the court masque designers) do survive, and these reveal much about the working method of the costume design process, although they are preparatory designs and the final result may have differed significantly to that in the drawing. While men appeared in masques, their costumes were less frequently recorded in paint (although Inigo Jones's designs include many male costumes). The most striking masque portraits represent elite women.

Masque dress could be extraordinarily expensive. In the earlier masques, costumes were often paid for by the participant and so were returned to them after the event. They would therefore have been freely available to be copied by the artist in paint. The expense of the masque outfit is one explanation for the popularity of masque portraiture during the Jacobean period – to be immortalised in paint allowed the appearance of an ephemeral set of a garments to be preserved for posterity, and might have gone some way to compensate for the extraordinary outlay of money that masque outfits could require.

Fig. 249 Isaac Oliver (c.1565–1617), *Anne of Denmark*, c.1610.
Watercolour on vellum laid on card, 5.2 x 4.2 cm.
RCIN 420025

FEATURES OF MASQUE DRESS

Although during this period loose hair was usually reserved for young unmarried women or brides, it was also displayed (either real or in the form of a wig, sometimes constructed from silk) at the courtly masque, where it was often paired with an elaborate headdress. An Isaac Oliver miniature of Anne of Denmark (fig. 249) shows the queen wearing masque dress, with her hair worn half loose, and the rest in a complicated arrangement of plaits, pearls, gemstones and silk.[2] Under normal circumstances it would not have been appropriate for a queen to be depicted with loose hair – all other portraits of Anne show her hair formally set, usually raised over pads. However, loose hair was considered most appropriate for the mythical creatures (sea nymphs etc.) and personifications that comprised the masque cast. In *The Masque of Beauty* the figure of Splendour is described by Jonson as 'dressed in a robe of flame colour, naked breasted, her bright hair loose flowing'.[3] 'Bright' here refers to blonde hair.

Masque dress characteristically incorporated elements of exotic styles from abroad that were known through engraved costume books such as Boissard's *Habitus Variarum Orbis Gentium* (1581). It has been conjectured that the figure of *Virgo Persica* (fig. 250) was the basis for the costume worn in *Portrait of an Unknown Woman* by Gheeraerts (fig. 251) – the conical headdresses with their long veils are strikingly similar.[4] The portrait is one of the most enigmatic in the Royal Collection. In typical Elizabethan tradition, it displays a complex allegorical message, and has been described as 'an emblem to be read, a static masque'.[5] Whether this

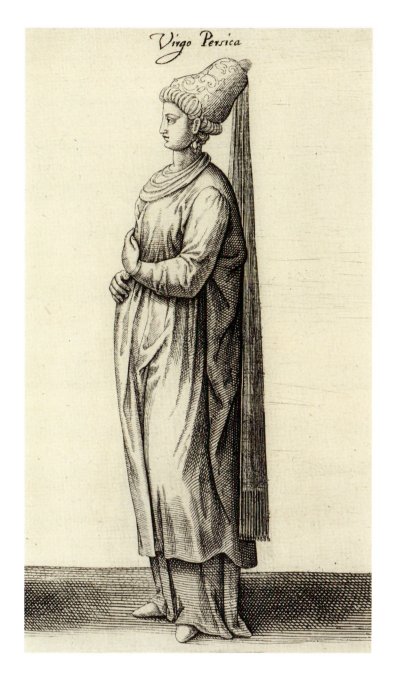
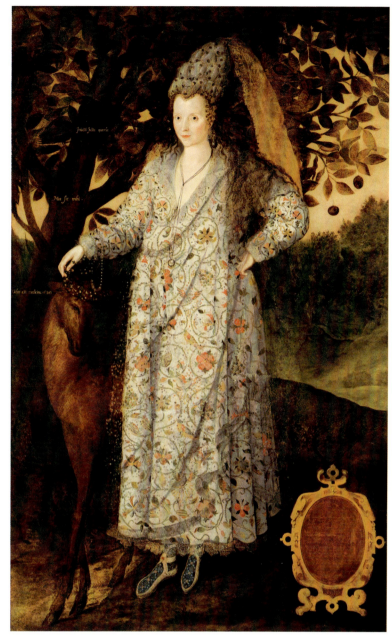

costume was an invention by the artist, or whether he was depicting an actual masque costume designed by someone with access to Boissard's publication, is unknown. The sitter wears her hair in loose waves around her shoulders. Her headdress is constructed from puffs of muslin and set with pansies (also known as 'heartsease' at the time). Pansies too are used to crown the weeping stag. Above her lace-trimmed linen smock, visible at the neckline and at the hem, the sitter wears two separate garments embroidered with a serpentine design of flowers and birds in coloured silk thread. Over a waistcoat, perhaps similar in construction to that from the Fashion Museum, Bath (see fig. 152) is a second gown, which may consist only of a large piece of embroidered fabric suspended over her left shoulder. The embroidery design on this upper garment is of a larger scale than that seen on the sleeves – so the sleeves belong to the waistcoat.[6] She also wears a mantle of diaphanous silk, trimmed with silver-grey

ABOVE LEFT
Fig. 250 After Jean Jacques Boissard (1528–1602), *Virgo Persica*, engraving, pl. 52 from *Habitus Variarum Orbis Gentium*, Mechelen: Caspar Rutz, 1581.
RCIN 1075214

ABOVE AND OVERLEAF (DETAIL)
Fig. 251 Marcus Gheeraerts the Younger (c.1561–1635), *Portrait of an Unknown Woman*, c.1590–1600.
Oil on canvas, 216.2 × 135.5 cm. RCIN 406024

PLAYING A PART 271

(probably metallic) fringe and covered with silver spangles. It falls in diagonal folds across the body, and as a result the fringing forms a waving pattern as it rises up from the hemline. The spangles are particularly evident on the sitter's right-hand side where the mantle hangs away from the embroidery, although they do cover the entire figure. This gauze-like fabric would have protected the delicate embroidery, and may be an extension of the fabric suspended from the headdress, wrapped around the back of the body then up over the left shoulder. The extraordinary slippers, quite unlike fashionable shoes, are decorated with beads, and their strap-like design recalls classical buskins. Suspended from her ear the mysterious sitter wears a cage-like earring constructed of pearls, together with a large teardrop-shaped jewel, which may have been carved from a semi-precious stone. It is possible to see with the naked eye that the artist initially placed this earring closer to the neck but moved and enlarged it, evidently to give it greater prominence. The meaning of this unusual object has not yet been fully explained.

It is interesting that the sitter's outfit consist of elements from the fashionable wardrobe (waistcoat, smock) with items probably specially made for a masque (veil, embroidered mantle, shoes). This painting is believed to date from late in the reign of Elizabeth I, but such embroidered bodices continued to be adapted as a component of masque dress well into the next reign. In a masque for Anne of Denmark in 1617, for example, Fortune was 'attired in rich garments of diverse colours, a waistcote embroadered with gold, many curious flowers wrought with silver and silke'.[7] The dual purpose of these embroidered waistcoats is indicated by their appearance in two types of portrait – the domestic, intimate setting, and the masque portrait as demonstrated here.[8]

Metallic and highly reflective details of dress – including spangles, metal fabrics like *tinsel*, metal thread embroidery and metal lace (from either precious metals or cheaper copper) – were key elements of masque costume that contributed to the magical shimmering effects under candle and torch light, while also maximising the limited illumination available. Candlelight is imprecise and serves to deaden certain colours so that dark blues and greens can darken to brown or black. According to Bacon, the colours that looked best were 'white, carnation, and a kind of Sea-Water Greene',[9] although Inigo Jones did not restrict his palette (his designs included some 35 colours).[10] Jones did, however, prefer pale colours for sleeves and stockings, so as to ensure gestures and dance steps would be seen on the darkened stage. Colours were also chosen for their symbolism and were used to help identify the characters. Like the trends in fashionable styles at the Caroline court, which favoured a limited range of colours (unlike the Jacobean era where eclecticism and exuberance in colour were the order of the day), so too the costumes for Caroline masque performances were usually limited to one or two key colours plus a neutral. This contributed to a sense of harmony in everyday fashionable clothing as well as on the stage.[11] In general, during the reign of Charles I the boundaries between masque costume and fashionable clothing became increasingly indistinct.

The asymmetrically arranged mantle – a rectangular length of rich fabric tied over one shoulder – first appeared in England as a feature of masque dress during the 1590s, and frequently makes an appearance in portraits of women during the Jacobean period. In his treatise on theatre design of 1566, Leone de' Sommi wrote that nymphs should wear 'a sumptuous

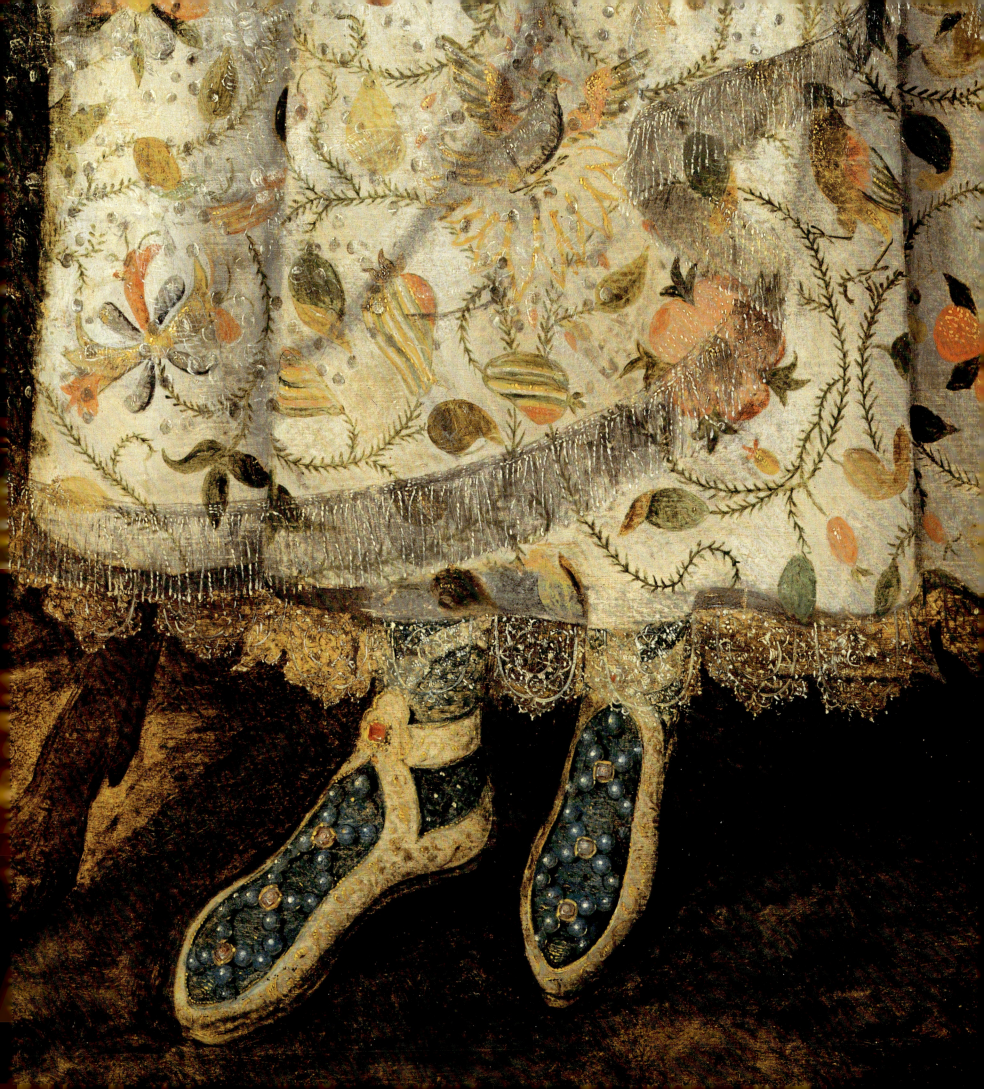

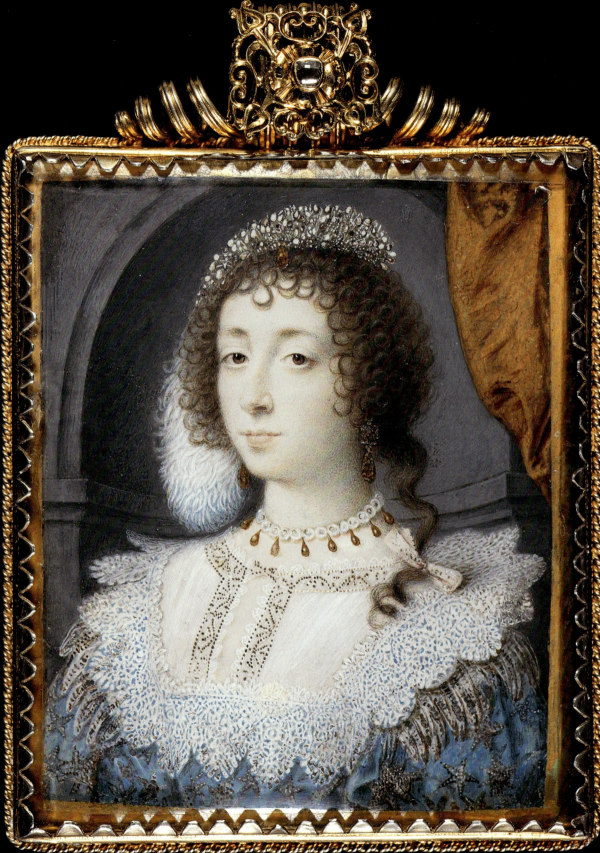

mantle which passes round one hip and is gathered up on the opposite shoulder'.[12] The wearing of a mantle appears to have been a fashion that in England crossed from masque dress into fashionable clothing. While that worn in the portrait of the unknown woman (fig. 251) is of transparent white silk, these garments were often of 'carnation' silk taffeta. Encompassing a range of shades from flesh colour to salmon pink, carnation was deemed a courtly colour. Mantles were sometimes embroidered with attributes associated with the character of the wearer, so for example in Samuel Daniel's *A Vision of Twelve Goddesses* (1604), 'Pallas was attyred in a blew mantle with silver embroidery of all weapons and engines of war'.[13] Sources for the development of the mantle in England include Italian theatrical dress of the fifteenth century as well as fashion books such as that by Boissard.

MASQUE PORTRAITS

The wives of both James I and Charles I took a particular interest in the masque. They were both enthusiastic patrons and active participants – although Anne only danced on stage, while Henrietta Maria also acted and sang, probably influenced by her upbringing at the French court where elite women had performed in such productions for some time. The costume worn by Henrietta Maria in a miniature by John Hoskins (fig. 252) is probably related to the costume worn by the sitter to play the role of Divine Beauty, in a performance of *Tempe Restor'd* at Whitehall on Twelfth Night in 1632. The outfit incorporates elements of fashionable clothing (such as a scalloped border of lace trimming the neckline of her bodice) with features that specifically suggest masque dress – such as the star patterning of the fabric. The surviving designs for this costume by Inigo Jones (fig. 253) do show Henrietta Maria wearing a gown covered with stars, although the costume is not identical to that in the miniature (fig. 252). Perhaps the queen adapted Jones' design for the performance. Alternatively it is possible that the queen's masque costume was transformed into a fashionable dress after the spectacle, and that this is what Hoskins depicts.[14] Into his design Jones incorporates a flap of paper to provide the queen with a choice of costume – this presumably ensured she felt actively involved in the artistic process. His designs for the queen frequently embodied what has been called 'a language of light'.[15] In this example, the stars covering the fabric are complemented by sunbeams at the waistline; together they represent the celestial universe while also recalling nativity stars and the drama of fireworks. Henrietta Maria is the personification of 'light triumphant'. The light also serves a proselytising purpose, it has been suggested, as a representation of her Catholicism.[16]

OPPOSITE
Fig. 252 John Hoskins (c.1590–1665), *Queen Henrietta Maria*, c.1632.
Watercolour on vellum, 9.2 × 7.9 cm. RCIN 420891

BELOW
Fig. 253 Inigo Jones (1573–1652), *Design for Divine Beauty and the Stars in Tempe Restor'd*, 1632.
Chatsworth, Collection of the Duke of Devonshire

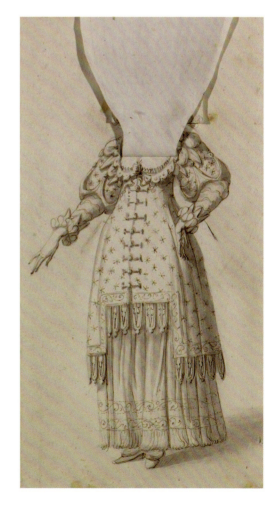

PLAYING A PART 275

Fig. 254 (detail from fig. 252) John Hoskins (c.1590–1665), *Henrietta Maria*, c.1632.
Watercolour on vellum, 9.2 x 7.9 cm. RCIN 420891

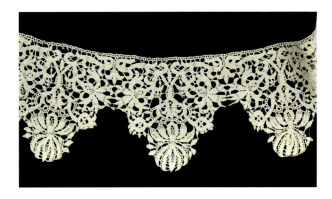

Fig. 255 Scalloped border of bobbin lace in the style of needle lace, Italian, 1620–40.
18.8 x 101.9 cm. Barnard Castle, The Bowes Museum, Blackborne Collection. Acc. 2007.1.1.1.67

The description of the queen as she appeared in *Tempe Restor'd* is similar to Jones's design: 'The Queen's majesty was in a garment of watchet satin with stars of silver embroidered and embossed from the ground and on her head a crown of stars mixed with some small falls of white feathers.'[17] While the miniature by Hoskins depicts the queen wearing a light blue (watchet) garment embroidered with stars, instead of the ruff and crown seen in Jones's design, she wears a more fashionable lace collar (similar to the lace in fig. 255) and a bonnet, although this is decorated with the noted 'falls of white feathers'. She wears a pink ribbon in her lovelock and the shoulders are decorated with pale pink ribbons (these may originally have been a deeper shade of pink, the red pigment being particularly prone to fading under exposure to light). The combination of watchet and carnation was especially popular in masque dress, and immediately signified to the contemporary audience the virtuous nature of the wearer. Their significance has been linked to traditional representations of the Virgin Mary, who was often depicted wearing a blue robe over a pink underlayer (or vice versa).

Masque portraits allowed the sitter to adopt an alternative persona and have themselves painted in an allegorical and somewhat unconventional manner – a rare opportunity for personal expression in a society still largely controlled by unspoken rules of etiquette, particularly for women. Moreover, masque dress was frequently more revealing and less structured than everyday fashions, so such portraits could function as seductive images for the eyes of a loved one. The character of 'Splendour' from *The Masque of Beauty* (1608) is described for example as 'naked breasted', and several of Inigo Jones's designs also show exposed breasts. Whether elite women did actually go topless on the stage is unknown. It has been suggested that they might have used prosthetic devices of the type adopted by cross-dressing male masque performers.[18] The majority of Jacobean masque portraits depict women with low necklines, in line with contemporary court dress, although two notable surviving masque portraits do show women with more revealing necklines than even Jacobean fashions would presumably have considered appropriate. The modesty of *Lady Elizabeth Pope* (Tate, London) is concealed only by her locks of hair while Isaac Oliver's miniature *Unknown Lady as Flora* (Mauritshuis, The Hague) shows breasts visible beneath transparent linen.[19]

Masque costumes were also remarkable for revealing other parts of the female anatomy. The short length of the skirts (ending well above the ankle in order to show the wearer's footwork) showed the female leg – unlike fashionable clothing. Anne of Denmark's costume for *The Masque of Blackness* (1605) revealed bare arms – a feature of female dress that had not been seen since classical antiquity, and which did not enter the fashionable female wardrobe until the 1630s, when sleeves shortened to elbow-length. Masque dress was a style only suited to the intimate courtly circle and singular occasion of the performance. This explains why there are so few pictures of the two masque-loving queens. It is no coincidence that both surviving records of queens depicted wearing masque dress are in the intimate miniature format. These are not images intended for public consumption, but are instead private images that could be held in the hand.

The masque was unlike other theatrical productions in that the recycling of existing costumes appears to have been very rare. Instead, costumes were specially designed and created by a combination of different craftsmen to suit the character and script.[20] This approach is in

contrast to everyday clothing, which was frequently altered according to changing tastes, and also to the public theatre companies which built up significant costume stores. The composite nature of masque costume, however, means that incorporating elements of informal clothing with fantastical elements was an option – perhaps this was more frequently adopted by less wealthy participants, playing less prominent roles. While Anne of Denmark had some of Elizabeth I's clothes transformed into outfits for a masque of 1604, this appears to have been due to the fact that the new king and queen did not have much time available, and was also perhaps a conscious demonstration of the continuity of the monarchy from the Tudor to Stuart line.[21]

Elite forms of courtly entertainment were popular throughout Europe. In the portrait by Hanneman, thought to been painted in The Hague during the 1650s, Mary, Princess of Orange, wears a form of masquerade costume (fig. 256).[22] The eldest daughter of Charles I, Mary had married William, Prince of Orange, at the age of nine. A letter of 1655 to the future Charles II from their aunt, Elizabeth of Bohemia, describes the courtly entertainment and notes that 'your sister was very well dressed, like an Amazon'.[23] The reference to the Amazon refers to the brightly coloured feathered cape for which the Tupinambá people of sixteenth- and seventeenth-century Brazil were famous. Count Johan Maurits of Nassau-Siegen, Governor of Pernambuco in Brazil (1630–54) and founder of the Mauritshuis, encouraged the cultural exchange of objects between the region and Europe. Such feathered mantles appear to have appealed to Europeans for their cultural context (they were worn during the ritualistic warlike ceremonies associated with cannibalism) as well as for their technical craftsmanship. Their scarlet feathers came from the scarlet ibis bird (*guará*), while yellow feathers could be produced by a process today known as tapirage – feathers of a different colour are plucked from a bird, and the open follicle is painted with a combination of skin secretions from a poisonous frog and plant extracts; the feather that grows back is yellow.[24] A surviving example of a feathered cape made by the Tupinambá people from this time is in the National Museum in Copenhagen, with an associated crown of feathers (figs 257 and 258). While capes could be imported to Europe already made up, the feathered cape worn by Mary in her portrait was probably sewn together in Europe, since it is lined with silk of an early seventeenth-century European design with small sprigs of flowers.

Unlike the South American crown of feathers, Mary's headdress is in the style of a turban, demonstrating the way different versions of the 'exotic' could be combined together in one theatrical costume. The striped fabric from which it is constructed matches that decorating the top of her bodice, and is similar to the striped scarf frequently appearing in paintings by Lely of the 1660s (see page 184)– it was probably a fashionable accessory at the time. The sitter's attire bears some resemblance to the description of an outfit designed by Inigo Jones for the *Memorable Masque of the Middle Temple on Lincoln's Inn* in 1613, and demonstrates the continued appeal of the 'exotic' in courtly performance: 'their robes were tucked up before, strange hoods of feathers and scallops about their necks, and on their heads turbans, stuck with several coloured feathers'.[25] South American feathers continued to be used in England after the Restoration to underscore cultural differences. A performance of Dryden's *The Indian Queen*

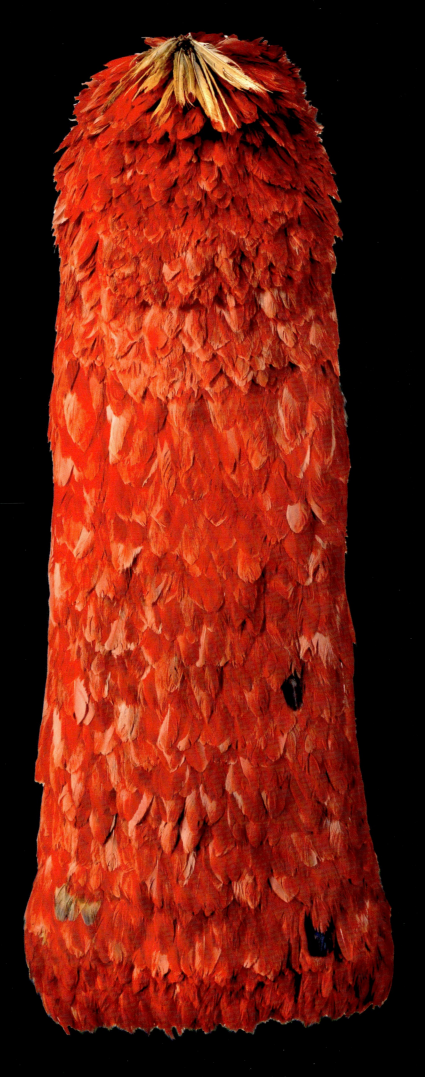
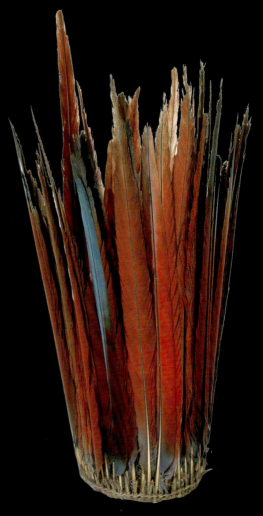

LEFT
Fig. 257 Feathered cloak, Tupinambá, Brazil, 1600–74.
Copenhagen, National Museum of Denmark

ABOVE
Fig. 258 Crown of feathers, Tupinambá, Brazil, 1600–74.
Copenhagen, National Museum of Denmark

OPPOSITE
Fig. 256 Adriaen Hanneman (1604–71), *Mary, Princess of Orange*, 1655?
Oil on canvas, 120 x 98 cm. RCIN 405877

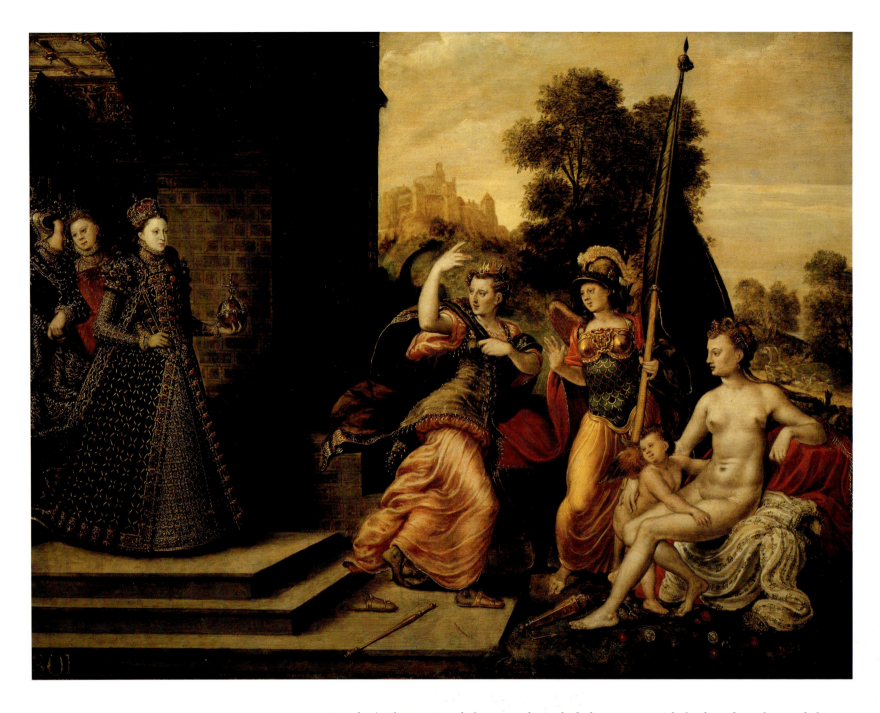

Fig. 259 Hans Eworth (active 1540–73), *Elizabeth I and the Three Goddesses*, 1569. Oil on panel, 62.9 × 84.4 cm. RCIN 403446

at London's Theatre Royal, for example, included costumes with feathered armlets and skirts – presented to the theatre by playwright Aphra Behn, who writes that she had been given them during a visit to Surinam in South America (probably in 1663).[26]

Fantastical masque-like costumes also appear in other types of painting. In the allegorical scene *Elizabeth I and the Three Goddesses* (fig. 259), the artist retells the mythological story of the Judgement of Paris by showing the monarch retaining the golden 'apple' (represented by the orb) instead of the traditional victor, Venus, goddess of beauty. The contemporary inscription on the frame explains: 'Pallas was keen of brain, Juno was queen of might, The rosy face of Venus was in beauty shining bright, Elizabeth then came, And, overwhelmed, Queen Juno took flight: Pallas was silenced: Venus blushed for shame.' The discarded smock belonging to

Venus echoes contemporary linen smocks, while the costumes worn by the figures of Juno and Minerva bear a striking resemblance to theatre designer Bernardo Buontalenti's later designs for the *Intermezzi* of 1589 at the Medici court in Florence. They are particularly close in terms of the tiered construction of the various tunic layers, the leonine figures on the armour and the fluttering draperies (fig. 260).[27] Whether conscious or not, this style of mannerist, *all'antica* clothing for the stage had entered the visual repertoire of artists in England, even when removed from its original theatrical context.

Fig. 260 Bernardo Buontalenti *(c.1531–1608)*, *Designs for the Intermezzi*, 1588–9. London, V&A Museum. Acc. E.614-1936

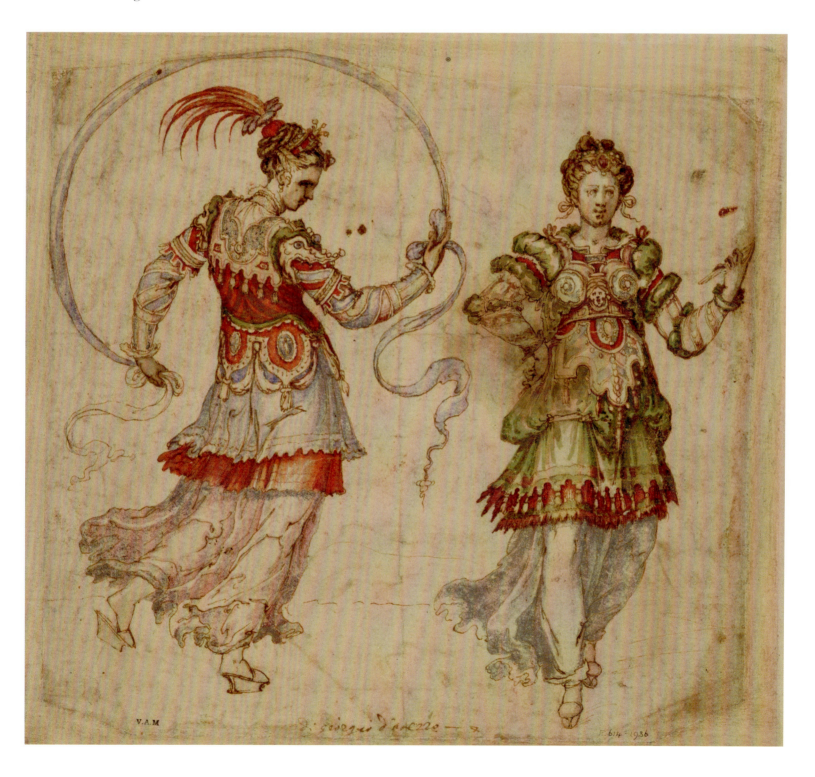

PLAYING A PART 281

THE RESTORATION THEATRE

The last masque to be performed under Charles I was *Salmacida Spolia* in 1640. The Civil War signalled the end of a form of entertainment that was not reinstated to the same degree under Charles II, who instead chose to focus his theatrical patronage on the public playhouses. The masque had been a diversion in which only the elite and their households were participants and spectators. By contrast, the Restoration theatre was populist and accessible, with the king himself as just another spectator amongst the diverse London crowd. The fashions worn by both performers and audience members were a matter of concern for the broad theatre-attending section of society.

Theatrical performances might draw on classical inspiration in order to clothe their characters, but contemporary tastes in hairstyle and silhouette often crept in and prevented complete historical accuracy. So, for example, classical figures were portrayed by actors wearing periwigs. Such wigs were a sign of social status, and therefore not something actors would enthusiastically leave off, even when adopting another persona. The traditional division between tragedy and comedy was maintained at the Restoration court and influenced the style of costume worn by the actor – tragedy was deemed suited to classically influenced clothing, while comedic productions were staged in contemporary fashions. The 'wrong' style of clothing for a character was noted by the observant audience.

The two most important rival theatre companies – the King's Company of Comedians, and the Duke of York's Players – were patronised by the two royal brothers, and their actors were considered part of the royal household. They were accordingly given Royal Livery, a situation that had also been the case under James I, whose 'King's Men' were provided with fabric to make up livery every second year. Royal patronage was largely based on the use of the royal name rather than the use of royal funds, and monarchs did not participate actively on stage, unlike in the masque. The monarch and other members of the nobility did, however, play an important role in loaning clothing. Charles II, for example, lent his Coronation robes (see fig. 109), which had originally cost over £2,000, to Thomas Betterton for the role of Prince Alvaro in a revival of *Love and Honour* by William Davenant in 1661. Similarly, the Duke of York lent a suit to Henry Harris playing Prince Prospero. The same garments were lent again for a production of *Henry the Fifth*.[28] Mary of Modena presented both her wedding and coronation dresses to the noted tragedian Elizabeth Barry. This generosity will have been a welcome addition to the theatrical manager's wardrobe. Costumes were the most expensive part of a theatre production, and the manager was responsible for providing them for the entire cast (although the actors provided their own linen and accessories, such as gloves).

The Theatre Royal was responsible for providing the costume worn by one of Charles II's favourite actors – the comedian John Lacy. His talent for adopting dramatically different personas is exemplified in John Michael Wright's unusual portrait showing three of his most famous roles (fig. 261), although their identification has been the subject of considerable debate.[29] The most widely accepted view is that it represents his appearances as Sauny the Scot from the actor's own adaptation of *The Taming of the Shrew* (1667), Monsieur Galliard from *The Variety* (written c.1641 but revived in 1662) and Scruple in *The Cheats* (1663). As the

OPPOSITE
Fig. 261 John Michael Wright (1617–94), *John Lacy*, c.1668–70.
Oil on canvas, 233.4 x 173.4 cm. RCIN 402803

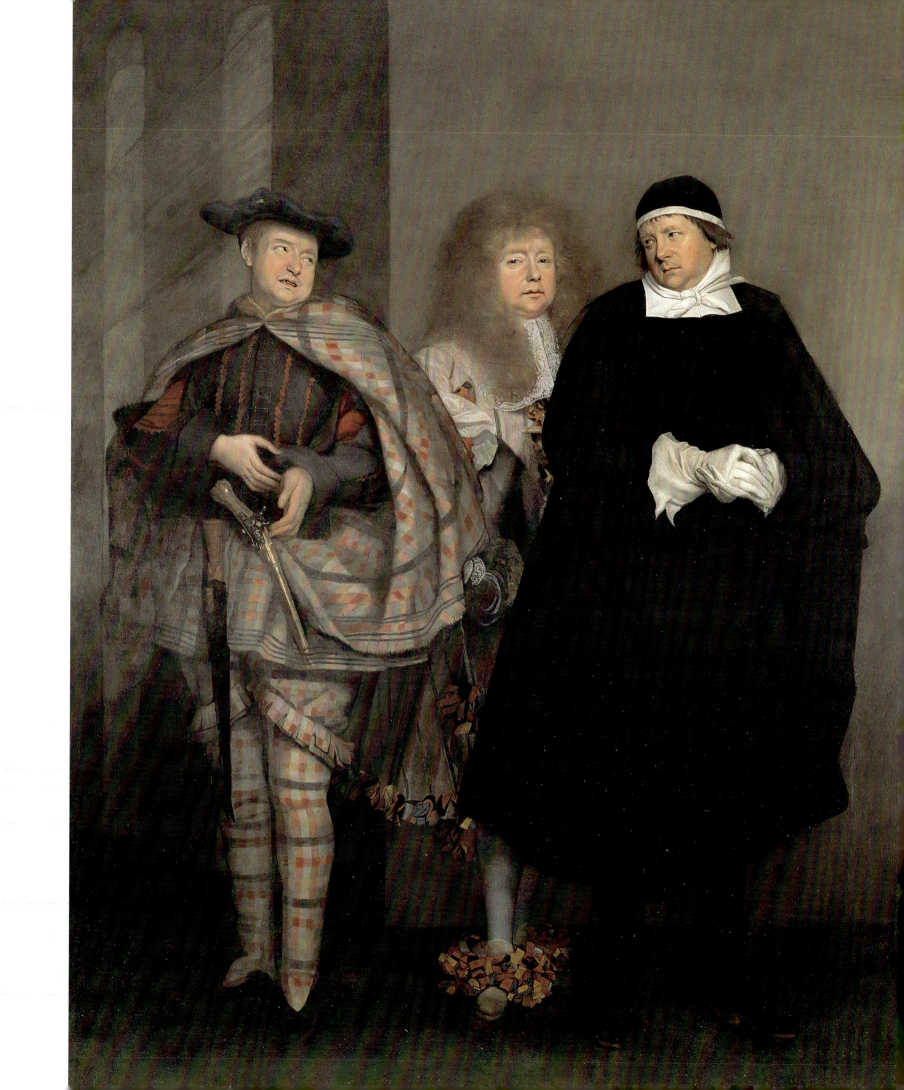

Scottish highlander Sauny, Lacy accordingly wears a large plaid, fastened at the neck, tartan tight-fitting trews and a blue bonnet. As the fastidious dissenting parson Scruple he wears austere black and white, his gaze loaded with disapproval. The visual differences made immediately apparent through the medium of costume served immediately to identify a character to an audience even before they started speaking.

Behind the other two characters, Lacy is portrayed as Monsieur Galliard, a French dancing master. As such he is the epitome of fashionable excess, loops of colourful ribbon almost overwhelming his shoes in the same way that his large periwig threatens to overwhelm his head. Pepys wrote of the sitter's performance: 'Lacy's part, the Dancing Master (was) the best in the world'.[30] The French fop – the embodiment of mindlessness and frivolity – was a frequent subject for satire in Restoration comedy. Monsieur Galliard's overriding ambition in *The Variety* is to teach everyone the perfect *révérence* – a type of bow that he sees as a cure for all social ills. In Wright's portrait Monsieur Galliard stands with his feet turned out, the stance the character considers ideal for both standing and walking. At one point in the play he boasts of a relative who trained Englishmen to swap their normal gait for walking 'vid deir toes out'.[31] *The Variety* ends with a parody masque entitled *Tempe* (set in a tavern), a conscious reference to *Tempe Restor'd* (1632) in which, as we have seen, Henrietta Maria played a starring role (see fig. 248). Within only a few years the Caroline masque has been transformed from the height of elite sophistication into a target for mockery.[32] The French fop is just one example of the way the theatre played a role in shaping English perceptions and stereotypes of national forms of dress from other countries. Similarly, throughout the seventeenth century Spanish male characters on stage were portrayed wearing tight-fitting uncomfortable clothes, large ruffs and high-crowned hats.[33]

MILITARY DRESS ON STAGE

Arms and armour (and all that they symbolise) appear frequently in Renaissance literature, and both contemporary and classicising armour were accordingly used heavily in theatrical productions. Hamlet's ghost is 'a figure like your father, Armèd at point exactly, cap-â-pie'.[34] His old-fashioned style of head-to-toe medieval armour represents ideals of chivalry which were being replaced by new modes of warfare and politics – symbolised by the figure of Claudius, who relies on mercenary soldiers and heavy artillery to maintain his rule. In designing masque costumes Inigo Jones may have been inspired by the dramatic outfits worn by Elizabethan courtiers at the Accession Day Tilts in November each year, to celebrate the accession of the monarch.[35] The outfits worn by the knights were suitably impressive as seen for example in the portrait of Sir George Clifford, 3rd Earl of Cumberland (National Maritime Museum, London).

Chapter 7 has already described how Roman military dress was adopted in portraiture of the seventeenth century in England. It also had an influence on costumes for the stage, and is particularly evident in the designs of Inigo Jones. He depicts Prince Henry as Oberon in *The Faery Prince* of 1611 as a Roman Emperor in a tightly fitted costume, emphasising his muscular physique (fig. 262). His helmet is topped with ostrich plumes and he wears a long cloak. It has been argued that the leonine shoulderpieces and buskins add an animalistic element to the civilised

Fig. 262 Inigo Jones (1573–1652), *Prince Henry as Oberon*, 1611.
Chatsworth, Collection of the Duke of Devonshire

OVERLEAF
(detail from fig. 78) German or Netherlandish artist working in England, *Portrait of a Man in Red*, c.1530–50.
Oil on panel, 190.2 x 105.7 cm. RCIN 405752

Roman attire, in keeping with the theme of satyrs (half man, half beast) running through the text of *Oberon*.[36] It is interesting that such leonine shoulders were never actually used on classical armour, being introduced in around the fourteenth century. One noteworthy feature of this design is that he wears trunk hose along the fashionable style, striped to resemble pteruges, rather than the more historically accurate Roman tunic skirt.

Charles I also wore a form of *all'antica* to play the role of the Roman Emperor Albanactus in *Albion's Triumph*, performed in 1632. He even adopted the correct overskirt formed of pteruges – although he retained his contemporary hairstyle.[38] Such clothing had become a visual shorthand for the audience to identify quickly the ruler or hero in a production. Heroes continued to be represented in productions on the Restoration stage wearing *all'antica* armour with helmets topped with ostrich plumes; the tradition continued in *opera seria* during the eighteenth century.

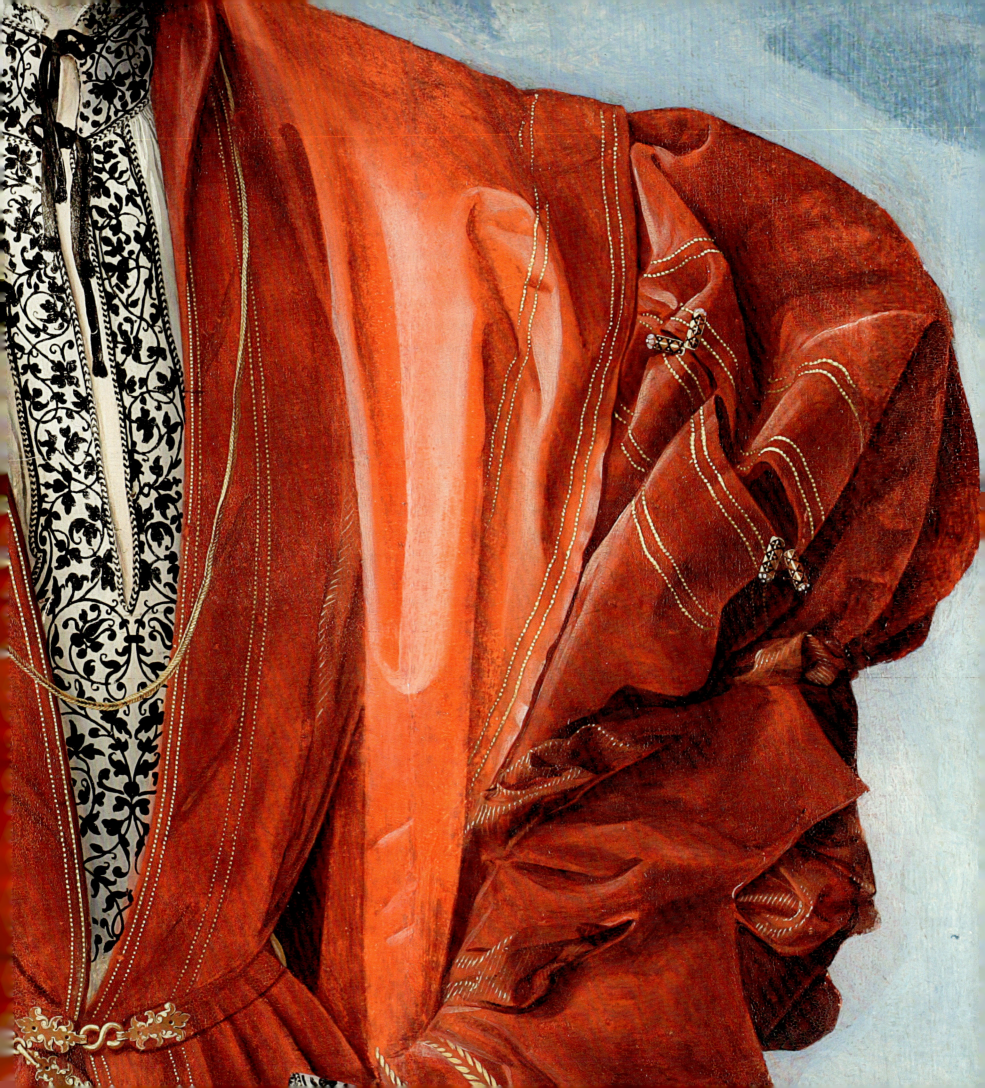

NOTES

INTRODUCTION

1. S. Butler, 'A Huffing Courtier, 1667–9', in A. Waller (ed.), *Characters and Passages from Note-books*, Cambridge, 1908, pp. 35–6.
2. This form of imitation theory was first proposed by Georg Simmel in 1904, although he did not use the term 'trickle-down'. For two useful summaries of the various theories of fashion, see Craik 2009 and Hunt 1996.
3. Begent 1999, p. 170.

CHAPTER 1 DRESS AND ITS MEANINGS

1. Palliser 1902, p. 340.
2. De Marly 1987, p. 42.
3. Cumming 1989, p. 38.
4. MacLeod 2001, p. 183.
5. Starkey 1987, p. 2.
6. ibid., p. 186.
7. Arnold 2008, p. 9.
8. Arthur Throckmorton financed his visit to court in 1583 by selling land and borrowing his brother's legacy, and was left paying interest many years after the event. Quoted in Ashelford 2009, p. 28.
9. Benhamou 1989, pp. 27–37.
10. This legislation dates from 12 February 1580. Quoted in Benhamou 1989, p. 31.
11. Benhamou 1989, p. 34.
12. Foister 2005, p. 231. The sleeve of the gown is noted as *karmin* (carmine – a red dye derived from cochineal), the plain section of the collar of the gown is *rot* (red), while the slashed section of the collar is noted as *sam* (*sammet* is velvet). From 1533 onwards, only people at the level of Baron or above were allowed to wear velvet of crimson, scarlet or blue (Hayward 2009, p. 29).
13. Hayward 2009, p. 173.
14. See V. Cumming, '"Great vanity and excesse in Apparell", Some Clothing and Furs of Tudor and Stuart Royalty', in MacGregor 1989 for a more detailed discussion of the structure of the Great Wardrobe and its changing function over the period.
15. D. Starkey (ed.), 'The Inventory of Henry VIII: The Transcript', vol. 1, Society of Antiquaries & Harvey Miller, 1998. These have been analysed in detail in Hayward 2007b.
16. Stowe MS 557 in the British Library; MS LR 2/121 in the National Archives, Kew; MS V.b.72 in the Folger Shakespeare Library, Washington D.C. These have been analysed in detail in Arnold 1988.
17. V. Cumming, '"Great vanity and excesse in Apparell", Some Clothing and Furs of Tudor and Stuart Royalty', in MacGregor 1989, p. 323
18. Strong 1980, pp. 73–89.
19. V. Cumming, '"Great vanity and excesse in Apparell", Some Clothing and Furs of Tudor and Stuart Royalty', in MacGregor 1989.
20. Carter 1984 and Doda 2011.
21. Additional but incomplete wardrobe records covering the period from c.1154 to 1830 are kept in the National Archives, Kew.
22. Author's own analysis.
23. Murdoch 1981, p. 9.
24. This point was first noted in Breward 1995, pp. 59–60.
25. Watt 2009, p. 46.
26. Starkey 2004, p. 651.
27. The works of Cornelis Engebrechtsz have been identified by his distinctive manner of painting these highlights, for example. See Van Duijn 2012
28. Two English examples are a portrait of Margaret Layton, which survives along with the embroidered jacket in which she is portrayed (both V&A Museum, London), and a portrait of Sir Richard Cotton by Mytens (present whereabouts unknown) which Janet Arnold identified as depicting a suit in the V&A Museum, London (T.28.1938). See Arnold 1985, p. 28 and p. 51.
29. N. Rothstein writes with reference to the wardrobe of Elizabeth I: 'Between September 1587 and April 1589, for example, there were 102 such alterations. They were probably needed, partly because of changes in fashion, and partly, more prosaically, because the queen was getting fatter'. See Jenkins 2003, vol. I, p. 535.
30. North 2011, p. 34.
31. Strong 1980, p. 78. It might be conjectured that this painting (the artist's first official commission for the monarch) was favourably priced in order to gain subsequent commissions. However the prices of later portraits reveal this level of discrepancy was not unusual. Van Dyck was also paid £100 five years later for *The Five Eldest Children of Charles I*, executed in 1637. By this date van Dyck has become well established as the king's most important painter.
32. Strong 1980, p. 73.
33. A. Gurr, *The Shakespearean Stage: 1574–1642*, Cambridge, 1992, p. 13.
34. Quoted in Cumming 1989, p. 46.
35. ibid., p. 46
36. V. Cumming, '"Great vanity and excesse in Apparell", Some Clothing and Furs of Tudor and Stuart Royalty', in MacGregor 1989, pp. 329–34.
37. E. Gombrich, *Art and Illusion*, London, 2002, p. 56
38. J. Marschner, 'Mary Stuart, Princess of Orange and Queen of England: Royal Dress and Politics in the Netherlands and England in the Late Seventeenth Century', in Pietsch 2012, p. 130.

CHAPTER 2 DRESSING WOMEN

1. Readers looking for a comprehensive chronological account of the changes in fashion during the period are encouraged to look at the *Visual History of Costume Series* (London).
2. Double running stitch is also known as *Holbein stitch* due to the frequency with which it is depicted in his portraits. See chapter 5 for more detail.
3. Janet Arnold first drew attention to the smock in this painting and described surviving examples. See Arnold 2008, pp. 54–55.
4. The different combinations of garments worn by women over the smock during the sixteenth century, together with their terminology, is a subject still open to debate and is complicated by there being so few surviving garments. For simplicity the terms *gown*, *bodice* and *skirt* are used most frequently throughout this text, but it is recognised that the terms *petticoat* and *kirtle* were also used for components of female dress covering both the torso and lower half of the body at different points. See Mikhaila 2006, pp. 20–4, for a useful summary.
5. Arnold 1988, p. 218. An example order from 20 October 1565 is as follows: 'Item to Roberte Careles our Pynner for xviij thousand great verthingale pynnes xx thowsand great Velvet Pynnes xxx and nyne thouwsande smale Velvet Pynnes and xix thowsand Small hed Pynnes all of our great warderobe'.
6. Arnold 1988, p. 208.
7. The question of whether the sitter is pulling on or removing her stocking has aroused some debate amongst scholars and is important for the message of the painting – is she inviting the viewer to pleasure by removing her clothes, or has the viewer already succumbed? Those who believe she is taking off her stockings cite the indentations at the top of her calves as evidence that they have recently been worn. However a similar Jan Steen composition in the Rijksmuseum shows the female with far more pronounced indentations, clearly intended to suggest the stocking in that painting is being removed. Those who believe she is pulling it on emphasise the similarity to Visscher's *Sinnepoppen*, which clearly shows a stocking being pulled on, and highlight the full chamberpot beside the bed. See H. Chapman et al, *Jan Steen, Painter and Storyteller*, Washington, 1996, pp. 161–2.
8. The English word *farthingale* comes from the French translation of *verdugado* – a name derived from *verdugo* referring to the smooth twigs produced from coppiced trees. These were originally used for stiffening rings of progressively increasing circumference.
9. Arnold 1988, p. 195.
10. Arnold 1985, p. 7.
11. Quoted in N. Waugh, *Corsets and Crinolines*, London, 1954, p. 33.
12. Quoted in W. Hilton, 'A Dance for Kings: The 17th-Century French "Courante"', *Early Music*, vol. 5, no. 2, April 1977, p. 162.
13. George Gower's skill at rendering these transparent sleeves floating above the layer of blackwork embroidery below can be seen in his portrait of Mary Cornwallis in Manchester Art Gallery (acc. no. 1953.112).
14. See Gordenker 2003, pp. 30–3, for a complete discussion of the disappearance of the gown in portraiture.
15. For a full discussion of pregnancy portraits, see K. Hearn, 'A Fatal Fertility? Elizabethan and Jacobean Pregnancy Portraits', *Costume*, no. 34, 2000.
16. Brides often had their hair down on their wedding day, but this action could be widely criticised when the couple in question were already believed to be lovers. Valerie Cumming draws attention to the example of Frances Howard, Countess of Essex, who received much adverse comment for wearing her hair loose during her marriage to Robert Carr, Earl of Somerset, in 1612. See V. Cumming, '"Great vanity and excesse in Apparell", Some Clothing and Furs of Tudor and Stuart Royalty', in MacGregor 1989, p. 349, note 25.
17. For a discussion of the depiction of these jackets in domestic settings, see D. Nunn-Weinburg, 'The Matron Goes to the Masque: The Dual Identity of the English Embroidered Jacket', *Medieval Clothing and Textiles*, vol. 2, 2006, pp. 151–73.
18. This is in contrast to the portrait of Margaret Layton and her surviving waistcoat in the V&A Museum, London, which shows that the sitter wears her skirt over a longer waistcoat to fit with the new fashion for higher waistlines.
19. Hayward 2007b, p.169.
20. Steele 2010, p. 496.
21. De la Haye 1999, p. 95.
22. Ben Jonson, *Every Man Out of his Humour*, 1598, Act III, scene iv.
23. J. Tiramani, 'Janet Arnold and the Globe Wardrobe', *Costume*, no. 34, 2000, p. 121.
24. J. Tiramani, 'Three Multilayered Ruffs in the Historisches Museum Basel', in Pietsch 2012, p. 95.

25 The rebato in this portrait was first noted by Janet Arnold, and is described in Arnold 2008, p. 34.
26 For a complete account of the murder of Sir Thomas Overbury and the significance of yellow starch, see Jones 2001, pp. 59–85.
27 The simplest pairs could cost as little as 3 pence per pair – equivalent to approximately £1.20 in 2013. See Cumming 1982, p. 21.
28 Cumming 1989, p. 40.
29 Stallybrass 2001, pp. 123–4
30 This was first noted by Janet Arnold. See Arnold 1988, p. 10.
31 ibid., p. 214.
32 Gablehood wire in Museum of London, acc. no. NN55.28. See G. Egan and H. Forsyth, 'Wound Wire and Silver Gilt: changing fashions in dress accessories c.1400–c.1600', in Gaimster 1997, pp. 226–229.
33 Hayward 2007b, p. 172.
34 ibid., p. 171.
35 Seigneur de Brantôme, *Oeuvres complètes de Pierre de Bourdeilles abbé et seigneur de Branthôme*, P. de Bourdeille (ed.), Paris, 1858–95 edn, p.x; 'Recueil des Dames', I, 'Discours III', p. 115.
36 The word 'pomander' could also be used for the actual scented material contained within the pomander vessel. This was often derived from plants such as jasmine, lavender or orris (from the root of the iris plant), and combined with secretions from animals such as musk or ambergris (an excretion from the intestines of whales), which increased the depth of the scent, and accordingly its cost.
37 Other similar frog purses are in the Museum of London and the Ashmolean Museum.
38 It should be recognised, however, that Hollar based several of his fashionably dressed females on portraits produced by Anthony van Dyck rather than from direct observation.
39 D. Smith, *The Dutch Double and Pair Portrait: Studies in the Imagery of Marriage in the Seventeenth Century*, 1978, PhD. Diss., Columbia University, p. 196.
40 De Winkel 2007, p. 88
41 Scarisbrick 1986, p. 230.
42 Hearn 1995, p. 192. This demonstrates how useful attire can be in dating paintings.
43 Acc. nos T.150–1963 and T.44–1962.
44 T. Carew, 'Upon a Ribband', *Poems*, London, 1640, p. 48.
45 E. Griffey, *Henrietta Maria: Piety, Politics and Patronage*, Aldershot, 2008, p. 166 and p. 174.
46 ibid., pp. 193–4.
47 Balfour 2008, p. 38.
48 Previous owners include Joseph Bonaparte and, most recently, Elizabeth Taylor. The pearl was sold at Christie's New York on 13 December 2011, Sale 2623, Lot 12.
49 The fashion for pierced ears was relatively new, and probably arrived in England from Spain. By 1575, Elizabeth I was being given earrings at gifts.
50 Henrietta Maria sold the pearls to her nephew, Louis XIV, in 1657 to raise funds.
51 R. Herrick, 'Upon a Black Twist, Rounding the Arme of the Countess of Carlile', *The Poetical Works of Robert Herrick*, G. Saintsbury (ed.), 1893, vol. I, p. 82.
52 Readers are encouraged to turn to Ribeiro 2011 for a comprehensive analysis of cosmetics since the Renaissance.
53 Latham 1997, entry for 26 April 1667.

CHAPTER 3 **DRESSING MEN**

1 Quote from John Harington of Kelston, quoted in I. Grimble, *The Harington Family*, London, 1957, p. 122.
2 Byrde 1979, p. 63.
3 Hayward 2002, p. 13.
4 Forensic tests in the 1950s and 1980s to establish whether or not the stains on the front are blood stains from Charles I were inconclusive.
5 Begent 1999, p. 168. Under Henry VIII the Lesser George was to be worn on a chain or from a lace, although by the reign of Elizabeth I it was usually hung from a ribbon around the neck. By the early seventeenth century the ribbon is also often shown being worn over the left shoulder.
6 I am grateful to Heather Toomer for her advice on the lace in this painting.
7 Strong 1980, pp. 73–89.
8 J. Farrell, *Socks and Stockings*, London, 1992, p. 14.
9 J. Tiramani, 'Janet Arnold and the Globe Wardrobe', *Costume*, no. 34, 2000, p. 121.
10 Arnold 1985, p. 53.
11 This proclamation intended 'the reformation of the use of the monstrous and outragious greatness of hose, crept alate into the realm'. It outlined the maximum amount of fabric and padding allowed for such garments. See Vincent 2009, p. 66.
12 I. Groeneweg, 'Men's Fashion circa 1660 – Some Historical Facts Concerning the Introduction of the Rhingrave, Innocent and Justaucorps', in Pietsch 2012, p. 83.
13 Randle Holme, British Museum, MS (Harley 2014), fol.63v, dated 1658 and 1659. Randle Holme wrote next to a sketch of petticoat breeches that the style was first worn in Chester by a Will Ravenscroft 'who came out of France and so to Chester in Sept 1658', the implication being that they were originally a French fashion.
14 L. Edwards, 'Dres't Like a May-Pole: A Study of Two Suits', *Costume*, no. 19, 1985, p. 90.
15 I. Groeneweg, 'Men's Fashion circa 1660 – Some Historical Facts Concerning the Introduction of the Rhingrave, Innocent and Justaucorps', in Pietsch 2012, p. 87.
16 J. Marshall-Ward, 'Mode and Movement', *Costume*, no. 34, 2000, p. 125.
17 Aileen Ribeiro discusses various possible exotic influences on the development of the new male suit, including the loose coats worn by Russian ambassadors at the English court and Persian costumes worn by actors on the stage, as well as influences from closer to home, such as the male riding jacket (*jumpe*). See Ribeiro 2005, pp. 230–8.
18 Hayward, 2007b, p. 96.
19 J. Roberts, *Holbein and the Court of Henry VIII*, Edinburgh, 1993, p. 36.
20 Hayward 2002, p. 13.
21 Piacenti 2008, p. 180–1.
22 W. Prynne, *The Unloveliness of Lovelocks*, London, 1628, p. 24.
23 Staniland 2005, p. 59.
24 W. Prynne, *A Gagge for Long-Hair'd Rattle-Heads who revile all civill Round-heads*, London, 1646 and T. Hall, *The Loathsomnesse of Long Haire*, London, 1653, p. 15.
25 Latham 1995, entry for 3 November 1663.
26 ibid., 2 November 1663.
27 ibid., 4 November 1663.
28 S. Stevenson and D. Thomson discuss the dating of this portrait in *John Michael Wright, The King's Painter*, Edinburgh, 1982, pp. 80–1. Valerie Cumming points out that the style of wig reinforces the later date (Cumming 1989, p. 31 and p. 208). The fact that Pepys notes that the King did not adopt a wig until 1664 also lends credence to the theory that the painting was produced some time after the Coronation.
29 North 2011, p. 12.
30 Hayward, 2007b, p. 114.
31 Scarisbrick 1986, p. 229.
32 For full details of all these jewels, see Strong 1997c, pp. 69–74.
33 For a full history of the Sancy diamond, see Ronald 2004.
34 Balfour 2008, p. 247.
35 'This morning, hearing that the Queene grows worse again, I sent to stop the making of my velvett cloak, till I see whether she lives or dies'. Latham 1995, entry for 22 October 1663.
36 Cumming 1989, p. 42.
37 M. Rogers, '"Golden Houses for Shadows": Some Portraits of Thomas Killigrew and his Family' in D. Howarth (ed.), *Art and Patronage of the Caroline Courts: Essays in Honour of Sir Oliver Millar*, Cambridge, 1993, pp. 220–42.
38 Gordenker 2003, p. 64.
39 R. Strong, 'The Elizabethan Malady: Melancholy in Elizabethan and Jacobean Portraiture', *Apollo*, vol. 79, 1964, p. 265.

CHAPTER 4 **DRESSING CHILDREN**

1 The date of this painting, and therefore the implied age of the sitters, is difficult to determine with certainty. It is believed that the painting was begun by Lely in c.1668–70, but the artist died before it was finished, probably having only blocked in the figures. It was completed by Benedetto Gennari after Lely's death in 1680.
2 J. Bedaux and R. Ekkart (eds), *Pride and Joy: Children's Portraits in the Netherlands 1500–1700*, New York, 2000, p. 64.
3 Another example is seen in the 1616 miniature of Richard Sackville, 3rd Earl of Dorset, in the V&A Museum.
4 I am grateful to Catharine MacLeod for suggesting this identification.
5 The emphatic fleur-de-lis symbolism is less easy to reconcile with the identification as Henry Frederick, although it could perhaps refer back to his great-grandmother, Mary Queen of Scots (who was, for a time, Queen consort of France through her marriage to Francis II).
6 For example, Frederic de Vinciolo, *Les singuliers et nouveau pourtraists et ouvrages de lingerie*, Paris, 1587. My thanks to Clare Browne for her advice on the lace in this painting.
7 Again thanks to Clare Browne for her advice on the dating of the lace on this set of christening garments.
8 V. Steele, *The Corset: A Cultural History*, Yale, 2003, p. 12.
9 Quoted in S. Barnes et al, *Van Dyck: The Complete Paintings*, New Haven and London, 2004, p. 478.
10 V&A Museum, London, acc. no. B.81–1995.

CHAPTER 5 **PAINTING DRESS**

1 M. de Winkel, 'The Artist as Couturier: The Portrayal of Clothing in the Golden Age', in Ekkart 2007, p. 71.
2 Strong 1969, p. 344.
3 E. Gombrich, *Art and Illusion*, London, 1977, p. 281.
4 P. Angel, 'Praise of Painting', trans M. Hoyle, with an introduction and commentary by H. Miedema, *Simiolus*, 24, 1996, p. 248.
5 L. Clarkson, 'The Linen Industry in Early Modern Europe', in Jenkins 2003, vol. I, p. 477.
6 ibid., p. 480
7 S. Chassagne, 'Calico Printing in Europe before 1780', in Jenkins 2003, vol. I, p. 514.
8 Monnas 2008, p. 299.
9 For a more detailed discussion of Ter Borch's technique in depicting satins, see A. Wallert, 'The Miracle of Gerard Ter Borch's Satin', in Wheelock 2004, pp. 32–41.
10 N. Rothstein, 'Silk in the Early Modern Period, c.1500 – 1780', in Jenkins 2003, vol. I, p. 549.
11 William Shakespeare, *Measure for Measure*, 1603, Act I, scene ii.

12 Hayward 2009, p. 89.
13 Janet Arnold first identified the similarity between this fabric in the V&A Museum and that in the portrait. See Arnold 1988, p. 18.
14 Lisa Monnas discusses van Dyck's use of these fabrics as backdrops. See Monnas 2008, p. 264.
15 Van Duijn 2012, p. 8.
16 Monnas 2008, p. 197.
17 A. Vandivere and M. Clarke discuss the depiction of shot silk in 'Changing Drapery: Recipes and Practice' in *Vision and Material: Interaction Between Art and Science in Jan van Eyck's time*, Brussels, 2012
18 Hayward 2009, p. 180.
19 Van Duijn 2012, p. 6.
20 Montgomery 2007, p. 358. It should be noted that the term *taffeta* has been used for a variety of fabrics at different points in time.
21 Smith 1693, p. 87.
22 Peacham 1634, pp. 132–5.
23 F. Vermeylen, 'The Colour of Money: Dealing in Pigments in Sixteenth-Century Antwerp', in Kirby 2010, p. 360.
24 J. Kirby Atkinson, 'Artist's Materials in Sixteenth-Century England: Import and Retail Trade', abstract from *Marking Art in Tudor Britain Workshop (National Portrait Gallery)*, London, 2007–8.
25 Harley 2001, p. 104.
26 Kirby 1999, p. 32.
27 Hayward 2009, p. 160.
28 M. Hayward, 'Fashion, finance, foreign politics and the wardrobe of Henry VIII', in Richardson 2004, p. 171.
29 Public Record Office LR.5.66. Bill from Humphrey Bradbourne, milliner, for April–June quarter 1638.
30 Talley 1978, p. 748.
31 'Draperie noire. Noir de Lampe, peu d'Vmbre, vn peu de blanc. Enfoncés auec Noir d'yuoire, mesle auec Verdet. Rehaussés auec noir de Lampe allie de blac & d'vn peu d'ombre.' Van de Graaf, *Het de Mayerne Manuscript als bron voor de schildertechniek van de Barok*, PhD thesis, Rijksuniversiteit te Utrecht, 1958, p. 153, no. 34b.
32 K. Groen and E. Hendriks, 'Frans Hals: A Technical Examination', in Slive 1989, p. 119.
33 The alternative gilding method, known as *water-gilding*, uses a red bole or clay as a preparatory layer and occurred before the rest of the painting commenced. It was more suitable for large areas of painting such as backgrounds and halos.
34 L. B. Alberti, *On Painting*, trans. J. R. Spencer, London, 1967, p. 85.
35 Peacham 1634, p. 135.
36 R. Thornton, and T. Cain (eds), *A Treatise Concerning The Arte of Limning by Nicholas Hilliard together with a More Compendious Discourse Concerning ye Art of Limning by Edward Norgate*, Manchester, 1981, p. 79.
37 Strong 1983, p. 16.
38 Arnold 1988, pp. 187–8.
39 An example of a leather jerkin showing this type of pinking is in the Museum of London (acc. no. 36.237) and is discussed in Arnold 1985, p. 19 and pp. 68–9.
40 J. Addison, *Spectator*, no. 129, 1712.
41 W. Sanderson, *Graphice or, The use of the Pen and Pensill, in Designing, Drawing, and Painting; with an exact Discourse of each of them*, London, 1658, p. 39.
42 Gordenker 2003, pp. 22–5.
43 Talley 1978, p. 748.
44 Campbell 1990, p. 157.
45 Quoted in C. Brown, *The Drawings of Anthony Van Dyck*, New York, 1991, p. 35.
46 Barnes 2004, p. 420.
47 M. de Winkel, 'The Artist as Couturier: The Portrayal of Clothing in the Golden Age', in Ekkart 2007, p. 69.
48 Roy Strong uses the example of the portrait of the Countess of Somerset (National Portrait Gallery, London) to illustrate this point: 'The face in the Countess of Somerset … is the dull work of an assistant, but the lace is painted with all the care of any in one of the full autograph portraits.' See R. Strong, *William Larkin: Icons of Splendour*, Milan 1995, p. 34.
49 MacLeod 2001, p. 51.
50 Kirby 1999, p. 39.
51 V&A Museum, London (acc. no. P.9–1943). Discussed in Arnold 1988, pp. 33–4.
52 Letter from Gerard ter Borch the Elder to his son in London, 3 July 1635. Quoted in A. Wheelock 2004, p. 189.
53 Barnes 2004, p. 421.
54 Latham 1995, entry for 30 March 1666.
55 Campbell 1990, p. 145.
56 J. Montias, *Vermeer and his Milieu: A Web of Social History*, New Jersey and Guildford, 1991, p. 339.
57 E. van de Wetering (ed.), *A Corpus of Rembrandt Paintings*, Dordrecht, 2005, vol. IV, p. 65, and Talley 1978, p. 748.
58 Talley 1978, p. 748. *Isabella* was used as a descriptive colour for clothing from 1600 onwards. It was a greyish-yellow, light buff colour (Oxford English Dictionary).
59 Hayward, 2007b, p. 33.
60 Arnold 1988, p. 190.
61 Blank medallions appear in several of Holbein's drawings, although surviving copies of associated oil portraits show them filled with religious subjects. See Foister 2005, p. 48.
62 Kirby 1999, p. 13.
63 Ribeiro 2005, p. 44.
64 Examples are the Earl of Bedford, who wears a coif in his portrait drawing and a hat in copies of a painted version, and Lord Cobham, who is portrayed in only a shirt in a drawing but fully clothed in copies of the subsequent painting. See Foister 2005, p. 55.

CHAPTER 6 FASHION ACROSS THE BORDERS

1 Levey 1990, p. 11.
2 A. Boorde, *The Fyrst boke of the introduction of knowledge*, London, 1870 (first published 1547), p. 116.
3 William Shakespeare, *The Merchant of Venice*, c.1596, Act I, scene ii.
4 Morrall 2008, p. 49.
5 B. Jonson, *Epigram LXXXVIII On English Monsieur*, in R. Dutton (ed.), *Epigrams and The Forest*, Manchester, 1984, p. 57.
6 B. Castiglione, *Il Cortegiano (1516)*, 1972 edition, E. Bonora (ed.), Milan, II, xxvi, p. 133.
7 Richardson 2004, p. 3.
8 F. Vermeylen, 'The Colour of Money: Dealing in Pigments in Sixteenth-Century Antwerp', in Kirby 2010, p. 357.
9 Calendar of State Papers, Domestic Series, 1672–73, quoted in De Marly 1987, p. 56.
10 Morrall 2008, p. 47.
11 K. Thomas, *Man and the Natural World*, New York, 1983.
12 J. Nichols, *The Progresses and Public Processions of Queen Elizabeth*, vol. III, London, 1823, p. 451.
13 Morrall 2008, p. 52.
14 See the portrait of Judith Norgate, wife of Edward Norgate painted by Peter Oliver, 1616–17 (V&A Museum, acc. P.71–1935) and Elizabeth Harding, Mrs Oliver by Isaac Oliver, 1610–15 (Private Collection).
15 J. Gerard, *The Herball, or Generall historie of plantes, gathered by John Gerarde of London, Master of Chirurgerie, enlarged and emended by Thomas Johnson*, London, 1636 edition, p. 4r.
16 F. Teague, *Shakespeare's Speaking Properties*, Pennsylvania, 1991, p. 26.
17 *Letters and Papers, Foreign and Domestic, of the Reign of Henry VIII: Preserved in the Public Record Office, the British Museum, and Elsewhere in England*, J. S. Brewer (ed.), vol. III, ii, London, 1867, p. 978.
18 S. Turner, *The New Hollstein German Engravings, Etchings and Woodcuts 1400–1700, Wenceslaus Hollar*, Rotterdam, 2009, Part II, p. 155.
19 For a summary see A. Dolan, *An Adorned Print: Print Culture, Female Leisure and the Dissemination of Fashion in France and England, around 1660–1779*, V&A Online Journal, no. 3, 2011.
20 A portrait of Lady Arabella Stuart at the age of 23 months shows the sitter holding what may have originally been a fashion doll (National Trust, Hardwick Hall).
21 Ribeiro 2005, p. 112.
22 A. Jordan, 'Influence of Spanish fashion on European 16th century court portraiture', abstract for the conference, *Dressing the Spanish Way (CEEH)*, Madrid, 2007.
23 Versions of the Dirck Stoop portrait are in the National Portrait Gallery, London (NPG 2563) and at Madresfield Court. The style of lace worn in engravings produced by N. Munier (Lisbon, c.1662) is different to that in these portraits and the Royal Collection miniature, and suggests an original portrait currently unknown. See MacLeod 2001, p. 83.
24 Latham 1995, entry for 24 March 1662.
25 J. Woodall, *Anthonis Mor: Art and Authority*, Zwolle, 2007, p. 222–5.
26 Arnold 1985, p. 8.
27 ibid., p. 8.
28 The Morgan Library & Museum, New York (Rulers of England collection, Henry VIII no. 33a).
29 A. Ribeiro, 'Una historia de orgullo y prejuicio: percepciones de España y del traje español en la Inglaterra del siglo XVII', in Colomer 2013, pp. 19–20.
30 Jenkins 2003, vol. I, p. 333.
31 Piponnier 2000, p. 20.
32 Hayward 2012, pp. xlvi–xlix
33 R. Davis, *English Overseas Trade 1500–1700*, London, 1973, p. 27.
34 Arnold 1988, pp. 129–31.
35 L. Whitaker and M. Clayton, *The Art of Italy in the Royal Collection*, London, p.68–70.
36 Prior to that period Spanish dress was more varied (reflecting the freedom of expression that characterised Renaissance ideals) but, like much of Europe, was particularly influenced by the colourful fashions in German *Landsknechts* soldiers. See A. Descalzo, 'El traje cortesano español en la época de los Austrias: señas de identidad', in Colomer 2013, p. 3
37 C. Bernis, 'La moda en la españa de Felipe II a través del retrato de corte', in Saavedra 1990, p. 66.
38 ibid., p. 67.
39 Anon, *The Taylor's Comple te Guide; or a Comprehensive Analysis of Beauty and Elegance in Dress*, London, 1796.
40 A. Hyatt Mayor, 'Renaissance Costume Books', *Bulletin of the Metropolitan Museum of Art*, 1942, vol. 37, no. 6, p. 159.
41 For more about Mary I's adoption of matching partlets for bodices in the Spanish style, see Doda 2011.
42 Wardrobe of the Robes for 1554, Public Record Office, London. Quoted in Ribeiro 2000, p. 38.
43 Ashelford 2009, p. 23.
44 Much of the information about the components of Spanish dress in this section is informed by the chapter by C. Bernis, 'La moda en la españa de Felipe II a través del retrato de corte', in Saavedra 1990.

45 The white silk damask fabric that makes up Isabella Clara Eugenia's clothing is woven with brightly coloured emblems, laden with dynastic and marital symbolism, suggesting that it is probably her wedding dress – interlocking rings and yellow violets referring to fidelity; the fleurs-de-lis as a reference to her mother, Elisabeth de Valois; red roses alluding to her Lancastrian descent; black saltires (resembling knotted branches) are found on the coat of arms of the house of Burgundy. These decorative features are probably created through a combination of embroidery and appliqué. See Van Wyhe 2011, p. 118.

46 G. Ungerer, 'Juan Pantoja de la Cruz and the Circulation of Gifts Between the English and Spanish Courts in 1604/5', *Shakespeare Studies*, 1998, p. 70.

47 ibid., p. 71.

48 These aglets were evidently highly valued heirlooms – the same ones reappear in portraits of different sitters.

49 A. Descalzo, 'El traje cortesano español en la época de los Austrias: señas de identidad', in Colomer 2013, p. 9.

50 It was likened to 'putting one's head in a snare'. See A. Descalzo, 'El traje cortesano español en la época de los Austrias: señas de identidad', in Colomer 2013, p. 11.

51 L. Miller, 'Dress to impress: Prince Charles plays Madrid, September-May 1623', in Samson 2006, p. 38.

52 ibid., p. 44.

53 A. Descalzo, 'El traje cortesano español en la época de los Austrias: señas de identidad', in Colomer 2013, p. 15.

54 Quoted in De Marly 1987, p. 122.

55 C. Mukerji, *Territorial Ambitions and the Gardens of Versailles*, Cambridge, 1997, p. 116.

56 Quoted in De Marly 1987, p. 64.

57 ibid., p. 89.

58 L. Stone-Ferrier, 'Views of Haarlem: A Reconsideration of Ruisdael and Rembrandt', *Art Bulletin*, LXVII, no. 3, 1985, p. 423.

59 ibid., p. 424.

60 Ben Jonson, *The Devil is an Ass*, 1616, Act I, scene i.

61 Levey 1990, p. 24.

62 M. de Winkel, 'The Artist as Couturier: The Portrayal of Clothing in the Golden Age', in Ekkart 2007, p. 67.

63 O. Feltham, *Brief Character of the Low Countries*, London, 1660 edition, p. 50.

64 B. du Mortier, 'Costume in Frans Hals', in Slive 1989, p. 49.

65 C. Bayly (ed.), *The Raj: India and the British 1600–1947*, London, 1991, p. 73.

66 B. Lemire, 'Fashioning Cottons: Asian Trade, Domestic Industry and Consumer Demand, 1660-1780', in Jenkins 2003, vol. I, p. 494.

67 Molière, *Le Bourgeois Gentilhomme*, 1670, Act I, scene i.

CHAPTER 7 DRESSED FOR BATTLE AND THE HUNT

1 S. Frye, *Elizabeth I: The Competition for Representation*, Oxford, 1996, p. 3.

2 O. Millar (ed.), 'Abraham Van der Doort's Catalogue of the Collections of Charles I', *Walpole Society*, vol. 37 (1958-60), 1960, London, p. 108, no. 20.

3 T. Richardson, 'The Royal Armour Workshops at Greenwich' in Rimer 2009, p. 153. Calculation into present day value (2013) using National Archives Currency converter.

4 For a more detailed discussion of the link between armour and fashion, see Patterson 2009.

5 D. Potter, 'The International Mercenary Market in the Sixteenth Century: Anglo-French Competition in Germany, 1543-50', *English Historical Review*, vol. 111, no. 440, 1996, p. 26.

6 Henry VIII's hawking glove, Ashmolean Museum, Oxford. Acc. no. 1685.B228.

7 C. Spiers, 'Deer Skin Leathers and their Use for Costume', *Costume*, vol. 7, 1973, p. 18.

8 ibid., p. 19.

9 Two of the set remain in the Royal Collection. The rest were presented by George IV to Greenwich Hospital in 1824, and are now in the National Maritime Museum.

10 Latham 1995, entry for 26 August 1664.

11 P. Verney, *The Standard Bearer*, London, 1964, p. 139.

12 Haythornthwaite 1998, p. 46.

13 Quoted in R. Sherwood, *Civil Strife in the Midlands 1642–51*, Chichester, 1974, p. 191.

14 Haythornthwaite 1998, p. 22.

15 B. Reckitt, *Charles the First and Hull, 1639–1645*, London, 1952, p. 57.

16 J. Cliffe, *The Puritan Gentry*, London, 1984, p. 57.

17 D. Smith, *A History of the Modern British Isles, 1603–1707 The Double Crown*, Oxford, 1998, p. 129.

18 L. Hutchinson, *Memoirs of the Life of Colonel Hutchinson*, N. H. Keeble (ed.), London, 1995, pp. 86–7.

19 Haythornthwaite 1998, p.144.

20 Quoted in M. Barthorp and A. McBride, *Marlborough's Army 1702–11*, Oxford, 1980, p. 28.

21 Palliser 1902, p. 336, n. 6. Calculation into present day value (2013) using National Archives currency converter.

22 Capwell 2012, p. 29.

23 ibid., p. 31.

24 ibid., p. 83.

25 ibid., p. 74.

26 ibid., p. 111.

27 R. Ascham, *The Scholemaster*, 1570, London, 1897 edition, p. 64.

28 ibid., p. 64.

29 Hayward, 2007b, p. 107.

30 Quoted in Cunnington 1969, p. 150.

31 Starkey 1987, p. 193.

32 Strong 1980, pp. 73–89.

33 N. E. McClure (ed.), *The Letters of John Chamberlain*, vol. 2, Philadelphia, 1939, pp. 286–7.

34 A. Wood, *The Life and Times of Anthony à Wood*, London, 1932, p. 114.

35 Latham 1995, entry for 12 June 1666.

36 Latham 1995, entry for 27 July 1665.

37 J. Evelyn, *The Diary of John Evelyn*, E. de Beer (ed.), 1955, vol. III, p. 463, entry for 13 September 1666.

CHAPTER 8 PLAYING A PART

1 Starkey 1987, p. 2.

2 Anne of Denmark participated in five masques, but the costume depicted in fig. 249 is believed to be either that worn for the *Masque of Beauty* (1608) or *Love Freed from Ignorance and Folly* (1611). Alternatively it could represent a generalised version of masque dress. See Reynolds 1999, p. 89.

3 S. Orgel (ed.), *Ben Jonson: The Complete Masques*, New Haven, 1975, p. 81.

4 F. Yates, 'Boissard's Costume Book and Two Portraits', *JWCI*, XXII, 1959, pp. 365–6.

5 Strong 1997b, p. 308. In this article Roy Strong discusses the allegorical meaning of the painting in detail. A forthcoming publication by Y. Arshad and C. Laoutaris proposes a new identity. See Arshad 2013.

6 J. Arnold, 'Elizabethan and Jacobean Smocks and Shirts', in *Waffen-und Kostümkünde*, Munich, vol. 19, part 2, 1977, p. 98.

7 Robert White, *Cupid's Banishment*, 1617, reproduced in S. P. Cerasano and M. Wynne-Davies, *Renaissance Drama by Women: Texts and Documents*, London, 1996, p. 88.

8 For a detailed discussion, see D. Nunn-Weinburg, 'The Matron Goes to the Masque: The Dual Identity of the English Embroidered Jacket', *Medieval Clothing and Textiles*, vol. 2, 2006.

9 F. Bacon, *Essays*, M. J. Hawkins (ed.), London, 1994, p. 99.

10 Ravelhofer 2006, p. 160.

11 ibid., p. 168.

12 Quoted in S. M. Newton, *Renaissance Theatre Costume and the Sense of the Historic Past*, London, 1975, p. 213.

13 S. Daniel, *The Vision of the Twelve Goddesses: A Royal Masque*, E. Law (ed.), London, 1880, p. 59.

14 Ravelhofer 2006, p. 149.

15 ibid., p. 179.

16 ibid., p. 180.

17 Orgel 1973, vol. 2, p. 481.

18 Ravelhofer 2006, p. 173.

19 A comprehensive discussion of the portrait of Lady Elizabeth Pope can be found in L. Gent and N. Llewellyn (eds), *Renaissance Bodies: The Human Figure in English Culture c.1540–1660*, London, pp. 36–59.

20 Ravelhofer 2006, p. 143.

21 Arnold 1988, p. 176, note 120. 'For the *Twelve Goddesses* warrants were issued to Lady Suffolk and Lady Walsingham to take Queen Elizabeth's robes from the wardrobe in the Tower.'

22 It is not clear whether this is the original version or a copy after a lost original. Another like but not identical version, which was apparently completed as a posthumous commission for the sitter's son, is in the Mauritshuis, and two other versions are known. See Millar 1963, p. 115.

23 See M. Françozo, '"Dressed like an Amazon": The Transatlantic Trajectory of a Red Feather Coat' in Hill 2012, p. 193.

24 A. Buono, 'Tupi Featherwork and the Dynamics of Intercultural Exchange in Early Modern Brazil' in *Crossing Cultures: Conflict, Migration, Convergence*, J. Anderson (ed.), Melbourne, 2009, p. 351.

25 Orgel 1973, vol. I, p. 256.

26 A. Behn, *The History of Oroonoko or, The Royal Slave*, Doncaster, 1759 edition, pp. 4–5.

27 Anne Hollander first pointed out this similarity. See Hollander 1993, p. 269.

28 J. Downes, *Roscius Anglicanus*, J. Milhouse and R. Hume (eds), London, 1987, p. 52 and p. 61.

29 For a summary, see K. Scheil, *The Taste of the Town: Shakespearean Comedy and the Early Eighteenth-Century Theater*, Lewisburg and London, 2003, p. 235.

30 Latham 1995, entry for 21 May 1662.

31 W. Cavendish, *The Variety*, Act II, scene i

32 B. Ravelhofer, 'Non-verbal Meaning in Caroline Private Theatre: William Cavendish's and James Shirley's "The Varietie" (c.1641)', *The Seventeenth Century*, 21 (2), 2006, p. 204.

33 A. Ribeiro, 'Una historia de orgullo y prejuicio : percepciones de España y del traje español en la Inglaterra del siglo XVII', in Colomer 2013, p. 14

34 William Shakespeare, *Hamlet*, 1603, Act I, scene ii.

35 Strong 1997c, p. 113.

36 Ravelhofer 2006, p. 201.

37 De Marly 1982, p. 14.

GLOSSARY

AGLET	Metal tags, often ornamental, that could be either attached to a garment, or used in pairs attached to a ribbon or cord, as a fastening or purely decoratively.
AIGRETTE	A jewelled hair ornament often adorned with a tufted plume of feathers. Fashionable in the early seventeenth century.
BAND	A collar made of linen worn around the neck of a shirt or smock. In the seventeenth century supplanted the ruff and was often starched or wired.
BEAVER	An expensive and fashionable hat made using beaver fur.
BODKIN	A long hairpin with an ornamental head.
BILLIMENT	Ornamental part of a woman's dress often relating to the decorative border of gold and jewels used to edge the upper and lower (called nether) curves of a French hood.
BLACKWORK	Black embroidery on white linen.
BODIES/BODYES	A bodice was often referred to as a 'pair of bodyes' (or boddies) made in two parts and joined at the sides. See 'bodice'.
BODICE	Derived from 'pair of bodies'. Refers to the upper part of a woman's dress (from bust to waist), often laced and intended to be worn over the undergarments.
BOBBIN LACE	Lace made by hand using threads attached to bobbins and worked over a design marked with pins on a pillow or cushion. Also referred to as *pillow lace* or *bone lace*.
BOMBAST	Padding made from wool, cotton or horsehair used to make forms appear stiff or puffed-up. From Old French *bombace*.
BONNET	Soft head covering, with a brim and crown leaving the forehead uncovered. Worn by men and women.
BOOT-HOSE	Hose or overstockings with decorative tops that could be folded down. Designed to be worn with boots.
BREECHES	A style of leg wear worn with separate stockings and designed to cover the hips and thighs.
BROCADE	Fabric which uses extra weft threads (either coloured or metallic) to produce a pattern.
BUFF COAT	Protective coat constructed of leather. Originally made from buffalo hide.
BUSK	A thin strip of whalebone, steel, or wood worn to stiffen the front of a pair or stays or bodice.
BUSKINS	Knee-length boots.
CALICO	A woven, cotton textile.
CANIONS	Tight-fitting, tubular extensions to trunk hose finished around the knee.
CARCENET	Heavy necklace, resembling a collar, and decorated with jewels and gold.
CLOCKS	Decorative features at the ankle of a pair of stockings. Either woven or embroidered.
CLOTH-OF-GOLD, CLOTH-OF-SILVER	Fabric woven either entirely from gold/silver thread or, partly using a warp of gold/silver and a weft of silk. Often sheer in appearance.
COCHINEAL	A vibrant scarlet dye made from the dried bodies of female *cochineal* insects.
CODPIECE	Flap or pouch shaped appendage worn by men to conceal the opening in the front of the breeches. Attached to the hose using points.
COIF	Unadorned, close-fitting linen cap tied under the chin.
COTTON	Fabric made from the soft downy fibres attached to the seeds of the cotton plant which are spun into yarn and made into threads for the purpose of weaving.
CUIRASSIER ARMOUR	Full-body armour named after the cuirassier cavalry who needed maximum protection.
DAMASK	Firm, glossy fabric with either a floral or geometric pattern, woven so that one side has a simple satin warp face design and the other side appears in reverse.
DOUBLET	Close-fitting men's garment covering torso, with or without sleeves, worn over the shirt.
ELL	Measure for cloth equivalent to 45 inches in England (39 inches in Scotland).
ENGLISH HOOD	A pointed headdress also known as a gable hood because its shape resembles the gable of a house. Typically worn with side panels and a black veil.
ERMINE	Soft white fur with black-tipped tails; the winter coat of a species of weasel only worn by nobles and royalty.
FARTHINGALE (FRENCH)	A padded hoop worn around the waist to widen the skirts at the hip area, causing the skirt to drape. Also called a drum farthingale.
FARTHINGALE (SPANISH)	A skirt stiffened with hoops of progressively increasing circumference, worn as an undergarment to add volume to the skirt.
FALLING BAND	Separate collar attached to the shirt, worn by men or women, usually linen, often decorated with lace.
FOREPART	Panel of decorative material attached to the kirtle. Revealed when the skirt above is parted at the front.
FORESLEEVES	Separate detachable sleeves covering the forearm, worn beneath the sleeves of the gown.
FRELANGE	A high, layered head-dress of frills and bows supported on a wire framework and attached to a linen cap worn on the back of the head.
FRENCH HOOD	Rounded hood worn over a coif with a jewelled crescent-shaped framework. Set back on the head revealing the hair at the front and usually worn with a veil.
FUSTIAN	A type of heavy-woven fabric of cotton and linen, or cotton and wool.
GARTER	Silk sash or ribbon tied just below the knee to secure stockings.
GAUNTLET	Part of a glove extending over the wrist. Often made separately to the body of the glove. Could be highly decorative.
GIRDLE	A narrow band, chain or cord worn at the waist to encircle, or 'gird'. Usually decorative and used to support items such as a small book, fan or pendant.
GORGET	Ornamental, steel collar worn by the military.
GOWN (MALE)	Outer layer of clothing worn by men. Becomes shorter during the sixteenth century and eventually by the cloak.
GOWN (FEMALE)	Full-length outer garment for women. Could be cut tight to the body or more loosely.
GRAND HABIT	Form of dress worn at court, introduced in France in the late seventeenth century. Consisted of a stiffly boned bodice with low neckline, trained skirt and flounces at the elbow.
GUARD	Band of material, in a contrasting colour to the body of the garment, used to cover a seam or act as a border. Often embroidered.
HANGING SLEEVE	A long, false, decorative sleeve with an opening at the front or side where the arm can pass through.
HOSE	Full leg covering for men. Traditionally footed. By the sixteenth century hose had been separated into upper stocks (or breeches) and nether stocks (stockings).
INDIGO	Deep blue / purple dye obtained from the plant *Indigofera tinctoria*.
JERKIN	Male garment worn over the doublet, with or without sleeves.
KERCHIEF	Square of fabric, usually folded diagonally and worn around the shoulders.
KERMES	Red dye made from the dried bodies of female scale insects in the genus *Kermes*. The English word *crimson* is derived from the word kermes.
KIRTLE	A loose tunic worn over the smock and under the outer gown. The term originally referred to a full-length garment covering the torso and legs, but after the middle of the sixteenth century the term referred to the skirt only.
LAPPETS	Pieces of fabric forming the decorative border of an English Hood. Designed to hang down either side of the face.
LAPS	Short sections of material arranged around the lower edge of a doublet or bodice. Also called *tabs*.
LINEN	Strong textile made from flax fibres. Varieties ranging from coarse buckram to delicate lawn.
LIVERY	Uniform or distinctive dress worn by the member of a particular group, household or livery company.
LOVELOCK	Long, curled piece of hair often tied with a ribbon and worn, by both men and women, hanging over the shoulder. Could also refer to hair worn longer on one side than the other.
MADDER	Herb whose root can be used as a source of red dye.
MANTLE	A long, usually sleeveless, cloak-like outer garment, open at the front.
MANTUA	Loose over-gown or robe offering a comfortable alternative to the boned bodice and separate skirt. Developed into the semi-formal fitted gown of the late seventeenth century. Held in at the waist with a belt or sash.

	
MORDANT	Chemical substance used to help dye attach to certain types of fabric or yarn.
NEEDLE LACE	Open fabric constructed using a needle and thread, often of linen. Initial forms utilised the structure of a woven ground but later worked without a support.
NIGHTCAP	Close-fitting, informal cap worn by men around the home.
NIGHTGOWN	A loose-fitting wrap or gown worn informally around the home. Also known as a banyan gown or Indian gown.
PANES	Panels of fabric running the length of the sleeve. Attached to the main body of the garment at either end.
PANTOFLES	Overshoes with a toe and deep cork sole, designed to protect the shoes worn beneath from dirt. Also spelt *pantobles*.
PARIS HEAD	Worn by widows, a wired linen cap which dipped over the forehead into a heart shape.
PARTLET	Decorative female garment filling the neck and upper part of the chest for modesty or warmth.
PATCH	Small black shapes, often cut from velvet and applied to the face. Used to emphasise the whiteness of the skin.
PEASCOD BELLY	A rounded, pea pod (or peascod) shape at the front of the male doublet, achieved by adding extra padding to the lower part of the doublet front, just above the waist.
PERIWIG	Male wig. Name derived from the French for man's wig, *perruque*.
PETTICOAT	Full skirt worn beneath an outer skirt, normally slightly shorter and ruffled or trimmed. Often designed to be seen.
PETTICOAT BREECHES	Very voluminous breeches popular during the early 1660s.
PINKING	Small decorative cuts in fabric, up to around 6 mm in length.
PLACARD	Separate piece of fabric, often decorative, covering the chest. Worn by men and women.
PLAIN WEAVE	Simplest form of weave in which the weft runs over one warp thread then under the next. Also known as *tabby weave*.
POINTS	Ribbon or cord ties with metal tips used to attach garments together or as a means of decoration.
POMANDER	Globular, perforated case containing perfume, often worn hung from a neck-chain or belt.
POMEGRANATE PATTERN	Later name for the large-scale ornamental fabric designs particularly popular during the fifteenth and sixteenth century, which incorporated foliate motifs including the pomegranate, thistle and pineapple.
POWDERINGS	Black pieces of fur, derived either from the tails of the winter stoat or black lambskin, set into white fur to create a spotted effect.
PUDDING HAT	Round circlet worn on the head by very young children, designed to provide padding in case of a fall.
PUFFING	Fabric manipulated into decorative puffs or rows of puffing, often pulled through a slit in layer of fabric above.
REBATO	Wire frame to support a separate collar off the shoulders. Also could refer to a wired standing collar itself.
RETICELLA	A type of needle lace with a recognisable geometric design made up of squares, circles and arching scalloped borders.
RIDING HABIT	Female suit often cut along lines of male doublet, worn for horseback riding or other outdoor activities.
ROLL	Tubular padding used to hold the skirt in a fashionable shape.
RUFF	Collar or frill made from stiffened pleats or folds of linen attached to a neckband. Often constructed in layers and fixed in place using heated irons.
SABATON	Piece of armour covering the foot.
SABLE	Fur of the sable, a species of marten. Highly valued for its delicately tinted pelt and softness when stroked in any direction. Typically used to decorate collars, hems, sleeves and hats.
SAFEGUARD	Outer petticoat worn by women when horse riding to protect against mud and dirt.
SATIN	A fabric with a typically glossy surface and a dull back created using a warp-heavy weaving technique and filament fibres such as silk.
SHAG	Thick-piled or long-haired textile, usually made of worsted (fine cloth made from wool) or silk, often used as a lining for waistcoats and breeches.
SHIRT	Long, loose-fitting male garment with full sleeves, worn neck to the body. Typically made of linen.
SHOE ROSES	Decorative rosettes of fabric or lace worn on shoes.
SILK	A fine lustrous fibre, creamy-white in colour, produced by cultivating the strong, elastic secretion of silk worms (*Bombix mori*).
SLASHING	Cuts or slits in the outer garment so that the sleeve of the inner layers show through.
SHIFT	A loose-fitting linen undergarment worn by women next to the skin. Also known as a *smock* or *chemise*.
SPANGLES	Small, thin, shiny disks of metal typically ovular in shape. Used to ornament fabric in the manner of sequins. Also known as oes.
SPANISH CLOAK	A short, full cloak with a decorative hood, often luxuriously decorated and lined. Typically worn over one shoulder.
STARCH	Liquid substance used to stiffen fabric, in particular ruffs and cuffs, before ironing. Made by mixing starch, a compound naturally found in plants, with water.
STAYS	A stiffened garment worn by women under a gown or bodice. Thin strips of whalebone were inserted into narrow pockets stitched into the fabric of the stays to create shape.
STEINKIRK	Long, flowing cravat worn by men with the front ends twisted together and passed through a buttonhole or pinned to the side. So named after the battle of Steenkerque in 1692 when soldiers were caught unawares and had no time to dress 'properly'.
STOCKINGS	Covering for the lower legs either constructed from cloth panels or knitted. During the sixteenth century also known as nether or lower stocks and during the seventeenth century as hose.
STOMACHER	Decorated triangular panel used to fill the gap between the edges of an unclosed gown or bodice. Held in place by ties or pins.
STUFF	Woollen cloth.
SUPPORTASSE	A firm, standing, collar-like frame attached to the neckband of a bodice or doublet to support a large ruff at the fashionable angle. Also known as a *pickadil* or *underpropper*.
SUMPTUARY LAW	Laws attempting to regulate habits of consumption. In England sumptuary laws dictated what types of clothing (colour, fabric, trim) were allowed to be worn by persons of varying rank.
TASSET	Piece of armour covering the thighs.
TINSEL	A rich silk fabric either plain or interwoven with metallic weft threads to produce a sparkling surface.
TISSUE	The most expensive form of cloth of gold or silver. Richly coloured and ornamented and woven using raised loops of metal thread in varying thicknesses and heights.
TWILL WEAVE	A type of textile weave producing distinctive diagonal parallel ribs, unlike satin or plain weave. The effect is achieved by passing the weft thread over, and then under, one or more warp threads and offsetting the weave.
TRICORNE	A style of hat in the shape of an equilateral triangle and worn with one point at the front of the head. Popular in both civilian dress and military uniform.
TRUNK-HOSE	Male garment covering the upper leg, swelling from the waist and gathered around the mid-thigh. Before c.1580 more commonly known as *round hose*. Also known as *upper stocks*.
VELVET	A soft fabric with a thick-piled surface made of looped warp yarns. Pile can either be cut or uncut.
VENETIANS	Full breeches, of varying volume, worn fastened just below the knee.
VEST	Tight-fitting, often sleeveless garment. Similar to a modern waistcoat. Initially knee-length.
VIRAGO SLEEVE	Style of bodice sleeve constructed of strips of fabric gathered into two puffs by ribbons at the elbow.
VIZARD	Mask worn outdoors by women to protect the complexion.
WAISTCOAT	Unboned female garment for upper body, worn over stays. Often embroidered.
WARP	The yarn which runs vertically on a woven fabric and intercepts the weft which runs horizontally.
WEFT	The yarn which runs horizontally across a woven fabric and intercepts the warp which runs vertically.
WHALEBONE	Bristle-like cartilage lining from the mouth of the baleen whale (grown in large sheets to filter out krill) used to stiffen stays and bodices.
WING	Roll or fold of stiffened cloth used to cover the joins between the sleeve and armhole. Often decorated.
WOAD	A blue dye produced from the leaves of the flowering plant *Isatis tinctoria* (common name 'Woad')

SELECT BIBLIOGRAPHY

ANON 1980
Anon. (Debrett's Peerage in association with the V&A), *Princely Magnificence: Court Jewels of the Renaissance 1500–1630*, London, 1980

ARNOLD 1985
Arnold, J., *Patterns of Fashion 3: The Cut and Construction of Clothes for Men and Women c.1560–1620*, Basingstoke, 1985

ARNOLD 1988
Arnold, J., *Queen Elizabeth's Wardrobe Unlock'd*, Leeds, 1988

ARNOLD 2008
Arnold, J., *Patterns of Fashion 4: The Cut and Construction of Linen Shirts, Smocks, Neckwear, Headwear and Accessories for Men and Women c.1540–1660*, Basingstoke, 2008

ARSHAD 2013
Arshad, Y. and Laoutaris, C., '"Still renewing wronges": Gheeraerts' Persian Lady Revealed', *The British Art Journal*, 2013, forthcoming

ASHELFORD 1978
Ashelford, J., 'Female Masque Dress in Late Sixteenth-Century England', *Costume*, no. 12, 1978

ASHELFORD 1983
Ashelford, J., *The Visual History of Costume: The Sixteenth Century*, London, 1983

ASHELFORD 1988
Ashelford, J., *Dress in the Age of Elizabeth I*, New York, 1988

ASHELFORD 2009
Ashelford, J., *The Art of Dress*, London, 2009

BALFOUR 2008
Balfour, I., *Famous Diamonds*, London, 2008

BARNES 2004
Barnes, S. (ed.), *Van Dyck: The Complete Paintings*, New Haven and London, 2004

BEGENT 1999
Begent, P. and Chesshyre, H., *The Most Noble Order of the Garter: 650 Years*, London, 1999

BELL 1976
Bell, Q., *On Human Finery*, London, 1992

BENHAMOU 1989
Benhamou, R., 'The Restraint of Excessive Apparel: England 1337–1604', *Dress*, vol. 15, 1989

BLACKMORE 1990
Blackmore, D., *Arms & Armour of the English Civil Wars*, London, 1990

BREWARD 1995
Breward, C., *The Culture of Fashion*, Manchester, 1995

BUCK 1996
Buck, A., *Clothes and the Child: Handbook of Children's Dress in England 1500–1900*, Bedford, 1996

BYRDE 1979
Byrde, P., *The Male Image: Men's Fashion in England, 1300–1970*, London, 1979

CAMPBELL 1990
Campbell, L., *Renaissance Portraits: European Portrait Painting in the 14th, 15th and 16th Centuries*, New Haven and London, 1990

CAPWELL 2012
Capwell, T., *Fashion and Fencing in Renaissance Europe 1520–1630*, London, 2012

CARTER 1984
Carter, A., 'Mary Tudor's Wardrobe', *Costume*, no. 18, 1984

COLOMER 2013:
Colomer, J. L. and Descalzo, A. (eds), *Spanish Fashion in Early Modern Europe: The Prevalence and Prestige of Spanish Attire in the Courts of the 16th and 17th Centuries*, Madrid and London, 2013

CRAIK 2009
Craik, J., *Fashion: The Key Concepts*, Oxford, 2009

CUMMING 1982:
Cumming, V., *Gloves*, London, 1982

CUMMING 1984
Cumming, V., *Visual History of Costume: Seventeenth Century*, London, 1984

CUMMING 1989
Cumming, V., *Royal Dress*, London, 1989

CUNNINGTON 1969
Cunnington, P. and Mansfield, A., *English Costume for Sports and Outdoor Recreation from the Sixteenth to the Nineteenth Centuries*, London, 1969

DE LA HAYE 1999
De la Haye, A. and Wilson, E. (eds), *Defining Dress: Dress as Object, Meaning and Identity*, Manchester, 1999

DE WINKEL 2007
De Winkel, M., *Fashion and Fancy: Dress and Meaning in Rembrandt's Paintings*, Amsterdam, 2007

DODA 2011
Doda, H., *Of Crymsen Tissue: The Construction of a Queen. Identity, Legitimacy and the Wardrobe of Mary Tudor*, MA Thesis, Dalhousie University, 2011

EARNSHAW 1991
Earnshaw, P., *Lace in Fashion from the Sixteenth to the Twentieth Centuries*, Guildford, 1991

EKKART 2007
Ekkart, R., and Buvelot, Q., (eds), *Dutch Portraits: The Age of Rembrandt and Frans Hals*, London, 2007

FOISTER 2005
Foister, S., *Holbein and England*, New Haven and London, 2005

GAIMSTER 1997
Gaimster, D. and Stamper, P. (eds), *The Age of Transition: The Archaeology of English Culture 1400–1600*, Oxford, 1997

GORDENKER 1999
Gordenker, E., 'Is the History of Dress Marginal?', *Fashion Theory*, vol. 3, issue 2, May 1999

GORDENKER 2003
Gordenker, E., *Van Dyck and the Representation of Dress in Seventeenth-Century Portraiture*, Turnhout, 2003

HARLEY 2001
Harley, R.D., *Artists' Pigments c.1600–1835: A Study in England Documentary Sources*, London, 2001

HARVEY 1995
Harvey, J., *Men in Black*, London, 1995

HASHAGEN 2006
Hashagen, J., and Levey, S., *Fine and Fashionable: Lace from the Blackborne Collection*, Barnard Castle, 2006

HAYTHORNTHWAITE 1998
Haythornthwaite, P., *The English Civil War, 1642–1651: An Illustrated Military History*, London, 1998

HAYWARD 2002
Hayward, M., '"The Sign of Some Degree": The Financial, Social and Sartorial Significance of Male Headwear at the Courts of Henry VIII and Edward VI', *Costume*, no. 36, 2002

HAYWARD 2007A
Hayward, M., 'Crimson, Scarlet, Murrey and Carnation: Red at the Court of Henry VIII', *Textile History*, vol. 38, no. 2, 2007

HAYWARD 2007B
Hayward, M., *Dress at the Court of King Henry VIII*, Leeds, 2007

HAYWARD 2009
Hayward, M., *Rich Apparel: Clothing and the Law in Henry VIII's England*, Farnham, 2009

HAYWARD 2012
Hayward, M. (ed.), *The Great Wardrobe Accounts of Henry VII and Henry VIII*, London Record Society, London, 2012

HEARN 1995
Hearn, K., *Dynasties: Painting in Tudor and Jacobean England, 1530–1630*, London, 1995

HILL 2012
Hill, K. (ed.), *Museums and Biographies: Stories, Objects, Identities*, Woodbridge, 2012

HOLLANDER 1993
Hollander, A., *Seeing Through Clothes*, California, 1993

HUNT 1996
Hunt, A., *Governance of the Consuming Passions: A History of Sumptuary Law*, Basingstoke, 1996

JENKINS 2003
Jenkins, D. (ed.), *The Cambridge History of Western Textiles*, Cambridge, 2003

JONES 2001
Jones, A. R. and Stallybrass, P., *Renaissance Clothing and the Materials of Memory*, Cambridge, 2001

KIRBY 1999
Kirby, J., 'The Painter's Trade in the Seventeenth Century: Theory and Practice', *National Gallery Technical Bulletin*, vol. 20, 1999

KIRBY 2010
Kirby, J., Nash S. and Cannon, J. (eds), *Trade in Artist's Materials: Markets and Commerce in Europe to 1700*, London, 2010

KUCHTA 1990
Kuchta, D., '"Graceful, Virile, and Useful": The origins of the three-piece suit', *Dress*, 17, 1990

LATHAM 1995
Latham, R. and Matthews, W. (eds), *The Diary of Samuel Pepys*, 9 vols, London, 1995

LEVEY 1990
Levey, S., *Lace: A History*, London and Leeds, 1990

MACGREGOR 1989
MacGregor, A. (ed.), *The Late King's Goods: Collections, Possessions and Patronage of Charles I in the Light of the Commonwealth Sale Inventories*, Oxford, 1989

MACLEOD 2001
MacLeod, C. and Alexander, J. M. (eds), *Painted Ladies: Women at the Court of Charles II*, London, 2001

MANSEL 2005
Mansel, P., *Dressed to Rule: Royal and Court Costume from Louis XIV to Elizabeth II*, New Haven and London, 2005

DE MARLY 1978
De Marly, D., 'Undress in the Oeuvre of Lely', *Burlington Magazine*, no. 908, vol. 120, November 1978

DE MARLY 1980
De Marly, D., 'Dress in Baroque Portraiture – the Flight from Fashion', *Antiquaries Journal*, 60, 1980

DE MARLY 1982
De Marly, D., *Costume on the Stage 1600–1940*, London, 1982

DE MARLY 1987
De Marly, D., *Louis XIV and Versailles*, London, 1987

MIKHAILA 2006:
Mikhaila, N. and Malcolm-Davies, J., *The Tudor Tailor*, London, 2006

MILLAR 1963
Millar, O., *The Tudor, Stuart and Early Georgian Pictures in the Collection of Her Majesty The Queen*, London, 1963

MONNAS 2008
Monnas, L., *Merchants, Princes and Painters*, New Haven and London, 2008

MONTGOMERY 2007
Montgomery, F., *Textiles in America 1650–1870*, New York and London, 2007

MORRALL 2008
Morrall, A. and Watt, M. (eds), *English Embroidery from the Metropolitan Museum of Art, 1580–1700: 'Twixt Art and Nature*, New Haven and London, 2008

MURDOCH 1981
Murdoch, J. et al, *The Enigsh Miniature*, New Haven and London, 1981

NORTH 2009
North, S. and Hart, A., *Seventeenth- and Eighteenth-Century Fashion in Detail*, London, 2009

NORTH 2011
North, S. and Tiramani, J. (eds), *Seventeenth-Century Women's Dress Patterns Book I*, London, 2011

NORTH 2012
North, S. and Tiramani, J. (eds), *Seventeenth-Century Women's Dress Patterns Book II*, London, 2012

ORGEL 1973
Orgel, S. and Strong, R., *Inigo Jones: The Theatre of the Stuart Court*, London, 1973

PALLISER 1902
Palliser, F. B., *History of Lace*, London, 1902

PATTERSON 2009
Patterson, A., *Fashion and Armour in Renaissance Europe*, London, 2009
PEACHAM 1634
Peacham, H., *The Compleat Gentleman*, London, 1634 edition
PIACENTI 2008
Piacenti, K. A. and Boardman, J., *Ancient and Modern Gems and Jewels in the Collection of Her Majesty The Queen*, London, 2008
PIETSCH 2012
Pietsch, J. and Jolly, A. (eds), *Netherlandish Fashion in the Seventeenth Century*, Riggisberg, 2012
PIPONNIER 2000
Piponnier, F. and Mane, P., *Dress in the Middle Ages*, New Haven and London, 2000

RANGSTRÖM 2002
Rangström, L., *Modelejon: Manligt Mode*, Stockholm, 2002
RAVELHOFER 2006
Ravelhofer, B., The *Early Stuart Masque: Dance, Costume and Music*, Oxford, 2006
REYNOLDS 1999
Reynolds, G., *The Sixteenth- and Seventeenth-Century Miniatures in the Collection of Her Majesty The Queen*, London, 1999
RIBEIRO 2000
Ribeiro, A., *The Gallery of Fashion*, London, 2000
RIBEIRO 2003
Ribeiro, A., *Dress and Morality*, Oxford and New York, 2003
RIBEIRO 2005
Ribeiro, A., *Fashion and Fiction*, New Haven and London, 2005
RIBEIRO 2011:
Ribeiro, A., *Facing Beauty*, New Haven and London, 2011

RICHARDSON 2004
Richardson, C., (ed.), *Clothing Culture, 1350–1650*, Aldershot, 2004
RIMER 2009
Rimer, G., Richardson, T. and Cooper, J., *Henry VIII: Arms and the Man*, Leeds, 2009
RONALD 2004
Ronald, S., *The Sancy Blood Diamond*, New Jersey, 2004
ROTHSTEIN 2012
Rothstein, N., *400 years of Fashion*, London, 2012

SAAVEDRA 1990
Saavedra, S. (ed.), *Alonso Sánchez Coello y el retrato en la corte de Felipe II*, Madrid, 1990
SAMSON 2006
Samson, A., (ed.), *The Spanish Match*, Aldershot, 2006
SCARISBRICK 1986
Scarisbrick, D., 'Anne of Denmark's Jewellery: The Old and the New', *Apollo*, CXXIII, 1986
SCARISBRICK 1994
Scarisbrick, D., *Jewellery in Britain 1066–1837: A Documentary, Social, Literary and Artistic Survey*, Norwich, 1994
SCARISBRICK 1996
Scarisbrick, D., *Tudor and Jacobean Jewellery*, London, 1996
SCHOESER 2007
Schoeser, M., *Silk*, New Haven and London, 2007
SLIVE 1989
Slive, S. (ed.), *Frans Hals*, Munich, 1989
SMITH 1693
Smith, M., *The Art of Painting According to the Theory and Practise of the Best Italian, French and Germane Masters*, London, 1693, Second edition
STALLYBRASS 2001
Stallybrass, P. and Jones, A. R., 'Fetishizing the Glove in Renaissance Europe', *Critical Inquiry*, vol. 28, no. 1, 2001
STANILAND 2003
Staniland, K., 'Samuel Pepys and his Wardrobe Part I', *Costume*, no. 37, 2003
STANILAND 2005
Staniland, K., 'Samuel Pepys and his Wardrobe Part II', *Costume*, no. 39, 2005
STARKEY 1987
Starkey, D. (ed.), *The English Court*, London, 1987
STARKEY 2004
Starkey, D., *Six Wives: The Queens of Henry VIII*, London, 2004
STEELE 2010
Steele, V. (ed.), *The Berg Companion to Fashion*, Oxford, 2010
STRONG 1969
Strong, R., *The English Icon*, London, 1969
STRONG 1970
Strong, R. and Reed, N., *The Elizabethan Image: Painting in England 1540–1620*, London, 1970
STRONG 1980
Strong, R., 'Charles I's Clothes for the Years 1633 to 1635', *Costume*, no. 14, 1980
STRONG 1983
Strong, R., *Artists of the Tudor Court: The Portrait Miniature Rediscovered 1520–1620*, London, 1983
STRONG 1997A
Strong, R., *The Tudor and Stuart Monarchy: Pageantry, Painting, Iconography. I. Tudor*, Suffolk, 1997
STRONG 1997B
Strong, R., *The Tudor and Stuart Monarchy: Pageantry, Painting, Iconography. II. Elizabethan*, Suffolk, 1997
STRONG 1997C
Strong, R., *The Tudor and Stuart Monarchy: Pageantry, Painting, Iconography. III. Stuart*, Suffolk, 1997

TALLEY 1978
Talley, M. K., 'Extracts from the Executors Account-Book of Sir Peter Lely', 1679–1691: An Account of the Contents of Sir Peter Lely's Studio', *Burlington Magazine*, no. 908, vol. 120, 1978
TALLEY 1981
Talley, M. K., *Portrait Painting in England: Studies in the Technical Literature Before 1700*, London, 1981
TAYLOR 1983
Taylor, L., *Mourning Dress: A Costume and Social History*, London and Boston, 1983

VAN DUIJN 2012
Van Duijn, E. and Roeders, J., 'Gold-Brocaded Velvets in Paintings by Cornelis Engebrechtsz', *Journal for Historians of Netherlandish Art*, 4, 2012, 1. www.jhna.org (visited 22 Jan 2013)
VAN WYHE 2011
Van Wyhe, C., *Isabel Clara Eugenia: Female Sovereignty in the Courts of Madrid and Brussels*, Madrid, 2011
VINCENT 2003
Vincent, S., *Dressing the Elite*, Oxford, 2003
VINCENT 2009
Vincent, S., *Anatomy of Fashion*, Oxford, 2009

WATT 2009
Watt, M. and Morrall, A. (eds), *'Twixt Art and Nature, English Embroidery from the Metropolitan Museum of Art 1575–1700*, New Haven and London, 2009
WHEELOCK 2004
Wheelock, A. (ed.), *Gerard ter Borch*, Washington, 2004

ACKNOWLEDGEMENTS

This book and the exhibition it accompanies would not have been possible without the hard work of a large number of Royal Collection Trust staff, and the help, advice and encouragement of many colleagues and friends from other galleries and institutions.

Firstly thanks must go to the lenders who have allowed us to display their precious objects in the 2013 exhibition In Fine Style at The Queen's Gallery, Buckingham Palace and reproduce them in this book – The Bowes Museum, the Fashion Museum, Bath, the Glove Collection Trust, Historic Royal Palaces, the Museum of London, the family of Lord Acton, Meg Colbourn and Family and a private collector.

Particular thanks must go to Aileen Ribeiro, for fostering an interest in seventeenth-century dress at the Courtauld Institute and for her support since then, and to Jenny Tiramani for being so generous with her time, and for her invaluable advice and inspirational enthusiasm. As is evident from the notes and bibliography this book draws heavily on the exemplary research in the field of dress history by the late Janet Arnold. Thanks must also go to Howard Batho, Beatrice Behlen, Jane Bridgeman, Clare Browne, Amy Buono, Quentin Buvelot, Paul Cattermole, Valerie Cumming, Cassie Davies-Strodder, Hilary Davidson, Diana Dethloff, Rupert Featherstone, Hazel Forsyth, Nickos Gogolos, Emilie Gordenker, Rosemary Harden, Joanna Hashagen, Maria Hayward, Karen Hearn, Matthew Hollow, Alexandra Kim, Rebecca Lyons, Catharine MacLeod, Jane Malcolm-Davies, Joanna Marschner, Ninya Mikhaila, Deirdre Murphy, Susan North, Georgina Ripley, Laura de Simone, Annabel Talbot, Heather Toomer, Elaine Uttley, Franca Varallo, Mark Weiss and Matthew Winterbottom.

My colleagues from the Paintings department – Desmond Shawe-Taylor, Alex Buck, Vanessa Remington, Jennifer Scott, and Lucy Whitaker – have provided advice almost daily on one subject or another. Lucy Peter compiled the glossary and helped in other ways far too numerable to list. Jane Roberts, Elizabeth Clark, Martin Clayton, Kate Heard and Lauren Porter provided guidance on items from the Royal Library and Print Room. Simon Metcalf provided help on arms and armour, Caroline de Guitaut and Kathryn Jones on works of art and Stephen Patterson on Insignia. Charlotte Bolland kindly shared her research with me. Cristina Alfonsin Barreiro provided much needed help translating articles in Spanish, while Helen Ritchie, Hannah Belcher and Kate Ainley-Marr helped with research and captions.

Within the paintings conservation studio I am grateful to Nicola Christie, Karen Ashworth, Al Brewer, Claire Chorley, Adelaide Izat, Rosanna de Sancha, Tabitha Teuma and Neil Vaughan for all their hard work treating paintings and for their technical research. Michael Field and Stephanie Carlton have created new frames for a number of paintings, prepared the frames for display and co-ordinated the movement of a huge number of paintings from various residences. Alan Donnithorne advised on digital micrograph photography of the miniatures and prepared the works on paper for display. Roderick Lane undertook the conservation of books with Susan Shaw. Stephen Sheasby and Perry Bruce-Mitford conserved frames. Deborah Clarke at the Palace of Holyroodhouse and Chris Stevens at Hampton Court Palace ensured objects from those residences were photographed and transported for the exhibition and book. Outside the Royal Collection Trust I would like to thank Carol Willoughby, Isabel Horovitz and Mary Kempski for their work conserving paintings and Deborah Phipps, Mika Takami, Christine Supianek and the team at Shephard Travis (led by Julie Travis) for conserving and mounting the textiles.

The exhibition would not have been possible without the hard work of the exhibitions team, in particular Sandra Adler who has embraced the challenges unique to this exhibition with her typical good humour, enthusiasm and impressive organisational skills. Thanks also to Theresa-Mary Morton, Roxanna Hackett, Rosie Razzall and Stephen Weber. Michael Perry produced the beautiful illustrations which were used on display panels within the gallery space. Roy Mandeville and Janet Wood together worked to create invisible acrylic mannequins for mounting the three-dimensional garments and accessories while Colin Bowles, David Westwood and George Carter designed mounts and display cases. Thanks also to Lucie Amos, Jemima Rellie, Elizabeth Simpson and Rachel Woollen for their ideas, advice and encouragement along the way.

I am grateful to the Picture Library team, including Daniel Bell, Dominic Brown, Stephen Chapman, Katie Holyoak, Karen Lawson, Daniel Partridge, Shruti Patel, Tung Tsin Lam and Eva Zielinska-Millar and also to Adam Sammut for obtaining comparative images.

The collective vision of the Royal Collection Trust publications department has enabled this book to become one of which I could only have dreamt before starting the research – thanks to Nina Chang, Jacky Colliss Harvey, Miranda Harrison, Debbie Wayment and Ray Watkins.

Most of all thanks go to my husband John, to my family on both sides of the Atlantic and to Pavlina Pospisilova, for their support and understanding. This book is dedicated to my two daughters Isabel and Ava – may they forever love dressing up.

INDEX

Addison, Joseph 172
Agatha Bas (Rembrandt) 48, *49*, 61, 70, 140, *141*, 144, 219, 220
aglets 23, 50, 72, 96, *97*, 106, 208
Alberti, Leon Battista: *On Painting* 162
Albion's Triumph 285
Alçega, Juan de: *Libro de geometría...* 202, *202*-3
alizarin 161
Andrea Odoni (Lotto) *199*
Angel, Philips 144
Anguissola, Sofonisba 177
Anne, Queen 7, 28, 214, 269
Anne of Cleves: portraits (Holbein) 197
Anne of Denmark 28, 42, 71, 75, 275, 276, 277
　portraits: Gheeraerts 6, 42, *42*, 59, 71, 75, 155; Oliver 71, *71*, 163, *163*, 270, *270*; van Somer 208, 258, *259*
Antonio, Dom, king of Portugal 75
armour 226, *228*-9, 230, 235, 237, 245
　Civil War 248
　classical 250, 255-8
　cuirassier 226, 242, 244-5
　and fashion 225, 234, 236-8
　painting of 162, *222*-3, 225, 232, 244-9
　portrayal in 92, 110, 225-6, 230-31, 233
Arundel, Thomas Howard, 2nd Earl of 68
Ascham, Roger 258
Avercamp, Hendrick: *An elegantly dressed couple on skates* 219, *219*

babies' clothes *120*-*21*, 123, *125*
Bacon, Sir Francis 272
badges 117, *117*; see also hat badges
Baen, Jan de: *William III when Prince of Orange* 258, *258*
bags, women's 68
banyan gowns 149
barbes 66, *67*
Barry, Elizabeth 282
Baynard's Castle 21
Behn, Aphra 280
Bernini, Giovanni: *Louis XIV* 256
Bernini, Lorenzo 87
Betterton, Thomas 282
billiments 23, 66
black/black fabrics 161-2
blackwork embroidery 15, 34, 48, 50, 85, *86*, 95, 113, 168, 191, 193, 200, *200*
bodices, women's 39, 41, *46*, 46-7, *47*, 48, 50, 53, *53*, 81, 83, *84*, 204
Boissard, Jacques: *Habitus Variarum Orbis Gentium* 190, *191*, 270, *271*
Boleyn, Anne 17
　portrait (Holbein) 54, *57*, 65
Bonnart, Robert (after): *Mary II* 54, *56*, 77, *77*, 191
bonnets, men's 108, *109*, 110
Boone, Gwillam 217
Boorde, Andrew: *The First Book of the Introduction of Knowledge* 186, *187*, 187
boothose 115
boots, men's *94*, 95, *97*, 115
Bosse, Abraham 29
　A man seen from behind 29, *29*

Bowes, Lady: portrait (British School) 48, 50, *51*, 170
brazilwood 161
breeches 81, *81*, 83, 92, 129, 133, 190
　petticoat 92, *95*, 101, 102, *103*
brocaded fabrics 155, 199
Bronzino, Agnolo: *Portrait of a Lady in Green* 200, *200*, *201*
Brunswick and Lüneburg, Christian, Duke of: portrait (Mytens) 249, *251*
buckles 117, 118
buff coats and jerkins 225, 238, *238*, 240, 241, *241*, 242, *242*, *243*
Buontalenti, Bernardo 269
　Intermezzi designs *281*, 281
Burton, Robert: *Anatomy of Melancholy* 119
buskins, women's 64
busks 42
Butler, Samuel: *Characters* 8
buttons 41, 96, *98*, 117
Byron, Eleanor Needham, Lady: portrait (Lely) *176*, 177

cambric 148
canions *94*, 95
canvas, use of 137
Capel Family, The (Johnson) 91
caps: children's *128*, 129, *131*; women's *57*, 65, 66
Carew, Nicholas 226
Carew, Thomas: 'Upon a Ribband' 73
Castiglione, Baldassare 187-8
Catherine of Aragon 15, 34, 41
　portrait (British School) 34, *35*, 65, *66*
Catherine of Braganza 15, 118, 177, 194, 261
　portraits: Cooper 194, *194*; des Granges (attrib.) 194, *194*; see also *Marriage of Charles II and Catherine of Braganza*
Cellini, Benvenuto: bust of Cosimo I 255
Charles I 9, 13, 18, 21, 108, 110, 116, 193, 208, 210-11, 231, 248, 261, 285
　armour *229*, 230, 244-5, *245*
　auction of 'Goods' 28
　buff coat 241, *241*
　doublets *26*, 26, 96, *96*, *97*, *98*, *99*, 101, 102
　Eikon Basilike 89, 90
　Garter riband 89, *90*
　masques 270, 272, 282
　nightcap 114, *114*
　portraits: Mytens 96, *97*, 115, 155, and see below
　sash 249, *250*
　silk vest 87, *87*
　sword 255, *255*
Charles I and Henrietta Maria Departing for the Chase (Mytens) 81, *82*-3
Charles I and Henrietta Maria with their two eldest children... ('The Greate Peece') (van Dyck) *26*, *27*, 28, 90, 91, 115, 144, *145*
Charles I in Three Positions (van Dyck) 87, *88*, 90, 110-11
Charles I, Queen Henrietta Maria, and Charles II when Prince of Wales Dining in Public (Houckgeest) 16, *17*
Charles I with Monsieur de St Antoine (van Dyck) 233, *233*

Charles II 13, 15, 16, 17, *17*, 18, 21, 27, 92, 102, 110, 111, 189, 193, 194, 196, 211, 215, 242, 253, 282
　armour 242, 244, 245, *245*
　Coronation robes 282
　equestrian monument (Gibbons) *256*-7, *257*
　mourning robes 118
　portraits: Vanderbank 90, *90*; Wright 112, 113, *113*, and see below; see also *Marriage of Charles II...*; *Three Eldest Children of Charles I*
Charles II Dancing at a Ball at Court (Janssens) 25, *25*, 46-7, *47*, 48, 64, *65*, 101, *101*, 110
Charles II Presented with a Pineapple (British School) 102, *103*, 113, 189
Charles II when Prince of Wales (Dobson) 245, *245*, 246-7, 248
Charles II when Prince of Wales, with a Page (Dobson) 248, *248*
Charles V, Emperor 190
　Emperor Charles V on Horseback at Mühlberg (Titian) 225, *225*
Charles X, of Sweden: suit *100*, 101, 102
Cheapside Hoard: sapphire pendant 75, *75*
Cheats, The 282, 284
Child in Leading Strings, A (Pantoja de la Cruz) 123, *125*
children's clothes 81, 83, 123, 126, 129, 133, 152
Civil War, English 28, 238, 241, 244, 245, 248, 249, 282
Cleve, Joos van
　Eleanora of Austria 73, *73*, 194, *195*
　Henry VIII 85, *85*, 236, *237*
Cleveland, Barbara Palmer (née Villiers), Duchess of: portraits: Cooper 194, *194*; Lely 180, *181*, 194
cloak bands, men's *see* falling bands
cloaks 106, *107*, 108, *108*
　of Charles X, of Sweden *100*, 101, 102
　Spanish 204
cloth-of-gold/cloth-of-silver 19, 65, 149
cloth-of-silver tissued with gold 150, *152*
coats 102, *102*, *103*
cochineal 161
codpieces 95, *104*, 234
Colbert, Jean Baptiste 212
collars 25; men's 83, 87, *94*, 95, 219; women's 48, 59, 61
colours 25, 161-3
Cooper, Samuel
　Barbara Villiers, Duchess of Cleveland 194, *194*
　Catherine of Braganza 194, *194*
　Frances Teresa Stuart, later Duchess of Richmond 241, *261*, 261-2
　Oliver Cromwell 254
　Unknown Man 261, *261*
Corneille de Lyon 194
cosmetics 77
cotton fabrics 148-9
Coysevox, Antoine: *Louis XIV* 256
Critz, John de 29
　King James VI and I 116, *116*
Crofts, William, Lord (?) 20, 119
Cromwell, Oliver 254
　portraits: Cooper 254; Walker 249

cuffs: men's 83, 87, 253; women's 59, 61
cypress 66

damask fabrics 155, 197, 199
Daniel, Samuel
　Tethys' Festival 268
　A Vision of Twelve Goddesses 275
Darnley, Henry Stewart, Lord 71
　Henry Stewart, Lord Darnley, and his brother Charles Stewart, Earl of Lennox (Eworth) 92, *93*
Darnley Jewel, the 71, *71*
dating portraits 23
Davenant, William: *Love and Honour* 282
Davies, John: *Hynnes of Astraea* 189
décolletage 48
Denbigh, William Feilding, 1st Earl of 220-21
　portrait (van Dyck) 221, *221*
des Granges, David (attrib.): *Catherine of Braganza* 194, *194*
deuil blanc 66
diamonds 72, *73*, 75, 85, 116-17
Dinghen van der Plasse, Mistress 217
Dobson, William
　Charles II when Prince of Wales 245, *245*, 246-7, 248
　Charles II when Prince of Wales, with a Page 248, *248*
Doort, Jacob van
　(attrib.) *Christian, Prince of Brunswick* 81
　(attrib.) *Princess Elizabeth of Brunswick* 42, *44*-*5*, 59, 60
doublets 81, 85, 85, 92, *92*, *94*, 95, *95*, 100, 101, 106, 204
　Charles I's *26*, 26, 96, *96*, *97*, *98*, *99*, 101, 102
　children's 129, 133
drapery 21, 54
drapery painters 177-9
drawers (underwear) 41, 92
drawings, portrait 18, 19, *57*, 65, 182-3
Dryden, John: *The Indian Queen* 277, 280
Duke of York's Players 282
Dürer, Albrecht 29
　Melencolia 108
Dutch Republic *see* Low Countries
Dyck, Sir Anthony van 29, 50, 68, 143, 144, 165, *172*-3, 174, 178, 179, 181
　Charles I and Henrietta Maria with their two eldest children... ('The Greate Peece') *26*, *27*, 28, 90, 91, 115, 144, *145*
　Charles I in Three Positions 87, *88*, 90, 110-11
　Charles I with Monsieur de St Antoine 233, *233*
　Henry, Prince of Wales 230, *230*-31
　Queen Henrietta Maria (c. 1632) 50, *52*, 53, 75, *160*, 161, 172, *173*, 174
　Queen Henrietta Maria (1638; profile) 75, *76*, 137, *138*, 139
　Queen Henrietta Maria (1638) 73, *173*, 173-4
　Sir Robert Shirley 182
　Thomas Killigrew and William, Lord Crofts 20, 21, 119, *119*
　Three Eldest Children of Charles I 131, 133 (1635); 123, *124*, 129, 150 (1635-6)
　William Feilding, 1st Earl of Denbigh 221, *221*
dyes 61-2, 161, *162*

earrings 71, *72*, *162*, 163
East India Company 221
Edgehill, battle of (1642) 245, 248, *249*
Edward IV (British School) 150, 152, *154*, *155*
Edward IV as a Child (Holbein) 152
Edward VI 116, 226
 portrait (attrib. Scrots) 95, *104*, 106, *139*, 139–40, 156
Eikon Basilike, Charles I's *89*, 90
Eleanora of Austria 194
 portrait (van Cleve) 73, *73*, 194, *195*
Elegantly dressed couple on skates, An (Avercamp) 219, *219*
Elizabeth I 13, 18, 19, 26, 28, 41, 42, 64, 110, 180, 182, 188–9, 196, 199, 217, 226, 234, 258
 jewellery 71, 75
 mourning robes 118
 portraits: *The Armada Portrait* 226; British School *14*, 48, *50*, 70; 'Ermine Portrait' (attrib. Hilliard) 116; Hilliard 50, *50*, 140, *142*, 143, 163, 181; *and see below*
 shoes 64
Elizabeth I and the Three Goddesses (Eworth) 34, *36*, 64, *64*, 280, *280–81*
Elizabeth I when a Princess (attrib. Scrots) 41, *43*, 48, *48*, 65–6, 143, 150, *153*
Elizabeth of Bohemia 277
 portraits: Mytens *62*, *63*, 64; Oliver *162*, 163
Elizabeth of Brunswick, Princess: portrait (attrib. van Doort) 42, *44–5*, 59, *60*
embroidery 23, 96, 113, *114*, 155, 165, 168, 170, 189–90, 271, 272 black 162, *see also* blackwork embroidery
ermine 156
Ernest, Archduke of Austria (Sánchez Coello) 105, *106*, 204
Erondell, Peter: *The French Garden* 122
Essex, Robert Devereux, 3rd Earl of 110, 118, 258, *260*
Evelyn, John 262
Eworth, Hans
 Elizabeth I and the Three Goddesses 34, *36*, 64, *64*, 280, *280–81*
 Henry Stewart, Lord Darnley, and his brother Charles Stewart, Earl of Lennox 92, *93*
Eyck, Jan van 143

Fairfax, Sir Thomas 250
falling bands (cloak bands) *87*, *89*, 90, 217, 254
Family Group, A (Graat) 23, *218*, 220
fans 70, *70*
farthingales 15, 41–2, 194
fashion dolls 193, *193*
fashion plates 25, 28, 191
Feather, the (jewel) 116
feathered capes and crown, Tupinamba 277, *278*
filé threads 149, 168, 189
Fitzroy, Henry *see* Richmond, Duke of Flanders
 fashion 215, 217
 lace 61, 219
 see also Flemish School
flax plant *147*, 161
Flemish fashion *see* Flanders
Flemish School *21*, *21*, 85, 86, 129, *129*
foreparts 42
Four Children of ... Rubens, and Helena Fourment with two maids (Fruytiers) *132*, 133
Four Eldest Children of the King and Queen of Bohemia, The (Honthorst) 255–6, *256*

Four Seasons, The (Hollar) 68, *69*
frelange headdresses 68, 81
French fashions 50, 65, 191, 211–12, 214–15, 220
French hoods 65–6
Fruytiers, Philip: *Four Children of ... Rubens, and Helena Fourment with two maids* *132*, 133
furs 156
fustian 148–9

Game of 'Lady Come into the Garden', The (Schalcken) 83, *84*, 85, 90, 111
Garter badges 117, *117*, 233, *233*
gemstones 71, *72*, 73, 75
 painting 163
Gerard, John: *The Herball* 189, 190, 237
German soldiers and armour 236, *236–7*
Germinus, Thomas: *Morysse and Damashin...* *192*, 193
Gheeraerts, Marcus, the Younger
 Anne of Denmark 6, 42, *42*, 59, 71, 75, 155
 Portrait of an Unknown Woman 170, *170*, 270–72, *271*, *273*
Gibbons, Grinling: *Charles II* 256–7, *257*
Giustinian, Sebastian 196–7
Gloucester, Henry Stuart, Duke of 110, 118
gloves, women's 62, *62*, *63*, 64, *70*
gold
 cloth-of-gold 19, 65, 149
 embroidery 113, *114*, 168
 painting 25, 162, 163
 see also jewellery; metal threads
golilla 210
Gower, George
 Lady Elizabeth Willoughby 22
 Sir Francis Willoughby 22
gowns 46, 50; *see also* mantua gowns; nightgowns
Graat, Barent: *A Family Group* 23, *218*, 220
Gramont, Elizabeth Hamilton, Countess of 196
 portrait (Lely) 174, *174*, 175
Gramont, Philibert, comte de 196
grand habit 56, 214–15
Grantham, Henrietta d'Auverquerque, Countess of: portrait (Murray) 54, *56*
'Greate Peece, The' (van Dyck) 26, *27*, 28, 90, 91, 115, 144, *145*
Great George (Vyner; Garter badge) 117, *117*, 233
Great Wardrobe 19, 21
gros point lace 90, *198*, 199, *232*, 233, 252, *253*, 253
Group of Muffs, Kerchiefs..., A (Hollar) 68, 70, *70*
guards (embroidery) 165
Guildford, Sir Henry: portrait (Holbein) 108, *109*, *146*, 148, 149

hairstyles: child's 129; men's 110–11, 113, *see also* wigs; women's 21, 25, 54, 77, 194
Halder, Jacob 230–31
 Design for Sir Christopher Hatton's Armour 234, *234*, 236
Hals, Frans 162
 Portrait of a Man 215, *215*, *216*, 217
Hamilton, James Hamilton, Duke of: portrait (Mytens) 91
Hanneman, Adriaen
 Mary, Princess of Orange 266–7, 277, *279*
 William III when Prince of Orange 222–3, 248, *249*
Harris, Henry 282

Harrison, Major General Thomas 248
Haselrig, Sir Arthur: 'London Lobsters' 244
hat badges 108, 110, *110*, 116
hats 108, *109*, 110
Hatton, Sir Christopher 234
 armour of 234, *234*, *235*, 236
Hayls, John: *Pepys* 181
headrails 66, *67*
headresses, women's 65–6, 68
headwear, men's *see* bonnets; hats
Helmschmid, Kolman: armour 236–7, *237*
Henrietta Maria, Queen Consort 13, 16, *17*, 21, 28, 73, 117, 193–4, 210, 211, 275–6
 jewellery 73, 75, 77
 mica overlays and miniatures *264–5*
 portraits: anon. 211; van Dyck 50, *52*, *53*, 75, 160, 161, 172, *173*, 174 (*c.*1632), 73, *173*, 173–4 (1638), 75, *76*, 137, *138*, 139 (1638, profile); Hoskins 29, *274*, *275*, 276; *see also under Charles I...*
velvet mules 64–5, *65*
Henry VII 7
Henry VII, Elizabeth of York, Henry VIII and Jane Seymour ('Whitehall Mural') (van Leemput) 13, 29, *104*, 106, 234, *234*
Henry VIII 13, 16, 17, 34, 85, 96, 102, 108, 119, 161, 182, 190, 196, 226, 236, 249, 258
 armour 237–8
 inventories 19, 29
 jewellery 108, 110, 116
 masque 269
 portraits: van Cleve *85*, 85, 236, *237*; Horenbout(?) *28*; *see also* 'Whitehall Mural'
 shoes 115
 sumptuary laws 18, 19
Henry Frederick, Prince of the Palatinate: portrait (Flemish School) *21*, 21, 126, *129*
Henry Frederick, Prince of Wales
 armour of 226, *229*, 230, 231
 as Oberon in *The Faery Prince* *285*, 285
 portraits: van Dyck 230, *230–31*; Hilliard 226, *228*, 230; Oliver 226, *227*, *253*, 253
Henry Prince of Wales with Robert Devereux, 3rd Earl of Essex in the Hunting Field (Peake) 106, 110, 118, 258, *260*
herbals *189*, 190, 237
Heriot, George 71, 116
Heron, Cicely: portrait (Holbein) 54, *54*
Herrick, Robert: 'Upon a black twist...' 77
Hilliard, Nicholas 22, *143*, 163, 181
 The Art of Limning 163
 Elizabeth I (*c.*1560–65) 50, *50*
 Elizabeth I (*c.*1595–1600) 140, *142*, 143, 163
 Elizabeth I ('Ermine Portrait'; attrib.) 116
 Henry Prince of Wales 226, *228*, 230
 Mary, Queen of Scots 22
 pendant with miniature of Elizabeth I *72*, 72
 Portrait of a Lady, perhaps Penelope, Lady Rich 33
 Queen Elizabeth in Robes of State 163
Hogarth, William 178
Holbein, Hans, the Younger 29, 182, 237
 Anne Boleyn 54, 57, 65
 Anne of Cleves 197
 Cicely Heron 54, *54*
 Edward IV 152
 Henry Brandon, 2nd Duke of Suffolk 155, *156*
 Jane Seymour 41, *183*
 Lady Ratcliffe 65, 66, *1823*, 183

Portrait of a Lady, perhaps Katherine Howard 23, *23*, 156
Sir Henry Guildford 108, *109*, *146*, 148, 149, 152
Thomas, 2nd Baron Vaux 18, 19
Thomas Howard, 3rd Duke of Norfolk 168, *168*, 169
William Parr, later Marquess of Northampton 19, 182, *183*
Holbein stitch 168
Hollar, Wenceslaus 68
 Aula Veneris 190–91, *191*
 The Four Seasons 68, *69*
 A Group of Muffs, Kerchiefs, Fans, Gloves and a Mask 68, 70, *70*
 Theatrum Mulierum (The Theatre of Women) 68
Holme, Randle 92
Honthorst, Gerrit van 50
 The Four Eldest Children of the King and Queen of Bohemia 255–6, *256*
hoods, women's
 English or gable 35, 65, *66*
 French 65–6
hooks and eyes 41, 96
Hopfer, Daniel: *Five German Soldiers* 236, *236*
Horenbout, Lucas
 Henry VIII 28
 Henry Fitzroy, Duke of Richmond and Somerset 85, *86*, 113
Horn, Clemens: sword blade 255, *255*
hose 41, *see* stockings
Hoskins, John
 Queen Henrietta Maria 29, *274*, *275*, 276
Houckgeest, Gerrit: *Charles I, Queen Henrietta Maria, and Charles II when Prince of Wales Dining in Public* 16, *17*
Howard, Lady Frances 62
Howard, Katherine: portrait (Holbein) 23, *23*, 156
Huguenots 212
hunting 258
Huysmans, Jacob: *Frances Stuart, later Duchess of Richmond* 241, *242*, 242,

Ibach, Josias: *Charles II* 256–7, *257*
Indian gowns 54
indigo 161
Infanta Isabella Clara Eugenia... (Pourbus) 204, 205, *206–7*, 208
inventories 19, 29
Isabella Clara Eugenia and Catharina, Daughters of Philip II... (Sánchez Coello) 130
Italian fashions 90, 197, 199–200

Jabach, Everhard 178
James I (VI of Scotland) 15, 16, 18, 71, 116, 180, 210, 231, 261, 282
 hat badge 116
 masques 270
 portraits: British School 106, 108, *108*; de Critz 116, *116*; van Somer 231, *231*
James II (*formerly* Duke of York) 15, 110, 111, 119, 123, *124*, 129, 215, 238, 282
 portraits: A. Killigrew *91*, 91; *see also Three Eldest children of Charles I and below*
 wedding bed 262
 wedding suit 262, *262*
James II, when Duke of York, with Anne Hyde, Princess Mary ... and Princess Anne (Lely) 123, *126*

INDEX 297

Janssens, Hieronymus: *Charles II Dancing at a Ball at Court* 25, *25*, 46–7, *47*, 48, 64, 65, 101, *101*, 110, 254, *254*
jerkins *105*, 106, 170, *171*, 172, 204
jewellery 23, 29, 71, 71–3, *72*, 75, *75*, *76*, 77, *116*, 116–17, *117*
 Henry VIII's 108, 110, 116
 painting 162–3
Johnson, Cornelius 143
 The Capel Family 91
 Portrait of a Lady 58, 59, 71, 72, *72*, 143, *144*
Joinville, Claude de Lorraine, Prince de 226
Jones, Inigo 29
 Masque of the Middle Temple 277
 masques 269, 270, 272, 275
 Prince Henry as Oberon 285, *285*
 Tempe Restor'd 275, 275–6, 284
Jonson, Ben 269
 The Devil is an Ass 217
 Every Man out of his humour 59
 The Masque of Beauty 270, 276
 On English Monsieur 187
jump (riding coat) 258, 261

Killigrew, Anne: *James II* 91, *91*
Killigrew, Thomas 21
 Thomas Killigrew and William, Lord Crofts (van Dyck) *20*, 21, 119, *119*
King's Company of Comedians 282
Kirke, George: marriage 114
kirtles 39
Kneller, Godfrey
 'Hampton Court Beauties' 177
 Mary II 157, *157*, *159*

lace 15, 18
 black 162
 bobbin 61, 90, 140, *140*, 219, *276*
 bone 61
 collars and cuffs 59, *60*, 61, 87, *88*, *89*, 90
 colouring/dyeing 61–2, 161
 cutwork 61, 129
 gros point (needle lace) 90, *198*, 199, 219, 252, *253*, *253*
 needle 61, 199, *253*, see also *gros point*
 painting 140, *141*, 143
 punto in aria 61, 199
 woven from hair 72
Lacy, John 282
 portrait (Wright) 282, *283*, 284
Landsknechte (German soldiers) 236, *236*
lapis lazuli 22, 161
Laughing Child, possibly Henry VIII (Mazzoni; terracotta) 128, *129*
lawn 148
Lawson, Sir John 238
 portrait (Lely) 238, *239*, 241, 249, 255
leading strings 123, *125*
Le Brun, Charles: Versailles ceiling paintings 256
Lee, Sir Henry 231
Leemput, Remigius van: *Henry VII, Elizabeth of York, Henry VIII and Jane Seymour* 13, 29, *104*, 106, 234, *234*
Leicester, Robert Dudley, Earl of 28
Lely, Sir Peter 161, 172, 174, 179, 181, 277
 Anne Digby, Countess of Sunderland 178, *179*
 Barbara Palmer (née Villiers), Duchess of Cleveland, with her son, as Madonna and Child 180

Eleanor Needham, Lady Byron 176, *177*
Elizabeth Hamilton, Countess of Gramont 174, *174*, *175*
Elizabeth Wriothesley, Countess of Northumberland 180
Frances Stuart, later Duchess of Richmond 178
James II, when Duke of York, with Anne Hyde, Princess Mary ... and Princess Anne 123, *126*
Mary II when Princess of Orange 15, *15*
Sir John Lawson 238, *239*, 241, 249, 255
'Windsor Beauties' series 178, *178*, *179*
Lennox, Lady Margaret Douglas, Countess of 71
Lennox, Charles Stewart, Earl of see under Darnley, Lord
Lennox, Ludovick Stuart, 2nd Duke of: portrait (studio of Mytens) *107*, 108, 113–14, *114*, 115, *115*
Lesser George (Garter badge) 117, 233, *233*
Letter, The (ter Borch) *134–5*, 137, 149, *151*
Ligne, Claude Lamoral, Prince de 110
linen 17, 28, 83, 87, 147–8, 161, 187, 217
 bleaching 148
 caps 57, 65, 66
 Holland 217
 nightcap 113–14, *114*
 painting 22
 ruffs 58, 59, *59*
 smocks 33, 34, *37*
 underwear 34, *56*
linseed oil 161
lockets 72
Lord and Lady Clapham (dolls) 193, *193*
Lord Mayor's Water-procession on the Thames, The (British School) 16, *16*
Lorica squamata (armour) 257
Lotto, Lorenzo: *Andrea odoni* 199
Louis XIV, of France 56, 119, 193, 194, 197, 211, 212, 214, 256, 257
Louis, the Grand Dauphin... (after Mignard) *212*, *212*, *214*
lovelocks 72, 110–11
Low Countries: fashion 50, 215, 217, 219–20
Lowestoft, battle of (1665) 238
lynx fur 156
Lyon, France: silk industry 212

madder plant 161
Man in Red see *Portrait of a Man in Red*
Man seen from behind, A (Bosse) 29, *29*
'Mancini Pearls', the 75, 77
mantles (as masque dress) 272, 275
Mantua, Guglielmo Gonzaga, Duke of 203
mantua gowns 54, *56*, *56*, 81, 214
Margaret of Austria 197
 portrait (Pantoja de la Cruz) *10–11*, 23, 24, 25, 75, 208, *208*, *209*
Maria Teresa, Infanta 193, 194
Marlborough, John Churchill, 1st Duke of 250, *250*
Marlborough, Sarah Churchill, Duchess of 28
Marriage of Charles II and Catherine of Braganza, The (Chantry) 92, *95*, 115
Mary I 21, 75, 119, 208
 portrait (after Mor) 34, 39, *39*, 75, *76*, 203, *203*
Mary II (*formerly* Princess of Orange) 15, 62
 account book 29
 patch box 77, *77*

portraits: after Bonnart 54, *56*, 77, *77*, 191; Kneller 157, *157*, *159*; Lely 15, *15*, 13, *126*; Wissing 156, *157*, 158, 177, *177*
Mary of Modena 282
 portrait (Verelst) 262, *263*
Mary, Princess of Orange 27, 47, 123
 portrait (after Hanneman) *266–7*, 277, 279; see also *Three Eldest Children of Charles I*
Mary, Queen of Scots: portraits: Clouet 66, *67*, 68; Hilliard 22
Mary Tudor, sister of Henry VIII 197
masks 68, 70, *70*
Masque of Blackness, The 276
masque portraits 274, 275–7
masques 269–70, 280
 dresses 29, 270–2, *271*, 274, 275, 276–7, 280
maternity clothing 53–4
Maurits, Count Joham 277
Mazarin, Cardinal Jules 75
Mazzoni, Guido: *Laughing Child, possibly Henry VIII* 128, *129*
Medici, Catherine de' (Pilon; bronze) 28
Medici, Don Garzia de': doublet and trunkhose 92, *92*
Medici, Marie de' 77, 194
Mercure Galant, Le (periodical) 211
metal threads 28, 47, 149, 155, 168, 170, 189, 272
Mignard, Pierre (after)
 Elisabeth Charlotte, Duchess of Orléans... 212, *213*
 Louis, the Grand Dauphin of France... 212, *212*, *214*
Milan bonnets 108, *109*
millstone collars 219
miniver 156
Mirror of Great Britain (jewel) *116*, 116–17
Mirror of Portugal (diamond) 75
Molière: *Le Bourgeois Gentilhomme* 221
Mor van Dashorst, Anthonis (after) 202
 Joanna of Austria 196
 John, Prince of Portugal 196
 Mary I 34, 39, *39*, 75, *76*, 203, *203*
Moreelse, Paulus: *Portrait of a Young Boy* *120–21*, 123, 126, *127*
mourning dress: men's 20, 21, 118–19, *119*; women's 66, *67*
mourning jewellery 73
muffs 68, 70, *70*
mules, velvet 64–5, *65*
Murray, Thomas: *Henrietta d'Auverquerque, Countess of Grantham* 54, *56*
Mytens, Daniel 29
 Charles I 96, *97*, 115, 155
 Charles I and Henrietta Maria Departing for the Chase 81, *82–3*
 Christian, Duke of Brunswick and Lüneburg 249, *251*
 Duke of Hamilton 91
 Elizabeth, Queen of Bohemia 62, *63*, 64
 Henrietta Maria 75
 Ludovick Stuart, 2nd Duke of Lennox and Duke of Richmond *107*, 109, 113–14, *114*, 115, *115*

neckwear, men's *see* collars; falling bands
Netherlands *see* Low Countries
Netscher, Casper 181, 220

New Model Army 250
Newcastle, Margaret Cavendish, Duchess of 77
nightcaps, men's 28, 85, *86*, *107*, 113–14, *114*, 170
nightgowns: men's *106*, 108; women's 54, *56*, 174
Norfolk, Thomas Howard, 3rd Duke of: portrait (Holbein) 168, *168*, *169*
Northampton, William Compton, Earl of: portrait (?) (British School) 111, *111*
Northampton, William Parr, Marquess of: portrait (Holbein) 19, 182, *183*
Northumberland, Elizabeth Wriothesley, Countess of: portrait (Lely) 180, *181*

oes *see* spangles
Oliver, Isaac 163
 Anne of Denmark (c.1610) 270, *270*
 Anne of Denmark (c.1611–12) 71, *71*, 163, *163*
 Henry Frederick, Prince of Wales 226, 227, 253, *253*
 Princess Elizabeth, later Queen of Bohemia 162, *163*
 Unknown Lady as Flora 276
 A Young Man Seated under a Tree 94, *95*, 119
Order of the Garter 9, 117
 badges 117, *117*, 233, *233*
Orléans, Elisabeth Charlotte, Duchess of: portrait (after Mignard) 212, *213*
Orléans, Philippe, duc de 211
Overbury, Sir Thomas 62
overgowns 50

painting techniques
 for armour 162
 for clothing 33, 137, 139–40, 143
 contrasting styles 143–4
 for drapery 177–9
 for fabric types 22, 25, 144, 147–50, 152, 155–7
 for folds in fabrics 139, 157
 for gemstones and jewellery 29, 162, 163
 for gold 162–3, 168
 for lace 140
 for patterns 152, 155, 165
 see also colours
panel paintings 137
panes/paning 50, 96
pantofles 64
Pantoja de la Cruz, Juan
 A Child in Leading Strings 123, *125*
 Margaret of Austria *10–11*, 23, 24, 25, 75, 208, *208*, *209*
 Philip III, King of Spain 208
Paris, John de 196
Paris head (cap) 66
partlets 48
patch box, Queen Mary's 77, *77*
patches 77
pattern books 191, 193
 lace 199
patterns 150, 152, 165
Peacham, Henry: *The Compleat Gentleman* 161, 162
Peake, Robert
 Henry, Prince of Wales 106
 Henry, Prince of Wales with Robert Devereux, 3rd Earl of Essex in the Hunting Field 110, 258, *260*
pearls 75, *76*, 77, 85
 painting 163

Pembroke, Philip Herbert, 4th Earl of: portrait (van Dyck) 248
pendants 23, 71–2, 72, 75, 75
Pepys, Samuel 15, 29, 77, 80, 102, 111, 113, 118, 182, 191, 194, 241, 262, 284
　funeral 118
　portrait (Hayls) 181
Peregrina, La (pearl) 75, 76, 208
periwigs 111, 113
petticoat breeches 92, 95, 102, 103
petticoats 42
Philip II, of Spain 75, 202, 203, 204, 208
　portrait (after Mor) 170, 171, 172
Philip III, of Spain 208
　portrait (Pantoja de la Cruz) 208
Philip IV, of Spain 208, 210
　portrait (Velázquez) 208, 210, 210
Philip the Good, Duke of Burgundy 116
picadils see supportasses
Pilon, Germain: Catherine de' Medici 28
pinking 53, 170
pins 41
placards 53
pomanders 68
pomegranate design 124, 149, 150, 155, 197, 198
Portrait of a Lady (?Katherine Howard) (Holbein) 23, 23
Portrait of a Lady (Johnson) 58, 59, 71, 72, 72, 143, 144
Portrait of a Lady in Green (Bronzino) 200, 200, 201
Portrait of a Man (Hals) 215, 215, 216, 217
Portrait of a Man in Red (Flemish School?) 85, 86, 192, 193, 254
Portrait of an Unknown Woman (Gheeraerts) 170, 170, 270–72, 273
Portrait of a Woman (British School, c.1605–10) 74, 75
Portrait of a Woman (British School, c.1620) 54, 55, 62, 165, 165, 168, 189
Portrait of a Young Boy (Moreelse) 120–21, 123, 126, 127
Portrait of a Young Girl (British School) 188, 190
Portsmouth, Louise de Kérouaille, Duchess of 211
Pourbus, Frans, the Younger 29
　The Infanta Isabella Clara Eugenia… 204, 205, 206–7, 208
'pregnancy portraits' 54, 54
prints 25, 28–9, 29, 68, 69, 90, 90, 92, 95
Prynne, William 111; The Unloveliness of LoveLocks 111
pudding hats 133
punto in aria (needle lace) 61, 199
Puritans 248
purses 68, 68

Quakers 110

rapiers 254–5
Ratcliffe, Lady Mary: portrait (Holbein) 65, 66, 182–3, 183
rattles, children's 123, 126, 127
rebatos see supportasses
Rembrandt van Rijn 181, 215
　Agatha Bas 48, 49, 61, 70, 140, 141, 144, 219, 220
　Portrait of Jan Six 144

Restoration theatre 282, 284–5
ribbons 23, 50, 56, 92, 96, 97, 101
　Charles I's 'Garter riband' 89, 90
　as love tokens 72–3
Rich, Penelope, Lady: portrait(?) (Hilliard) 33
Richmond, Henry Fitzroy, Duke of (Horenbout) 85, 86, 113
Richmond, Lady Mary Howard, Duchess of 85
Richmond, Frances Stuart, Duchess of 211, 241, 242
　portraits: Cooper 241, 261, 261–2; Huysmans 241, 242, 242, 243; Lely 178
riding 258
riding coats 258, 261
Robinson, Thomas 91
Rose, John 102, 113, 189
Rubens, Peter Paul 182
　Robin, the Dwarf of Earl of Arundel 182
Rudolf, of Austria (Sánchez Coello) 105, 106, 204
ruffs: men's 83–87, 216, 217, 253, 253; women's 58, 59, 59, 61–2
Rupert, Prince 255
Rustat, Tobias 256

sabatons 234, 234
sable 156
saffron 62, 161
Salmacida Spolia (masque) 282
Sánchez Coello, Alonso 177, 202
　Archduke Ernest of Austria 105, 106, 204
　(attrib.) Isabella Clara Eugenia and Catharina, Daughters of Philip II… 130
　Rudolf, Emperor of Austria 105, 106, 204
Sancy, Nicolas de Harlay, seigneur de 116, 117
Sandwich, Edward Montagu, Earl of: sketch of vest and coat 102, 102
sashes, coloured silk 248–9, 250
satin 53, 149
　painting 22
Sancy Diamond 116
Schalcken, Godfried: The Game of 'Lady Come into the Garden' 83, 84, 85, 90, 111
Scrots, William
　(attrib.) Edward VI 95, 104, 106, 139, 139–40, 156
　(attrib.) Elizabeth I when a Princess 41, 43, 48, 48, 65–6, 143, 150, 153
Sea Triumph of Charles II, The (Verrio) 257, 257
Seymour, Lady Jane: portraits (Holbein) 41, 65
Shakespeare, William 269
　Hamlet 12, 284
　Henry IV, Part I 224
　Henry IV, Part II 83
　Henry V 282
　Measure for Measure 150
　The Merchant of Venice 187
　The Merry Wives of Windsor 34
　Othello 190
　The Taming of the Shrew 32, 282
　The Tempest 282
shifts, women's 34, 83, see also smocks
Shirley, Sir Robert: portrait (van Dyck) 182
shirts 83, 84, 85, 86, 87
shoes 25; men's 81, 102, 102, 115, 115, 118, 212, 212; women's 64–5, 65
silks 87, 87, 147, 149–50, 152, 165, 187, 197, 199
　black 77
　French 212
　shot 155

silver
　cloth of 149, 150, 152
　painting 162, 163
sinnepoppen (Visscher) 41
sitters/sitting for portraits 25–6, 180–81
skirts 15, 28, 39, 42, 46, 47, 50
slashing 33, 85, 95, 96, 106, 162, 170, 171, 172
sleeves: men's 96; women's 34, 39, 39, 46, 47, 48, 50, 53, 64, 208
slops (trunk-hose) 95
Smith, Marshall: The Art of Painting 136, 157, 161
smocks, women's 33, 34, 37, 38, 39, 200
Somer, Paul van
　Anne of Denmark 208, 258, 259
　James VI and I 231, 231
Sommi, Leone de' 272, 275
Sorceau, Claude 196
South, Robert: swords 255
Southampton, Elizabeth Vernon, Countess: portrait (anon.) 41, 41
spangles 50, 170, 272
Spanish fashions 50, 194, 197, 202–4, 204, 208, 210–11
sports, courtly 269
sprezzatura 144
starch 217
stays 39, 41; children's 123, 133
Steen, Jan: Woman at her Toilet 30–31, 40, 41, 64, 156
stockings: men's 15, 90–91, 91, 92, 93, 95; women's 40, 41
stomachers 48, 50, 53, 54
Stoop, Dirck: Catherine of Braganza 194
Stradanus, Johannes: Women Winding Silk 147, 147
Strafford, Thomas Wentworth, 1st Earl of 233
Stuart, Frances Teresa see Richmond, Duchess of
Suffolk, Henry Brandon, 2nd Duke of: portrait (Holbein) 155, 156
suits, threepiece 15, 102
sumptuary laws 17–19, 172
　French 212
　Spanish 208, 210
Sunderland, Anne Digby, Countess of: portrait (Lely) 178, 179
supportasses 59, 61
swords 254, 254–5, 255

tabby weave 149
taffeta 161
Tempe Restor'd (Jones) 275, 275–6, 284
ter Borch, Gerard 181
　The Letter 134–5, 149, 151
Theatre Royal, London 282
thistles (motifs) 150, 152, 154, 155
Three Brothers, the (jewel) 116, 117
Three Eldest Children of Charles I (van Dyck) 131, 133 (1635); 123, 124, 129, 150 (1635–6)
Titian 144, 182
　Emperor Charles V on Horseback at Mühlberg 225, 225
　Portrait of the Duchess of Urbino 181
Townshend, Mary: marriage 114
tricorne hat 110
trunkhose 90, 91, 92, 92, 94, 95
Tupinambá feathered capes and crown 277, 278
Turner, Anne 62
Turquet de Mayerne, Théodore 162

ultramarine 22, 161
undercaps 57, 65
underproppers see supportasses
undersleeves 96, 97
underwear 34, 56, 92
Unknown Lady as Flora (Oliver) 276
Unknown Man (Cooper) 261, 261
Urban VIII, Pope 90

Vanderbank, Peter: Charles II 90, 90
Variety, The 282, 284
Vaux, Thomas, 2nd Baron: portrait (Holbein) 18, 19
Velázquez, Diego 144, 194
　Philip IV, King of Spain 208, 210, 210
velvets 26, 150, 157, 157, 159, 197, 198, 199
Venetian lace 61, 90, 199, 233
Venetians (breeches) 92
Verelst, Simon: Mary of Modena, when Duchess of York 262, 263
Vermeer, Jan 29
　Girl with a Pearl Necklace 181
Verney, Sir Edmund 244
Verrio, Antonio: The Sea Triumph of Charles II 257, 257
vests 87, 87, 102, 102
Visscher, Roemer: Sinnepoppen 41
vizards 68, 70, 70
Vyner, Robert: Great George (Garter badge) 117, 117

waistcoats, women's 54, 55, 164, 165, 165, 166, 167, 168, 271
Walker, Robert: Oliver Cromwell 249
Wallhausen, Johann: Art militaire a cheval 244, 244
Walpole, Horace 28
Wardrobe of the Robes 19
weaving fabrics 149–50
Whitehall, Palace of 16, 16
'Whitehall Mural, The' 13, 29, 104, 106, 234, 234
wigs 15, 111, 113
William III 15, 110, 119, 233, 258
　portraits (as Prince of Orange): de Baen 258, 258; Hanneman 222–3, 248, 249; Wissing 232, 233, 252, 253
　silk stockings 91, 91
Willoughby, Lady Elizabeth: portrait (Gower) 22
Willoughby, Sir Francis: portrait (Gower) 22
Wilton Anime armour 238
Wissing, Willem
　Mary II when Princess of Orange 156, 157, 158, 177, 177
　William II when Prince of Orange 232, 233, 252, 253
Wolsey, Cardinal Thomas 16
Woman at her Toilet (Steen) 30–31, 40, 41, 64, 156
Wood, Antony à 261
wool fabrics 144, 147, 149, 188–9
Wright, John Michael 29, 179
　Charles II 112, 113, 113
　John Lacy 282, 283, 284
Wriothesley, Sir Thomas: The Wriothesley Garter book 250, 250

York, Duke of see James II
Young Boy, A (Flemish School) 129, 129, 133
Young Man Seated under a Tree, A (Oliver) 94, 95, 119

INDEX 299

Written by Anna Reynolds.
Published by Royal Collection Trust / © HM Queen Elizabeth II 2013. Reprinted 2013

All rights reserved. Except as permitted under current legislation no part of this work may be photocopied, stored in a retrieval system, published, performed in public, adapted, broadcast, transmitted, recorded or reproduced in any form or by any means without the prior permission of the copyright owner.

ISBN 978 1 905686 44 5

British Library Cataloguing in Publication Data:
A catalogue record for this book is available from the British Library

014447

DESIGNED BY Raymonde Watkins
EDITED BY Miranda Harrison
PROJECT MANAGED BY Nina Chang
PRODUCTION MANAGED BY Debbie Wayment
TYPESET IN Trajan Pro, MillerDisplay and Myriad Pro
PRINTED ON Gardamatt 150gsm
COLOUR REPRODUCTION BY Altaimage, London
PRINTED BY Graphicom srl, Italy

Unless otherwise stated all works reproduced are © HM Queen Elizabeth II 2013. Royal Collection Trust is grateful for permission to reproduce the following:

Figs 14, 94 Private Collection
Fig. 22 The Metropolitan Museum of Art. Photo © Janet Arnold
Figs 25, 119 The Collection of the Duke of Buccleuch and Queensberry
Figs 24, 39, 48, 131, 141, 174, 175, 182, 186, 215, 220, 229, 245, 247, 260 © Victoria & Albert Museum, London
Figs 31, 54, 68, 80, 110 © Museum of London
Fig. 35 © National Museums of Scotland
Fig. 43 Courtesy of Christie's
Figs 45, 64, 189, 192 © The Metropolitan Museum of Art/Art Resource/Scala, Florence 2013
Fig. 46 © Bayerisches Nationalmuseum
Fig. 50 The Glove Collection Trust / Photographed by Matthew Hollow
Figs 82, 183, 233, 235, 255 © The Bowes Museum, Barnard Castle, UK. The Blackborne Lace Collection
Fig. 87 Royal Ceremonial Dress Collection
Fig. 89 © Palazzo Pitti
Figs 91, 105, 140 Courtesy of Yale University Press
Fig. 96 © Royal Armoury of Sweden
Fig. 97 © The British Library Board 10807.e.9 opp.pg 284 Pl V
Fig. 112 © Museum of London. Lent by Meg Colbourn and Family
Fig. 114 © Historisches Museum Basel
Figs 115, 227 © Scottish National Portrait Gallery
Fig. 125 Galleria Sabauda, Turin; photo © Scala, Florence 2013
Fig. 164 © National Portrait Gallery, London
Fig. 152 Courtesy of the Fashion Museum, Bath and North East Somerset Council / Photographed by Matthew Hollow
Fig. 200 © National Gallery, London
Fig. 201 © Museo Nacional del Prado
Fig. 216 Deutsches Historisches Museum, Berlin
Fig. 218 Kunsthistorisches Museum, Vienna
Fig. 221 © Lord Acton
Fig. 226 © Royal Armouries
Figs 253, 262 © Devonshire Collection, Chatsworth. Reproduced by permission of Chatsworth Settlement Trustees.
Figs 257, 258 © National Museum of Denmark

White leather gloves dyed mushroom brown, trimmed with ribbons, c.1660–90.

Worshipful Company of Glovers of London, Acc. 233681 + A © The Glove Collection Trust
Photographed by Matthew Hollow

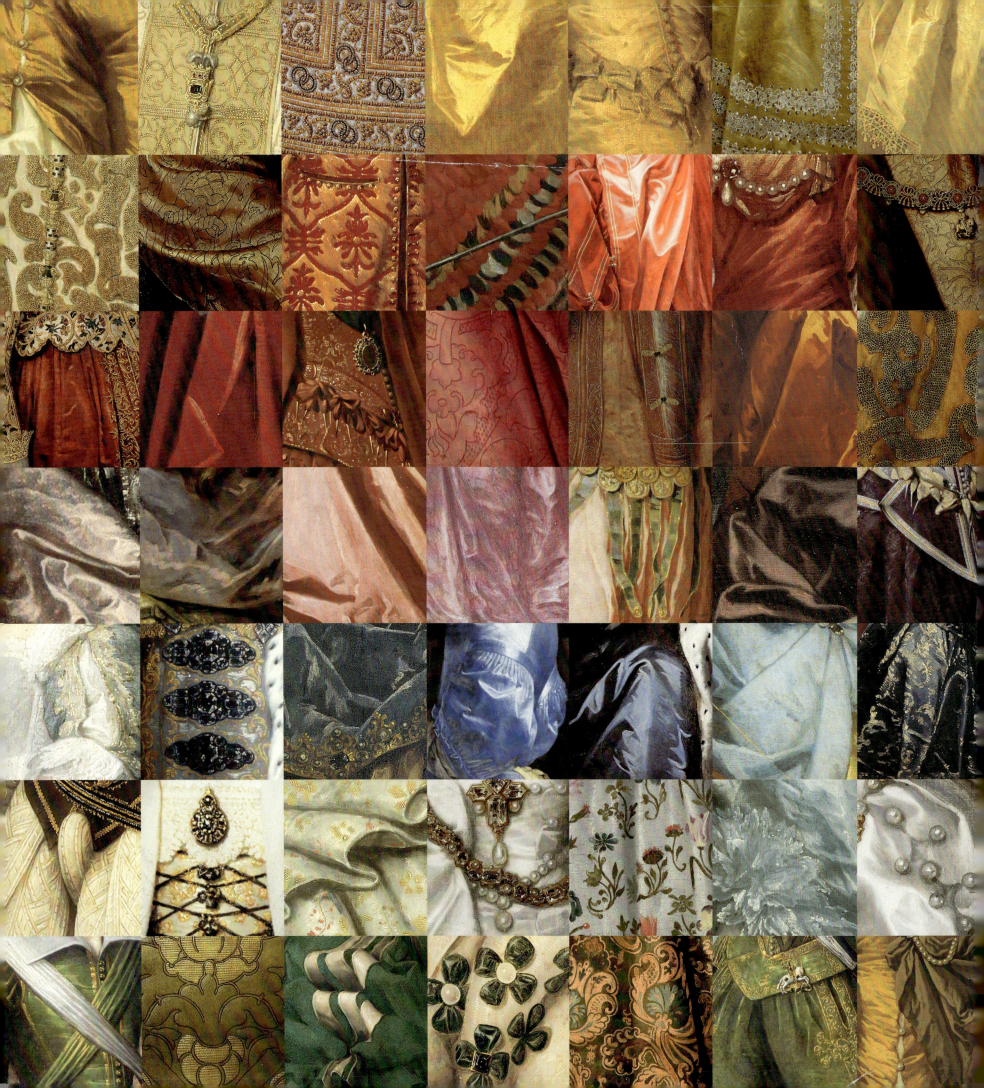